BRITISH ARTISTS AND THE MODERNIST LANDSCAPE

BRITISH ART AND VISUAL CULTURE SINCE 1750
New Readings
General Editor: David Peters Corbett, University of York

This series examines the social and cultural history of
British visual culture, including the interpretation of individual
works of art, and perspectives on reception, consumption and display.

In the same series

The Emergence of the Professional Watercolourist
Conventions and Alliances in the Artistic Domain, 1760–1824
Greg Smith

The Quattro Cento and *Stones of Rimini*
A Different Conception of the Italian Renaissance
Adrian Stokes

Difficult Subjects
Working Women and Visual Culture, Britain 1880–1914
Kristina Huneault

Memory and Desire
Painting in Britain and Ireland at the Turn of the Twentieth Century
Kenneth McConkey

Art and its Discontents
The Early Life of Adrian Stokes
Richard Read

British Artists and the Modernist Landscape

Ysanne Holt

ASHGATE

Published by
Ashgate Publishing Limited
Gower House
Croft Road
Aldershot
Hants GU11 3HR
England

Ashgate Publishing Company
Suite 420
101 Cherry Street
Burlington, VT 05401-4405 USA

Ashgate website: http://www.ashgate.com

British Library Cataloguing in Publication Data
Holt, Ysanne
 British artists and the modernist landscape. –
(British art and visual culture since 1750:new
readings)
 1.Landscape painting, British – 19th century
 2.Landscape painting, British – 20th century
 I.Title
 758.1'41

Library of Congress Cataloging-in-Publication Data
Holt, Ysanne.
 British artists and the modernist landscape /
Ysanne Holt.
 p. cm. – (British art and visual culture since
1750, new readings)
 Includes bibliographical references.
 ISBN 0-7546-0073-4 (alk. paper)
 1. Landscape painting, British – 20th century.
 2. Painting, Victorian – Great Britain. 3. Painting,
Edwardian – Great Britain. I. Title. II. Series.

ND1354.6 .H65 2003
758'.1'09410904–dc21
 2002027774

ISBN 0 7546 0073 4

Printed on acid-free paper.

Typeset in Palatino by Manton Typesetters, Louth,
Lincolnshire, UK and printed and bound in Great
Britain by Biddles Ltd, Guildford and King's Lynn.

Contents

Illustrations

Acknowledgements

The content of this book has been a major preoccupation for me since the mid-1990s when, as a PhD student at the University of Northumbria, I first began to examine the relationship between modernity and modernism, landscape painting and the culture of ruralism in Britain from the end of the 19th century up to the eve of the Great War. One of the most significant moments in terms of my particular 'rethinking' of that relationship came through my involvement in an extremely timely conference at the University of York in 1997 – 'Rethinking Englishness: English Art, 1880–1940'. This event very usefully reconsidered enduring assumptions that the concerns of national identity and of supposedly native traditions – as they emerged within British art of the period – were of necessity antithetical to the ambitions of modernism. *British Artists and the Modernist Landscape* is an attempt to think through the implications of those forms of questioning in terms of a specific, small group of artists' depictions of the actual or imagined rural scene.

Four of these chapters are drawn and revised from previous publications. The 'Poetry of the Peasant' appeared in embryo as a brief essay in 'British Impressionism', a catalogue of an exhibition by Kenneth McConkey, which travelled to Japan in 1997. 'The Joys of Sight' is a revised version of an article 'Nature and Nostalgia: Philip Wilson Steer and Edwardian Landscapes', published in *Oxford Art Journal* (Vol. 19, no. 2) in 1996. My thanks to Andrew Hemingway for extremely helpful editorial advice on that occasion. A version of 'An Ideal Modernity: Spencer Gore at Letchworth' is included in a collection of papers from the York conference, *The Geographies of Englishness, Landscape and the National Past, 1880–1940*, edited by David Peters Corbett, Fiona Russell and myself and published by Yale University Press in 2002. The extended material here on Augustus John has evolved through several research papers. I particularly need to thank Simon Faulkner for his response to a paper on John's Martigues paintings, which I gave at a research seminar at Manchester Metropolitan University in June 2001. A version of that paper is included in a themed issue of the journal *Visual Culture in Britain* on 'Travel and Exoticism' (edited by Simon Faulkner), Vol. 4, no. 2, Spring 2003.

For their conversation and constructive comment I am also indebted to David Peters Corbett, both in his role as co-editor of *The Geographies of*

Englishness and as series editor here, also to Fiona Russell, to William Vaughan and Christiana Payne, to Tom Jennings and particularly to Kenneth McConkey. My thanks are due to the public collections, private owners and artists' descendants for permission to reproduce paintings. I should also thank Pamela Edwardes and the editorial staff associated with Ashgate Publishing.

YH

In memory of my mother and father, Moyra and Ian Holt.

Landscape and modernity

In 1904, in an unprecedented foray into the field of contemporary painting, *The Connoisseur* published a survey on the current state of 'Landscape in England'. The author, Adam Palgrave, characterized the range of work currently being produced. Alfred East, for example, 'has a certain voluptuousness of line which is very grand and imposing'. Philip Wilson Steer 'is interesting, but too self-conscious, often amusing in his endeavours to be peculiar'. Ernest Waterlow is 'intensely English, dreams of moorland roads, green sheltered pastures, and lonely churches', and so on. Individual painters could now be perceived in terms of specific schools, like 'the Vibrant School' of Mark Fisher which, 'sprang by way of Corot and Diaz, through Monet and the French Impressionists, and had arrived with a good footing into English landscape art'. Then there were those painters most favoured by Palgrave, like George Clausen and Henry Herbert La Thangue, who people the landscape with 'the figures of the country'. The 'village painters, by the sea and in the country' like Stanhope Forbes, are rather too prosaic and journalistic, and fellow Newlyn painter Frank Bramley 'has painted one picture and many canvases'. Older artists like the still practising Benjamin Williams Leader, are to be dismissed: 'They are the producers of nature's fashion plates, the high priests of the common place, the chatterers in holy places.' With these exceptions, Palgrave was proud of the national school of landscape; each aspect of rural England now had its 'poet and its painter', and its members were able to 'arrest the winds, stay the sun in its course, halt the growing flower, putting them down in paint for the freshening of our tired eyes and jaded brains. So is England painted, so are we the better for it'.[1]

By the turn of the century in England, the sheer abundance of landscape paintings and rural scenes to be viewed in popular exhibitions at the Royal Academy, at alternative venues like the Royal Society of British Artists, the New English Art Club and the Society of Landscape Painters, and at the proliferating provincial galleries, illustrates the extent to which those painters engaged in representing the countryside were producing images that were essentially fantasies and were endlessly appealing.[2] Landscape, of course, is never a neutral absolute to be viewed objectively. As Palgrave's commentary

demonstrates, it is an aesthetic category, and one writer has remarked that landscape in itself simply cannot exist, it can only be perceived: 'no-one ever digs the landscape or, as he falls into a peat-bog, damns the landscape for the dirt and the wet'.[3] For W. J. T. Mitchell, outlining recent approaches to the subject, 'landscape as a cultural medium … naturalizes a cultural and social construction, representing an artificial world as if it were simply given and inevitable'.[4] So Mitchell's aim was to change the word itself from a noun to a verb, to think landscape 'not as an object to be seen or a text to be read, but as a process by which social and subjective tendencies are formed'.[5]

The painters Palgrave identified offered framable views of nature, within the same sets of values and assumptions as the particular middle-class urban markets on which they depended for their livelihood and critical acclaim. Showing regularly at London or provincial exhibitions and illustrated in periodicals, their works shaped knowledge and opinion on the country from within the city. There is, in this respect, a circuitous relationship between the perceptions of the countryside amongst painters, purchasers, spectators and tourists. One crucial, common element in this relationship is the determined avoidance of modern rural conditions. As Raymond Williams once observed, there is an important distinction between 'a real history of the land and an ideological history of landscape'.[6] To extend his remark to its rightful conclusion, the history of landscape painting has indeed been deeply duplicitous.

One focus here is the extent to which Williams' remark relates not just to the more predictable, consensus view of landscape as revealed in popular Royal Academy exhibitions, but also to those who increasingly abandoned both Naturalism and Impressionism in a progressive engagement with developing European modernism. I consider the degree of compliance between early modernism, intent on greater aesthetic autonomy, formal experimentation and a rejection of so-called native traditions, with the wider impulses and insecurities of the Edwardian era. I observe in the formal developments of the works of selected painters like George Clausen, Philip Wilson Steer, Augustus John, J. D. Fergusson, Spencer Gore and Stanley Spencer, a commitment to both technical development and individual temperament that at the same time corresponds to more general 'nonaesthetic interests'. The very fact of a persistent interchange between these conditions may, to a degree, account for what has been the inevitable decline of the genre of landscape in the twentieth century. Landscape, precisely because it is never a neutral category, was perhaps never able to shake itself free, to become 'disinterested' or, in Charles Harrison's terms, to 'be put in place as a vehicle for the implementation of a kind of Modernist "purity" in painting'.[7] And yet, as he discusses, it is in the development of the landscapes of Monet and Cézanne that Modernism, of the Greenbergian self-critical tradition, has its origin. To a considerable extent this book examines the complexities, the spaces in between what, on the one hand, were successive attempts by British artists to respond to modern aesthetic developments and, on the other, the very fact of a continual 'embeddedness' in wider national, cultural

and material conditions and preoccupations. So my argument is for a more densely structured 'modernism' in which Steer, John and Fergusson's technical procedures emerge in the spaces between modernism and modernity.

The genre of landscape for Palgrave's contemporaries had already extended into a considerable industry, a ruralist culture that was devoted to the production of guide books, country literature like the activities of the Homeland Association,[8] and periodicals like Edward Hudson's *Country Life*, which first appeared in 1897. Several thousand volumes of verse, novels, natural history, topography, books about rural activities and rural sports, houses and gardens etc., were written annually. All were specifically directed to 'the villa residents and the more numerous others living in London or on London', all to varying degrees of merit, and all 'up to the neck in the country'. Many, like those of W. H. Hudson or Ralph Hodgson, were 'of profound literary expression', but 'crowds are written to order'.[9] Literary or artistic expression and subjectivity were essential and readily admitted. As J. J. Hissey, in his book *Untravelled England* declared: 'To thoroughly enjoy the country one must needs look upon it with an artist's or a poet's eye … [the painter] casts a glamour over all he observes till the reality becomes a romance – the ugly fades away and only an impression of beauty remains.'[10]

Artists' relations to contemporary anti-urbanist discourse are fundamental here. By 1905, the 'Back to Nature', 'Back to the Land' or 'Simple Life' movements, emanating largely from the Arts and Crafts traditions of the 1880s and 1890s, had become so widespread and diffuse that they were being regularly satirized in *Punch* cartoons, replacing the more usual attacks on urban aesthetes.[11] A large number of city-dwellers with virtually no experience of life outside the urban centres, maintained a loathing for the increasingly over-crowded and sprawling chaos of Edwardian London which, it was observed in 1904, had increased in population by 900,000 between 1891 and 1901.[12] Painters continued to reinforce a widespread and fashionable pastoralism and their representations of rural life were mediated through metropolitan ideals and aesthetic codes which appealed to a variety of class, cultural and political positions.[13] By this date the English countryside was widely perceived to be a national asset. It was already regarded as 'heritage', as the establishment of the National Trust in 1895 indicates.[14] Ten years before one critic, discussing the works of Leader, defined the relationship that existed in the popular imagination between land, the countryside and nation:

A long national history and the immemorial laws and traditions that rule over the hamlet, the parish, the fold and field, and the river have had their slow but sure effect upon every part and detail of the landscape. All refers to feudal England, and farther back to that England of families and farms overseas which emptied its conquering people upon the British lands. The whole story, lost in the modern town, is written in the modern fields, in the very growth of the hedges and clustering of the trees.[15]

The continuing power of these beliefs accounts for David Lowenthall's contentious remark that: 'Nowhere else is landscape so freighted with

legacy. Nowhere else does the very term suggest not simply scenery and *genres de vie*, but quintessential national virtues.'[16] Of course to argue for a preoccupation with landscape and the rural as some typically English phenomenon is to ignore the much wider international context in which the paintings considered in this book have their place. The rediscovery of national identity and native traditions was prevalent throughout the western world at this period and in some places precipitated broader political realignments, most obviously, for example, the Celtic Revival. Struggles for independence and the impact of Celtic fringe countries on contemporary ideas of Englishness are not insignificant here, as the study of Augustus John will indicate. Of particular relevance too will be the ways in which contemporary aesthetic and cultural constructions of a classic 'Frenchness' focused around the Mediterranean were negotiated and adapted by British artists with specific results. Less preoccupied with the conventional associations of Englishness, the artists considered in the middle chapters experienced what were often fundamentally similar concerns and apprehensions to do with the land and modernity.

The deep-rooted tendency to define a connection between land, countryside and nation as somehow innately English predominated throughout the Edwardian era and into the inter-war period. Furthermore, as David Cannadine has recently remarked, at the height of Empire before 1914, the colonies and dominions were frequently envisioned (and vastly oversimplified) 'as a more wholesome version of society than could be found in the metropolis' and as 'a layered, rural, traditional and organic society'.[17] So both the Empire and English rural life are perceived in joint contrast to the hostile forces of urbanization. Social order and traditional deference endured, apparently, in both the colonies and the countryside and each could provide escape from 'the furies of modern life – disillusion, doubt, democracy'.[18] A concern in the following pages is the extent to which we can observe particular shared characteristics in the developing processes of both modernism and colonialism, necessary if both the countryside and the overseas dominions were ever to be perceivable in the terms that Cannadine describes.

As several writers, including Martin Wiener, have demonstrated, since the end of the nineteenth century the gravitational pull of economic interests to the south and the relative decline in heavy industry in the north led to the victory of what has often been described as the 'Southern Metaphor' for the nation.[19] It has also been shown that the imagined landscape of the South Country was predominantly of a unified type, gently rolling and encompassing, according to Edward Thomas, 'the country south of the Thames and Severn and east of Exmoor'.[20] Counties like Surrey and Sussex epitomized the culture of the Home Counties, where the middle and upper classes socialized, sent their children to school and aspired to the domestic architecture of C. F. A. Voysey and Edwin Lutyens and the English country gardens of Gertrude Jekyll. Links with Empire are apparent here too in the extent to which colonials emulated the landed squirearchy of the mother country, cultivated their gardens and commissioned Lutyens or Lutyens' style country houses.[21]

A web of connections emerge, therefore, between the idealization of traditions and the rural and the modern pursuit of commerce and capital investments both at home and overseas. Contemporary arts journals entered into this currency with, for example, *The Studio* magazine from its foundation in 1893 proffering illustrations of recent country cottage and suburban villa designs and advice on the planning of country gardens, alongside its frequent accounts of landscape artists and their exhibitions.[22] The study of *The Studio* also reveals an insatiable appetite for 'sketching grounds' and 'artists' haunts' that played to the burgeoning tourist trade, another important 'modern' phenomenon. A county like Sussex, where Edward Stott produced his Virgilian evocations of a timeless, ancient existence, is a perfect example of these reciprocal relations.[23] Englishness, therefore, was in perpetual dialogue with other ways of life. It was shaped by 'modern' conditions – in the case of agriculture by economic decline and the import of cheap grain from the prairies.

Notions of national identity and national virtues are never singular; constructions interact and compete during specific periods, but associations between an assumed spirit of Englishness and the countryside were especially emphasized during the period of this study, while the conflation of Englishness and Britishness was at a peak.[24] This was an era of consistent concern over the implications of slow recovery of the agricultural economy from the depression of the 1870s and 1880s, resulting in government inter-ventionist measures that fed a broad-based cultural interest in rural regeneration.[25] Montague Fordham, the author of *Mother Earth*, here lamenting the effects of rural migration, provided a typical example of this in 1908:

The problem is perhaps the most serious by which the country has ever been faced. It involves the decay of the manhood of the nation; if this decay is to be arrested we have not only to stem these streams of people from the country, but also to create a strong counter current from the town. For this a great national effort is needed to make country life attractive.[26]

In the writings of certain key cultural critics and social reformers of this period, like Rider Haggard and the liberal politician and author C. F. G. Masterman, we find appeals to each of these sentiments. In a series of works including, most famously, *The Heart of Empire*, 1901, *In Peril of Change*, 1905 and *The Condition of England*, 1909, Masterman made frequent use of the nostalgic pastoral metaphor in the expression of shared anxieties.[27] His is a perfect example of what has been seen as the attempt amongst English intellectuals 'to provide a collectivist social outlook which would be immune equally from the mechanical vulgarities of statism and the revolutionary demands of socialism'.[28] As with Montague Fordham and Haggard, so Masterman's *The Condition of England* was full of concern for racial degeneration in rural areas, a preoccupation born out of Social Darwinism.[29] 'No-one today', he wrote, 'would seek in the ruined villages and dwindling population of the countryside the spirit of an "England" four-fifths of whose people have now crowded into the cities.'[30] Much of this concern for national degeneration emanated from the alarming numbers of those found unfit for active service during the Boer

War, resulting in the formation of a government Inter-Departmental Committee on Physical Deterioration in 1902. Observational studies of the health and living conditions of the working rural and urban classes underscored the anxieties of the urban middle classes.[31] The widespread preoccupation with bodily health and wholeness that is so insistent a feature of this period resonates through the 'figure in the landscape', one of the key visual themes here.[32]

Aesthetic tendencies underpinned broader social and economic imperatives and the imagery of the rural labourer, as depicted by George Clausen, obviously has to be seen in this modern context. It was a developing understanding of aspects of modernism that enabled the painter to depict the 'peasant' in ideal, elemental relations expressed in a rhythmic harmony between man and soil. Similarly, anxieties about urban degeneracy and declining standards of health, both physical and moral, helped shape coastal pictures of women gazing wistfully out to sea – whether the figure be a Newlyn fishwife or one of Laura Knight's young models reclining on the cliff tops.[33] Connections between the sound, unsullied virtues and racial purity of the country-dweller were deliberately implied at all levels of political and cultural discourse, and underlying these was the sense that the costs of modern progress may well be outweighing the benefits. But such identifications were clearly not new. Raymond Williams charted the extent to which they might be traced backwards in literature, through Leavis, Sturt, Hardy, Cobbett, Clare and so on, right back to Piers Plowman.[34] Bound up, however, with nostalgia for an imaginary past or an idealized childhood, each of these memories of the past acquired specific meanings at different times.

Nostalgia is a vital undercurrent running throughout the late Victorian and Edwardian period, informing painters' references to pre-industrial, pre-modern Golden Ages as well as the utopian ideals of things to come. No account of this period can ignore its significance. There has, however, been much discussion of this cultural phenomenon in recent years from the original definition, as a medical condition signifying extreme homesickness, to discussion of its special relationship with the modern experience of rapid social change, growing secularization, mass democracy and the spread of capitalist economies. In such circumstances the past is regarded as a site of authenticity, of harmony and orderliness, and as a place where we once experienced life more vividly, when our senses were sharper.[35] So nostalgia for a rural past and the construction of particular, idealized traditions and virtues, are inextricably bound to the maintenance of national identities, which are both upheld and to varying degrees contested throughout the Edwardian period – as the study of Steer's landscapes demonstrates. However, these conditions are not inherently antithetical to modernist practice. While the extent to which perceptions of landscape were connected to the articulation of a national identity, the genre continually supported a wide variety of cultural and aesthetic standpoints. Landscape has always proved a perfect site for the construction of class and racial identities and for reflections on personal and national histories, but it also uniquely provides the vehicle for more formalist speculations beyond the restrictions of the

fashionable academician's studio and the teaching atelier. Steer emerges in this book as one who continually engaged and experimented with the intrinsic properties of paint, be it in oils or watercolour, while at the same time satisfying the growing market for grand panoramic vistas – timeless evocations of the native landscape. As with Clausen, Steer's success in this last respect resulted in the purchase of works to form part of the museum collections in the dominions, in major cities in Australia, New Zealand and South Africa – archetypal reminders for colonials of the *ideal* landscapes and organic social relations of their native country and ultimate models for those they now occupied.[36] So Stephen Daniels' comment on late-eighteenth and early-nineteenth-century landscape painting is equally applicable in the Edwardian context – landscapes can address both 'moral order and aesthetic harmony'; they can be adopted in the interests of aesthetic enquiry or co-opted in the cultural cause.[37]

A manifest desire for order and harmony underpins the work of all those considered in this book. Born out of the disordered and discordant experience of the everyday, it inevitably figured in the idealization of traditions, the cult of rural life and in assertions of an essential Englishness. It is also, of course, a dominant feature of much early modernist practice before 1914. My discussion of Spencer Gore's paintings demonstrates one example of a unity between these different elements. But the same desire also resulted in what seemed for some a necessary escape from England and from overt affirmations of national character. My argument is that British artists' identifications with specific aesthetic and cultural geographies of the Mediterranean were also especially significant in providing them with a utopian counter to what, in most cases, was considered to be the vulgar mediocrity of modern English life – a view certainly held by those celebrated Francophiles, the Bloomsbury Group.[38] The artists considered here, alive to both French modernism and to the land of France, complicate simplistic associations of Englishness and the native landscape. Bohemian figures such as Augustus John were certainly in flight from the increasingly clichéd home-counties landscape, but his underlying preoccupations were often strikingly similar to those of George Clausen for example, a situation which offers some insight into the values and consequences of modernism in Britain before the Great War and, I would argue, afterwards.

Modernist painting, as advocated by contemporary critics like Roger Fry and Frank Rutter, was to be increasingly preoccupied with the analysis of form, the rigorous self-scrutiny of the medium, the abandonment of narrative and the mimetic and with the expression of inner states of consciousness. For many, including Scots and American ex-patriates like J. D. Fergusson and Anne Estelle Rice, a rhythmic, decorative landscape, conveying an all-important sense of both harmony and stability, could be best produced through time spent away in the South of France – in the landscapes of Puvis de Chavannes, Denis, Matisse and Cézanne. In the heat and light of the Midi, the transitory, fleeting qualities of light and atmosphere were to be banished, replaced with a brilliant intensity and an air of permanence. As a

result the ideal body of the rural labourer, as depicted by Clausen in the 1890s, achieved its ultimate realization in John's and Fergusson's depictions of their models and mistresses. All become, in the translation of Fergusson's painting, *Les Eus*, 'The Healthy Ones'.

Within a short time a new visual language could be adapted for representations of sites and locations that were regarded as typically 'authentic' – from the west of Ireland to north Wales, from the Midi to Cornwall. Modern artists in their chosen travels both shaped and reflected the desires of a growing number of modern tourists. Modernism evolved a formal, visual language with which to counter the fragmentation, the rootlessness and the attenuated sense of self that characterized the experience of modernity as it was described by contemporary sociologists like Ferdinand Tonnies, Georg Simmel and Emile Durkheim.[39] Arthur Symons, who appears in several contexts throughout this book, encapsulates this experience in his perceptions of the metropolis on a return from the countryside in 1909:

What a huge futility it all seems, this human ant heap, this crawling and hurrying and sweating and bearing burden, and never resting all day long and never bringing any labour to an end. After the fields and the sky London seems trivial, a thing artificially made, at which people work at senseless toils, for idle and imaginary ends. Labour in the fields is regular, sane, inevitable as the labour of the earth with its roots … In London men work as if in darkness … They wither and dwindle … They are making things cheaper, more immediate in effect, of the latest modern make. It is all a hurry, a levelling downward, an automobilization of the mind.[40]

To Symons, the countryside – whether in England or in France – is seen repeatedly in its restorative capacity, and modernist paintings of rural scenes and landscapes continually operated on this level. Like other cultural forms they defined and contained acceptable sentiment.[41] Simplicity and authenticity stand opposed to Symons' two, equally negative definitions of modern experience; either the crawling, hurrying 'ant heap' or the 'automobilization' of rigid bureaucracy and rationalization.[42] Clearly his is also a yearning for the non-problematic class relations and old hierarchies which, from the later nineteenth century, were shifting and transforming in the modern city, sustained by the mass circulation of newspapers, popular forms of mass entertainment catering to the growth of a new, lower middle class, the spread of trade unionism and a series of damaging labour struggles, and the developing militancy amongst women.[43] It is in this context of an anxiety at the pace of change and the subsequent sense of the loss of a 'felt life', a loss of subjectivity and inner experience, that the epiphanic visions of Stanley Spencer and Paul Nash have their place.

As such, the idealization of the rural appears to be underpinned by a fundamental mood of bereavement. Beyond these considerations, however, I will argue that a significant strand of British landscape painting avoided the prevailing sentimentalities about the countryside and played an active role in pointing the medium towards more formal concerns identified latterly as classically modernist. An artist like Gore in his depictions of the new Garden City at Letchworth was also proposing new settings in which ideal social

relationships and a new kind of rurality described in a modernist visual terminology might be established. Above all else, the painters discussed in the following chapters, in their handling and in their deployment of at times apparently conflicting ideals, all produced works which were powerful negotiations of the urban experience of modernity and modernism. So when Augustus John painted a group of bare-footed earth-mothers walking down to the sea in northern France, he was actively engaged with the age of the motorbus, the typewriter, the telephone, the mass-circulation magazine and, perhaps most notably, declining middle-class birth-rates and vociferous suffrage campaigns in the London streets. In fact the particular significance of these representations, much of the time, lies precisely in that which is unrepresented.

Until very recently, there have been precious few studies of themes and developments in landscape painting in early-twentieth-century Britain.[44] One reason perhaps emerges within the period itself, just prior to the First World War, when the genre was increasingly regarded in progressive circles as peripheral to serious developments within modernism. The artists most cited in surveys of modern British art are essentially not landscape painters. From Sickert to the Vorticists, those most commonly discussed (and primarily in the form of monographs) were primarily inspired by city life and/or aspired towards abstraction.[45] An antagonism towards landscape painting *per se* issued from the voices of dissent raised amongst the emergent radical modernists in the period itself.[46] In 1914, Wyndham Lewis 'blasted' the Georgians 'for something harder, tougher, more to do with machines than nature'.[47] Association with nature and the pastoral had no place within the circle of Vorticism, which was opposed to liberal ideals of a consoling whole, favouring rupture and fragmentation in its language and pictorial ideals. So pre-war radicals and iconoclasts like Lewis, David Bomberg, C. R. Nevinson and T. E. Hulme had little sympathy for those objectified forms of aesthetic enjoyment which Hulme's mentor Wilhelm Worringer perceived as 'empathetic', 'life-affirming' and which were 'released in us by the reproduction of organically beautiful vitality'. Empathy and its associated qualities of order, harmony and unity, of a 'pantheistic relationship' between man and the external world, stood opposed to the 'urge to abstraction [which] finds its beauty in the life-denying inorganic … in all abstract laws and necessity'.[48] But these identifications prevailed only temporarily within British art, to be effaced in the destructive carnage of the Great War. That experience refocused and gave an additional urgency to many of the aesthetic and cultural processes considered in the following chapters – processes which, I argue, have their roots in the tensions between the modernism and modernity that emerged in the 1890s.

Poetry of the peasant

By the 1890s the inhabitants of the countryside were already well perceived in the urban middle-class imagination as embodying the finest qualities of the national character. In the words of Masterman's *The Heart of Empire,* they were a 'healthy, energetic population reared amidst the fresh air and the quieting influence of the life of the fields'.[1] Actual conditions amongst rural workers were obviously misrepresented in accounts like this for, in real terms, years of severe agricultural depression had resulted in that steady exodus to the cities.[2] With low agricultural wages and poor housing, together with the lure of potential opportunity in the city, despite dire warnings, the younger generation simply lacked the incentives to stay on the land.[3]

To a political and cultural elite, such a situation threatened disastrous implications. Imperialist statesmen like Lord Milner, echoing Montague Fordham, uttered sentiments which extended widely across class and political persuasions: 'Of all forms of productive capacity … there is none more vital, indispensable and steadying than the application of human industry to the cultivation of the soil.'[4] But a substantial shift in ideological representation had been necessary before this view could become widely acceptable.[5] This chapter deals with the role of images of the rural worker presented in popular exhibitions from the mid-1890s in a process that, at first obliquely, exposed the tension between modernity and modernism.

The impulse of painters like George Clausen, Edward Stott and Henry Herbert La Thangue to record passing ways of life in the countryside was, of course, common amongst writers from Thomas Hardy to Richard Jefferies in the 1870s and 1880s. But there was still, in the 1890s, a strong sense in which representations of field-workers witnessed a desire to 'fix' an image of those who were in danger of turning into unruly industrial proletarians.[6] The results of the artist's or writer's attentions were therefore clearly determined, laden with preconceptions, half-remembered facts mingled with wishful thinking. All of this was conditioned by Edward Thomas's perceptions in 1913 of a 'modern sad passion for nature', and the awareness that 'the countryman is dying out and when we hear his voice, as in George Bourne's "Bettesworth Book", it is more foreign than French. He had long been in decline and now he sinks before the *Daily Mail* like a savage before pox or

whisky. Before it is too late, I hope that the zoological society will receive a few pairs at their Gardens.'[7] Clausen and La Thangue were engaged in a similar project – at once both preservationist and anthropological. Thus La Thangue was described in 1896 as 'to some extent consciously perhaps, producing a series of pictures of the agricultural life of our time which is sure to have some permanent historical value'.[8]

Such a commemorative desire can be observed in Clausen's renderings of ploughing, an activity he began to record in the mid-1880s and revisited in 1897 with *Autumn Morning, Ploughing* (Plate I). By this date the artist's interests had shifted from the more direct treatment and detailed observation of earlier works like *Ploughing*, 1889, and there is in this later picture less of a literal description of an activity and instead an increasing sense of the subject as an icon, of the plough and ploughman as sign of a timeless, rural existence.[9] Naturalist actuality declines before the impressionist 'envelope'; artistic purpose changes in what becomes an inexorable process that increasingly implies a move towards a modernist reductivism. It is in this aesthetic process that the rural worker is transformed from a potentially troublesome malcontent to a decent, dignified and time-honoured land-worker.

Flora Thompson's account of rural Oxfordshire during the 1880s, *Lark Rise to Candleford*, demonstrates that while, at that time, it was still possible to see ploughing teams at work, new developments were already visible. 'Every autumn appeared a pair of large traction engines, which, posted one on each side of a field, drew a plough across and across by means of a cable. These toured the district under their own steam, for hire on the different farms.'[10] Innovations like these were rarely, if ever, recorded by painters or photographers and were only described by ruralist writers in terms of regret. Paintings by Clausen and La Thangue obscured the fact that mechanization was advancing apace. In contrast to the intrusion of modern machines, the plough itself, according to Edward Thomas, was 'a universal symbol', 'a sovereign beautiful thing which man has made in his time … the dirge at their downfall passes inevitably into a paean to their majesty'.[11] In the meantime it appeared as though traditional and specialist rural skills would be lost. By 1902, Rider Haggard's 'rural rides' led him to conclude that before long, ploughmen 'will be scarce indeed … the farm labourer is looked down upon, especially by the women of his own class, and consequently looks down upon himself'.[12] Significantly, on Haggard's own farm the traditions of ploughing continued. He, like Clausen and Edward Thomas along with their reading and viewing public, all revealed the same anxieties which they attempted to displace in strikingly similar ways.

By the early 1890s the stylistic influence on Clausen of the French Naturalist painter, Jules Bastien-Lepage was in steady decline, and this had important consequences for the critical reception of his works.[13] From this date 'Rustic Naturalism' was under attack from the increasingly influential 'new critics' like R. A. M. Stevenson, George Moore and D. S. MacColl, the last of whom dismissed the method as 'a manual dexterity inspired by no real sentiment of vision'.[14] In line with his elaboration of the idea of 'congruous beauty',[15]

MacColl saw Naturalism's failing in the extent to which 'sentiment, subject and technique remained obstinately detached from each other, (whereas) good technique … is simply a way of seeing and feeling, and follows indistinguishably upon that impulse when the seeing has become clear'. Critics were therefore relieved when Clausen and La Thangue, those 'giants of the period of the peasant child who stuck his boots in our faces, of the black open-air scene, of the square brush, with its halo of French wickedness' abandoned the technique and 'Mr Clausen … removed his peasants to a safe distance'.[16] By this date Clausen's allegiance had turned ostensibly to the figure compositions of Millet for, as he wrote in 1904: 'No other has seen so clearly or shown so well the beauty and significance of ordinary occupations, the union of man with nature.'[17]

Clausen had first encountered Millet's work at Durand-Ruel's London gallery as early as 1872 and the artist was more widely popularized by biographical accounts like that of Julia Cartwright in 1896.[18] His significance from the 1890s onwards, as revealed in exhibitions at the Grafton and Leicester galleries in 1905 and 1906 respectively, was increasingly understood to lie in the depiction of type and in the expression of action or sentiment, whereas Bastien's interest was perceived to be in the quasi-scientific portrait of a specific individual in a particular environment – with all the worrying potential for brutal honesty that such a method might entail. By contrast, Millet's example enabled Clausen to depict a symbolic and universal relationship between 'peasant' and place.

Aside, however, from the obvious debt to Millet, there were also signs of a renewed interest in the painters of the 'idyllic school' of the 1870s, of George Mason, George J. Pinwell and especially of Fred Walker. By the turn of the century, Walker was described in the approved critical terms of the period, those applied to Millet and, increasingly, to Clausen as well. According to Claude Phillips in 1905, Walker's art, though it had absorbed foreign influences, was fundamentally national in feeling and character. His romanticism was tempered with realism and imagination, and in this he had drawn from the works of the French Salon painter Jules Breton, popular in England for pictures like *La Fin de la Journée*, with its 'serene melancholy' and 'the idyllic grace which he infuses into modern rustic life'.[19] Millet's *Gleaners* and *The Angelus*, later to find echoes in the works of Clausen and La Thangue, had also already influenced Walker in terms of 'the increased effort to infuse into the treatment of rustic and open air subjects, a certain rhythmic harmony'[20] – again presaging the simple and rudimentary relationship between the figure and the earth that emerged throughout early modernism across Europe. In all instances there was an attempt to 'see men and things in a large synthetic way, to express the beauty and harmony of the type, not the individual; to marry the human element to the environing landscape so that one cannot be conceived of without the other'. The result was a unity of impression, simplicity of intention and a truthful atmospheric envelopment. But in spite of the derivations from French painting, for this writer, Walker remained 'one of the most English of the modern English

painters', and he spoke of his 'wistful tenderness which goes so far to redeem our time of trouble and misgiving, in art as in life'.[21]

Bound up with these aesthetic considerations was not only the desire to confirm a poetic national temperament but, as a direct effect of the modern reaction against Naturalism, a tendency to caricature the countryman to the extent that real individuality is lost. It was therefore possible and acceptable to speak of pictures of rural labourers as 'representations of country life, impersonally considered, rather than as depicting any real human interest in the workers'.[22] As Haldane MacFall stressed in relation to Clausen, 'He takes just those exquisite ordinary scenes [and] these he puts down for us in that broad colour sense in which our memory retains them … in all essential truths.'[23] To deal in essentials or 'types' allowed for a discriminating vision, and by implication, one that could omit nagging detail and fact. As Dewey Bates remarked: 'The poetry of the peasant lies in the eye that sees.'[24]

The cleansing and purifying aspect of this approach is therefore crucial. Discussing Edward Stott, the critic of *The Art Journal* observed that his pictorial vision had 'enabled him to strip actuality of ugliness'.[25] As his comment reveals, despite the evasions and mythologies, the real conditions of rural life were widely appreciated, both the conditions of rural housing and the physical condition of the worker as well. In spite of national antagonisms it was generally accepted that the peasant in France was rather more picturesque than in Britain: 'There is less squalor there, and … the painter is less tempted to over-idealize or conventionalize his subjects in an effort to impart to them what he conceives to be a proper measure of charm and poetic significance.' By contrast:

The British peasants have lost the character which made them formerly worthy of the artist's attention; they have got out of relation to nature, their life has become conventionalized, and their costume has degenerated into ugliness. They dress in the cast-off clothes of their superiors, in things inappropriate to their employment and out of keeping with their surroundings, so that they never seem to be properly in the picture.[26]

By the 1890s, young labourers had cast aside traditional 'peasant garb' of smock and gaiters which they now perceived as a sign of servility. But, on occasion, painters still depicted past forms of dress, as did La Thangue in his *Old Peasant*, in the collection of Sharpley Bainbridge of 1898.[27] The fact that few seriously believed that peasants still looked like this was exactly the point. Reality was indeed persistent, making La Thangue's images less believable yet at the same time more affecting. So to return to Baldry, to get 'out of relation to nature' presupposed a concept of nature that, like the photographer Peter Henry Emerson's images of East Anglian life, was harmonious, poetic and picturesque – that is 'like a picture'. Any encroachment of modernity into the rural communities was both culturally and aesthetically disagreeable. It was threatening to traditional order in class terms as well as national art traditions.

Edward Stott's works were perhaps the most successful in terms of a distancing from modernity in the critical opinion of the later 1890s.

Reviewers spoke of his romanticism and poetic discernment, and this was attributable to his immersion, since the late 1880s, in 'the dreamy old world village of Amberley' in Sussex.[28] From contemporary accounts it emerges that the specific charm of Sussex was that it was 'so little spoilt by modern notions' and, because of its isolation, had retained so much of old-fashioned English ways. Amberley itself, in 1912, was still 'a huge stock yard, smelling of straw and cattle ... It is sheer Sussex – chalky soil, white washed cottages, huge wagons', there 'is nothing more beautiful under the stars than a white washed cottage when the lamp is lit'.[29] In this account of the simple vernacular of humble country cottages we find an essential purity and simplicity, a taste that draws on timeless and ancient forms but at the same time underpins early modernism. So this ideal, reductivist modern aesthetic, regarded by contemporaries as traditional and timeless, ultimately resists the brash and the vulgar, the chaotic newness increasingly identified with the spread of the suburbs – or H. G. Wells' 1904 predictions of dense networks of railways, telegraphs and novel roads – of 'nervous and arterial connections'.[30]

Amberley's appeal to Stott and to his contemporaries lay in its seclusion in the South Downs and in its picturesque decay, the sense of time having stood still.[31] The village possessed an embattled castle, tumbling to decay, and an Early English church and both painters and tourists alike could feel themselves transported into the Middle Ages: 'The changes of four to five centuries have passed over it, touched it lightly, but left it substantially as it was in the days of the Edwards ... In the gloaming, at least, we are in a village of which it is safe to say the main features were the same three centuries ago.'[32] Centuries of historical change are here glossed over and displaced into a naturalized English identity, and circumstantial detail has been reduced – 'In the gloaming, at least'.[33]

In his scenes of children in country lanes, e.g. *Saturday Night*, 1900, or gathered around thatched roofed cottages, like *Sunday Night* (Figure 1.1), of figures in the field with seasonal and atmospheric effects, as in *The Gleaners*, 1903 and *Peaceful Rest*, 1902, Stott was perceived to have drawn out the spiritual essence of place through constant observation and devotion. His pictures were typical of 'every phase of English pastoral life'.[34] But the painter's specific rendering of village life at Amberley was, despite his long association, seen determinedly from a distance. His was the view of an outsider. There is, emphatically, nothing in his works to confirm the anxieties of writers concerned, for varying motives, about the migration from the country villages and expounding on their 'dullness, (their) antiquated, tumble down cottages, ill ventilated and worse drained'.[35] Stott presented Academy audiences with a delightful dream of an organic, traditional, and an utterly harmonious natural world, in which the worries of the reformists would seem, if only momentarily, quite misplaced.[36]

Such a dream accorded with those of the writer P. H. Ditchfield who in 1912 set about recording the countryside in his book *Cottage and Village Life* on the premise that it was well to 'catch a glimpse of rural England before

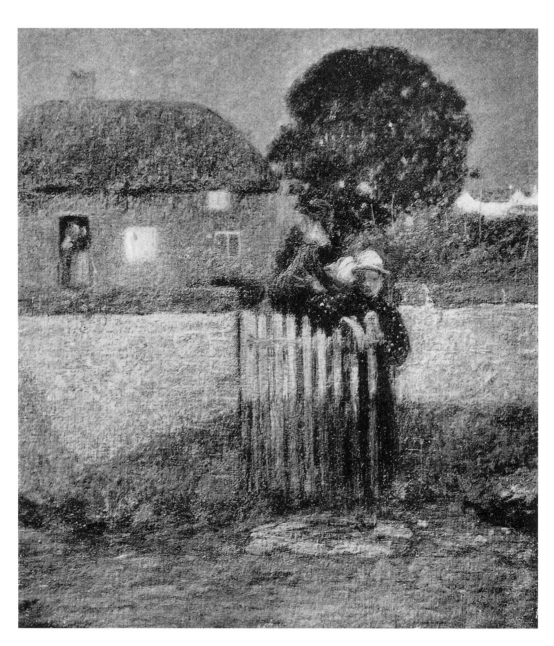

1.1
Edward Stott,
Sunday Night,
1897

the transformation comes and to provide a record of the beauties that for a time remain'.[37] This transformation, which for Ditchfield had been developing over the previous twenty years, had already seen many villages degenerate into suburban colonies of villas. Old livelihoods like hay-making, thatching, harvesting, turf-cutting and hop-picking were disappearing, farms were being broken up and 'the rustic who remains tends the strips of villa gardens or drives a coal cart and his wife goes out charring'.[38] George Bourne's writings also underline the rapid pace of change in rural communities:

The labourer can hardly look from his door without seeing up and down the valley some sign or other telling of the invasion of a new people, unsympathetic to his order. He sees and hears too. As he sweats at his garden, the sounds of piano playing come to him, or of the affected excitement of a tennis party; or the braying of a motor car inform him that the rich who are his masters are on the road ... (the old home of the labouring people), is at the mercy of a new class who would willingly see their departure.[39]

Earlier, in *The Spectator*, Ditchfield had suggested to the National Trust that they should purchase an 'ideal hamlet', which could well have been Amberley, to preserve as a memorial for future generations for instructive, not just sentimental purposes.[40] The resonance here with the recreation of a native African village in the Franco-British Empire exhibition of 1908 – an exotic visitor attraction – is striking.[41] But Ditchfield's suggestion was based on the belief, widely shared, that there was nothing so beautiful as an unspoilt English village, 'one untouched by modern innovations, by the production of strange anomalies and the association together of materials which nature has not blended'.[42] A country cottage evolved through traditions handed down over generations and it blended inevitably with the landscape. Delicate harmonies were the result, 'the modulation from man's handiwork to God's enveloping world that binds one to the other without discord or dissonance'.[43]

Stott's handling and technique, his subtle colouristic effects, the warm glow and gently suffused light in his pictures, perfectly coincide with Ditchfield's descriptions. As one admirer remarked, a photographic 'unfeeling eye', could never have achieved such inspired results. The painter proceeds by rejecting detailed Naturalism and without ever 'defying the unities', he knows 'what to add, what to leave out'. Echoing Whistler, he 'must know nature as a skilled musician knows his keyboard'.[44] Frequently Stott enveloped, or shrouded, his scenes, in the mysterious atmosphere of night, as Millet had done. These atmospheric veilings were also to be seen in the work of another French painter, Le Sidaner, described in 1901 as one 'devoted to solitude and silence ... the mystery and the reveries which dwell in ancient places'.[45] Like Stott, Le Sidaner had established himself far from cliques and coteries, protected from the 'ever pernicious influences of artistic centres', in the neighbourhood of Beauvais, 'a little village morte, half village, half town, encircled by big trees and ancient ramparts – a place full of reminiscences of the past'. His soft handling decked reality with 'an infinite charm', just as in Stott's, *The Penfold*, shown at the Royal Academy in 1898 and regarded as the finest pastoral of the year, where nature was 'pleading with tenderness, softness and mellowness'.[46] This infinite charm here equates with George Moore's 'enchantment' and the Impressionist envelope[47] an edited version of the world that ultimately gives way to modernism.

Like Samuel Palmer at Shoreham, and later Stanley Spencer at Cookham, Edward Stott pursued a vision of an ideal community, a spiritual world where, at times, biblical scenes like *The Good Samaritan* (Royal Academy, 1910) might feasibly occur. A relationship to more modernist religious compositions in France might be perceived here. Although Stott's painting

may be technically more conservative than Maurice Denis there is no mistaking a shared intention. In what was termed the 'lyric intensity'[48] of an English village, as on the Cote d'Azur, one may just come upon a Madonna or a figure from the New Testament.

On occasion certain critics of the later 1890s did express reservations about the representation of the rural worker. For D. S. MacColl, Clausen was not quite the English Millet, nor did he match up to George Morland's abilities in his dealings with the Essex peasant: 'One watches his efforts with material too brutal perhaps for his gentle nature, with curiosity and sympathy.'[49] A few months later, MacColl's doubts had increased. By this time, as another reviewer in *The Art Journal* had observed, 'Mr Clausen has painted an almost complete gallery of types of workers in the fields, and is succeeding in doing for the agricultural labourer what Millet and his compeers did for the French peasant. Whether the figure be a reaper, a mower or a sower, it is always convincingly chosen.'[50] MacColl disagreed. To him, although Clausen as well as La Thangue 'work hard at giving a reading of the English field labourer', their subjects lacked the character appropriate to their size on the canvas. Instead the painter 'darns the trousers, darns the complexion, darns the lighting of Millet's Breton [sic] peasants, and dilutes thereby something that Millet left perfectly expressed. The biblical air that Millet found in his own people overweighs what Mr Clausen with his ability and honesty might draw from the English Hodge.'[51]

Honest perceptions of individual character might be lacking but for many, and on this occasion for George Moore, the generalization that Clausen produced in pictures like *The Mowers*, shown at the Royal Academy in 1892, mercifully replaced a handful of dry facts with 'a passionate impression of life in its envelope of mystery and suggestion'.[52] For others, Clausen's pictures qualified under the heading of 'Idealistic art': 'The motive is simply that primitive yet at the same time thoroughly modern one, a number of labourers rhythmically mowing in the bright light of a sunny afternoon.'[53] Despite the claim, the motif was hardly modern. Scenes like Clausen's were declining and with the advent of mechanical reapers, the mower was increasingly only to be found confined to the edges of the field, clearing a path for the machinery.[54] But the mower, like the ploughman, was now equally iconic. A journalist in *The Saturday Review* lamented his displacement by the mowing machine, which now did in one day what had previously taken two good scythe men the better part of a week, and spoke of: 'the ancient trade of the old mower … the glory of the scythe departed, the skilled mower ceased hereabouts some twenty years ago: the great days of Herculean work and commensurate beer are over'.[55] This writer's description of the mower's movements and the sounds that he makes were in essence the very qualities that Clausen's depictions pursued:

… an even pulse of sound, both in rhythm and in tone after Nature's pattern, in tune with the sound of winds and waters … a thing of art in its own way … And for the eye's pleasure there is the balanced swing and turn of the body, the shifting of the light on the sunburnt arms, the easy grace of the man's knack.[56]

Works like *The Mowers* and *Sons of the Soil* (Plate II), may well have recalled to contemporary audiences the phenomenon of gang labour. By this period, however, the large groups of travelling workers were beginning to disappear from the rural scene, having been regulated by Parliament since the 1860s, although they still provoked debate and were still required at specific seasons.[57] To Alun Howkins: 'gangs stood outside the paternal structures of regular employment, deference and social order. In the voice of a contemporary, gang labourers were about the worst specimens of barbarianism we could desire to meet.'[58] Through Clausen's sunlit palette and in his selective approach, however, a representation emerges in which any residual prejudice about rough unruliness would appear hopelessly misjudged or, in the discourse of Imperialism, the barbaric savages had been transformed into noble primitives. Those who, despite moral anxiety, were yet a necessary part of the agricultural system, are controlled by a concentrated, unified movement and in a rhythmic grouping. Clausen represents what may be three generations of one family joined communally and without conflict in a life of toil.

In contrast, in 1899, Lord Walsingham was urging Rider Haggard to 'Look at the pure bred Cockney, I mean the little fellow whom you see running in and out of offices in the City … And then look at your average young labourer coming home from his day's field work and I think you will admit that the city breeds one stamp of human being and the country breeds another.'[59] As such he had become the archetype of 'vigorous manhood' and his existence, described here again in imperialist terms, needed to be preserved with 'something of the same determination with which we set about, say, the destruction of the Transvaal'.[60]

The Royal Academy of that year was notable for two strikingly similar compositions of harvesters by Clausen and La Thangue. In Clausen's *Going to Work*, a lone figure dominates the composition, striding across the landscape with his scythe across his shoulder and his hempen bag in his hand. La Thangue's harvester returns from his labour at the close of day, his girl at his side, in *Love in the Harvest Field* (Figure 1.2).[61] He carries his scythe in the same way, crossing the canvas, as in the Clausen from right to left. Neither face is visible, their features shaded by the brims of their hats – individual character is disregarded. In spite of these similarities there appear to be no contemporary reviews linking the two works. By this point full-length, close-up compositions of rustic types like these were so common that the coincidence was unremarkable. The theme of the young rustic lovers in the La Thangue was already so well established, for example, with images like Maurice Greiffenhagen's extremely successful *An Idyll*, 1891, as to connect his work to a specific tradition.[62] The popular symbolism of the inevitable process of ageing and decay meant that Clausen's picture was perceived instead by the critic of *The Art Journal* rather as 'a natural pendant to Edward Stott's *Harvester's Return*', shown at the same Academy, where the old reaper with his sickle 'is replaced by the young and lusty mower in Mr Clausen's'.[63] On observing the Stott, MacColl had discovered 'an art that doth mend nature'.[64]

1.2 H. H. La
Thangue, *Love in
the Harvest Field*,
1899

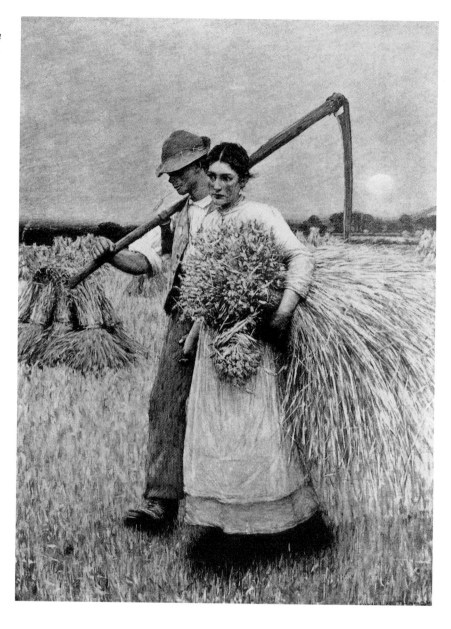

In La Thangue's picture the epic size of the male figure presented a problem for MacColl. If the work had been by Millet, there would have been greater dramatic sense and feeling for movement. In La Thangue those qualities were reduced by the laborious collection of lesser observations, and 'an attempt is made to add movement to them as a detail of the same order, to wind up the figures when they have been painted still'.[65] The suspicion that La Thangue's work was becoming inflexible and his compositions repetitious was confirmed by Laurence Binyon in 1909: 'His rustic figures shaking down apples are admirably painted, but we always seem to have seen them before.'[66]

The relationship between individual observation and the depiction of a universal type was more easily resolved by Clausen and certainly by Stott who, for MacColl, was more sure of his intentions: 'He follows a rather special game with real intentness.'[67] But even if La Thangue provoked unease amongst perceptive writers like Binyon, that very repetition and instant recognition was a consistent reassurance to urban audiences.

From 1898 La Thangue, like Stott, was also working in Sussex, at Bosham, an area where as Thomson recorded 'the soil is fertile, and well farmed by methods still comparatively simple', as a result the spectator is presented:

... with striking renderings of many phases of a rustic life which still has many picturesque elements. For the steam plough and the threshing machine have not driven manual labour out of the country. The ploughman has by no means ploughed his last furrow in sleepy Sussex, and the travelling harvester with scythe on his shoulder ... is even now taking form upon the painter's canvas.[68]

Bosham was a perfect site in which to pursue subjects that were now deeply ingrained on his and on the gallery-goer's consciousness. Choice of subject was now determined by the seasons that governed the lives of the labourers he depicted. In a certain sense his own practice had itself become part of the natural cycle.

Sussex in this period provided a perfect example for those agriculturalists keen to emphasize the value of dairy and fruit-farming. Rider Haggard, for instance, believed that the potential profitability of fruit-farming would encourage labourers and employers to go back to the land, with more success than the inducements of 'three acres and a cow'.[69] Others saw the benefits in the opportunities of fruit-growing for women and children in supplementing the family income.[70] La Thangue's pictures like *Gathering Plums* (Figure 1.3), and *Cider Apples*, 1899 both shown at the Royal Academy, provided further evidence of the benefits of these trends. His model in *A Sussex Farm*, 1904 exemplified Ditchfield's view of the virtues of the rustic woman who passed her days in the open air: 'hysteria and sentimentalism', the afflictions of women confined to the city, could not exist in such an atmosphere.[71]

But the proximity of Sussex and Kent to the capital, at this time being increasingly settled by London commuters, disrupt the conventional notions of an abrupt division between town and country in interesting ways.[72] To a reviewer of a guide to the county in 1906:

It has been said of Sussex that it is the most thoroughly Saxon of all the English counties ... In spite of the transformation now going on ... especially along the principal arteries of communication, where one regrets to see so many evidences of 'suburbanisation' ... the general reader will perhaps be more interested in the [study] of the characteristics of the Sussex peasant, the chief of which is his rooted conservatism.[73]

At the very moment that Sussex was becoming dangerously modern, it was described as embodying characteristics that were innately and even archaically English. Contemporary interconnections have been noted in the symbolic presence of the London coster-monger or fruit-seller, a stock character appearing in one instance in a popular contemporary music hall act, and regarded as one

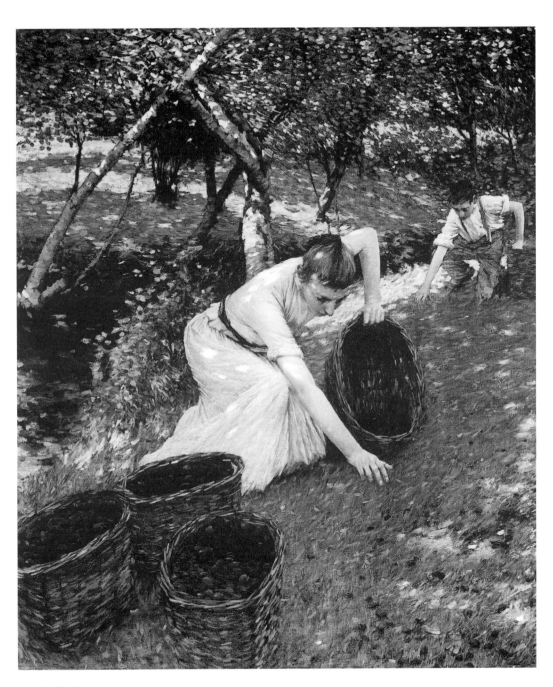

1.3 H. H. La
Thangue,
Gathering Plums,
1901

who 'brings the rural into the heart of the urban'.[74] Costers constituted
specifically English urban types, as seen for example in William Nicholson's
Coster in his series 'London Types' of 1898 but, through the nature of their
trade – selling the fruits of the countryside – they connect with the rural.[75]
Images of fruit-sellers and fruit-pickers had consistently represented the health
of the countryside and the abundance of nature, as for example in Fred

Morgan's *An Apple Gathering* at the Royal Academy in 1880; in numerous Sussex studies by La Thangue; in at least one instance by Edward Stott – *Apple Gatherer* – at the New Gallery in 1900 and, within a few years, by Stanley Spencer for the Slade sketch club in 1912. In poetry too, the gathering of apples was deeply symbolic of rural life. John Masefield's post-1914 lament on the decline of the *Land Workers*, uses apple gathering as a focus for gathering reminiscences:

Then, more September memories
Of apples glowing on the trees,
Of men on ladders in the sun
Gathering apples by the ton,
Of heaps of red-fleshed cider-fruit
Wasp-pestered at each apple root
And smell of pommace warm in air
From cider-presses everywhere.[76]

The fruit- and more particularly the hop-pickers who descended into Kent from the East End of London in September, on what was for them both holiday and a means of earning additional income, were regarded with both fascination and contempt by local inhabitants and urban commentators. Anecdotes of uncleanliness and drunken debauchery echoed the anxiety caused by the travelling gang labourers who roamed from district to district. But in both instances the rural economy required their presence. The difficulties inherent in representing hop-pickers in the face of reports of their conduct meant they were rarely depicted by artists.[77] In fact the only painting on the subject from the mid-1890s onwards to feature in the *Royal Academy Illustrated* appeared in 1909: *Life and Laughter in the Kentish Hop Fields* (Figure 1.4), by Robert Fowler. An artist, previously known for rather weak pastiches of Albert Moore et al., here presented an extraordinary vision of a group of modern-day hop-pickers in predominantly classical poses. Unlike the few earlier examples such as David Murray's *Nooning in the Hop Garden* shown at the Royal Academy in 1889, as in contemporary photographs of hop-pickers which tended to take up a safely distanced aerial position, the transformative effects of Fowler's manner of representation permits a close viewpoint, gazing up at the figures rather than looking down from above.[78] As a result the central figures emerge caryatid-like, redeemed of the commonplace details of time, place and character. It is only in a rural context that such an ideal, aesthetic transformation can occur. These particular East Enders inhabit the secluded, leafy refuge of the dryad. The only male figure in this idyllic sun-dappled scene is garlanded with a wreath of hop flowers. The children and women, two in the flat-brimmed straw hats worn by town costers rather than country women, are as healthy and sound as the rural types painted by La Thangue and Clausen. Indeed Fowler's painting was praised by the critic Laurence Binyon for its 'boldness and sincerity', although he felt the artist might have concentrated yet further on the 'rhythmic relations' between the figures and with 'what is elemental in his subject'.[79] There can be no fears here about the dangers of urban incomers. All have been absorbed into a

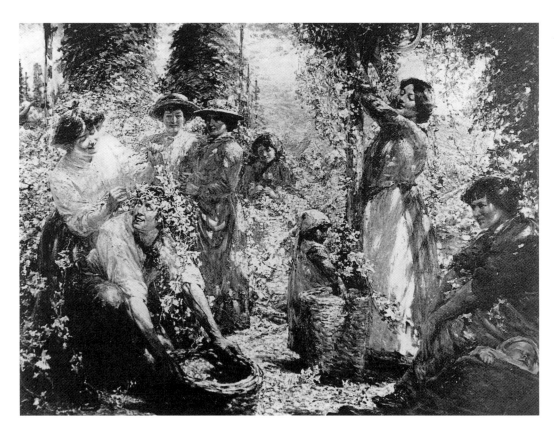

1.4
Robert Fowler,
*Life and Laughter
in the Kentish Hop
Fields*, 1909

quintessentially English scene, as observed by Masefield in lines from the
same poem, *The Land Workers*:

> Then, like to maypoles set in lines,
> The hopyards of the English vines:
> The cribs, wherein I picked for hours
> The resined, flakey, pungent flowers,
> Whose gummage stained my fingers brown:
> Then ... all those rascallies from town,
> The hoppers, cribbing deep, with hooting
> Newcomers, till they paid their footing ...[80]

In Fowler's *Life and Laughter*, the urban as well as the rural type is redeemed
through the natural surroundings.

If urban reformers at times cast their eye with concern on the itinerant
fruit and hop harvester, their major preoccupation was with the potential
benefits of allotments and smallholdings.[81] In 1899, Clausen exhibited at the
Royal Academy his *Allotment Gardens*, viewed from his front garden at
Widdington in Essex. By the turn of the century this was something of a
marginal zone, in between town and country, although in 1909 Masterman
was describing a vast wilderness, where the houses were tumbling into
decay – all the more needy of the potential benefits of allotmenteering.[82] By
then the local market gardener there was already perceived as one 'continually

mingling the soil of his acres with the mud of London'.[83] As Mingay observed, by the end of the nineteenth century the rural labourer was consistently poised between two civilizations:

He had moved out of his rural isolation … He was no longer a member of the lower orders but of the lower classes … The old style of rural life had broken down, but the farm labourer had not yet entered, or was fully equipped to enter, the new semi-urbanized existence which had taken its place. His culture had become town oriented, revolving round town goods, town amusements, town newspapers, town ideas, but his life and work were still rooted in the country.[84]

Such was the difficulty that faced conservative traditionalists like Ditchfield and Haggard. Amidst these dilemmas, allotment gardening and especially smallholdings were a potential solution to economic problems in rural areas and, at the same time, morally improving. The premise of the Small Holding Acts of 1892 and 1908 was that they would supply a career to the labourer, stop the drain of the best rural blood and provide a source of available and reliable casual work to larger farmers.[85] The labourer was to become an independent cultivator, a specialist producer of the small man's products – vegetables, market garden stuff, soft fruit, poultry and eggs – a development that could be supported by the spread of the railways.[86] So allotment schemes attracted agriculturalists worried about rural poverty and depopulation, but also, as P. J. Waller noted, because they were believed to 'reduce the number of poaching and other offences, to encourage personal thrift and enterprise, and maintain the national character and physique'.[87] In other words, their support was underpinned by a fundamental distrust of the labouring class, both rural and urban. In this respect the idealizing of the 'peasant' was even less than skin deep. The English Hodge, just like the city-bred type, was also potentially lawless and needed to be kept in check. One way to do this was to represent him as a universal stoic in elemental compositions and to absorb him into a cast of stock, emblematic types of rural characters inhabiting an ideally stable countryside.

Throughout an essay extolling the virtues of smallholdings, every utterance of Clausen's friend Dewey Bates reveals middle-class distance and bias. Popular national education is dismissed as potentially ruinous – 'the fields would be choked with weeds, the flowers unplucked' – and field women would 'have colour box and sketch book in hand'. The school-room would have even more pernicious effects for boys who would become too accustomed to a warm room, too averse to working outside in the cold and rain.[88] Haggard also reveals the deep-seated prejudices about the rural inhabitants, despite protests to the contrary, 'only the dullards and wastrels stay on the land … and it is this indifferent remnant who will be the parents of the next generation of rural Englishmen'.[89] Painters, wrote Bates, were largely responsible for elevating the position of the labourer in the public's imagination. In reality he was a prosaic individual, and 'fortunately is totally ignorant' of that situation.[90]

Examples of such condescension abound throughout the period.[91] In 1899, Laurence Housman described the faces depicted by Edward Stott as rather

'vegetable in form', and as 'imaging for us, almost to excess, the stagnation of dull rustic intelligence'.[92] Not only were the peasants unintelligent, they were incapable of appreciating the qualities of the countryside and the beauties of the natural world. For Haggard, 'nature (only) appeals to the truly educated'.[93] If the idea of a popular education in rural areas was as unthinkable to Haggard as it had been to Dewey Bates, then the situation would continue.

As dim-witted as he was believed to be, nevertheless the rural worker knew his craft and so proved his superiority to the – equally caricatured – urban type. Ditchfield's contempt for the urban working class was such that he had no time for the ideals of the Back to the Land Movement, which he regarded as straightforwardly socialist in intent. Having spent much time lecturing and talking to the 'men of the East End', he dismissed their wish to be back amongst the green meadows of their native counties, and away from their hard lives in the 'wilderness of bricks and mortar'. Their wishes were anyway irrelevant: 'We have no use for town folks in our country. They are a useless kind of creature. They may think themselves very clever and smart, and they can talk, but what use are they when they try to plough a furrow, or milk cows, or thatch a rick or manage a reaper?'[94]

The rural images discussed here were invariably constructed from the perspective of writers like Ditchfield. They embodied, and deflected, deeply ingrained preconceptions of class and race, ideologies that at times revealed deep contradictions. But the enthusiasm and the critical fervour with which paintings like *Sons of the Soil* were received was enough to conceal doubt and unease, and this was a substantial part of their function. A review in *The Connoisseur* of 1904 illustrates their success:

Clausen's soil stained sons, his gleaning women, his healthy children are all fine English types: he has pictured in many works the great song of toil in the open from the Sowing to the Reaping, from the Reaping to the Garnering of wheat, the song of the Barn, the stubble field, the song of the beauty of the Corn field, the Dignity of the Plough. It is a great feeling to look at Clausen's pictures and to feel English, part of all this, one with the village folk, the countryside, the quiet field of corn.[95]

By the turn of the century, Clausen's direction was clearly changing. His concern to memorialize groups of labourers increasingly diminished and, as Dyneley Hussey observed in 1923, a process of transmutation took place, where the interest was no longer with the figure in a landscape but rather with the rendering of landscape with figures.[96] Hand in hand with this came the brightening and lightening of the palette, the growing preoccupation with rendering atmosphere, or 'envelopment', the result of increased familiarity with French Impressionism from the 1890s. The process of removing the worker to a safe distance was now complete. In the space of ten years between three works like *In the Bean Field* (Royal Academy, 1904), *The Boy and the Man* and *In the Fields in June* (Figure 1.5) vast panoramic landscapes and immense skies begin to dissolve the figures into the evanescent haze that surrounds them. So, by the eve of the Great War the labourer was simply an accessory, an attribute of the English landscape and no longer

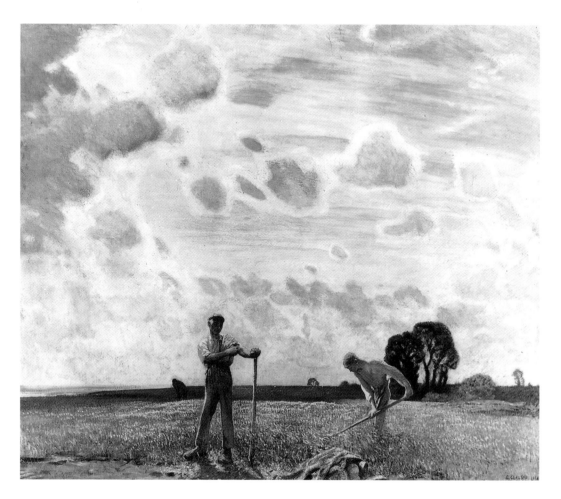

1.5
George Clausen,
*In the Fields in
June*, 1914

such an essential icon. All this only increased the sense of the English countryside as a tranquil idyll, a complete contrast to the crowded, grimy city and the confusion of modernity, but it was also, at the same time, an idyll that could only be appreciated from the position of the modern. Clausen's own writings reflect that position. Lecturing to his Royal Academy students in 1904 he insisted that the appeal of landscape was:

… to the primitive instincts – not to primitive people, not so much to people who pass their lives in the open air; for they take nature and its changes as a matter of course, and look on the weather as a capricious master whose whims have to be met. But the artist's view is outside this; and a picture of landscape appeals mainly to the primitive instincts of cultivated people who live in the cities, who look from the standpoint of civilization with a sentimental longing towards a more simple state.[97]

It is precisely this sentimental longing for a more simple state that ultimately connects the paintings of Clausen, La Thangue and Stott with the more overt modernism of Augustus John and J. D. Fergusson, for example. Through the progressive elimination of naturalist detail, to the atmospheric envelope of

Impressionism, to the rhythmic and decorative handling derived from Post-Impressionism, the search was for appropriate forms of expression and for appropriate locations, capable of sustaining the primitive instincts of cultivated people. Seeking those locations would inevitably take artists (and tourists) further afield as the modern processes of suburbanization advanced. The mythic nobility of the Anglo-Saxon peasant was a fiction that was ever harder to believe in and painters increasingly turned either to pure landscapes, to landscapes incorporating posed family and friends, or to imaginary, mystical scenes of the imagination. In all cases modern civilization was less likely to impinge.

The joys of sight

In a review of the artist's one-man show at the Goupil Gallery in 1909, 'The Joys of Sight: Mr Steer's exhibition', Laurence Binyon reflected upon the nature of vision. He argued against the possibility of 'pure seeing', for an individual's knowledge of the physical world is informed rather through experience of its tangible textures and relations. The tangible world and the visible world are clearly not the same thing, nevertheless the vision of the individual is inevitably 'dyed with associations and suggestions':

Thus in the same landscape the farmer will see land good for this crop or that, or for none at all, the speculator will see eligible plots for building or prospective golf links, the geologist will see interesting formations of strata, the schoolboy will see a happy hunting ground for birds' nests: and so on. None of them, of course, really *sees* anything of the kind: they see patches of green and brown in various tones, with blue or grey above; everything else is supplied by experience and association.[1]

Simple vision is a virtual impossibility because the mind can never be entirely emptied of acquired associations. Nevertheless, by isolating a motif and by focusing upon it with intent and absorption – as when a single word is repeated endlessly – it becomes possible to 'reduce the tangible object to the merely visible' and to acquire a heightened sensation – a 'feeling of strangeness and of a dream'. For Binyon, it is in this 'revelation of strangeness' that the special value lies of an art 'which renders the impressions of pure seeing'; which brings a shock of strangeness and revelation to a spectator habituated to the practical use of the eye. Out of this intensity in the painter's mind emerges 'pure joy', and no living painter expresses this sense of the 'joy of pure seeing' better than Steer in his pictures of sunlight. From his art the critic experienced an untainted exhilaration of the senses. The artist revealed an 'instinctive affinity' to the 'large things in nature … the "bones" of the landscape'. And so Binyon was able to discern a 'masculine power' underpinning the subtle rhythms and 'a real variety both of mood and of design'. In a few simple sentences Steer's art is conflated with both the characteristic qualities of early modernism but, at the same time, with an idealized English tradition. Binyon's case for Steer confounds the conventional polarities of Englishness and modernism. Steer's art is concerned with rhythm and with design, it contains a potential for expression that is not simply tied

to the conventional appearances of nature, and it possesses a masculine authority. But it is also 'steeped in English character' and 'Mr Steer belongs to the central English tradition'. Importantly, however, he is no mere copyist of Turner and Constable. In fact his works reveal a greater ability than the latter to 'carry the force and freshness of a sketch' through into a larger composition. This is one way in which the artist retains a uniquely individual quality – a kind of personal handwriting, or a signature style, which constantly surfaces regardless of the shifts and turns and the array of influences bearing upon his practice from the later 1880s onwards.

Binyon perceived a continuity of preoccupation in Steer's works where later critics found only a rejection of innovative modernism in favour of retrogressive pastiche. I want to develop the possibility of thinking about Steer in the way Binyon's review suggests, and to argue with him that, contrary to later opinion, the fundamentally unique characteristics of his art persisted. His is not simply a tale of youthful radicalism fading into complacent middle age, as writers like John Rothenstein suggested.[2] In terms of the standard tropes of modernism, his integrity persisted. And once we see his experimentation with style as a commitment to exploring the materials and processes of painting, then a very different view of the painter emerges than that which relies too easily on the customary accusations of eclecticism – implying some kind of inevitable failure or loss of faith. Steer's tenacity, originality and authenticity emerge intact.

The issue for this chapter, however, is not simply to assert Steer's continued modernism, but to consider the extent to which we can read the apparently sudden transformation in his work as it occurred around 1893 – witnessed by the distinct differences between works like *Girls Running, Walberswick Pier* (Figure 2.1) and *A Classic Landscape* (Plate III) – in relation to the widespread reassessment of native traditions, the struggles to assert national identities and the broader culture of ruralism. Is it then possible to think about Steer's re-evaluation of Turner and Constable as ultimately very different from that of contemporaries like David Murray, Mark Fisher and Alfred East who, unlike Steer, all showed regularly at Royal Academy exhibitions throughout the 1890s and on until the Great War?

The last chapter was concerned with the extent to which artists' engagement with French Naturalism was modified through various stages and rendered more acceptable to English audiences. This chapter explores a similar process in relation to the assimilation in this country of French Impressionism. It is clear that in shifting his attention away from the more controversial influence of Monet, Seurat and Whistler to the increasingly celebrated, English landscape tradition of Turner and Constable, Steer not only made himself more popular with a larger audience, he was also – along with more commercially successful painters – regarded by many as returning to the very sources of French Impressionism.[3] To an extent the latter involved a concern to make French art more palatable to hostile British audiences, but its larger significance lay in its appeal to nationalistic sensibilities. The radical difference in style of Steer's pictures from around 1893 was indeed very

2.1 P. W. Steer,
*Girls Running,
Walberswick Pier,*
c.1889–1894

apparent at the time, and contemporary accounts of this transition illustrate perfectly the way in which a belief that there are essential, distinguishing qualities in British painting figured in the construction of national identity in the years around 1900.[4]

In terms of a canonical modernism, the artist's heroic period was obviously in the late 1880s. By that date Steer's experimentation with recent French painting from Monet to Seurat was painfully apparent to conservative English critics, whose taste continued to be for sentimental anecdote and highly finished canvases. Pictures like *Boulogne Sands*, c.1888–1894 were therefore condemned for sloppy handling, crude ugliness and jarring colour relationships and, sensitive to this critical failure, he ceased to exhibit more adventurous works for some time after they were produced. William Rothenstein later recalled that Steer's studio in the 1890s was crammed with unsold pictures 'of yachts and the sea, and of girls with long slender legs like Sheraton tables'.[5] General opinion was that works of the 1880s were inspired by the more extreme examples of French art and were quite simply a travesty of nature; they were not consoling, reassuring or pleasant; they were difficult and disturbing. In this respect Steer shared the experiences of John Singer Sargent, whose *Carnation, Lily, Lily, Rose* he had admired at the Academy in 1887. Although there were many more radical instances of Sargent's experimentation with Impressionism around these years, it was this particular picture that, in the words of one critic, established the artist as an arch apostle of the 'dab and spot' school – a label that, as has been pointed out,

only emphasizes the limited understanding of Impressionism in England in the late 1880s.[6]

On exhibition in 1888, *A Summer's Evening* was clearly felt to strike at the heart of cherished convictions about both art and nature. Steer's vivid handling of a time-honoured Arcadian theme of three graces delighting in the sun, sea and sand departed from the usual pseudo-classical depictions of that subject, of figures in timeless and traditional scenes. Reviewers were typically disturbed and uncomfortable with the 'utter unnaturalness and audacity' and the 'aggressive affectation' of the work.[7] Linked to the problem that Steer's pictures upset preconceptions about art and nature was the crucial factor that their source of inspiration was French.[8] In itself this was symptomatic of the widespread insularity and xenophobia of the late 1880s and early 1890s.[9] The influence of French Impressionism at this point appeared symbolic of an imminent breakdown in all areas of social and cultural life, one that extended far beyond mere artistic debate. An anti-French feeling mounted throughout the period of colonial disputes in the Far East, which were finally only resolved with the signing of the Anglo-French agreement in 1904. But this did little to affect popular animosity towards the French and this sentiment certainly had its effect on the originally pro-French New English Art Club, where Steer's most uncompromising works were to be seen, amongst the generally more acceptable works of Clausen and Stott.[10]

From 1890, however, a small group of supporters for Steer began to emerge, of whom Moore and MacColl were the most outspoken. Their advocacy was integral to their general denunciation of the quality of popular art from the Royal Academy, of conformist middle-class taste and crass philistinism. To Moore, the Royal Academy was 'conducted on as purely commercial principles as any shop in the Tottenham Court Road', and 'the RAs are merely concerned to follow the market'.[11] Steer, on the other hand, refused to pander to the 'stockbroker's taste' and was 'never common or vulgar'.[12] Moore's distaste essentially coincided with Masterman's worries about 'an England vulgarized by the clamour and vigour of the newer wealthy'.[13] To *The Studio*'s 'Lay Figure' in 1905, no serious collector of art bothers with Royal Academy exhibitions, he feels irritated at 'being wedged into mobs that he despises for their stupidity and hates for their unaestheticism'.[14]

MacColl, son of a Presbyterian minister in Glasgow, originally trained for the church but was drawn instead to art and aesthetics, due partly to his acquaintance with Walter Pater and Mark Pattison at Oxford.[15] Subsequent experience as a peripatetic lecturer on 'English painters', for the Oxford Extension Movement in the late 1880s encouraged a missionary zeal towards the teaching of art history, confirming his views about the role of the educator, class and social type.[16] A combination of Puritanism and a refined aestheticism informed his art criticism in the following decade, so by 1895 MacColl was confident that only a very few possessed a sincere understanding of art. Genuine Philistines, drawn mostly from the upper and lower classes, openly professed their ignorance and were harmless. The problem lay rather with 'a terrible number of the middle class', for 'instead of being good Philistines,

they are Cultured Persons … semi-educated into a pretence to tastes they do not possess'. Further, their affectation 'vulgarises life; it is only a pretence and transgression you encourage. A nation whose rulers and the bulk of whose people are without this taste, will be happier and more honest if they let painting be.'[17] The proper appreciation of art was therefore a minority preserve – a sentiment later echoed in the writings of Clive Bell in particular and within modernism in general – art and criticism become increasingly self-conscious, self-referential, preoccupied with intrinsic qualities communicable only to a small circle of initiates.

Increasingly MacColl used Steer as a focal point for the development of his aesthetic theory and evolved an appreciation of art divorced from any consideration of subject. In an ideal world, subject was a mere pretext for laying paint on canvas and in this respect MacColl's views, descending from Pater and Whistler, correspond to the Modernist 'concept of "purity" in art'.[18] Painting was to be assessed solely via the pictorial qualities of design, colour and organization. Technique was 'a condition under which one sees things, not a mechanical beauty stuck upon the surface of a picture and detachable from it'. MacColl's account of Steer's art involved a radical revision of the understanding of Impressionism, no longer to be seen simply as a phase within modern French art. An Impressionist technique did not necessarily denote a hastily conceived and executed sketch, nor was it a fad, but an artistic tradition with firm historical antecedents, and this was a seductive argument for a public devoted to sound traditions. For MacColl, French Impressionism had two features. One was 'a keying up of lights as near as might be to their natural pitch', along with a rendering of shadows in colour rather than tone. The second was 'the snatch technique', whereby the artist produced studies at intervals when the light conditions were fairly steady, 'with the speed of a shorthand reporter'.[19]

This did not allow for any conscious process of selectivity or arrangement. MacColl's perception of Monet was of a detached and wholly objective reporter of visual fact drawing on contemporary research in the science of optics and perception. So he disregarded the extent to which Monet's rendering of the 'effect' of nature involved the expressive subjectivity that brought the movement close to symbolism.[20] MacColl presented instead what became the Modernist version of French Impressionism, elaborated for example in Maurice Denis's later account of Cézanne,[21] but MacColl contrasted this further with his exposition of an English tradition. He maintained, for example, that the idea of eliminating distracting detail in art was established long before the 1870s. Joshua Reynolds had warned that too many details would 'dissipate the attention'. From Reynolds and Gainsborough, MacColl claimed, we learned that a subject should be seen according to a painter's interest. In fact the eye naturally carries out this selective process. As a result, he condemned both aesthetically and scientifically the Pre-Raphaelite painter's depiction of a church, which included 'all that could be noticed by the architect, by the worshipper, by the dreamer, and by the person looking about the floor for pins'.[22]

Impressionism in France, he argued, proceeded from a logical and scientific position, whereas in England it derived from a poetic and romantic temperament, dating at least from the turn of the nineteenth century but temporarily obscured by mid-century aberrations like Pre-Raphaelitism.

Steer expressed this same view in a lecture to the Art Workers' Guild – also in 1891. Impressionism was the highest tradition in art: 'Is it a craze', he asked, 'that we should recognise the fact that nature is bathed in atmosphere? Is it a fashion to treat a picture so that unity of vision may be achieved by insisting on certain parts more than others? No! It is not a fashion it is a law.'[23] A 'unity of vision' was sorely lacking in Royal Academy pictures of the day, for out of 'these tiresome exercises of misguided industry you may make six out of one and each is as finished and as badly composed as the others'. 'Impressionism', declared Steer, 'is of no country and of no period; it has been from the beginning; it bears the same relation to painting that poetry does to journalism. Two men paint the same model; one creates a poem the other is satisfied with recording facts.' Of the New English Art Club show of that same year, MacColl spoke of a 'refined vision of an object', unlike a French painter's desire to 'render fleeting and transitory things that will not sit'. This again implied a lyrical interpretation of nature in contrast to the apparently more rational, naturalistic approach of French art.[24] In this way two national, artistic and, by extension, cultural sets of characteristics were forged. However untenable the proposition was in reality, it exercised the minds of a number of writers in the period. In one instance, a critic cited Hazlitt's comments about Reynolds of eighty years earlier: 'The English seem generally to suppose that if they only leave out the subordinate parts, they are sure of the general result. The French, on the contrary … imagine that, by attending successively to each separate part, they must infallibly arrive at a correct whole.'[25]

From 1893 Steer was installed as Professor of Painting at the Slade under its new Principal Fred Brown and his assistant Henry Tonks. These appointments coincided with the growing respectability of the New English Art Club and the two institutions were closely associated from this date. As the 1890s continued their once perceived radicalism diminished and their seriousness was contrasted with the standards at the Royal Academy, whose pictures were increasingly criticized for their conformity and superficial flashiness.[26] The Slade, by contrast, was distinguished by its emphasis on sound technique and respect for tradition, encouraged by its own stable of critics like MacColl and Stevenson.

In MacColl's terms the transitions in Steer's style resulted from that search for 'Congruous Beauty', in which technique was appropriate to the subject. Steer was indeed habitually drawn to artists with a uniquely distinct style and French Impressionism, with its woven brushmarks, summarily drawn figures and prismatic colour, was entirely congruent with his late 1880s seaside subjects and the representation of bright noon-day sunlight. It was a method well suited to expressions of childhood innocence and idyllic summer days, such as *Children Paddling, Walberswick* (Figure 2.2), in which, according

2.2 P. W. Steer,
*Children Paddling,
Walberswick,*
1889–1894

to George Moore, the mood was one of 'oblivion'. Form and technique were thereby directly allied to the expression of subject matter, presaging Denis's claims for the 'correspondence between external forms and subjective states'.[27] An intangible and abstract quality was increasingly apparent in works from this date, comparable at times to the Symbolist poetry of Arthur Symons. Both sought out a quality of atmosphere beneath superficial appearances. In Steer's case this appeared as the relinquishing of a blatantly extreme handling, and this was clearly apparent at his first one-man show at the Goupil Gallery in 1894 where, as Stevenson remarked, he 'wisely omitted his most doubtful and tricky experiments'.[28] To MacColl, a picture like a *Procession of Yachts*, c.1892, retained a 'freshness of inspiration' but was nevertheless 'composed like music'; its masts 'like the phrasing between the intervals of bars'.[29] His analogy suggested Whistler rather than Monet, emphasizing the lyrical, selective qualities of Steer's art.[30]

Increasingly Steer was regarded as an instinctive artist. He possessed, to William Rothenstein, an: 'instinctive rightness of judgement peculiar to a certain kind of Englishness',[31] and for MacColl: 'he works by instinct more than culture'.[32] This view persisted, although by the mid 1940s it had acquired negative connotations. Thus, for Douglas Cooper, to say that a painter was 'intuitive' implied amateurism and lack of discipline, and he applied the term as an accusation to all those painters so revered at the turn of the twentieth century – Constable, Turner, Girtin and Cotman.[33] But while we can see that,

during the 1890s, the idea of English instinctiveness in art positively supported the identification of a poetic and romantic national tradition, it is clear also that the value of a natural, unsuppressed intuition was fundamental to European modernism. That distinction between Englishness and modernism as suggested by MacColl could really only operate within the particular framework of the critic's opposition to Monet and Seurat. Steer was drawn into these distinctions at an early stage, and in a manner that suited urgent contemporary debates – but the mistake is to forever cast him in that light, to take on historical construction as irrefutable fact.

Even an avowed Francophile like Walter Sickert contributed something to this state of affairs, however sardonically, in a remark of 1910:

A painter is guided and pushed by the atmosphere of English society, acting on a gifted group of painters who had learnt what they knew ... in Paris ... [This] has provided a school with aims and qualities altogether different from those of the Impressionists ... the Impressionists put themselves out more than we do in England. We all live like gentlemen, and keep gentlemen's hours.[34]

Sickert's remarks were intentionally ironic, playing on a perception of English life that had less credibility as the years passed. Frank Rutter, well aware of the encroachment of modernity, later recalled that by the turn of the century, both artists and the wider public felt that something was, 'slipping away, a settled and rather beautiful way of life which was now gone never to return'.[35] The romantic view of the countryside, the awareness of a disappearing culture, appeared to pervade the work of Steer as much as the 'peasant' painters of the last chapter and the broader group of pure landscape painters popular at the Royal Academy. One writer in 1900 was struck by 'how great a hold the spirit of romanticism is gaining upon ... the British School'.[36] This revealed a 'preference for decorative freedom over pedantic exactness'. The result was an abstract kind of naturalism based on a sound study of nature, but which concerned itself with 'larger subtleties of the open air, with problems of illumination rather than obvious facts' – in other words with 'atmosphere'. This was a defining characteristic of a successful work of art for modern painters at the turn of the century, just as 'rhythm' became a preoccupation a few years later. A crucial quality of the British School for this reviewer was that it was 'essentially sound and well-balanced'. This was important, for it was not to be mistaken for Romanticism based on a decadent imagination. English romanticism had its feet on the ground, it was not extravagant, but it did possess its 'full measure of imaginative charm'. As a result, 'it has just the right note of pastoral simplicity ... which so many artists are ... wisely striving to make clearly heard'. Again, from a biased and partial position, Steer's art could be assimilated into nationalist assertions like these.

After the turn of the century, his reputation developed primarily as a landscapist and his works were, at times, regarded critically in much the same way as painters like Mark Fisher and Alfred East. And although he was never drawn to such overtly sentimental scenes as the contented cattle winding their way back to pasture in Arnesby Brown's idyllic and nostalgic

2.3
P. W. Arnesby
Brown, *Full
Summer*, 1902

Full Summer (Figure 2.3), nevertheless he shared a concept of nature that appeared to be fixed and unchanging.[37] Studies of pastoral simplicity continued to provide reassurance and continuity between past and present and a measure of control over both, and they acquired a symbolic value which could, at times, manifest itself in the pastiche and hackneyed imagery of pictures like David Murray's *In the Country of Constable* (Figure 2.4). The point for us is to be able to distinguish the degree of difference between Murray's literal re-workings, and the imaginary propositions of ideal, predominantly rural, golden ages that preoccupied European modernists. The fundamental impulse is effectively the same, but the qualitative distinctions reside largely in the handling and in the degree to which an

2.4
David Murray,
*In the Country of
Constable*, 1903

individual artist is concerned with producing an authentic response to nature. So, in the quality of the marks that Steer makes on his canvases – in the expressive and heavily impasted surface of his work, there is a uniquely personal process at work that relates to the modernist desire to 'represent' rather than to simply 'reproduce' the scene.[38] Murray, with his over-blown but, compared to Steer, more finished and bland surfaces, seems content to do the latter and his picture gives a sense of an engagement with Constable and Constable country through a study of illustrated monographs, rather than through individual close contact.

A Classic Landscape, of 1893, provides the clearest example of the transition in Steer's work of the early 1890s and represents perhaps the severest test for us in arguing for his continued authenticity and integrity. How does *A Classic Landscape* succeed in these terms whereas *In the Country of Constable* it evidently does not? An atmospheric, thinly painted and very muted depiction of Richmond Bridge, *A Classic Landscape* seemed to signal the influence, in both setting and handling, of painters like Claude and Turner. The relationship to the latter's Thames series of 1805–1812 is important in this context, for Steer's picture bears a particular resemblance to *Walton Bridges* of 1806, which he could have seen at Thomas Agnew's in 1893.[39] Andrew Hemingway's discussion of Turner's river paintings pointed to the significance of representations of the Thames, both in relation to contemporary nature poetry and as symbols of national, political and economic well-being. For Turner, the Thames was symbolic of the 'pastoral

prosperity and commercial wealth of Britain', but as Hemingway demonstrated, Turner's Thames paintings deliberately excluded commercial or modern agricultural elements. The Claudean effects produced a mistiness that conveniently masked the reality of the scene, so the artist achieved 'a blending of nostalgia, poetry and nationalist associations'.[40] The less fashionable areas of inner London, conceived in the early nineteenth century, as in the early twentieth, in terms of their squalor and chaos, are displaced. But if we replace Turner's example with Whistler's Thames *Nocturnes* of the 1870s, we can make similar observations about the aesthetic displacement of modernity. Whistler's atmospheric haze 'cloaked' the Thames in mist and mystery – just as Monet's concentration on the 'effects' of sunlight on the river at Argenteuil evaded the signs of industry on its banks – and, equally, just as Cézanne's carefully adopted viewpoint towards the sea at L'Estaque missed out signs of industrialism in the Bay of Marseilles.[41] As a result the specific 'nationalist associations' might appear less relevant to discussion of Steer.

At the time of painting *A Classic Landscape*, however, Steer was interpreted as returning to the very sources of French Impressionism, as repeatedly stressed later in the writings of Wynford Dewhurst and Frederick Wedmore.[42] Turner, like Constable, they argued, had worked in the open air, recorded the transitory effects of nature and light and developed a similar handling. For Dewhurst, the lights and shadows in Turner's handling of colour, his sunrises and sunsets, the dissolving web of light and its reflections on surfaces in his late work along with a relative lack of drawing, were all assimilated by Monet and Pissarro on their visit to London in 1870. This appeal to nationalist sensibilities ignored the fact that Pissarro, for example, denied any substantial debt to British art. To Dewhurst, the Impressionists had 'the great merit of having perceived the value of the Englishman's discovery', and he defended his genesis of Impressionism in chauvinist terms: 'Englishmen, who are taunted with following the methods of the French Impressionists, sneered at for imitating a foreign style, are in reality but practising their own, for the French artists simply developed a style which was British in conception.'[43]

Steer was familiar with Turner's art from childhood and was fascinated by a watercolour which hung in his bedroom. His admiration combined personal, past experience with a continued fascination with technique, all of which were given a particular slant in the critical encouragement of friends. His earliest explorations of around 1893–1894, in what has been termed the 'classical machinery of landscape composition', began with scenes around London.[44] But soon after he began to leave the capital at the end of the Slade summer term and go further afield in an effort to find the exact locations from which Turner had painted. MacColl maintained that Steer took a miniature edition of Turner's *Liber Studiorum* on what were effectively pilgrimages to Yorkshire and the Welsh Borders, as an 'Authorised Version of the English Landscape'.[45] These visits were a search for an ideal landscape and Steer came to feel that those settings provided an unsullied 'heightened sensation' – that revelation of seeing described by Binyon.

Artists' summer-time retreats from the city also fall into the wider culture of ruralism but, increasingly, the concern was not for the condition of the 'peasantry'. Rural workers generally appeared only as an occasional note in Steer's compositions – as they did in much contemporary French landscape painting after 1890. For MacColl, 'the art of landscape as Steer took it over ... occupied the middle earth of England in sunny or troubled weather, ignoring man and his toils even in the field'.[46] Steer was attracted to the Wye and Severn valley partly because of his interest in the aesthetic potential of Turner's landscape technique and partly because it was the landscape of his childhood. For MacColl, however, it was because this was a 'holy ground for English poetry, for Milton, Pope, Gray and Gilpin'.[47] Certainly, as the century closed, those literary figures who celebrated the special virtues of the countryside were particularly valued in terms of a national heritage. The appeal of late-eighteenth and early-nineteenth-century painters from Gainsborough to Girtin, also conformed to class and nationalist perspectives in the 1890s. For the established literary and artistic class, with their antipathy towards business and fondness for a leisurely, gentlemanly existence, an idealized view of the eighteenth century certainly evoked an ordered hierarchy of relations.[48] But although these attitudes may have had undercurrents in Steer's thinking, they were not necessarily the determining factor. Just as his experiments with a range of watercolour techniques were to develop at this period, so he seems preoccupied above all with the search for the most appropriate painterly means with which to respond to particular landscape types – be it through Turner, Constable or Cotman. As Cal Clothier commented in his study of the artist's watercolours: 'He is not "satisfied with recording facts" but is concerned with depicting emotional and spiritual states through landscape.'[49]

In his search for historical and literary sites Steer inevitably came into contact with an ever more mobile lower-class public – just as keen as he was to escape the city grime on holiday and weekend visits.[50] MacColl remembered that 'Steer set up his "moving tent" in pleasant scenery such as it had become the habit of his countrymen to seek out for an annual holiday'.[51] As the years passed these countrymen became more of an irritant, and Steer began to see his favourite sites like Corfe Castle engulfed by 'coach loads of overfed and apathetic tourists (on) the regulation round before their mealtime'.[52] He preferred to keep to himself what was described as his 'deep, exclusive love for England', for the 'old bones of his country'.[53] This introspection accounted for his fondness for the picturesque, the atmospheric appeal, the sense of time past which was visible in the decaying structures of *Chepstow Castle*, painted in 1905 from a position identical to one taken up previously by Turner. Steer's is a new vision, however, his handling is much denser, his palette knife and brushstrokes, more visible.[54]

Dilapidated scenery clearly evoked the loss of the old order, a sentiment occasionally relished for its own sake and, at times, this 'faint-hearted hankering' could prove a frustration, as Laurence Houseman observed in 1904:

The taste of the age in which we live finds too much beauty in ruins, preferring the pictorial disorder of decay to symmetry which is still fit and efficient to the purpose for which it was created. And as this is true of the popular taste in architecture, so is it to some extent also true of our appreciation of nature. We like to ache and yearn over it as though it were a doomed and disappearing quantity, a fugitive before the advance of modern civilisation.[55]

This fascination for the 'old bones' of the country extended before and beyond this period. In the inter-war years historical relics and ancient sites indicated permanence and stability at an uncertain time, but the roots of this tendency were clearly well in place by the Edwardian era. There are two sides to this picturesque taste, then. Either it provides the reassurance of continuity in periods of turbulence or, as Houseman believed, a sense of loss to be savoured. So, in one sense picturesque scenes of an unsullied English countryside were quite simply a safe territory with a broad appeal, which explains their predominance at the Royal Academy as well as the New English Art Club in the early 1900s. By that time the Academy was clearly engaged in efforts to present a consensus view of English art, one characterized by its inoffensiveness. Its procedure was generally to co-opt those painters, many originally from the New English as seen in the last chapter, who were the most moderate in technique. With pictures like *Hill and Dale*, c.1902, the American-born painter Mark Fisher who showed at both the Academy and at the New English managed, according to George Clausen, to assimilate Impressionism 'within the limits considered to be acceptable by the selection committee of the RA'.[56] A mild degree of the Impressionist handling of Monet and Sisley overtook the influence of Corot and the Barbizon painters and heightened the atmosphere of a sun-dappled scene of pastoral contentment.

Steer's persistent technical experimentation saved his work from clichéd repetition. Throughout the 1890s he continued to develop a greater expressive freedom with crude, intense colours and thick brushstrokes, as in the dense background of trees in *The Embarkment* (Figure 2.5). His old theme of young women beside the water was restated here, but given a new painterly eloquence with an impasted surface, drawn partly from the important encounter with Adolphe Monticelli, whose violent delights, as Arthur Symons put it, produced an 'abstract intoxication of the eyes'. Monticelli's painting, displayed in London in 1892, was itself 'like the way of seeing, hurried, fierce, prodigal, the paint laid on by the palette-knife in great clumps which stand out of the canvas'. The effect, like music, was to 'escape the bondage of matter', to 'purify vision to the point of getting disembodied colour'. His was a uniquely personal vision of nature, unlike that of the average man with his 'deplorable faculty of imitation'.[57]

Similarly Steer was drawn to Constable's *alla prima* oil sketches for the expressive spontaneity of his thickly applied pigment. But from this point too Constable was widely portrayed as the archetypal British landscape painter and, with Turner, was prominent in the expanded South Kensington Museum's new display of British painting.[58] His importance to the national

2.5 P. W. Steer,
The Embarkment,
1900

artistic identity was thereby deemed official, a process that had already begun with, for example, the Cornhill exhibition of 1899; with C. J. Holmes's search for Constable sites in the Stour Valley from the mid-1890s and, in 1902, the publication of his influential *Constable and his Influence on Landscape Painting*.[59]

For Holmes his subject's importance lay in the balance he struck between tradition and nature. He stepped beyond mere naturalism to a greater pictorial unity, so he could depict the shifting moods of nature with more breadth of vision. Constable presented a perfect mixture of poetry and natural observation, rendering him – to Holmes – far superior to modern French artists. Further, he declined visits around Europe in a patriotic affection for the sites of his own youth. Likewise, Steer's own tendency to paint in areas of his childhood paralleled his growing reputation as a painter in the native romantic tradition.[60] Yet there is no clear reason why such a tendency should be seen as inherently anti-modernist – Cézanne of course painted for most of his adult life in the area he had known since his youth.

Art magazines of the early years of the twentieth century are full of references to Constable or to those apparently following in his wake. In 1906 he was 'the most English of the triad of the English school'. The reasons are

illuminating, for he does not have 'the refined, scholarly approach of Wilson or the subtlety of Turner':

His vigorous treatment of his subjects, his largeness of view and full colour, seems to be typical of the sturdy yeoman of this country of ours ... He loved his England with her rich and glowing colour, and all the signs of her prosperity that surrounded him in his native country.

The writer quoted Constable himself, 'I was born to paint a happier land, my own dear England, and when I cease to love her may I, as Wordsworth says, "Never more hear her green leaves rustle, nor her torrents roar".'[61] Sentiment such as this reverberates throughout literature and criticism from the turn of the century through to the nostalgic pastoralism of the Georgian poets at the eve of the Great War, despite a certain modernizing. Essential to all was that acceptance of the Anglo-Saxon character in terms of sturdiness, vigour and wholeness. So Englishness is defined again both culturally and aesthetically. It was for this idealized view of the English countryside and native tradition, more than his proto-Impressionist technique, that Constable was prized by the wider public and Cook's Tours of 'Constable Country', organized with the Great Eastern Railway from 1893, are an indication of this. While, for Steer, the painter's importance lay primarily in the immediacy and the perceptual freedom of the sketches – the quality he had also admired in Monticelli – the autobiographical element and intimacy with his surroundings in Constable also corresponded to Steer's own nostalgic perceptions of the English countryside. The major point is that in his sketches Constable, like Steer, was seeking to evolve an appropriate authentic response to his surroundings and personal associations. Both painters were concerned to avoid that 'deplorable faculty of imitation' and in this lies the real distinction with the large-scale Royal Academy landscapes of David Murray.

Between 1895 and 1897 Steer spent his summers in North Yorkshire and in 1898, began to revisit the landscape of the Welsh borders, earlier explored alongside his father.[62] Childhood experiences of the 'rolling fertile prospects' of the Wye valley 'implanted that love of lucent expanses of pastoral and wooded country', in the words of Frank Rutter.[63] By 1905, A. C. R. Carter could speak more generally of an older school of 'panoramists', referring particularly to Leader. He might have referred here to Across the Heath (Figure 2.6) as an example of artists' 'wide expanses of land or sea surveying, which mightily please the free born Englishman ... the man pent up in cities feels grateful to the artist who reminds him of holidays and of an unfettered outlook upon a long stretch of field and water'.[64] Steer's works from the later 1890s were seen to fall into different categories. Initially, according to J. B. Manson in 1914, they had 'no dynamic centre', but were 'vaguely comprehensive', possessing a 'quality of large grasp – that power of seeing things, particularly great expanses of country, in their entirety'.[65] Gradually a sense of composition became more apparent. By the time of The Horseshoe Bend of the Severn, and The Severn Valley (Figure 2.7), Steer had clearly established his taste for Constable's 'spacious valleys', for wide open vistas

2.6 Benjamin
Williams Leader,
Across the Heath,
1902

and unpeopled 'pure landscapes'. With these eighteenth-century-style panoramas, he developed his dense paintwork to such a degree that he could supposedly tell by the weight if a picture was finished. All of this reveals that continued interest in the properties of the medium itself, with the result that he avoided pastiche by drawing attention to his own act of seeing and transcribing. As the comparison with Leader shows, Steer also tended to avoid the repeated use of conventional landscape devices like the *repoussoir* in his panoramic oil paintings. Nevertheless occasional notes of complaint arose. J. B. Manson found that the colour range in some of these later works became a little conventional – as if the artist was setting out to paint old masters, using an adopted scale of effect. 'The first impression received is of … an accomplished painting … Mr Steer seems definitely to choose a colour scheme, so his pictures have an atmosphere de tableau rather than an atmosphere of nature.'[66]

There is a sense though in which expectations of Steer's work also came to prescribe it. From 1900, he was celebrated as Constable's successor and as expressing the special qualities, the atmosphere of the English countryside. Rutter commented on how much the artist had made a certain view of the landscape his own, to the extent that one could be struck, on travelling through certain areas of England, by 'a regular Steer'. From 1904, he was the most consistently highly praised artist showing at the New English and

2.7 P. W. Steer,
The Severn Valley,
1909

received something like adulation for the one-man show in 1909. Opinion on his achievements had become hackneyed by the end of that decade and the continued recitation of the limited tropes of Englishness in the end detracted from his essentially modernist engagement. Englishness becomes something of a red herring in this regard and obscures the fact, for example, that Steer was able to respond, unlike so many of his contemporaries, to the formal qualities in Cézanne's rendition of his own native landscape, the *Mont Ste Victoire* which hung at the Salon d'Automne in 1907.[67]

Between 1896 and 1906 Steer produced a small series of pictures from the same vantage point overlooking the River Teme at Ludlow, exemplified in *Ludlow Walks* (Figure 2.8). These are reminiscent of his earlier Walberswick pictures. Once again images of youth and a lost world of innocence seem to refer back to his own ideal childhood. With this series he brought together the atmosphere of his Walberswick paintings with the rolling open countryside of his own youth. Through changes in technique he looked for ways to achieve the most direct painterly expression of what he himself described as the sentimental feeling he had towards the landscapes of the Welsh borders. Such feeling also had a poetic counterpart in A. E. Housman's *A Shropshire Lad*, of 1896. Housman evoked a specific area of countryside, Steer's own, also in the context of images of loss – most literally in Housman's words where, 'blue remembered hills [are] a land of lost content'. The poet remembered the Shropshire landscapes of his childhood from the distance of London. There is the same blend here of retrospective nostalgia and regret. 'A land of lost

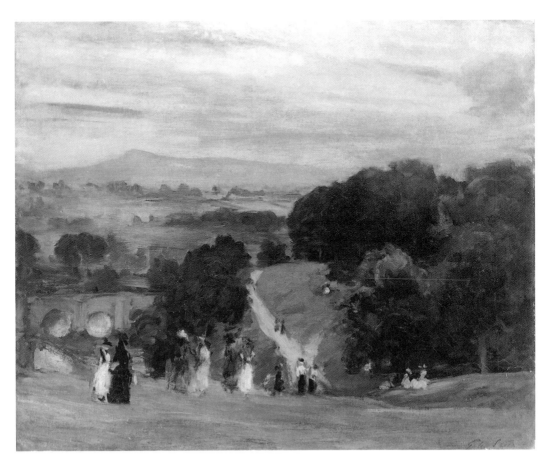

2.8 P. W. Steer,
Ludlow Walks,
1898–1899

content' is an appropriate title for so many of Steer's landscapes, but there is a distinction to be made between these and the more straightforwardly mawkish, Tennysonian idylls to be seen at the Royal Academy. So, while imperialist ideologies resulting in calls for a national tradition in British art account for much of the wider praise of Steer's work, the private, solitary reflection, the nostalgia for one's own roots, and the persistent search for pictorial means to expression all relate to something of a change of spirit that can be recognized as the Edwardian era progressed and this was certainly in evidence across Europe at the time.

In 1909, Steer's work began to be acquired by the Tate where MacColl was then Keeper. The Goupil Gallery exhibition included *Corfe Castle and the Isle of Purbeck* (Figure 2.9), the largest work in the show (likened by Holmes to Constable six-footers such as *Salisbury Castle from the Meadows*), which was later sent to Johannesburg where it stood as a symbol of Englishness only a few years after the end of the Boer War. *Corfe Castle* was painted after a visit to Dorset in 1908. The castle is a minor note, set amidst a sunburst in the centre of a vast overall design of the sweeping landscape of the Purbeck Hills with their dark shadows and heavy brooding skies overhead. All detail is subordinate to the total effect created by the thick layers of oil paint

2.9 P. W. Steer,
*Corfe Castle and
the Isle of Purbeck*,
1908

rapidly laid with brush and palette knife. These processes and techniques are fundamentally in tune with modernist preoccupations – even if the picture in the end looks like an old master. In the context of the emerging radical groupings in British art just prior to World War I, however, Steer was taken to represent the standards that appeared to be slipping away. Far from being dangerously anarchic and dependent on foreign styles as he was in the late 1880s, he was now something of a national icon. But the error is to mistake the adulation for accurate assessment – to imagine that nostalgia, a preoccupation with childhood sites and native landscapes, and the expression of a romantic and poetic sensibility are necessarily anti-modernist tendencies.

3

Seeking classic lands

Referring to the New English Art Club's summer exhibition of 1908, Binyon expanded on the qualities which for him characterized the national school: 'a feeling of out of doors, a pleasure in human grace and human character, enjoyment of pretty things; these struck foreign observers ... a century ago, and these persist in the New English group'. But despite his continual admiration for Steer, Binyon felt the lack of any 'fierce intellectual life' in much New English art: 'Even their impressionism they have worn as a mode, or taken and got over like the measles.' And their general outlook was 'so sheltered ... so untroubled in its equanimity, that at times a craving comes upon one to see it produce something sad or mad, something passionate or bitter'. Only the art of Augustus John really satisfied his craving. Only John 'brings a gust of strangeness and disquiet, a breath of outlandish liberty and revolt into the sunny morning-rooms of his comrades'.[1] Two years earlier and in the same journal, John's admirer Arthur Symons had established similar comparisons between him and Steer. Although the latter's landscape was technically by far the best at the New English, it was nevertheless 'without something which is the root of greatness':

Look across it to a small and too rashly coloured landscape by Mr John, a moor with a gypsy van and you will see in it something which is not in Mr Steer's landscape. That something I would define in a phrase of Browning: 'the moment eternal'. Mr John snatches the eternal and throws it away; but Mr Steer's average moment will never become eternal.[2]

So the terms of praise (and criticism) for John were clearly marked out. Both the artist and his art declined the 'exterior graces of life', embodying boldness, rebellion and the deeper springs of emotion.[3] Early modernist constructions of masculine artistic identity are of course, fundamental here and crucial to John's self-perception.[4] In the conceptualization of the artist-outsider, the decadent associations of the Aesthetic Movement had been cast aside in favour of a desire for a renewed 'masculine vigour' by the early years of the twentieth century. Such was the concern to eliminate the exaggerated eccentricity of the 1890s, that Slade students were treated to a course of lectures in 1910 from Anthony Ludovici on the art opinions of Nietzsche.[5] For Ludovici it was 'impossible to overrate the value of his [Nietzsche's] Art

doctrine – especially to us, the children of an age so full of perplexity, doubt and confusion as this one is'. A vogue for Nietzsche contributed to an ideal of 'man' as the supreme individual, standing 'in no need of public testimony', and this in turn affected the perception of 'artist' amongst a cultured elite. In the philosopher's own words, as quoted by A. R. Orage, editor of *The New Age*: powerful and expressive minds were necessarily sceptical of the principles and values of others: 'Convictions are prisons ... A spirit who desires great things, and who also desires the means thereto, is necessarily a sceptic.'[6] For Ludovici, adopting 'a Nietzschean standpoint, the painters and sculptors of the present age are deficient in dignity, in pride, in faith and, above all, in love'. In such a climate of fashionable thought, an ideal of masculinity and an artistic ideal were inevitably conflated, and both were reflected in the persona and in the art of individual ex-Slade artists like John himself. In his refusal to be closely identified with any particular group or movement, as in his compulsive philandering, he typifies the Edwardian male artist's belief in his own individual and creative dominance.[7] The argument here is that John's specific artistic identity with its accompanying contempt for the bland inauthenticity of modern life, resulted in an assertion of primitive, remote, elemental scenery and of a particular type of figure in landscape painting which, ultimately, proved reassuring to those concerned with racial and cultural decline and degeneracy.

John's particular primitivism revealed itself most profoundly in his fascination with the culture of gypsies, his desire to understand their language and customs and to be accepted into their community.[8] He identified with their culture to the extent of occasionally pretending, perhaps even believing, that he was descended from gypsies himself.[9] Gypsies were hardy, open-air figures who were redeemed from the commonplace and untainted by the degeneracy of urban living. More importantly, they were not English 'peasants' who had suffered the ravages of decline in the rural economy. They were glamorous figures of the imagination.

From this perspective the identity of the artist and the gypsy merge, an identity already well established in France by the 1830s. The myth of the gypsy is an essentially bourgeois myth and by latching on to it, in the words of Marilyn Brown, the artist was expressing, 'not his alienation from but rather his sensitivity to society and its urgent forces'.[10] Furthermore, the myth distils a taste for exotic 'others', which ultimately appropriates and controls. So, like the vogue for Celtic 'others' and in this sense views of the countryside itself, the appeal of the gypsy needs to be regarded in relation to early-twentieth-century colonialism. Of course, those who praised gypsy culture in the 1900s did not regard themselves in those terms – quite the contrary – even though their language was frequently full of colonialist rhetoric. They represented the gypsies as survivors of a free civilization, a freedom that desperately needed to be preserved. Thus for Symons again, this time writing in the *Gypsy Lore Society Journal* of 1908, they were:

Our only link with the East, with mystery and magic. The gypsies are nearer to the animals than any race known to us in Europe. They have the lawlessness, the

abandonment, the natural physical grace in form and gesture, of animals; only a stealthy and wary something in their eyes makes them human. To the natural man the freedom of the gypsy is like a lesson against civilization; it shows him that it is still possible to live, do as one likes, thrive, be healthy, and take for one's pattern the instinctive, untameable life of the animals.[11]

Symons' account resonates with John's pictures from this date, from his illustrations of gypsies for the *Gypsy Lore Society Journal* to the peculiar cast of the representations of his mistress Dorelia in flowing robes and with a knowing glint in her eye.[12] But in his obsession with Romany culture John shared in wider concerns about the declining knowledge of folklore and disappearing cultural forms. These also preoccupied his friends, such seemingly disparate individuals as William Butler Yeats and Lady Gregory at Coole, Lord Howard de Walden at Chirk, Scott Macfie and John Sampson.[13] John spent time entertaining Lady Ottoline Morrell in her drawing room with tales of 'gypsies and troubadours'. In this respect, voguish phenomena such as the cult of the gypsy were, like the flourishing Celtic Revival, to be viewed alongside the distaste for what Yeats termed, the 'massed vulgarity of the age'. So anti-urbanism, alongside expressions of nostalgia for past and supposedly unified cultures, linked bohemian, non-conformist artists, writers and poets together with more conventional cultural critics like Masterman and a group of leisured aristocrats with time on their hands and a fondness for dressing up.

Nor was John alone amongst contemporary British artists in this respect. Alfred Munnings, whose *plein-air* Naturalism of around 1905 was rather similar to John's out-of-door scenes at that date, was also an habitual observer of gypsy life.[14] Like John, he mingled with renowned gypsy families, in his case with the Grays and the Boswells. He lived the life and fancied himself as a latter-day Jasper Petulengro from George Borrow's *Lavengro*; he owned a gypsy cart and employed gypsy models. Although his own attachment derived from his childhood and adolescence amongst the horse fairs in his native Suffolk, his example indicates further the extent to which the cult of the gypsy was widespread after the turn of the century. But changing representations of the gypsy were inevitably shaped by very particular social and cultural experience and specific identities. Munnings's naturalistic renderings like *The Vagabonds*, 1902, are of itinerant horse-traders, picturesque nomads straggling down a muddy lane. In these he followed the lead of Clausen and La Thangue in their records of declining types of rural activity, in their case the ploughmen and hedgers and in his gypsy hop-pickers and fortune-tellers at country fairs and at the races. Unlike John, he felt no need to adorn himself in gypsy garb; his was a different kind of attachment, one bound up with an inherited understanding of bloodstock and personal experience of rural custom.

But John was less detained by the breeds of ponies, and in this he relates more closely (in spite of himself perhaps) to the fashionable, urban-based ruralism of the simple-lifers which ranged across the middle and upper classes after the turn of the century, providing amusing copy for *Punch*

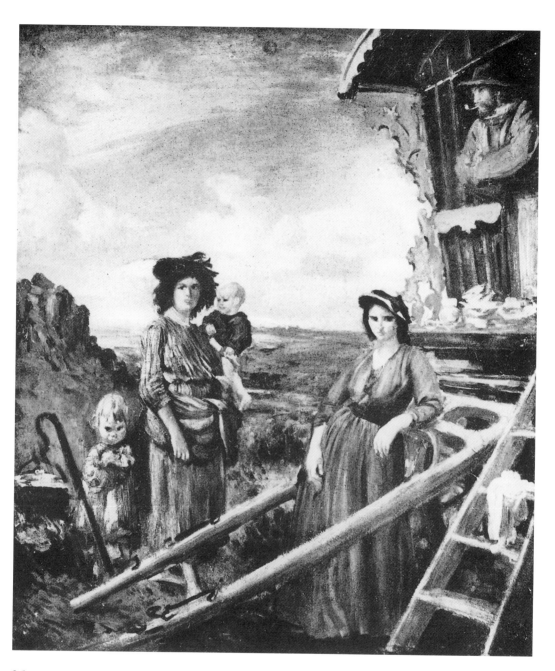

3.1
Augustus John,
*Encampment on
Dartmoor*, 1906

magazine in its wake. In addition, Munnings's approach, deriving from
Naturalism, was that of a conventional picture-maker, whereas John began
from a reductivist modernist premise. It is in this context that an early
painting of 1906, *Encampment on Dartmoor* (Figure 3.1) might be viewed; a
scene from his own raggle-taggle family life, of bonny bairns and romantically
dishevelled women-folk gathered around the cooking-pot, all overseen from
the caravan by the patriarch, John himself, sagely drawing on his pipe.[15] The

barren moorland in the background marks a sharp contrast to the rolling, fertile terrain or those 'picnic landscapes' more typically favoured amongst both Royal Academy and New English Art Club painters and audiences at the turn of the century.

This taste in landscape type presages important developments in John's art and it is clear that his particular landscape settings resulted from a complex mixture of influences, of specific artistic sources and the aesthetic qualities of specific sites like Dartmoor and Dorset in the west of England, certain coastal areas in northern France, remote locations around Bala in north Wales, in Martigues in southern France from 1910, and later (from 1913) in Galway in the west of Ireland. The defining character of these not-quite definable landscapes is an untamed, uninhabited, elemental atmosphere – a barren featureless domain over which there is a faultless azure sky, in contrast to those secure, home-counties sites, traditionally characterized as the epitome of the English countryside and therefore implicitly of that unique 'Englishness'. John is not concerned with topography, much less with Victorian conventions. His landscape deals in the rudimentary – trees, fields, hedgerows all get in the way and confuse the big, important issues of earth and sky. From these alternative locations and in these demanding, unrelenting landscapes a new race might emerge.

A painting such as *A Family Group* (Figure 3.2) demonstrates these attributes at a significant stage in John's development, where he had become especially interested in the decorative style of Puvis de Chavannes, with which he was familiar at least by 1899.[16] By 1907 he was proclaiming the artist to be 'the finest modern'.[17] As Gabriel Mourey proclaimed in his 1895 article on Puvis in *The Studio*, 'how powerful is the symbolic simplification of Puvis de Chavannes, and how, while never ceasing to be thoroughly modern, he resembles in his limpidity his prototype Giotto'.[18] Puvis's importance for John lay in his indeterminate settings, which were at once an abstraction and an ideal. The dress of his figures was simplified to the same classical abstraction which eliminates literal and material considerations. No circumstantial evidence is permitted to appear, nothing that can pin down time or place or give clues to the character of an individual. These observations are confirmed for us by Charles Ricketts, a chapter of whose *Modern Painters* appeared in the *Burlington Magazine* in 1908, extolling Puvis as one 'who dealt in quintessences and abstractions in a period devoted to the noting of detail and incident'.[19] From Ricketts's account he emerges as 'among the great designers in the history of art', one who substitutes the 'mood of a man (out of doors) for that more complex expression of life and experience which is the field of the figure painter'. Puvis establishes the sense that the 'essential conventions of landscape painting have been invented by figure painters'. It is the specific emotional charge between figure and landscape type which, for the most part, preoccupied John in the period up to and beyond the Great War when his major objectives – largely unrealizable in the end – lay in the creation of a series of mural paintings inspired primarily by Puvis's 'noble schemes'.

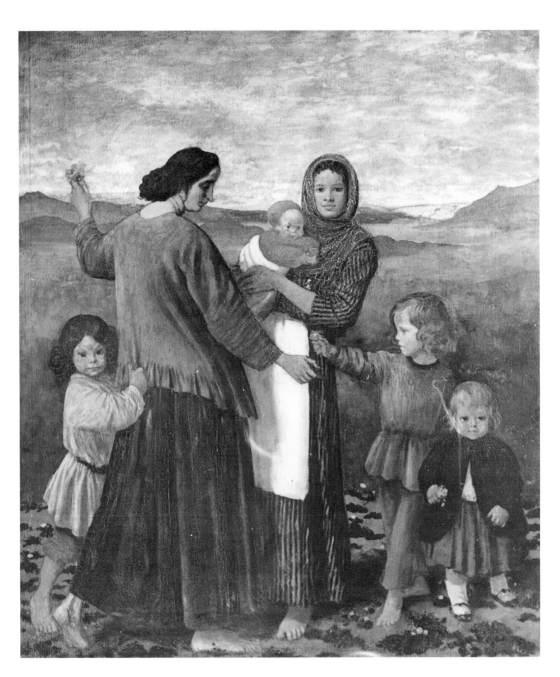

3.2
Augustus John,
A Family Group,
1908

A Family Group (also entitled *A Decorative Group*) presents an early step towards these ambitions with a classically composed grouping of John's extended family, set in a remote and unspecific landscape. Dispensing with irrelevant additional detail, John concentrates on the women and children. Included in the group is his first wife Ida Nettleship, the promising ex-Slade student who had abandoned her own painting career in order to nurture John's apparent genius and his children. The painting, completed after her

death following childbirth in 1907, presents her, perhaps as a memorial, at the centre of the composition holding her baby and calmly and directly surveying the spectator. Dorelia, John's model and mistress is absorbed by the children and has her back turned. Her position, with the diagonally sweeping gesture of her arms, contributes a more dynamic but also a unifying force within the work. As a result, the group forms a closely knit and self-sufficient unit that would appear to exclude others.

A Family Group transposes classical composition and gesture into modern rural imagery and results from a series of closely related works, the most immediate being a charcoal-and-wash drawing of a year earlier where the structure of the group is essentially the same. Significant differences include Dorelia's dress and her stance. In the earlier study she, unlike Ida, returns the spectator's gaze with a coquettish expression and with hand on hip. She wears more dashing and contemporary, if bohemian, dress with a wide-brimmed hat and the flourish of a long scarf. Ida in her turn looks to one side, her shawl covering her hair.[20] In the final work, with the addition of another child, possibly her own Pyramus, Dorelia's appearance is more demure. Hatless and gazing inwardly at the children, she is reconciled to the group.

There is, significantly, a considerable gulf between John's works like this one and the atmospheric *plein-air* studies of figures on the cliffs and rugged hilltops painted by a range of artists including Charles Furse, Charles Sims, William Orpen and Harold Knight. Yet even Laura Knight, as P. G. Konody remarked, 'while aiming at a certain decorative splendour of vivid colour notes, still remains a realist', whereas 'Mr John's aims are utterly different, and so is his manner of painting'.[21] Far from feeling the breeze and the sunlight on their faces, John's figures occupy an often weather-free environment, where the desire to portray visual fact is subordinate to the desire to express a symbolic ideal. Instead of Naturalism, John and close followers like Henry Lamb concentrated on creating strong, pared down relationships in a synthetic and decorative style. John's symbolism was an attempt to capture the quintessence of an ideal. His women and children were members of a proud race, potential archetypes for the nation's mothers and fine, clean-limbed children, contrasting with the enfeebled weaklings to be seen on large city streets – all in the historical context of the emerging Eugenics Movement. Hence one critic's remark in 1905, 'Mr John ... now comes forward in paint with the authority of one almost savagely intent on capturing what is vital. He wrestles with motives of full-blooded strenuous life.'[22]

The qualities ascribed to the figures were inextricably related to their outdoor settings. John had affection for Thomas Hardy and later painted his portrait. The author's imaginative transformation of Egdon Heath in *The Return of the Native* (1878) reads in places like a *mise-en-scène* for John's figures. Hardy's character Eustacia, rather like John's Dorelia, 'had pagan eyes, full of nocturnal mysteries'.[23] She was rarely depicted indoors, she was often a figure seen on a hilltop or by the edge of a cliff, creating what Hardy saw as the necessary unity, the figure in the landscape. This female type is

perfectly synonymous with that view of nature, both primitive and vigorous, elsewhere in time and place. John's imagery in later years became quite formulaic, but this was only to the satisfaction of James Bone: 'A bracing wind seems always blowing and the hills are darkling in the distance ... his people are never in an interior, except sometimes in a tent. They stand firmly on the earth and regard civilization with eyes that have judged it and found it wanting.'

For Bone, John's works were securely rooted in the 'distrust of cities, of society in its present organization, even of civilization, and the desire for a simple life, and the recovery of virtues that lie in a more physical communion with the earth'.[24] Those desolate stretches of countryside were also portrayed in contemporary poetry, despite the preponderance of more familiar and secure sites. In *Lollingdon Downs*, John Masefield, who forms a link between the Symbolist poetry of the 1890s and the Georgian era, demonstrated the appeal of the lonely moorland and the evocation of an ancient existence that a number of artists tried to create. For here, as he wrote:

On the hills where the wind goes over sheep-bitten turf, where the bent grass beats upon the unploughed poorland, ... Here the Roman lived on the wind-barren lonely ... Lonely Beauty came here and was here in sadness, Brave as a thought on the frontiers of the mind, In the camp of the wild upon the march of madness.[25]

The melancholy beauty of such ancient, barren landscapes, stripped of all cultivation, was admired as much after the turn of the century as the secure, cultivated places that poets and painters later generally preferred to remember from the context of World War I battlefields.[26] In spite of the accepted notion that the national ideal lay in the south country, in the 'haunts of ancient peace', there is enough evidence in popular regional literature of the period and in the way that certain paintings were interpreted, to suggest that pre-war landscape tastes were more diverse and inclusive. The experience of the Somme and its hellish, treeless, lunar landscapes would rise up to challenge the wild beauty metaphor contained in John and his followers. But this was all to come. For the present, in the run up to John's exhibition at the Chenil Gallery in 1910, the blossoming verdant country of the home counties could no longer be considered sufficiently robust.

In John's case this taste had to be constantly nurtured by his travels. Interspersed between prolonged periods in Paris and return visits to London, John and his shifting entourage explored the northern coast of France and, between April and June 1907, perhaps nourished by the Gauguin retrospective at the 'Salon d'Automne' in 1906, he found himself in Equihen, an isolated fishing village in the Pas-de-Calais near Boulogne. In letters to William Rothenstein and to Dorelia he sang the praises of the magnificent fisherwomen he encountered there, who moved around 'in wonderful groups', reminding him of a community in his native Wales who 'go all over Pembrokeshire selling oysters in a peculiar costume'.[27] John's imagery in fact conflates his earlier childhood memories with present experience and his fascination for the exotic mystery of the gypsies. These Equihen studies are relatively rare instances of paintings and summary sketches of actual rural inhabitants,

although the poses to some extent suggest references to works by Puvis de Chavannes, now filtered through Gauguin.[28] Like the gypsies then, the fisherwomen in Equihen were untainted by modernity, seemingly immune from civilization, protected in a 'little colony' in a 'desolate little place'.

The same predilection drew Henry Lamb to northern France. He had accompanied the Johns on their trip to Equihen and in the following summer went with them to Normandy. By the time of his first visit to Brittany in 1910, Lamb was carrying the current Gauguin fever.[29] Ever since the period of *plein-air* Naturalism of the 1880s, Brittany had been a magnet for young British artists, drawn initially by the example of Bastien-Lepage and later by the Pont Aven School. Since the late 1880s followers of Gauguin, Emile Bernard and Louis Anquetin had made it their principal base. Roderic O'Conor resided there and, in 1894, Robert Bevan encountered Gauguin himself. However, while the Pont Aven School in the 1890s was mixed up with Symbolism, the Catholic revival and with Divisionism, the Gauguin who emerged from the South Seas at the posthumous Salon d'Automne exhibition was now seen as a classicist in clear relation to the work of Puvis.[30] This was Lamb's inheritance. As Frank Rutter observed on reviewing the Camden Town exhibition at the Carfax Gallery in 1911 where Lamb's *Brittany Peasant Boy* was displayed, the artist was 'a modern classicist, just as Gauguin – whom he so discriminately admires – was also essentially a classic'.[31] The key to this classicism was to eliminate the unnecessary details, to emphasize essentials, to create a mood of enduring self-possession and calm.[32] Typically, representations of the region tended to assume qualities like those described in a book review of 1909 entitled 'The Soul of Brittany'.[33] Accounts of the primitive communities, their religious fervour, their quaint dress and customs dominated contemporary travel literature, as is clear here: 'Everything in Brittany seems as old as the world. All is primitive, Virgilian, Biblical … Brittany is the last bit remaining in Western Europe of an older and simpler world, with its … unworldliness, its leisure, its charm. It is possible that all these things are doomed.'[34]

We are now looking at something more generalized than specific 'place myths'.[35] Associations of the perceived characteristics of locations had of course been important to generations of British artists' and tourists' preconceptions of northern France since the 1880s. However, when Lamb and John visited these regions they had something much less local in mind. Indeed they wished to escape the specificities of the guide-book picturesque. They were engaged with pre-modern, uncultivated landscapes and picturesque 'primitive' communities, with scenery and ways of life that appeared to be increasingly unavailable in Britain, that might still only just be made out in areas of Cornwall, north Wales and the west of Ireland.

The sketches that John produced in Equihen served as preliminary studies for the oil painting *The Way Down to the Sea* (Figure 3.3) which was exhibited at the New English in 1909.[36] With Ida at the head of the descending group (derived from a sketch of 1906, but here with an apple in her outstretched hand), and with the figures of Dorelia and Pyramus on each side, the picture

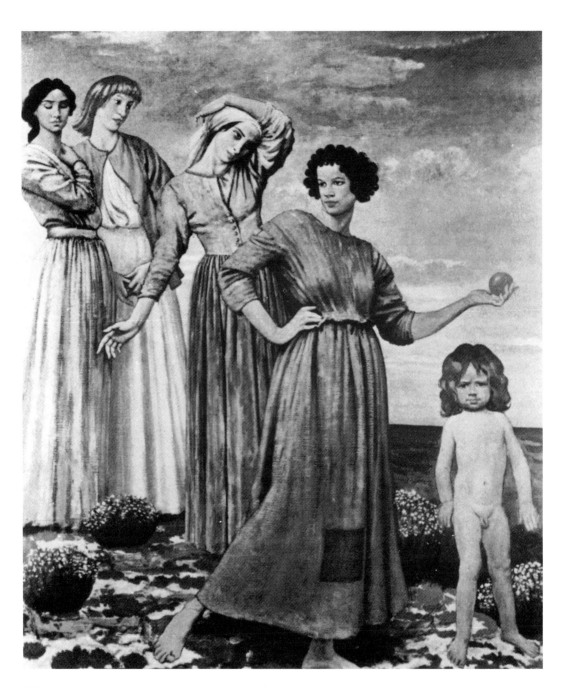

3.3
Augustus John,
*The Way Down to
the Sea*, 1908–
1909

compares with *A Family Group* in its portrayal of John's own family in timeless, statuesque poses, and so looks forward to *Lyric Fantasy* of 1911–1914.[37] His own kin might take on the personality of those fisherwomen or gypsy types and, in effect, might colonize their landscapes.

In 1908 John gathered his tribe at Dielette, a lovely place, 'so varied – sandy beaches, rocks, harbours and prehistoric landscapes behind' and

3.4
Augustus John,
*David and Dorelia
in Normandy*,
1907

declared that he wished 'to God I had a sense of figures'.[38] In a portrait of Dorelia seated on the grassy cliff-top in a languid, almost cross-legged posture with Ida's barefooted son David like a 'healthy vagabond' at her side, John successfully established a figure in landscape composition that would recur frequently throughout the years up to 1914 (Figure 3.4). Paint is applied freely and sketchily with patches of canvas clearly visible in places. The restricted palette of blue, green and ochre combined with fluid brushstrokes and simple forms establish an indissoluble relation between the models and the setting, presaging the Provençal studies of two years later. This quest for a unifying, harmonious composition perhaps connects with his interest, described at the time to Ottoline Morrell, in the searching intensity of Cézanne, but the simplicity of Dorelia's pose appears more closely related to Gauguin's two- and three-figure Tahitian compositions. At the end of that season he reported, again to Morrell, his desire to 'get to the Pyrenees or further instead of lingering in the chilly north', but financial restraints prevailed and it was two years before he was able to realize his ambitions to travel south.[39] It was there ultimately that John's particular fantasies – both his utopia and his golden age – were most likely to be achieved.

3.5 J. D. Innes,
In the Pyrenees

In 1907 John had first met fellow Welshman and ex-Slade student J. D. Innes in London, later describing his appearance in 'A Quaker hat, coloured silk scarf and long black overcoat [and his] features of a slightly cadaverous cast with glittering black eyes'.[40] In the spring of the following year Innes had embarked on his first trip to the south of France with the architect and innkeeper John Fothergill.[41] Their travels took them to Bozouls, to Caudebec and then to Collioure although it seems, at this point, without any particular sense of the significance of Matisse and Derain's stay there in 1905. From 1908 Innes continued to travel intermittently to the south of France where the effects of the Mediterranean light, of the 'heat, light and gaudy colour', caused him to brighten his palette and to depict scenery with the intensity that John was himself moving towards. Fothergill later summed up Innes' experience: without that French trip his friend would have remained 'just another exponent of the veiled charm of a pale English sunshine'.[42] As a result, the earlier influence of Steer's scumbled landscapes, as seen in *The Wye Near Chepstow*, 1907, was to be overthrown by the experience of scenes like *In the Pyrenees* (Figure 3.5).[43] Steer had apparently told Fothergill that the south of France was 'quite unpaintable'. 'Steer', according to Fothergill, 'liked the veil, Turner saw through it, Innes tore it away and got nature with the brilliance of stained glass'.[44] He painted pure landscapes with a fevered vision that drew from the colouring of French painters like Derain and, in some cases, the decorative quality of the Japanese print (see *Bozouls, Sunset*

in the Pyrenees (Figure 3.6)). He keyed up the elements of the scenery around him to correspond with his own internal visions or, as Fothergill put it, 'he played with landscape as if it were a doll's house'.

Bozouls is positioned on the edge of a great tumbling chasm, an ideal vantage point from which to view 'the bizarre and spectacular, violent perspective, pictures with no horizons or with two vanishing points'.[45] But Innes declined that potential and Fothergill interpreted what he termed the 'longitudinal tendency' of Innes' paintings as confirmation of 'Dr Loewy's [*sic*] "Fear of depth"'. In Emanuel Löwy's *The Rendering of Nature in Early Greek Art* (1900) primitive art is characterized by conceptual rather than perspectival representation and based on memory images featuring limited, typical forms, linear patterns and outlines, flat areas of colour without light and shade and a lack of three-dimensional space.[46] Fothergill accepted what appears here to be a comprehensive account of modernist formal tendencies in early-twentieth-century landscape painting as a sign of the artist's refreshing innocence and naivety. Those same tendencies, however, provoked censure from some conservative critics. Thus, Steer's admirer C. H. Collins Baker remarked of Innes' 'self-conscious methods':

The kind of intellectual exercises that the new school of landscape sets itself, the school in which Mr Innes is a clever scholar, inevitably blocks the way to Nature's confidence. [Innes is] not concerned with Nature save as a conventional excuse for

his original contributions ... While Mr Innes' school of landscape is topical and 'the latest craze', let it be merry; for it is not likely to appear amusing to a decade that is engrossed with a new crop of theories. ... He is occupied rather with the effectiveness of his formulae – his ingenious way with lines that are an amusing substitute for clouds, his slangy paraphrases of rock form and his conventional, somewhat jammy purples 'for decorative mountains' – than with trying to gain nature's confidence.[47]

For Collins Baker, Steer's majestic, atmospheric, but topographically correct panoramas of the Wye and Severn Valleys were the *ne plus ultra* of British landscape painting, they now set the standard and he felt the contrast with Innes' paintings acutely. In the 'latest craze' for the dislocalized, decorative, modernist ideal, all native traditions and sensibilities were, he believed, in jeopardy.

Innes travelled to Collioure and to Spain with the Australian ex-Slade school painter Derwent Lees at different points between 1910 and 1913, although he interspersed his visits with periods in north Wales. He favoured mountainous sites like Mount Arenig and Mount Canigou but his taste was decidedly not for the sublime and Romantic. John Rothenstein recalled one critic's jibe that the artist 'made molehills out of mountains'.[48] Perhaps with potential critical reactions in mind, Fothergill chose to play down modern French influences on Innes' decorative landscapes, citing the linear, sparse forms of Cotman as a more likely source. Although he had encountered works by Matisse and Cézanne on his visit with Matthew Smith to Leo Stein's house in Paris in 1908, Fothergill insisted that Innes was largely unresponsive and more impressed by his frequent visits to the Japanese print collection at the British Museum. While Fothergill may be reining Innes back to his own orthodoxy, there can be little doubt that the painter's fantasy of nature was a mental rather than a strictly topographical landscape, one in which the distinctive terrain of north Wales and the south of France would eventually unite. Like John he preferred a landscape that was in a large degree 'other', remote from metropolitan life, from the hackneyed imagery of the home counties, and from actual experience. As ever, landscape was to be a back-drop onto which personal and wider cultural dispositions could be both expressed and reinforced and both artists, though from rather different sources, refined a modernist handling to these ends.

This chapter began with an account of John's status as artist-outsider, an identity that was clearly assumed by Innes as well. Innes' consumption, to emerge at the end of his first travels with John Fothergill, along with his heavy drinking and his fiery, temperamental character all combined to produce the 'cadaverous cast' of his features and the 'glittering black eyes' described by John and depicted in Ian Strang's portrait of the artist, posed appropriately against a wild, mountainous background.[49] From 1910, John and Innes were to exert a considerable influence on each other's works and personalities. Crucial here was their mutual tendency to sudden flight, to take off on impulse to wherever the imagination willed and for as long as it seemed necessary. These tendencies, with or without caravan, were symptomatic of a specific taste for

travel rather than tourism, and this John acknowledged in his autobiography: 'the artist … is also a born adventurer. His explorations, unlike those of the tourist, are rewarded by the discovery of beauty spots unmentioned in the guidebook.'[50] John was simply at pains to preserve the myth of the artist's distance from the concerns of everyday life and common experience. In his own terms, the experience of the traveller is authentic and whole while that of the tourist is superficial and inauthentic – a preoccupation clearly founded on traditional nostalgia for more unified and organic cultures believed to have once existed. Associated with the implicit critique of an homogeneous urban society was the belief that it resulted in the loss of personal freedom, which both John and Innes valued highly. In common with all contemporary critics, they would distinguish between two forms of non-middle-class culture quite unequally. Modern, urban popular culture was inauthentic and pertained to an unruly, potentially destructive working class, whereas rural and primitive forms were bona fide and seemingly above all matters of class, a cultural prejudice that strengthened the links between artists and a wide range of critics and intellectuals in the pre-war period.

Towards the end of 1909 John was commissioned by Lady Gregory's nephew, Sir Hugh Lane, to create a decorative scheme for Lindsay House, his home in Cheyne Walk.[51] John embarked on the scheme with much enthusiasm, partly for financial motives but more fundamentally because, following Puvis's example, such had been his ambition for several years. As Michael Holroyd's biography reveals, however, John soon appreciated the implications of his task. There was the constant irritation of Lane's petty snobberies and his interruptions, coupled with the realization of just how much time would be required to complete the work properly. Typically, perhaps, John's thoughts turned to a means of escape, but in this case justified by what he saw as his fundamental need for contemplation:

It seems my fate to be hasty but I have serious thoughts of quitting this island and going somewhere where life is more stable and beautiful and primitive and where one is bound not to be in a hurry. I want absolutely to grasp things plastically and not merely glance at their charms, and for that one needs time.[52]

Salvation appeared early in 1910 in the form of a cheque from his new patron, the American lawyer and art collector John Quinn. After some complicated domestic arrangements, John was now free to travel to the South and to absorb the atmosphere of a geographical location which was by then synonymous with qualities of permanence, stability and the primitive – the very foundation of the modernist landscape.

John's travels to Italy and to the south of France in 1910 realized a cherished ambition. 'As if', he wrote, 'in answer to the insistent call of far off Roman trumpets, I set out early one autumn for Provence. The classic land had for years been the goal of my dreams.'[53] Villeneuve-les-Avignon looked to him like a Jehan Fouquet illustration from the *Book of Hours*; he admired Simone Martini's frescoes in the Pope's palace but varied this particular Grand Tour in interchanges, in dialect, with a passing gypsy girl, in drinking cheap red

wine with a 'humorous vagrant' and in the company of *maquignons*. Arles, once the capital of Provence and in earlier times a Greek colony, was disappointing however. The 'famous classic features' of its inhabitants had been modified by a 'later influx of Belgian workmen employed in the building of the railway' and local costume had 'declined to a sober uniformity of black and white'. But on departure for Marseilles he found himself skirting the northern shores of the Etang de Berre from where he caught a fleeting, magical glimpse of the spires and buildings, which appeared to belong to a town sitting in the water. Feeling that he might now find what he was seeking – 'an anchorage at last' – he returned, following his short visit to Italy, via Marseilles on the little railway that led to Martigues. 'On arriving my premonition proved correct: there was no need to seek further.'[54]

This short passage from John's writing speaks volumes. It indicates the extent to which certain artistic tastes, tastes in travel and tourism and certain struggles for cultural capital intersect, although the later characterization of his travels may well have been a hindsight reading in the light of Gauguin's revulsion at the sham Europeanization of Papeete (Tahiti). Gauguin's response clearly foreshadows John's belief that, in Arles, the Greeks were being replaced by modern Belgian railway workers; ancient civilization was being displaced by the vestiges of modernity. The rest of this chapter considers how the paintings John produced in Provence are intrinsically bound up with his own disaffection for modernity, coinciding with the discourses around health and degeneracy and with certain tendencies within early modernism. There has been much discussion of the significance of the Mediterranean as a site upon which French artists negotiated the shifting terrain of national and cultural identities.[55] The aim here is to consider its aesthetic geographies from the perspective of British artist-travellers.

Martigues may have come as a surprise to Augustus John when he first arrived there in March 1910, but it was already well established as a popular destination for French painters. To John's disappointment, in fact, this 'Venise de Provence', where 'old houses of exquisite picturesqueness rise from the narrow quays', with its moored fishing boats and fishermen in 'perpetual contemplation of the weather', had already been discovered by painters like Charles Pellegrin, whose *Le Port de Martigues* (1905) typified those who, according to John, were 'occupied in transposing with their palette knives the pearl-white and rose of the buildings into the more popular scheme of mustard and mauve'.[56] Modernists like André Derain, whom John does not mention, also painted there.[57] The presence of other painters was an annoyance, although he acknowledged the company of the poet Roy Campbell, critic T. W. Earp and the musician E. J. Moeran, there to collect folk tunes. The sense of Martigues as the unspoilt object of a pilgrimage was crucial. Unlike Arles, it was 'untouched as yet by fashion or big-business, no squalor meets the eye' and its inhabitants, 'concerned only with their craft, heed not the rumblings of distant war drums'.[58] Normal modern behaviour was in abeyance; this was a liminal zone for John and, with an equivalent languor, he could sit with the fishermen and feel himself to be equally

authentic, simple, ascetic and unostentatious. He typifies the tendency, described by John Urry and Bourdieu, of that romantic, usually middle-class traveller who seeks to be a peasant for a day and so subverts, symbolically, the rituals of bourgeois order – of cultivation.[59] Bourdieu, for example, described those richest in 'cultural capital' as most likely to possess an austere and ascetic disposition and to be drawn to the economically cheapest (though culturally most legitimate) forms of leisure and recreation.[60] John belongs to this element, as critical of the taste of the aspiring philistine new wealthy as of the complacent aristocracy, and eager to be distinguished from the dull conformity of modern man who is 'composed of personal paragraphs in the illustrated daily papers'.[61]

So Martigues, first and foremost, was clearly not modern. It was also not Britain, or rather it didn't look like England and, even more particularly, it looked nothing like the populist consensus landscapes of the New English, where John continued to show. To many artists and intellectuals, the commodification process of the English countryside itself was almost complete by 1910. The fundamental anxiety here, as always, is about class, about vulgarity, disorder, impermanence and impertinence, about moral and immoral geographies and about the extent to which particular landscapes assume a certain cultural authority.[62]

If Martigues and the Mediterranean were utterly unlike the suburbanite's English countryside, they were also unlike the city. A glaringly obvious point, of course, but important. To Symons, as we have seen, London was a huge futility, an ant heap. Similarly, in his inter-war travel book, *Provence*, Ford Madox Ford maintained that:

In our over-gas, steam-, or oil-heated apartments, fighting in our climates that are unfitted for human life, the endless chills on the liver, nights without sleep and four-in-the-morning horrors, we shall go on getting grosser and ever more gross, further and further away from *Latinity* [my emphasis] and plunging deeper and deeper into mass-production, ruin, reaction and massacre.[63]

Salvation, for Ford, could only be achieved in the Mediterranean, in the temperament and pace of 'Latinity' away from the muddle and mediocrity of the English city. The discourse continues to focus on health, or rather ill health and the body – and the figure in the landscape. John, of course, was perpetually in flight from the crushing, stifling sameness identified by Symons and Ford and his yearning for the exotic accounted for that identification with gypsy life. Spanish and even Russian gypsies were available to him in Marseilles. He spent time in their company and occasionally hired them to come to Martigues and pose. In this way he can usefully be compared to Stephen Eisenmann's account of Gauguin as an 'ethnographic tourist', one who samples 'a variety of human "types" or races' and cuts himself off 'from the company of his own kind'.[64] To John the gypsies continued to represent cultural difference and an ideal 'patriarchal order'.[65] They were aloof, mocking, suspicious and regulated only by the laws of nature, in accord with his ideal of the artistic traveller. But they were also healthily contained within their own codes and regulations, unlike those other exotic outsiders,

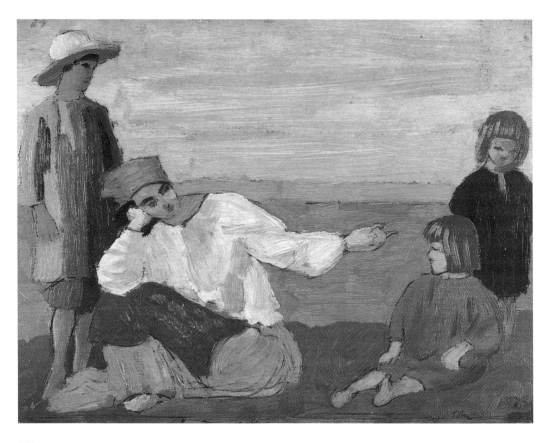

3.7
Augustus John,
*Dorelia and the
Children at
Martigues*, 1910

the prostitutes, whose quarter he occasionally visited in Marseilles with fascination but also with disgust. In *Chiaroscuro* he writes, 'let us leave this infected area and return to Martigues'.[66]

The 'Provençal Studies', 48 small oil panels shown at the Chenil Gallery in December 1910, are primarily simple landscapes or studies of Dorelia and/ or the children in the olive groves, on the arid, sun-scorched hillsides, on the flat, featureless shores of the Etang, or near to their rented house, the Villa Ste Anne (Figure 3.7, Plates IV and V). These he produced 'after a necessary interval spent in observation and experiment' once his eye had been attuned to the light of the region which shone through the atmospheric veil without casting shadows. 'In the marvellous light of Martigues' he wrote 'I woke up to colour.' John was not a picturesque scene painter and, possessed of the romantic and solitary gaze, could not paint actual, recognizable scenes of Martigues or of the local inhabitants, save for the occasional gypsy. This inability, already noted, emerges as an important characteristic of the modernist landscape. Social contexts rupture the unity of ideals – real people need to be edited out – and John is an early example of this process amongst those British artists who act as mediators, proposing a metaphoric landscape and an ideal spectator's identity. Crucially, then, John's ideal is dislocalized; his is an imagined arcadia, his own edition of the 'universe of space' – made

rather than found.[67] His models are languid and inactive. They have no
particular task and, like colonists, they have cleared out and now possess the
space and command the view. As figures they are in perfect harmony with
the environment. The tourist gaze, as Urry describes it, is constructed
specifically in terms of contrasts and in relation to its opposites, to 'non-
tourist forms of consciousness'.[68] The figures in John's paintings therefore
absorb or reflect on their surroundings. In a sense they are a physical
embodiment of us, the spectators, and of our ideal imaginings of the perfect
tourist idyll – a quality apparent to one writer who described the 'Provençal
Studies' as 'gaily coloured mementoes of happy expeditions'.[69] For James
Bone, artists of the 'new movement' of whom John was leader 'dislocalise
their figures – so that they belong to no class, no place, no time [they
produce] a lean, athletic art [running] deeper into our consciousness'.[70] Into
our consciousness and also into our memories. All of us, spectators, models
and artist, engage in a daydream, in consuming that experience.

Memory was fundamental to the process of John's paintings, which are
themselves visualizations of accumulated imagery. His work at Martigues
continued to recreate or synthesize pictures previously seen, like the linear,
idyllic forms of Puvis de Chavannes. The figures of women seated on the
ground cooking fish in the foreground of Puvis's *Massilia, Greek Colony* (Figure
3.8), for example, seem a very likely influence for studies of Dorelia and the
children. John could have seen a sketch for this work at Durand-Ruel's

3.8 Pierre Puvis
de Chavannes,
*Massilia, Greek
Colony*, 1869

exhibition in 1899 and he would certainly have studied the mural itself in the Palais Longchamp in Marseilles. Puvis's attempt to reconcile both a naturalistic scene and a classical *mise-en-scène* would have particularly appealed to him at this point.[71] Of continued influence too were the monumental, dreaming figures in Gauguin's Tahitian idylls, especially compositions such as *Eiaha Ohipa, Ne Travaille Pas* (1896) and *Trois Tahitiens ou Conversation* (1898) – which John would have been able to see at the 1906 'Salon d'Automne' retrospective.[72] Also significant were the melancholic Blue Period Picassos, seen in Paris in 1907 on visits to the artist's studio and in which he recognized common ancestry in Puvis and in Italian Primitive art.[73] But it was the latter influence in particular that John was most willing to concede. In *Horizon* in 1941 he traced his 'cultural beginnings', 'ultimately to Italy ... names such as Giotto, Duccio, Massacio, Piero della Francesca'; and so on.[74] So this particular place in Provence becomes a generalized, ahistorical Mediterranean, as demonstrated in a work like *Notre Dame de Martigues* (Figure 3.9) – the languid turn of the Madonna/model's neck and her massive bare feet, the flattened perspective, the iconic olive trees, the sun-bleached earth.[75] Those big feet, so unlike the dainty Edwardian ideal, summon another comparison with Eisenmann's account of Gauguin and his monumental natives, their counter to modern 'Europeanized' bodies with their 'soft contours, weak constitution and tender feet'.[76] Dark-haired Dorelia and the Madonna of Martigues are emphatically not modern English types, not the figures that Derain, for example, protested about in a letter from London in 1906:

The young, very blond women whose hair is slovenly twisted, with their tight braids wound around ... faces ... made in order to appear in the haze of the streets or in the cold tranquility of the British interiors. On the contrary, the woman from the South of France, with her impressively noble and voluptuous face ... made to move in bright light, affirms a precise, ample line that is infinitely more grand than the blurred forms that emerge from the fog [here in London].[77]

John's gaze seeks out the essence of healthier southern 'types' and of southern-ness or 'the south' through reference to other works of art, independent of actual location. And in this respect works by Maurice Denis, like the *Madonna au Jardin Fleuri* shown in Roger Fry's first Post-Impressionist show are instructive, if not as a direct influence then at least as a significant modern counterpart. John admitted in a letter to Quinn after visiting the show to having occasionally admired that artist's work.[78] And it is clear that Denis was found to be one of the most acceptable artists at the Grafton Gallery in 1910–1911. Contemporary reviews speak of his *Madonna* as 'possessing simplicity and reverence' and the 'divine sanctity' of Primitive painting, and it seems that Denis could be quite easily assimilated into a late Pre-Raphaelite, Symbolist tradition which, as with Puvis, held currency on both sides of the Channel.[79] In France, however, this tradition as it manifested itself in Denis was more closely associated with the sentiment of the Catholic revival, its spiritual foundations explicitly associated with the south.

For Ford Madox Ford, it was only in the south that art, indeed civilization, could exist. This again was partly due to the sensuous physicality of the

3.9
Augustus John,
*Notre Dame de
Martigues*, 1910

experience: 'The sun rises and scorches your limbs whilst you prune your vines, your throat knows the stimulation of the juice of your own grapes.'[80] In this Bacchic Latinity, the symbolic cultivation of the vine signifies the very basis of civilization. By contrast, popular pictures of the English countryside, of holiday-makers and Sussex farms, were 'indescribably amiable but completely without meaning or purpose'.[81] Proper art could not exist without Latinity, a 'clear light, a life of dignity'.[82] Sussex, with its 'fugitive sunlight, its Morris dancers, its yokels balanced on sticks, whiskey barons and Real Lordships', was as nothing set against the permanencies of Provence.[83] Ford's sentiments were already felt amongst certain painters at the turn of the century when, for example, the rustic naturalist La Thangue, considered earlier for his depiction of rustic types in and around Sussex cider farms in the late 1890s, departed for Provence and Liguria to paint peasants tending their vines.[84]

A desire for 'Latinity' was, of course, a consistent feature of intellectual, literary and artistic life since the earlier part of the nineteenth century. John Pemble, for example, in *Mediterranean Passion*, recites Gautier's remark about 'the propensity of the British to wander', the result of social and geographical claustrophobia.[85] Cultural and class snobbery had always been implicit in the drive to the south, and as Pemble demonstrates, travel was underpinned by a desire to escape from the irritation of others. 'On the threshold of the South he [the British traveller] experienced an apotheosis. He passed from the circumference to the centre of things, and his thoughts dwelt on roots, origins, essentials and ultimate affinities.'[86] Escape from the complexities and the dullness of modern life could only be achieved by 'Mediterranean-izing' oneself.[87] But the sense that this process could never be quite complete renders the yearning yet more intense, so that Ottoline Morrell, en route to a meeting with John and Dorelia but finding herself first surrounded by the teeming life of the Vieux Port in Marseilles – the chaotic emporium of east and west; the fascinating and the unknown – realized that 'it would be impossible to shed the mantle of one's own past and one's own inherited code of morals sufficiently to enter into this strange world'. John, however, did all that he could to accomplish the feat and Morrell describes their encounter at Aix, 'having travelled from Martigues in a gypsy cart ... she [Dorelia] appeared as a gypsy woman and John as a dissipated Frenchman, his beard cut in a pointed French style'.[88] So as wider, ever more complicated shifts took place within Edwardian social, familial and gendered relations, the south assumed a crucial significance for artists like John, as for a diversified tourist culture. For them it was the authenticity, but also the potential stability and order of a renewed classical ideal, that was unimagin-able in the context of contemporary moral codes and in the conventional geographies of Englishness around 1910.

This all-inclusive notion of 'Mediterraneanizing oneself', however, has meant that a resort hierarchy, significant for both British (and American) artists and tourists, has been rather under-estimated. It is clear though that specific cultural and aesthetic geographies were in force, which differentiated

between locations in the south, and this was particularly the case as travel was progressively democratized through the 'magic carpet miracles of the modern tourist agent'.[89] The minutiae of distinctions over where one travelled and whose company one kept, or avoided, connect in interesting ways with the development of a Francophile modernism. This extends out from palpable snobbery about class to notions of health and ill-health, to the body and, ultimately, to gender.

A. & C. Black's guide to *The Riviera* of 1907 is a compendium of Edwardian class prejudice and preconceptions about travel. Groups of tourists and the particular resorts they frequented all had readily identifiable traits. Marseilles was only a stopping place for the Riviera; Hyères attracted a quiet, relatively unexcitable class of visitor; the picturesque fishermen at Mentone were, the author suspected, retained to haul their nets at the public expense, simply to look charming for the visitors. Antibes, on the other hand, had been 'wrecked by the pestilent craze for modernity', and so on.[90] Most visitors, apparently, came to the Riviera with little ability to observe or appreciate. Unlike John's models, they sought a collective, convivial experience.[91] They crowded the *trains de luxe* and rushed 'blindly from one well known resort to another'. They didn't stop to gaze; they glanced. They were also identifiable types; 'old maids of both sexes', German couples courting rather too noisily, our 'accomplished cousins from across the Atlantic', '"Arry of the Riviera", with his loud clothing, "flash" jewelry and demonstrative ties' and the 'light fingered gentry'. There was a mixing of races here, but all were vulgar and, in their own ways, rendered effeminate in the author's account.

The more recent habitués of resorts like Cannes and Nice had been gradually outnumbering earlier types of visitor, drawn specifically by the therapeutic qualities of climate and hoping to stay the degenerative effects of tuberculosis. J. D. Innes, of course, suffered from the disease and had travelled to the south since 1908 though not, it must be noted, to the resorts along the Riviera. In the winter of 1912 he and Derwent Lees worked, rather ironically, around Vernet-Les-Bains, a health resort and sanatorium for tubercular cases in the Pyrenees, overlooked by the artist's favoured motif, Mount Canigou. *Cook's Traveller's Gazette* featured this resort in a winter issue of 1910, describing the majestic mountain and the splendid panorama seen from its summit, which could be reached by the mountain railway – not something that Innes chose to depict. 'The calmness and purity of the air', the article continued, 'and the protection from the winds afforded by the Canigou, all combine to make the town especially suitable at any time of the year for convalescent patients.'[92]

So, if the numbers of tubercular cases in the south were reduced by 1910, they certainly still retained a presence, not least in the popular consciousness. Vulgarity and effeteness therefore mingled with what has been termed 'an ideology of invalidism'.[93] This may also have coloured John's judgement. Nice, he wrote, was 'a paradise invaded by bugs (human ones)'.[94] These were the real people who had to be left out of John's art, confirming the misanthropic tendencies of early modernism, a modernism that here evades

modernity. But if John ignored the sick in his art, he struggled harder to accommodate them in his life, if only for a while. Meeting Innes in Marseilles in 1913, he eventually found his illness 'insupportable', his friend was 'going off his head and stuttering dreadfully'. Despite taking him to the Etang de Berre in the hope of a recovery, eventually John found that the 'company of a sick man gets on one's nerves in the end'.[95] He took him to Paris and sent him back to London for treatment.

John's experience reveals the extent to which what has been described as the 'romantic cult of TB' associated with the decadence of the 1890s had diminished by 1910, replaced by those assertions of vigour and healthfulness in art and literature.[96] To a degree, anxieties about effeminacy identified with aestheticism could be associated with those tubercular cases taking the rest cure in particular (and newly decadent) locations along the Riviera. So the author of Black's *Guide* in 1907 could remark that 'The sick and the suffering, like the poor are "always with us".'[97] He described a pallid but dainty sufferer from the condition, barely able to walk unsupported, who with hacking cough and hectic flush, was daily decaying, bound soon for the quiet graveyard on the hillside.

There was a typology of frail female types especially prone to the disease, young women under thirty who had spent physically confined lives, narrow chested, with fine textured skin and soft hair.[98] These tubercular types contrast sharply with John's characteristic representations of women on the shores of the Etang or on the barren hillsides, described by Bone as 'deep-breasted, large bodied, steady-eyed'.[99] Personal circumstance clearly underpinned John's idealized representations of strong mothers. Ida had died of puerperal fever after giving birth in Paris in 1907 and Dorelia gave premature birth to a dead child at Martigues in 1910. Fear of ill health was therefore a major preoccupation, something to be displaced in John's art. It had already been a consideration in his observation of the work of others, most notably in his response to Picasso's emaciated *Saltimbanque* who, in his words, 'had been undermined by phthisis'.[100]

John's antipathy towards certain tourist types, his desire for solitary sites away from the beaten track, his anxieties about illness alongside the wider cultural distaste for weakness and signs of effeminacy – in art as in life – all reinforce his aversion to those popular holiday locations along the Côte d'Azur. 'Flash Arry' with his gaudy ties, 'old maids of both sexes' and tubercular young women suggest perceptions of the Riviera as a negatively defined gendered space, correlating with essentially urban, reformist anxieties about the declining birth rates, racial decline and shifting gender relations in England. Illness opposes classical medical and political ideals of balance; it undermines nineteenth-century positivism, hence its mystification as degenerate. Illness is a form of imbalance and its treatment lies in restoring the right hierarchy.[101] Cultural representations of the south are consistent with these ideals of balance and health – as significant in their own terms for British as for French artists.[102] By the end of the nineteenth century, tuberculosis, at one time a disease associated with environmental neglect, was increasingly being viewed as a

'disease of contact and social space' and amidst developing debates over public health, there were growing concerns over contagion.[103] The point for John's modernism was to avoid those contagious spaces, those sites inhabited by the infirm.

His paintings of figures in the remote, healthy, dislocalized spaces around Martigues, in the words of Laurence Binyon, 'haunt one's memory'.[104] Reviewing figures in the 'Provençal Studies' exhibition, Binyon described:

> ... creatures of the infancy of the world, aboriginals of the earth, with an animal dignity and strangeness, swift of gesture, beautifully poised. [John's] art is solitary and untamed. But in it there is a jet of elementary energy, something powerful and unaccountable, like life itself ... in our English painting, which has haunted drawing rooms all too persistently, this is a welcome apparition.[105]

Now, Binyon's account of John's women and children resonates with much of the terminology associated with modern French painting, in particular with those artists, critics and theorists – devotees of Fauvism – identified with the magazine *Rhythm* from 1911, as we shall see in the next chapter. Binyon's account of John emphasizes the empathetic expression of an inner, vital essence fundamental to life's core, not perceivable in superficial appearances. The critic had already been describing John's art in the language of *Rhythm* by 1909; it attested to 'character, life and rhythmic power ... There is ... hope and health for art ... in Mr John's return to the governing interest of design and elemental form', he wrote.[106] His commentary contrasts with the reactionary criticisms of modern French art expressed by older, more conservative individuals like William Blake Richmond or Ebenezer Wake Cook (author of *Degeneracy in Art*) in terms of the diseased mentality, the crude, anarchic gestures of charlatans and the incapable.[107] The distinctions are crucial and underline the competing claims for cultural authority in British art before 1914, claims continually made in the terminology of health, fitness or the diseased, uncontrolled body.

Paintings that provoked a language of energy, life, power, elemental design and so on, proposed a cure, metaphorically at least, for a disordered state of (female?) health. Or perhaps rather than a cure, they produced hope of re-birth. The seeds of a new race might best emerge from an unlocated, uncultivated southern landscape. The key was to eliminate the unnecessary, circumstantial details, to avoid the seductions of 'atmosphere', to concentrate on that unified, pared down, elemental synthesis. These were the qualities which John and supportive critics had discerned in Gauguin, Puvis, Denis and in the 'primary colours with the freshness and unconscious depth of the Italian Primitives',[108] works which possessed a 'primitive intensity of pose', a 'grandeur of conception'.[109] Figures in these representations required equivalent 'moral' landscapes that were cleansed, purified, composed and fit – not over-crowded Riviera resorts, not suburbanite trippers' destinations at home. Landscapes needed to be evacuated before this 'new aristocracy' – the superior, pioneering new middle classes – could take up residence and indulge in pure, spiritual enjoyment of the scenery. In this it is clear that, in spite of himself, John could never evade his own class position; could never,

3.10 J. D. Innes,
*Arenig, Sunny
Evening*, c.1911–
1912

as Ottoline Morrell pointed out, 'shed the mantle ... of one's own inherited code of morals'. In what Eisenmann would term his 'exoticist anxiety', John, like Gauguin, found himself 'both alienated from metropolitan culture and society, and yet representative of that same colonizing power'.[110]

Having evolved a style of painting signifying an essential southernness, John, along with Innes and Derwent Lees, could then produce a landscape imagery of the wilder parts of north Wales or the west of England that was virtually interchangeable with depictions of the Mediterranean. So in Innes' *Arenig, Sunny Evening* (Figure 3.10), topography has been smoothed out, contours rounded, shapes distilled, to create an abstract harmony in pictorial terms and something elemental in physical terms. Weather has gone, to be replaced by an afterglow, shining paths of some natural force. It was amidst these now purified 'moral' landscapes that all three artists found a fitting back-drop for figures in landscape compositions of hardy female types like Derwent Lees' portrait of his wife *Lyndra by the Blue Pool, Dorset* (Figure 3.11) or John's *Lily on the Mountainside, Blaenau Ffestiniog*. The impasted technique, crude colouring and the reflective self-containment of the figures contributes to the desired effect, the expression of what John Rothenstein later termed the 'grace of wild-spirited women in repose' and the 'near monumental dreaminess [in] John's imagined Arcadia'.[111]

Innes' struggles with life drawing at the Slade were resolved in his own romantic Welsh figure in landscapes, in a literal fusion of nature and the

3.11 Derwent Lees, *Lyndra by the Blue Pool, Dorset*, 1914

female. His models dwarf their surroundings while seeming to emerge out of the mountainside on which they stand. Conventional perspective and anatomical accuracy were inappropriate to subjective and poetic representations like these; they would have merely weakened their impact. Such overtly symbolist work in one sense continued the late Pre-Raphaelite tradition of Burne-Jones and Rossetti, then undergoing a revival.[112] With the Pre-Raphaelites, this generation shared a romantic taste, an admiration for fourteenth-century Florentine painting and, crucially, a conception of women as the ideal muse, as instinctive and exotic, as strong and resourceful but, crucially, as essentially unthreatening.

John and Innes' idealizations displaced deep-seated anxieties and suggest a fundamental desire for control that was produced in the wider context of increasing independence amongst modern women, accentuated by the militant suffragette demonstrations after 1905. All of this helped fuel the continued flight to remote landscapes and timeless subjects that takes place right up until the Great War. Henry Lamb, for instance, transferred his interests from the Celtic fishing communities of Brittany to the west of Ireland when he travelled to Middleton, Donegal in 1912. There the combined effect of the early modernist influences of Puvis, Gauguin and the Italian Primitives transfigured the appearance of *Irish Girls* (Figure 3.12) – their shawls shielding them from the Atlantic gales – into robust and sturdy but essentially mute and reserved, universal 'peasant' types. A similar effect emerged from the work of his and John's friend John Currie, whose own visits to Ireland had begun in 1908.[113] While studying part-time at the Slade in 1910, Currie had become attached to the short-lived 'Neo-Primitive' group, which included Mark Gertler, C. R. Nevinson and Adrian Allinson, all of whom shared a common interest in the contemporary revival of tempera and in early Florentine sources. As a result of these common visual derivations, Currie's pictures of monumental, statuesque peasant women in Galway (Figure 3.13) possess the same enduring stoicism, the same passivity and calm acceptance of their fate. By this date perceptions of the west were filtered through the literary influence of symbolist poets like W. B. Yeats, whose 'doctrine of tragedy' was founded on his declared hatred for the 'real world' and who clung to the ideal of a medieval Ireland, one unaffected either by the Renaissance, the industrial revolution or by a modern existence in which 'people hurry and get nowhere'.[114] John, already acquainted with Yeats since painting his portrait in 1908, was naturally susceptible to these idealizations. Returning to Ireland in July 1912, he stayed at the poet Francis Macnamara's house in a small fishing village, Doolin, not far from Ennistymon. There and especially on visits to the nearby Aran Islands, he once more encountered the groups of primitive women-folk that continued to stimulate his fantasies: 'Women and girls in black shawls and red or saffron skirts [who] stood or moved in groups with a kind of nun-like uniformity and decorum.' They appeared to him as 'some forgotten people [upon] the precipitous Atlantic verge'.[115]

In 1913 Lamb painted at the isolated location of Gola Island off the Donegal coast which he believed, at least for a while, to be his 'promised land': 'There

3.12
Henry Lamb,
Irish Girls, 1912

are mountains, a lake, rocks, cliffs, caves & white strand: the people are more lovely and angelically dispositioned than on the mainland' although, as Keith Clements observed, the island population was dwindling consistently as a result of bleak economic prospects and, ironically enough, the spread of tuberculosis.[116] *Fisherfolk, Gola Island* (Figure 3.14) resulted from studies of the native McGinnley family, which he later worked up in his Hampstead studio. Influenced by Puvis, Denis and also by his observations of Stanley Spencer's *The Apple Gatherers* (Figure 7.4), Lamb's stylized and harmonious composition of 'uncommunicating figures' he later termed his 'Gola Sonata'.[117] For James Bone the musical reference was clearly detected. 'Lamb', he wrote,

'with subtle gifts for colour and design in the high Italian tradition seems to
be seeking in many strange ways to find pictorial expression for conceptions
as far from sentient experience as is music.'[118]

 Bone's comment is apposite, for the modernist, anti-naturalistic conceptions
of what Sickert rather disparagingly termed the 'Ecole de John' were indeed
'far from sentient experience' and that of course was their merit for a growing
audience. Shaped by the aesthetic geographies of particular regions of France
or of the west of Ireland, they offered consoling visions of fit and decorous
bodies in appropriate settings and in this respect, despite formal, stylistic

3.14
Henry Lamb,
*Fisherfolk, Gola
Island*, 1913

distinctions, they provided a view of an authentic rural existence that was just as evasive as perennial Royal Academy pictures of a healthy rosy-cheeked peasantry. So early modernism continued to provide an imagery which, regardless of the cultivated outsider status of many of its practitioners, in the end accorded well with wider anxieties, prejudices and imperatives and displayed a shared distaste for the vulgarizing effects and the power struggles implicit in the processes of modernity.

Landscapes and rhythm

In his article in 1913 on 'The Tendencies of Modern Art', James Bone identified two distinct groups of artists. One group, including Augustus John, Henry Lamb, Duncan Grant and Maurice Denis, aimed 'to revive the importance of subject-matter, and to concentrate upon the emotional significance that arises from the subject'. The other, including most French artists at the Grafton in 1912, have 'accepted and carried further the negation of subject-matter, but ... seek to make the composition monumental in its own right by the value of the pigment, the strength and integrity of colour, and the simplification of form to shapes that convey this sense of permanence'.[1]

The distinctions between these two forms of modernism before 1914 arose from specific engagements with different aspects of recent French art and from different ways of responding to particular locations in the south of France. Augustus John's painterly response to place was primarily a translation rather than a transcription. He may have received artist-visitors in Martigues, but he seldom painted alongside them there. By contrast J. D. Fergusson, S. J. Peploe, Anne Estelle Rice and Jessica Dismorr, who were all connected to the art, music and literature journal *Rhythm* from 1911, worked more closely together, at times from the same motif.[2] In this sense the 'Rhythmists' were looking for the social cohesion of an artistic community, akin to that found typically in artists' colonies of the nineteenth century.[3] Whereas John worked in isolation with his extended family, they functioned like casual groups or colonists and they shared in what Judi Freeman termed the 'social practice' of the Fauves.[4]

Where John depicted quasi-symbolist figures in spartan sun-bleached landscapes, Fergusson, Peploe and Rice's Mediterranean is a more convivial world of brightly painted boats in harbours and of villages – their rooftops harmoniously integrated with their surrounding hillsides. In some respects, though, the Collioure paintings of Lees and Innes of around 1911–1912 do come closer to this group of artists; both depicted views of the shore from the sea or the sea from the shore, with the sails of fishing boats dipping in the breeze, or of simple cottages nestling amongst hillsides and olive groves. Lees's work in particular shows the influence of Derain and, in one case, of Manguin especially. His *Pear Tree in Blossom* (Figure 4.1) seems in its handling

4.1
Derwent Lees,
*Pear Tree in
Blossom*, 1913

and composition to be clearly related to the latter's *Landscape*, illustrated the previous year in *Rhythm*.[5]

Affinities with the group discussed in this chapter are with the works these French artists produced after 1907, including Herbin, Othon Friesz, and above all with the influence of Cézanne. Like their French models, these painters were all working with the idea of a small souvenir, a canvas or panel which would contain enough of the place to call its topography, its sounds and smell to mind. Roger Benjamin has observed that 'arguments for the involuted status of place within high modern landscape could be made for Derain, Braque or Friesz painting the landscapes of Provence in the wake of Cézanne'.[6] And he notes correspondence from Derain on cycling through the Midi: 'One sees the whole series of Gauguins, of Van Goghs from Arles and finally, on arriving, the most beautiful Cézannes.' As Benjamin terms it, a 'particular aesthetic effect results from a series of encounters with specific art-historical identities'. Place and past masters become fused in the eye.

The evolving aesthetic geographies of France, from Channel coast resorts like Paris-Plage to Royan on the Atlantic coast and finally to small Mediterranean harbours, ports and/or coastal resorts like Collioure, Cassis, St Tropez and La Ciotat, chart a trajectory from Impressionism towards

distinctive modes of Post-Impressionism. For British artists, experiences in the ateliers in Paris and exhibitions like the 'Salon des Indépendants' and the 'Salon d'Automne' were crucial but, at the same time, they were still influenced by the cultural preoccupations, art politics and aesthetic debates raging in London galleries and the art press. This triangulation process makes their histories and identities complex and unique.

The very act of crossing the Channel to northern France provided a release, not just from a comparatively moribund Edwardian art world, but from the amiable yet insipid atmospherics described in the last chapter by Ford Madox Ford, and from the constraints of respectable English and Scottish society. For these young painters the Quartier Latin, increasingly a feature of Paris guide books, proved a liberation from stifling conventions of behaviour, but there was an invigorating quality to the French countryside as well. To Huntly Carter, the journalist, art and theatre critic, writing in the *New Age*:

From Newhaven to Dieppe the sea spread like a waveless plain saturated with vaporous air. Trailing rhythmically across this green plain were soft amethyst columns of vibrating light that dipped far below into the sea-dissolved air and the air-dissolved sky, seeking infinity islanded by the vast world of consciousness. From Dieppe to Paris there were corresponding symbols of the rhythm and continuity of life ... landscapes stained a faint green – hills shouldering the pink and amber of the westering sky ... blossoming orchards shining like pink snow under the sinking sun ... in all these were signs of creative evolution. Art is the symbol of infinity; the new form of art is the perception and expression of continuity. The new intuition of the apprehension of Reality underlying forms of life, of things living and evolving.[7]

French skies and soil were therefore imbued with the same new, creative spirit that the writer was travelling to witness in Paris exhibitions. Implicit in the descriptive quality is less a concern with detailing the exact appearance of nature, of visual fact, but an attempt to engage a corresponding state of mind. Expressive and symbolist tendencies, developing out of and at the same time reacting against Impressionism, were evident to Robert Dell, the curator of the 'Modern French Art' exhibition in Brighton in 1910.[8] But perhaps a further difference exists between the groups of artists distinguished by Bone. For Roderic O'Conor, Augustus John was a 'mere illustrator', whereas a 'special intuition' was required to understand modern painters like Matisse and Cézanne.[9] O'Conor had associated with Gauguin and worked in Brittany between 1898 and 1904. He was also an admirer of Seurat, and especially of the Arles and Saint Rémy paintings of Van Gogh, whose influence was apparent in the ribboned, expressionist brushstrokes and intense yellows of a work like *Fields of Corn, Pont Aven* (Plate VI). Colour and handling embody the artist's subjective response to the undulating rhythmic forms of nature before him and, within a short period, O'Conor was in the vanguard of the Fauves.[10] In his *Red Rocks* series around 1900, O'Conor moved away from strict adherence to Gauguin and Van Gogh and into a more expressive style, which anticipates the Chatou canvases of Vlaminck.

Peploe and Fergusson took a rather different route. They had first responded to the local scenery and the beaches on the Channel coast between

1904 and 1906 with a fluid Whistlerian handling, mediated in part through the influence of Scottish painters like Arthur Melville.[11] Increasingly the surface of the paint thickens and is more vigorously applied in works like *Grey Day, Paris-Plage*, 1905.[12] At his Baillie Gallery exhibition in London in 1905, Fergusson's 'Prologue' accounted for this shift in terms of a struggle for truth, 'sincerity in art consists of being faithful to one's emotions … to restrain an emotion is to kill it'.[13] The pace of his development away from Whistler and Impressionism quickened by 1907, by which time he had encountered the American illustrator-turned-painter, Anne Estelle Rice, at Paris Plage.[14] Later that year in Paris he showed for the first time at the October 'Salon d'Automne' where he witnessed the Cézanne memorial exhibition along with Matisse's study for *Music*, the sketch for *Le Luxe*, landscapes of Cassis by Derain and paintings of La Ciotat by Othon Friesz. Personal contacts with French painters like Dunoyer du Segonzac also developed through part-time teaching at Jacques-Emile Blanche's Académie de la Palette.

For Fergusson, as for Derain, Dufy and Friesz, the 56 paintings on display at the Cézanne exhibition had an immediate impact in terms of their formal and architectonic qualities. Cézanne's desire to construct a harmonious whole from a patchwork of tiny perceptions – 'petit sensations' – was self-evident. His emphasis on the conceptual and his study of the structural properties of landscape could only be aided by the fact that the Midi, with its consistently equable climate, clear skies and persistent sunshine, led the eye away from a preoccupation with 'effects'. Van Gogh had persuaded Gauguin to visit him at Arles in 1889 with similar observations.

It was apparent that only in the south was this stability and condensation of sensations attainable. Cézanne's perceptions of that quality of permanence in Provence were reiterated by Derain in his letter to Vlaminck from Martigues in 1908, 'It is very difficult to make paintings in Paris, one loses all point of contact. And I believe that here is the only place where all one has are the sensations of a painter.'[15] The relationship between the formal practice of Matisse and Derain and their location in the south is clear. Their intense, unmodulated colour with areas of unprimed canvas resonates with the (French) cultural identification of that location as healthful, authentic, natural and harmonious.[16]

The spontaneity and the ease of expression increasingly associated with the south were also partly due to the very nature of the 'Salon d'Automne'. Benjamin points out that, unlike the spring Salons featuring larger-scale works produced in studios over the winter months, the 'Automne' showed smaller, more intimate and experimental paintings, 'made before the motif in the summer, impregnated with sunshine'.[17] This accounts in part too for the fact that the Rhythmists, once they travelled to the south around 1912, did not attempt to recreate the imaginary, classically inspired compositions of nymphs and nudes that Signac, Cross and Matisse had produced from the turn of the century in sites around St Tropez and Le Lavandou.[18] They concentrated instead on the picturesque rather than the pastoral or *paysage*

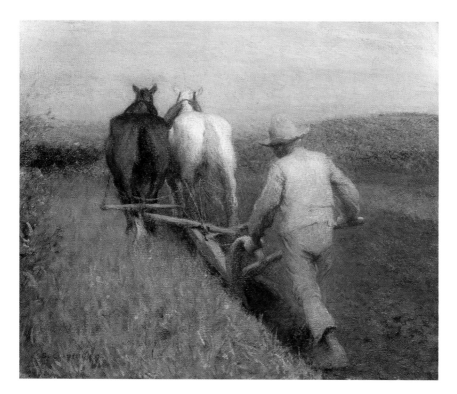

I George Clausen,
*Autumn Morning,
Ploughing*, 1897

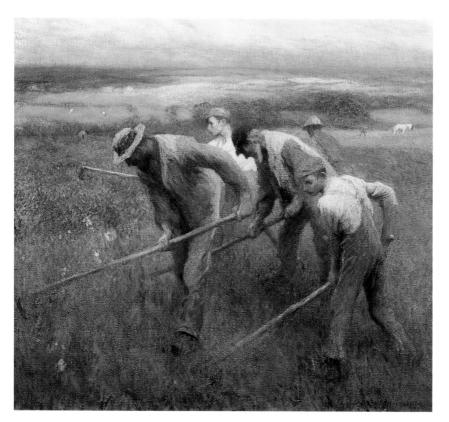

II George Clausen,
Sons of the Soil,
Royal Academy,
1901

III Spencer Gore, *Letchworth, The Road*, 1912

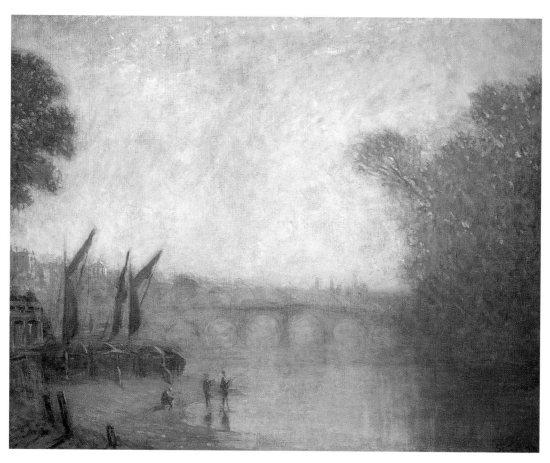

IV P. W. Steer, *A Classic Landscape*, 1893

V Augustus John, *Blue Lake, Martigues*, c. 1910-1912

VI Augustus John, *Provençal Study*, c. 1910-1912

VII Roderic O'Conor, *Fields of Corn, Pont Aven*, 1892

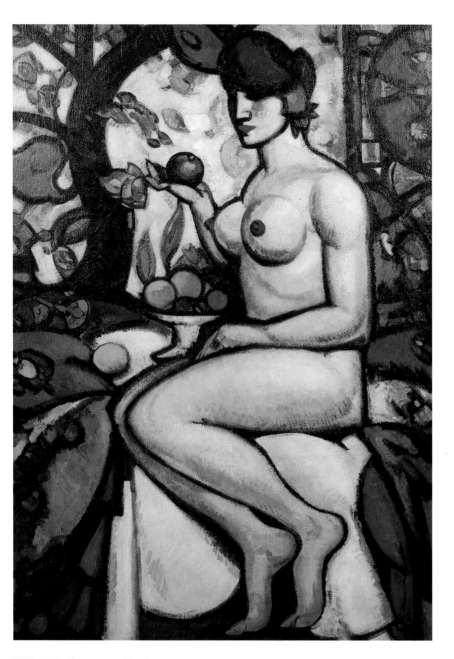

VIII J. D. Fergusson, *Rhythm*, 1910

IX Roderic O'Conor, *Landscape*, 1913

X Ann Estelle Rice, *Ajaccio, Corse*

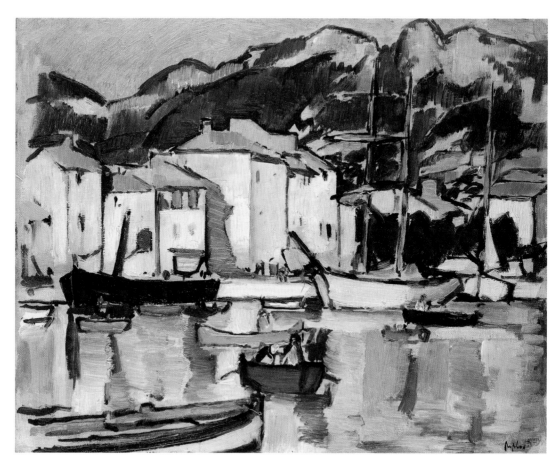

XI Samuel J. Peploe, *Landscape at Cassis*, c. 1912

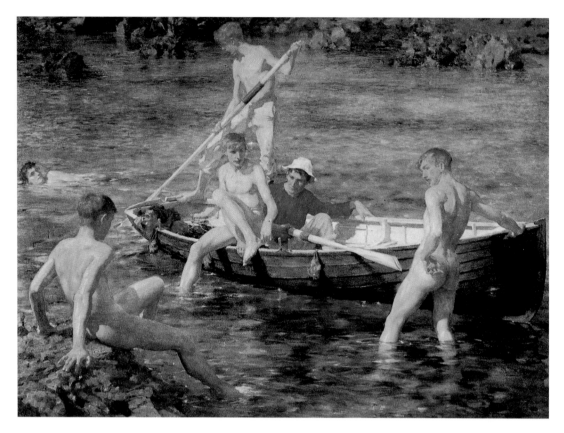

XII H. S. Tuke, *Ruby, Gold and Malachite*, 1902

XIII Paul Nash, *Wittenham Clumps*, 1914

composé, referring rather to the more informal compositions of the Collioure works of Matisse and Derain first shown at the 'Salon d'Automne' in 1905, to Derain's Martigues paintings and to Braque's paintings of l'Estaque. The fact that their encounter with Fauvism took place around 1907 at the same time as their encounter with Cézanne is also significant in this respect.[19] The growing confidence of the 'Salon d'Automne' reinforced the division between concepts of the painter as a visionary dweller in arcadia engaged in decorative schemes and the painter as an interpreter of the hidden structures in direct experience.

The paintings of Provence which Ottoline Morrell observed at the 1909 'Salon d'Automne', like the 'passionate and flame-like, pure and beautiful' works of Van Gogh and the Cézannes at Monsieur Pellerin's, in which 'rocks and villages of Provence, rough and rugged Nature' were expressed by 'magic and made permanent', were yet more forcible for their conception of a terrain, atmosphere and expression so utterly distinct from British landscapes and from the comparatively restrained New English Art Club handling of paint.[20] Before actually travelling to the south, Morrell et al. had already acquired the appropriate visual and verbal terminology with which to describe its exoticism, simplicity and authenticity. Cézanne's paintings revealed the scenery in advance and, via the particularities of the paint, signified the kind of physical sensations to be experienced there. For Morrell, resident of Bedford Square and an Oxfordshire country cottage, the revelation was especially acute: 'The beauty of the land that inspired Cézanne and that gave up to him its secret and its magic, and which formed into a new creation, seemed to me doubly beautiful. Beautiful in itself and beautiful by having been revealed by him.'[21]

The profound sense in Cézanne of an artist struggling to achieve a harmonious relationship between the natural world 'out there' and his own re-presentation of that world on a flat two-dimensional canvas found an immediate echo in Matisse, whose 'Notes d'un Peintre' appeared in *La Grande Revue* in December 1908.[22] The notion that an artist was simply a recorder of fleeting impressions of reality was now emphatically swept up into more important objectives – to achieve a distillation of experience communicated through an expressive pictorial composition.

The thought of a painter must not be considered as separate from his pictorial means – Composition is the art of arranging in a decorative manner the diverse elements at the painter's command to express his feelings … A work of art must be harmonious in its entirety … I want to reach that state of condensation of sensations which makes a painting [and to] recognize it as representative of my state of mind … A rapid rendering of a landscape represents only one moment of its existence [durée]. I prefer, by insisting upon its essential character, to risk losing charm in order to create greater stability … From the relationship I have found in all the tones there must result a living harmony of colours, a harmony analogous to that of a musical composition.[23]

Fergusson, reviewing the 1909 'Salon d'Automne' for Frank Rutter's journal *Art News*, was most impressed by the 'Matisseistes', those 'who are not

concerned with academic procedures but subordinate their technique to dictates of emotive expression ... frankly and fearlessly'.[24] Matisse's emphasis here on achieving a harmony analogous to music would have had a special resonance for an artist negotiating a path from Whistler, and suggests that the break was not necessarily so traumatic. But at this particular moment in the development of his own aesthetic, Fergusson turns from Whistler or Impressionist-inspired landscapes and beach scenes to concentrate instead on experiments with the figure, and in a painting such as *Closerie des Lilas* (1909) perhaps with the example of Matisse's *Woman with a Hat* (1905) in mind. This follows the general modernist pattern of figure painting as the genre most commonly reserved for stylistic experimentation and so most likely to excite, if not outright hostility, then at least misapprehension. But Fergusson's experiments were carried out with the quite respectable goal of attaining greater pictorial unity from the constituent elements of brighter and cooler colour. In this decorative principle a rhythmic pattern, line or patch of colour repeated or re-formed throughout the composition conveys the artist's own personal experience with an emotional emphasis.[25]

In 1910 there was apparently little to distinguish between Fry's and Rutter's responses to recent French painting despite their personal difficulties of a year or two later.[26] Rutter's argument in *Revolution in Art* – that the function of art is to state an emotion: the more simply conveyed, then the 'purer and higher is the art' – is essentially the expressive theory underpinning Fry's Grafton Gallery exhibition of 1910–1911.[27] For Fry, Impressionism had tended to regard 'the flux of sensation in its totality' and it was Cézanne who first made the transition towards a 'non-representative and expressive art' via his revolutionary use of form and colour.[28] Fry departs from Rutter in emphasizing that this tendency was widely present in art up until the Renaissance, but it was also, in his view, symptomatic of a renewed spiritualism, a contemporary cultural reaction against the materialism of the age. 'Art', he wrote, 'like religion, appeals to the non-mechanical parts of our nature, to what in us is rhythmic and vital.'

Laurence Binyon was of the same opinion, perceiving just as the Grafton exhibition opened that, 'The "new" aim was to get behind the appearance of things, to render the dynamic forces of life and nature, the emotional significance of things. Away with imitation, let us get to primal energies and realities ... the first business of art [is] rhythmical design.'[29] Both Fry and Binyon regard rhythm as the fundamental quality of a work and both make use of the term in advance of the journal *Rhythm*'s appearance in 1911 and, indeed, of Fergusson's painting of that title. Definitions clearly varied. However, around 1910, as Rutter later recalled, 'Rhythm was the magic word of the moment. What it meant exactly nobody knew, and the numerous attempts at defining it were not very convincing. But it sounded well. ... When we liked the design in a painting or drawing, we said it had Rhythm.'[30] But Fry was rather more precise in early 1911: rhythm resulted from the artist's ability to apprehend and express the 'imaginative necessity' of appearances – not descriptive facts.[31] The implication then is that the artist's

creativity lies in giving pictorial expression to some pre-ordained order and harmony. The crucial point was that the coherence and the decorative unity of the imaginative world evoked by the artist through colour and linear design must not be endangered by 'the illusion of a third dimension' introduced through light and shade, modelling and transitions of tone. Fry's examples, Cézanne and Herbin, abandoned this third dimension and constructed a relatively shallow space. But a crucial factor is that the south actually looked like this, thus Cézanne could tell Pissarro in 1876 that the seashore at L'Estaque is 'like a playing card. Red roofs over the blue sea ... The sun here is so tremendous that it seems to me as if the objects were silhouetted not only in black or white, but in blue, red, brown and violet. I may be mistaken, but this seems to me to be the opposite of modeling.'[32] For Fry, decorative painting resulted from strict principles of artistic unity, principles which preceded Cézanne in Italian Primitive paintings like those of Piero della Francesca. It was essentially a southern form of painting.

From the time Fergusson, Peploe and Rice abandoned the Channel resorts in a move towards the Mediterranean – first in 1910 to the harbour and resort town of Royan at the mouth of the Gironde – Fergusson adopted what has been described as a landscape manner with 'strictly demarcated colour zones and modelling achieved by a Cézanne-like "constructive brush"'.[33] In works like *Royan* (Figure 4.2) bright, unmixed colour and simplified forms appear, with contours delineated in blue and red. The ornate Belle-Epoque architecture of the promenade, hotels and casino of the bustling seaside resort are ignored in favour of the simple shapes of boats, sails and the block-like, uncluttered forms of buildings. These plain surfaces and shapes, observed earlier in the simple Sussex cottages depicted by Edward Stott, presage a modernist taste which, for the Scots painters especially, link the traditional, unpretentious crofters' cottages at Barra (where Peploe, for example, had painted in 1903) to the taste for bleached Provençal stone that appealed to Le Corbusier on the Riviera in the 1920s.[34] Modernism and a vernacular tradition merge once again. Modernism here is not, as Fry was constantly at pains to point out, a decisive rupture with the past – only with the vulgar, the tawdry and the transient qualities of the present.

Despite Fry's appreciation of the anti-materialist yearnings of his time, there is a clear sense that Rutter, as well as Middleton Murry and Michael Sadleir who founded *Rhythm* in the summer of 1911, had in mind a different conception of the creative process, more dependent than Fry, for example, on the significance of Bergson's writings.[35] From its inception, *Rhythm* expounded the Bergsonian principles of the 'supremacy of intuition, of the spiritual vision of the artist in form, words and meaning'.[36] Murry, then reading *L'Evolution Créatrice* (1906) and intending to study under Bergson at the Sorbonne, was impressed by his emphasis on individual intuition and by his belief that intuition was implicitly opposed to positivism and logic in its expression of the continuity of life and its essential truths. In a letter of April 1911, Murry outlined the significance of the new journal in terms of a particular understanding of modernism, which 'means, when I use it,

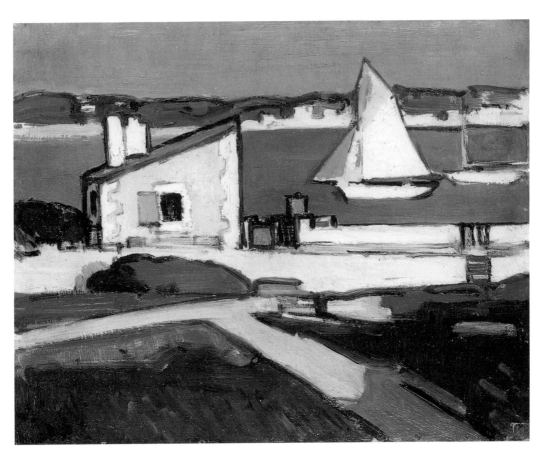

4.2
J. D. Fergusson,
Royan, 1910

Bergsonism in Philosophy … a conscious concentration of vision'.[37] But for Murry and Rutter, this concentration was ultimately of a quite different character to that 'disinterested vision' celebrated by Clive Bell and Roger Fry. Murry argues in his letter that 'Bergsonism stands for Post Impressionism in its essential meaning – and not in the sense of the Grafton Exhibition: it stands … generally if you like for "guts" and bloodiness'. Vitality and virility here represent a degree of engagement that stands opposed to an insular, over-educated and class-bound aestheticism, a similar view to that expressed later by Wyndham Lewis who famously described Bloomsbury as a 'party of Strayed and Dissenting Aesthetes'.[38]

As the journal's art editor, Fergusson produced a design closely related to his painting *Rhythm* (Plate VII) as its cover image.[39] This decorative female nude, perceived as embodying the very essence of rhythm, was shown in its worked-up version after publication of the journal in the summer of 1911 at the 'Salon d'Automne'. Although static – the figure is seated – the simplified solids that compose the form are as inherently rhythmical as those of Matisse's architectonic nude, *Carmelina*, 1903.[40] The curvaceous, voluptuous figure resonates with the lush forms of fruit and foliage in the flat stylized background and heralds the Paris compositions produced up to 1912.[41] This

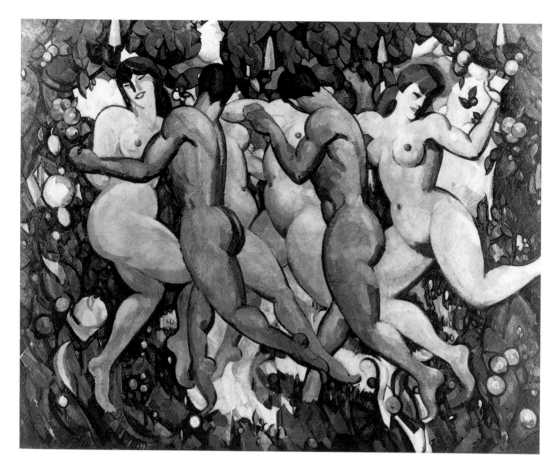

4.3
J. D. Fergusson,
Les Eus ('The
Healthy Ones'),
1911–1912

was a period of decorative portraits of models and friends and tightly orchestrated representations of iconic male and female nudes, of ideal bodies. On occasions, groups of figures are locked into bacchic dances or fertility rites, as in *Les Eus* ('The Healthy Ones') (Figure 4.3) with obvious echoes in Derain's *The Dance*, 1906, itself inspired by Gauguin's exotic, primitivist Tahitian paintings, but also by the ritual 'Sardana' folk dances performed by fishermen in Collioure.[42]

The *ronde d'enfants*, the circle of dancing figures in nature, features throughout French art, from Poussin's allegorical *A Dance to the Music of Time*, c.1639, to Jules Breton's *The Festival of St John*, 1875, where the local country girls enact a traditional custom in the rural calendar.[43] But the taut energy of Fergusson's representation connects it quite emphatically to modern forms of dance. From the Ballet Russes to Isadora Duncan to Jacques Dalcroze's writings on eurhythmics, dance was culturally crucially significant in bohemian and artistic circles both in London and Paris before the War.[44] The sensuality and exoticism of Fergusson's *Les Eus* was especially influenced by the Diaghilev Company's performances and, in an article on the Ballet Russes in *Rhythm*, Ann Estelle Rice praised the 'undulating movement' and the 'maddening whirl of sound, colour and curve' of their performance of *Shéhérezade*.[45] An understanding of

the particular inspiration of dance for the Rhythmists emerges from an essay on Pavlova by Fergusson and Rice's friend Holbrook Jackson in his anthology of 1911, *Romance and Reality*. The Russian dancer here epitomizes the all-important quality of cosmic universality which is 'the very spirit of the dance', and Jackson's account connects closely to contemporary Rhythmist visual imagery with its common, underlying symbolism: 'The leaves dance in the breeze, the flowers dance in the sun, the worlds dance in space, and Pavlova is part of this cosmic measure.'[46]

Inspiration for modern dance was derived primarily from the Orient or from the southern Mediterranean. It celebrated an elemental purity of body and spirit in harmony with nature that was initially shocking to bourgeois taste in Paris and more especially in London. Jackson described how 'the frigid morality of English respectability, would be touched to strange emotions … a new wakefulness'. Dancing is 'rhythmic life' at its most intense, only appreciated by those 'who shun the ideals of money, appearance and prestige', 'children, simple peasant folk, common East End Cockneys'. Pavlova's swaying form 'rhymed and romped with life and joy, with love and beauty', and the author was moved to quote from Keats's imaginings of Bacchus and his kin:

> Like to a moving vintage down they came,
> Crowned with green leaves, and faces all on flame;
> All madly dancing through the pleasant valley,
> To scare thee, Melancholy.[47]

But the conservative audience in 1910 was ill-prepared for these evocations, and still less for the stylized, hieratic forms depicted in Anne Estelle Rice's *Egyptian Dancers*, shown at the Baillie Gallery in 1911 and roundly criticized in the conservative press as 'the extravagance of a lunatic'.[48] Michael Sadleir defended the artist in 'Fauvism and a Fauve' in *Rhythm* in 1911 and his account of Fauvism in the characteristic terms of energy, vibrancy, 'strength and decision' clearly confounds orthodox accounts of a conventional femininity.[49] To Sadleir, Rice's outlook was 'vigorous and personal', her methods 'definite and unhesitating'. Joy in colour and curvaceous form was a reaction not just against the mechanical perceptions of Impressionism, but the 'moribund flickerings' and the precious 'jaded palette' of the aesthetic movement; it signalled a wider commitment to a 'need for width, for blood, for fresh air'. Rice's *The White Sail*, also displayed at the Baillie Gallery, revealed in the surging, decentralized design of the 'subtle correlations' of the sails and the prows of the barges 'the same rhythmic repose always on the edge of action'. So line, colour and shape conveyed essential energy and force and could be expressed as clearly in the depiction of sailing boats at sea as in an animated circle of dancing figures. The landscape itself contained the life force. It contained the rhythms and flashes of pure colour as nowhere else. This had been seen clearly by Van Gogh and it was evident now to Michael Sadleir, who observed the artist's non-naturalistic colour and his vibrant frenetic brushmarks in his *Rhythm* article: 'To him landscape vibrated,

lived in its every line'.[50] Expression of location and more particularly of the sensations of heat, light and colour were determined by a physical, bodily reaction rendered in equivalent painterly terms. The journal played a considerable role in promoting a particular view of the south through its illustrations and reproductions of specific French artists' works, like for example Manguin's *Landscape*, Othon Friesz's depictions of nude and palm trees and his *Landscape*, of hills and valley. In its literary content too the journal represented the south as a therapeutic place of mental calm, stability and distance, thus of Aix en Provence – 'ici en peut se retrouver dans le silence'.[51]

A preoccupation with the physicality of perception led Roderic O'Conor southwards. By 1912, this time following in the footsteps of Braque, Derain and Friesz, he had taken a studio overlooking the Bay of Cassis. He returned again in the summer of 1913, this time renting the Villa Marguerite in the old part of the town – at the same time as Peploe, Fergusson and Rice. Ignoring the scenery around the fishing village itself, O'Conor painted at Les Calanques, the rocky inlets to the west, and the cliff of Cap Canaille to the east.[52] Jonathan Benington records that O'Conor painted over twenty oils here, with a Cézanne-like commitment to motif. The bodily sensations of warmth, light and atmosphere are conveyed in intense colour, loose brushmarks and in a staining technique, with patches of pigment that reveal bare canvas in places, partly resembling Othon Friesz's highly distinctive, experimental paintings of La Ciotat from 1907.[53] O'Conor's *Landscape* (Plate VIII) (inscribed to Roger Fry in 1915) reveals what was by then a typical use of broken brushwork, a thinner paint quality, very little drawing and dappled colour effects also reminiscent of Bonnard, whose pictures were exhibited annually at Bernheim-Jeune's gallery from 1910.[54] Sensations, expressive of states of mind and formed in particular conditions, are here ultimately concerned with notions of pleasure. If pleasure was the fundamental goal of the decorative harmonies of Matisse, it was to be experienced in its essence on the Côte d'Azur. So Fergusson took a small cottage on the Cap d'Antibes in 1913 because he 'wanted more sun, more colour'.[55] Like John, he shunned the fashionable resorts and the Cap was ideal because the painter had 'seen no English or chic people here at all'.

France itself created good states of mind. Roger Fry recorded a cycling tour with Clive Bell and Duncan Grant; 'When one gets into France' he declared 'and the sun is shining on little towns, all grey-brown roofs and grey walls, and the poplars are golden in the autumn light, I must be rather happy at the mere sight.'[56] Exhausted by preparations for the second Post-Impressionist exhibition, France restored Fry's physical and mental well-being. It encouraged states of disinterested contemplation, where mood is affected purely by formal qualities of line, shape and colour.[57] This was the ultimate goal of decorative painting for Fry, and its archetype lay in Cézanne, 'the most disinterested of painters'. Cézanne reflected the 'Classic spirit', which characterized 'all best French painting from the 12th century'. The spirit of Poussin was therefore bequeathed to Derain in the form of a

contemplative vision, 'a classic concentration of feeling'.[58] A dominant characteristic of Fry's modernism is the urge to attain a pictorial purity and as such it clearly relates to the aestheticism of the later nineteenth century, from Pater to Whistler. As Simon Watney pointed out, Fry's 'ruthless fetishism' of the formal qualities of design and technique signalled an isolationist modernism, free of all social commitment, indeed an 'aesthetic eugenics'.[59] Watney viewed Fry's ambition as the creation of an 'aesthetic nirvana' only appreciable by the truly discerning, those 'connoisseurs of pleasure' capable of achieving a state of transcendence, a temporary loss of consciousness; 'the perception of a higher and more stable order of reality'. Cézanne, as ever, provided the benchmark. Thinking the matter over in 1914, Clive Bell believed that in gazing at a familiar stretch of countryside at Aix-en-Provence, the artist experienced the revelation that was to set a gulf between the painting of the nineteenth and twentieth centuries, that landscape is not a 'player in the great game of human life'; 'Every great artist has seen landscape as an end in itself – as pure form.'[60]

Rice, however, regarded her paintings in rather different terms. *Ajaccio, Corse* (Plate IX), one of the landscapes from her visit to Corsica in 1913, consciously established a symbolic significance associated with a gendered perception of nature and her own creativity. In an interesting comparison with the vertical and horizontal emphases in Peploe's *Landscape at Cassis* (Plate X) of the same year, Rice plays up the rhythmic, undulating curves of the trees and the earth. Her painting accords rather with her partner O. Raymond Drey's assertion that Cézanne's landscapes, composed of a mass of smaller masses knit together by a natural rhythm, point to a new aesthetic excitement, touching the 'strings of a universal capacity for response'.[61] In Rice's terms the patterning of circular rhythmic forms connects to principles of female sexuality associated with nature.[62] And Carol Nathanson cites a letter from the artist to the American writer Theodor Dreiser from Corsica, in which she declares that 'all nature here is so beautiful and pregnant and rises up to compete with the ascending mountains. My own ideas have this for a beginning.'[63] Such a view problematizes Bergson's premise that it is essentially the creative male artist who discerns the fundamentally female principles underlying natural processes. Female creativity is traditionally and stereotypically perceived to reside purely in the reproductive abilities of women, but Rice's example here appears to reject that simple conflation.[64]

If the decorative quality of Rice's painting might be attributed to her previously established skills as a designer, then something of the reverse effect resulted from Fry's experiences of painting in the south. Following her stay in Corsica, Rice eulogized Cassis as a place 'where the artist's vision has a chance to expand, where glorious design, color, volume and line obviously exist'.[65] Fry's visit to Provence, following his quarrel with Wyndham Lewis over the 'Ideal Home' exhibition in 1913, resulted in his painting of a 'wonderful valley' discovered along with his French companion Henri Doucet, which he later transformed into a design for an Omega Screen.[66] For Fry, seeing decoratively meant turning his back on the obvious subjects, such as

the medieval castle at Villeneuve-les-Avignon and concentrating hard on the harmony, balance and equilibrium to be perceived in the underlying geometries of nature. Seeing in this way meant breaking down the eternal distinctions between high art and decorative art, so that modernism in Fry's conception amounted to what has been termed a 'social restorative', compensation for the experience of long-term residency in 'Bird's Custard island'.[67] In this respect, the south of France was crucial in the construction of what has been seen as the Bloomsbury flight from philistine bourgeois domesticity in England into ideal new spaces, settings for new ways of life.[68]

But Fry's critic T. E. Hulme was unconvinced by his efforts in this respect. 'The colour is always rather sentimental and pretty. He thus accomplishes the extraordinary feat of adapting the austere Cézanne into something quite fitted for chocolate boxes.'[69] Fry's own pictures quite simply lacked energy or vitality. While this might result from hesitancy about his own abilities, a reserve in general underpins his and Bell's aesthetic theories and, in the end, distinguishes Fry's representations of the south from those of the Rhythmists. Celebration of a disinterested vision might, as Antliff observed, reveal 'the individuality of things and beings', but to those more in accord with Bergson's analysis in *Creative Evolution*, 'artistic creativity was transformed from a form of individual expression into an agent for a vitalistic creative force'.[70] This was a much more positively engaged vision of the artist's relations with the world. Middleton Murry could speak, therefore, of the artist as a 'vehicle of the spirit', which was 'forever wrestling with its own materiality'.[71] And Fergusson, in this view, 'penetrates and seeks to identify himself with this timeless progress in order that he may ... become the taproot of the spirit which is at work in the world he contemplates.'

After *Les Eus*, a taste for a more instinctive decoration and what Rutter termed a more 'fleshly, robust paganism' prevailed over a classic spirit of calm and repose or a contrived, imaginary arcadia.[72] Reactions were invariably mixed, however, when the picture was displayed at the Doré Galleries in London in February 1914: 'Anaemic critics, who found a Rubens coarse to their taste, were in revolt against Fergusson's trumpet-like call to the joys of life. This, I take it, was the real significance of the composition. *Les Eus* means "The Healthy People", and the painting aimed at something more than suggesting a bacchanalian procession.'[73] The trumpet heralds an existence already being enacted by the Rhythmists themselves in their own modern lifestyles; lifestyles that leeched into their art. So Middleton Murry recorded Fergusson 'stripped to the buff polishing the floor of his studio before starting work for the day'.[74] Margaret Morris is photographed striking poses and dancing on the beach at Cassis. Fergusson sketches her languishing in a hammock at Antibes in 1914, even if he then calls the painting *Summer, 1914* (Figure 4.4) and so perpetuates all those Bergsonian notions about femininity, the cycle of the seasons, fecundity, etc.[75] But what connects all of these images is that they involve real people (incomers, admittedly) living out a healthy, vibrant, regenerative and intuitive life. These are self-consciously modern idylls of a very particular kind, not set in a remote past with actors

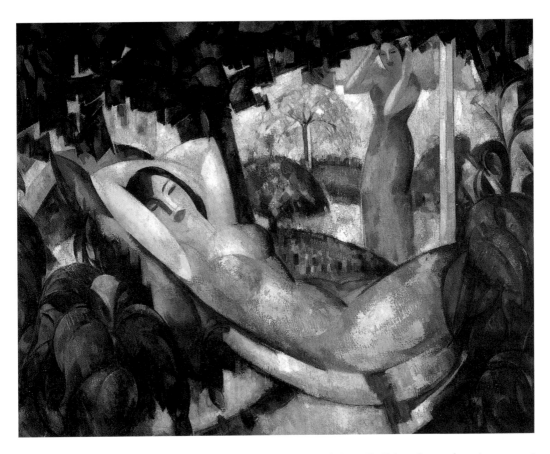

4.4
J. D. Fergusson,
Summer 1914,
1934

assuming allegorical poses, not, as with Dorelia John, dressed up in peasant costume with the air of a saintly Madonna. Morris and Fergusson place their figures against a dense background of foliage or alternatively against the back-drop of a café bar in Cassis harbour. On the evidence of John's paintings, it seems unlikely that Dorelia ever reached the bar in Martigues.

A sympathetic country

In 1913 Dorelia turned up once again posed in a rugged and remote landscape and in yet another location – this time leaning against the rocks in Cornwall (Figure 5.1), a site which for John fulfilled many of the requirements of those he frequented in France, north Wales and the west of Ireland.[1] This chapter explores some of the shifts and transformations that had already occurred in the representations of Cornwall in the years up to John's arrival, paving the way for a modernist interpretation before the Great War.

By the turn of the century the popular appeal of paintings of Cornwall was phenomenal, with reports that more pictures were painted there in a year than in any other county and, in 1896, that the old town of Newlyn was represented in every room at the Royal Academy exhibition. From the early to mid-1880s, as is well documented, artists like Stanhope Forbes and Frank Bramley had been drawn to the 'English Concarneau', because they wished to recreate the subjects and adopt the technique of their mentor, Bastien-Lepage.[2] In the years to follow, those earliest artist-colonizers had gradually abandoned their sober depictions of the working lives of local fisher folk, like Forbes's *Fish Sale on a Cornish Beach*, 1885, for brighter, sunnier paintings like *Gala Day at Newlyn*, 1907, a carefree vision of a Whit Monday village celebration. This movement developed at much the same rate as the artists' popularity at London exhibitions increased. So, by the later 1890s native Newlyners were commonly viewed as arranged appealingly in nature, behaving appropriately inside well-scrubbed cottages or at colourful and well-organized village fêtes.

Subjects like fêtes and Methodist processions reflected wider shifts in the perception of Cornwall from a site of work to one of innocent and civilized leisure. These 'collective recreation ceremonies' and holidays were regarded by Emile Durkheim in 1912 as a 'means of moral remaking ... in which the life of the nation was re-affirmed' and the indigenous population safely organized.[3] From the mid-1890s up to the Great War, Cornwall functioned as a perfect site on which to reflect and mediate specifically modern, urban, middle-class fears about the physical and moral health of the nation, concerns about the moral health of English art, recent departures from traditional late-Victorian gender stereotypes and, most fundamentally, anxiety about

5.1 Augustus John, *Dorelia in Cornwall*

shifting middle-class patterns of behaviour from within that class itself. Artists' representations of the figure in the Cornish landscape reflect something of the modern culture of tourism, itself a powerful determinant of inherent modernism, as we have seen. Paintings of Cornwall operate in much the same way as the processes of tourism, described as 'an ideological framing of history, nature and tradition; a framing that has the power to reshape culture and nature to its own needs'.[4]

From the turn of the century the county developed rapidly as a tourist resort, aided by the Great Western Railway's successful marketing campaign of the route to the 'Cornish Riviera' after 1904.[5] Developments in painting thereafter were undoubtedly affected by greater appreciation of what made the area appealing for the tourist and, by extension, the picture buyer. By the close of the nineteenth century, the expansion of the railway into west Cornwall meant that resident painters could have their pictures transported up to London for Royal Academy exhibitions, and tourists could be transported down on its return – their expectations significantly shaped in advance by the paintings seen in galleries or reproduced in magazines.[6] There are interesting correlations between specific representations of Cornwall at this date with variations in the culture of tourism itself. Pictures of bucket-and-spade holidays, like for example Laura Knight's rosy-cheeked young children in *The Beach* (Figure 5.2), epitomize Edwardian ideals of healthy family holidays during the era of declining birth rates and concerns for child welfare in large cities. Hence *The Ladies Realm*'s comment that the aspiration to be near the sea runs throughout the city 'from Whitechapel to West Kensington' each July. Those unable to make the journey, forced to remain 'sweltering in the heat of the great city (together with the) weary children from the slums of Westminster, (can always) wander through the public art galleries and study the waves as they roll across the canvas'.[7]

In Knight's *The Beach*, children function as idealized embodiments of health and purity amidst concerns over large urban populations of working-class children, overworked and failing to thrive, which culminated in the widely debated 'Children's Act' of that same year.[8] Children of the underclass were largely absent from popular Edwardian paintings and *The Beach*, like *Flying a Kite*, of 1910, mark Laura Knight's move away from the depiction of the children of fisher-folk to a rhythmically composed Impressionist idyll of young, healthy holiday-makers with bright faces, clean smock dresses and shady hats, playing barefoot in the sand[9] – a perfect representation of the type of leisured scene of which an important function, 'was to display the stability and affluence of the Victorian (and Edwardian) middle class family'.[10] Such imagery might have been produced at any seaside location – it takes no account of the specificity of Cornwall – and the tourist experience referred to in these images is collective, not solitary and romantic.

Knight's healthy holiday-makers were also a significant departure from the type of childhood imagery typically produced in Cornwall – the sons of fisher-folk learning their trade, as depicted by Stanhope Forbes, or the (apparently) local lads messing about in rowing boats by Henry Scott

5.2
Laura Knight,
The Beach, 1909

Tuke.[11] They contrast even more sharply with works by artists like Elizabeth Forbes and Thomas Cooper Gotch. After a trip to Florence in 1891, Gotch had been drawn to a symbolic, Neo-Renaissance manner in place of his earlier Bastien-Lepage derived form of Rustic Naturalism. Works like *The Child Enthroned* of 1894 exemplified his representations of the 'sweetness and joyous serenity' of children and young adolescents in ornate and decorative settings – at times in entangled, blossoming nature, at others in medieval or ecclesiastical interiors.[12] A symbolic intensity also characterized many of Elizabeth Forbes's child subjects, with their Shakespearean or Arthurian allusions and her depictions of Cornwall as a land of romance; of elfin children and Pre-Raphaelite maidens cavorting or merrily processing through pastures, wooded valleys and along river banks in an imaginary and consoling fairy-land. As such her own version of the *ronde d'enfants*, a dancing circle of graceful young women in flowing robes, *On a Fine Day* (Figure 5.3), contrasts sharply with those of Matisse and J. D. Fergusson. The strength of her symbolism of the bounty of nature, the cycle of seasons and the passage of time is weakened, comparatively, through fancy-dress

5.3
Elizabeth Forbes,
On a Fine Day,
1901

and through the allusions to medieval legend that crop up in her works from this period.[13]

Qualities to be regarded most essentially as un-English and identifiable with the pre-war construction of Cornwall emerge particularly in paintings of the rugged coastline and in the depiction of the male and female nude or semi-clothed figure posed on remote rocky shorelines and cliff-tops. Artists active in Cornwall take on a larger brief which increasingly identifies specific sites with generalities, and this seeming paradox explains the appeal of remote coastlines and the rocky coves of the Cornish coast, which lend themselves more readily to the fantasies of modernism. The developing construction of Cornwall is therefore based almost exclusively, geographically, on its outer edges – its beaches and cliff-tops, leaving aside fishing villages, inland wooded areas, and certainly any signs of traditional industry like tin-mining and clay pits.

Remote from the confusion, the trivial and fragmentary existence of modern life in the burgeoning cities, Cornwall stood for spiritual purity at a time when, as Masterman complained in 1909, 'the middle class' is 'losing its religion', is 'slowly or suddenly … discovering that it no longer believes in the existence of the God of its fathers, or a life beyond the grave'.[14] Tourism, born of the modern condition, was the antidote to urban impoverishment and so the culture of tourism needs to be seen not just as a series of evasions of the problems of modernity and the urban, but as essential commentary upon them. My contention is that this opens the space for artists' engagement

with classically modernist preoccupations. Rob Shields, in his discussion of 'imaginary geographies', speaks of a number of sites which we might extend to include Cornwall, to be regarded as 'marginal places' to the dominant culture. These are sites that have been left behind in the race for progress, but are essential as symbols and metaphors, expressing states of mind and different value positions from within that dominant culture.[15] This situation has been further characterized in terms of an 'enduring relationship between an "English" centre and a "Cornish" periphery (which) has perpetuated Cornish "difference" over time'.[16]

Writing in *The Studio* in 1909, the painter Norman Garstin claimed that: 'To those who live in the crowded centres the very thought of capes and headlands which thrust themselves out into the lonely sea comes with a sense of relief from the jostle and jumble of the intricate schemes of city life.'[17] It was the isolation of Cornwall, not just from the crowded centres but from an England viewed with disaffection that was significant. Cornwall seemed as far as it was possible to get from a country that was becoming increasingly homogenized through urban sprawl, changing class boundaries and patterns of work and education. In 1912 Knight's *Wind and Sun* (Figure 5.4) represented a moment of transition in her work from what here is an essentially breezy, atmospheric, Impressionist rendition of young women lying on the sunny cliff-tops to what, after the Great War, were to become increasingly vertiginous settings depicted with a brighter and more intense palette. Knight produced a similar subject, also painted in 1912, of young women, presumably her models, reclining on the rocks, simply entitled *Cornwall*.[18]

For Knight, Cornwall was like nowhere else, it was 'free of the ordinary', 'neither time nor the vulgar can conquer its indomitable spirit ... you don't know why, but you aren't in England any more'.[19] Likewise for D. H. Lawrence, who lived at Higher Tregerthen, Zennor in 1916–1917: 'I like Cornwall very much. It is not England. It is dark and bare and elemental, Tristan's land.' Lawrence lay flat on the cliff gazing down into a cove, a view-point adopted by several painters, including Knight, 'where the waves come white under a low black headland ... it is old, Celtic, pre-Christian. Tristan and his boat and his horn. All is desolate and forsaken, not linked up, but I like it.'[20] In another place the writer is quoted as finding in Cornwall something still like King Arthur and Tristan. 'It has never taken the Anglo-Saxon civilization, the Anglo-Saxon sort of Christianity. One can feel free here for that reason – feel the world as it was in that flicker of pre-Christian civilization when humanity was really young.'[21] This was far from the gently romantic quality of the Arthurian tales as depicted by Elizabeth Forbes. Lawrence's tastes for the pre-modern and the pre-industrial are offended by those popular tourist destinations along the south coast, increasingly regarded as over populated and over visited by weekend trippers from London – from Brighton to Bognor. In other words, remoteness meant selectness.

Popular seaside resorts were ever more distasteful to some middle-class observers because they had anaesthetized the public from appreciation of

5.4
Laura Knight,
Wind and Sun,
c.1912

the 'real sea'. To one commentator in 1908, it was 'rare now for an individual to come unprepared upon a first sight of the sea from the edge of a high cliff … We have learned to call the sea that grey-green stripe behind the railings of the Brighton Front.' It was necessary to go as far as Cornwall where 'are still to be found lonely field and furze grown wastes with a brink whose crumbling turf drops into the tide three hundred feet below … without a sign of man's presence to disturb the spirit of the place'.[22] The writer W. H. Hudson's account of his experience at Land's End in that same year evokes the same sentiment:

I was in a sense the last man in that most solitary place, its association, historical and mythical, exercised a strange power over me. Here because of its isolation, or remoteness from Saxon England, because it is the very end of the land … the ancient wild spirit of the people remained longest unchanged.[23]

These narratives connect with those of contemporary guide books describing equivalent locations in similar terms. In the majority, the character of the inhabitants of Cornwall was predetermined and frequently misrepresented. In this respect, the framing of the county by artists like Knight and Garstin

intersects with the desires of middle-class tourists for the apparently authentic, as opposed to the inauthentic, transitory conditions which contemporaries like Simmel and Durkheim identified with that middle-class projection, urban anomie, arising from life in the modern city.[24] Visitors to Cornwall knew what they were seeking on arrival, an experience as far from their actual lives as possible. But their ideal was also strikingly remote from the actual lives of native Cornish people, who would have been hard put to recognize themselves in the terms of this quote from *Cook's Traveller's Gazette*: 'Here in a tempered climate fanned by healthful breezes flourish a hardy, thrifty and hospitable people … among scenes of wildest beauty and rocky grandeur, tilling the soil once trodden by ancient saints … by a race savage and mystic.'[25] The tourist journal echoes John's interpretation of the remoter parts of Brittany and of the ancient communities he encountered at Aran.

These idealizations of a racial type were invariably linked to fears about the deterioration of the national physique in the overcrowded cities, and Cornwall in particular emerges as a perfect site within Britain for the displacement of those anxieties. Issues concerning health and the proper maintenance of the body were endlessly emphasized in newspapers and journals and the fostering of a national interest in the beneficial effects of the outdoors formed an important part of the purity campaign associated with the Physical Culture Movement.[26] This preoccupation with ideal body types in respect of physical and moral health was essential to the appeal of Knight's imagery around 1912.

From the early 1890s the paintings of Henry Tuke, an artist of Clausen and Stott's generation, also demonstrates the more general shift in representations of Cornwall from a place of work to one of leisure. His scenes of naked young lads in boats on the sunlit waters of Falmouth harbour, like *August Blue* (the title of a poem by his friend Arthur Symons) (Figure 5.5), replaced 'disaster at sea' pictures like *All Hands to the Pump*, Royal Academy, 1889.[27] Tuke's continued success with scenes like these was confirmed in a review of 1902: 'Impressions … in whose rendering he excels, are those of the dancing sunlit waters, wherein from a reef of rock or an old boat lads bathe or, in unhastening joy, attend the call of sun and wind and sea. The lads are lithe and natural; they act with the unconcern of youth. Boats, rocks, sea, are the reverse of the unfaithful.'[28]

Painted mostly in the open air in secluded coves and beaches only reachable by boat, these boys emerge as sturdy archetypes for the nation's youth, with a self-possession that renders them unaware of the spectator's gaze. For the critic Marion Hepworth Dixon in 1905: 'The healthy mind in the healthy body is a motto which is writ large on every canvas.'[29] Of course concerns like these took different forms and levels of implication and, in one sense, liberal anxieties for the nation's vigour were only a short step from the overt Aryanism of symbolist works like, for example, the German painter H. A. Buhler's *To the Unknown God*, illustrated in *The Studio* in 1908.[30]

Since the 1890s, consistent interest was shown in art historical methods of formal and racial classification and in varying definitions of the classical

5.5 H. S. Tuke,
August Blue,
1893–1894

spirit in art and beauty. Walter Pater, who died in 1894, took on a renewed relevance here, especially for his studies of *Winckelmann*, first published in 1867, and *Greek Studies*, published a year after his death.[31] For Pater, Winckelmann's affinity to Plato was wholly Greek, alien from the Christian world, 'represented by that group of brilliant youths in the Lysis, still uninfected by any spiritual sickness, finding the end of all endeavour in the aspects of the human form'.[32] The manifest homoerotic content of Tuke's work is underpinned by a contemporary desire for innocence and new beginnings to be found in largely urban, middle-class imaginings about the essential purity of nature and rural life. There is a clear trajectory between Tuke's paintings like *Ruby, Gold and Malachite* (Plate XI), and the Neo-Paganist veneration of the male body through to eugenics and racism, but this was rendered the more acceptable, to large audiences, through the disguise of being seen as 'an appealing new version of the ubiquitous "rural myth"'.[33] In this respect classical ideals, however interpreted and identified, acquired their significance from a much wider range of modern social conditions and experiences.[34] The number of available readings of Tuke's representations of the male nude was crucial to their wide appeal, explaining the near-constant presence of his endlessly repetitive pictures at annual Royal Academy exhibitions, right up to World War I, and right through the furore created by Roger Fry's two Post-Impressionist exhibitions.[35] They proffered visions of an ideal unity between man and an untroubled nature, of a certain recall to order. To this end the anonymity of his figures was vital.[36] As Kains Jackson

asserted, 'imagination does not consist in losing hold of reality; rather may it be said to reside in the perception of whatever there is of reality behind fancy. The god who obliges by wearing his halo does not stimulate the imagination, but dispenses with it.'[37]

Just as allegorical works were unsuccessful, so overtly mythological paintings of the nude male were hard to assimilate by the 1890s. They were too closely associated with those of Royal Academicians, like Frederic Leighton and Alma Tadema, rejected in the later 1880s by artists drawn instead to French Naturalism and Impressionism. Because mythological nudes summoned up specific literary associations, they were more difficult to interpret, consciously or not, as modern icons in the light of real worries about modern urban conditions. In 1893 Tuke had been advised by John Aldington Symonds 'to develop studies in the nude without pretending to make them subject pictures ... Your own inspiration is derived from nature's beauty. Classical or Romantic anthologies are not your starting point.'[38] Classical attributes were to be eliminated, but the pose or body type itself was enough to function as a sign of ideal spiritual health and platonic beauty.[39] It was important for Kains Jackson that the artist's youthful models, 'from fishery or foundry', should emerge as 'part and parcel of their surroundings in the open air, the cliff, the beach, the green and blue waters'.[40] Tuke's figures, therefore, tend increasingly to be inactive, languid and contemplative. Their main purpose was simply 'to be' in their environment and the artist becomes preoccupied with the male form rather than the specific location. Nor do they address the infinite, as John and Laura Knight's figures do.

The ideal Greek body type was, as Sander Gilman has pointed out, being deployed from the late-nineteenth century onwards as the normative healthy body in the context of aesthetic physiognomy. Illness resided in the ugly and deformed which contrasted with 'Kant's idealized body, with its pseudo Greek colour, balance and proportion'.[41] The classically proportioned young lads depicted by Tuke, especially when posed in nature, on remote sun-filled Cornish beaches and on cliff-tops, might function as exemplary of young male beauty and physical health that had as much to do with concerns about declining levels of fitness amongst middle- as well as working-class urban types in the context of imperialist discourses, as with the predilections of Kains Jackson's circle.

Not only did the classical ideal divert Tuke from the modernist path, it appeared to present an alternative to prevailing conceptions of much contemporary modern painting in Europe. The outrage and hostility provoked by the first Post-Impressionist exhibition had resulted in accusations about the moral degeneracy of those involved. Ebenezer Wake Cook, whose *Anarchism in Art* of 1904 was indebted to Max Nordau's *Degeneration*, 1895, was at the forefront of these attacks.[42] His review in *The Morning Post* called for a psychological and pathological rather than art critical analysis of the painters exhibited. The 'Modernity movements in art', were 'sickening aberrations', which he equated with language reduced to chaos, beauty subverted and nature libelled and distorted.[43] In his attack on Nordau's

book Bernard Shaw complained about the plethora of native writers – 'now imitating his sham-scientific vivisection in their attacks on artists whose work they happen to dislike'.[44] Sir William Blake Richmond was one such, and he assigned the 'morbid excrescences' and 'hysterical daubs' on display at the Grafton Galleries to the 'disordered mentality … common to these times'.[45] Both reviews were constructed in the terminology of the diseased body and the deranged mind. Modern European painting was deformed, impure and disordered. T. B. Hyslop echoed Richmond a year later, describing the 'art of the insane', equivalent to that of modern artists, as marked by, 'faulty delineation, erroneous perspective, perverted colouring … distorted representations of objects, or partial displacements of external facts'.[46] As Kate Flint has shown, this kind of art criticism was based on a set of polarities, implying moral values, such as health/disease, mental equilibrium/insanity, decorum/unruliness or vulgarity, all of which played to the modernist agenda. As a result the finished work of art was 'conceived as a body, possessor of mental and physical attributes and defects'.[47]

The elaboration on the classical ideal derived from the attack on the prevailing philistinism associated with the changing social hierarchies and the emergence of the new middle classes since the nineteenth century. For a whole host of writers, from Tory reformers to early sociologists, the root causes of cultural, racial and physical decay lay in the experience of modernity and urban life. To describe that experience was to use terms similar to those used to attack modern painting. It was to speak of rupture, discontinuity and disorder – all terms that contrast with classical ideals of calm, discipline and order. Winckelmann's *History of Antique Art* had similarly interpreted the 'classicalness' of Greek art in terms of its 'static, harmonious, lovely features … noble simplicity and tranquil grandeur'.[48]

In a piece that might have been written in the 1900s, Walter Pater had described 'The Hellenic ideal in which man is at unity with himself, with his physical nature, with the outside world'. 'Certainly for us of the modern world', he went on:

… with its conflicting claims, its entangled interests, distracted by so many sorrows, so bewildering an experience … the problem of unity with ourselves is far harder than it was for the Greek within the simple terms of antique life. Yet now, not less than ever, the intellect demands completeness, centrality … What modern art has to do in the service of culture is so to arrange the details of modern life, so to reflect it, that it may satisfy the spirit.[49]

Much of Laurence Binyon's writing reflects Pater's sensibility. In his article on 'Art and Life' in 1910, he declared; 'we feel intuitively that art exists, not for a temporary and ever-shifting set of conditions, but for an ideal order. Its relation to life is the ideal life.'[50] A classical ideal then was perceived by numerous critics, of both the 'new' and the more traditional variety, to define a pure, unsullied and redemptive art which was fundamentally immune to the infections of both modern art and modernity itself.

To allay fears of contagion from the modern art on display at the Post-Impressionist exhibition, Blake Richmond reassured his readers that 'the

youth of England, being healthy, mind and body, is far too virile to be moved save in resentment against the providers of this unmanly show'.[51] The very consistency of the appearance of Tuke's paintings was therefore all the more compelling, his mythology all the more alluring. In contrast to the works of Picasso and Matisse, even more so those of the Futurists to be displayed at the Sackville Gallery in 1912, his nudes appeared, to some, as reassuringly wholesome and ideal, based on proportions of harmony and equilibrium.

D. S. MacColl emerges as one of the few dissenting commentators on Tuke, perceiving in his works 'an awkwardness and a wavering from the original thought'. 'Mr Tuke's sensitiveness is not backed by science of drawing or the necessary instinct of design, and therefore threatens to be of little use to him'.[52] Tuke's drawing is 'sticky, done in little bits', his 'only thought in composition is to avoid impropriety in presenting his nudes'.[53] *Hermes at the Pool*, is described as 'simply a British hobbledehoy rendered in the act of posing'.[54] Tuke's bodies had become too big for his subject, 'the effect of colour on sunlit sea and the bodies of bathers' and the weaknesses of his conception of form were revealed. Instead of that overall impression of vigour and grace, the painter was revealing nothing but 'observations of a trifling order'. The result being that we 'the spectators, [become] – if not shocked – at least conscious that we are face to face for no sufficient reason with a nude model'.[55] Fundamentally, Tuke lacked competence as a draughtsman and designer and so was technically unable to express the classical ideals of 'vigour and grace'. With the best of intentions, to quote H. Heathcote Statham: 'You cannot produce a Greek god by merely stripping an ordinary lower middle class youth of his tailorings.'[56] It may have been possible for Tuke's naturalist imagery to convey notions of health, the outdoors and the goodness of nature, but heroic, classical ideals and proportions were beyond his capabilities.[57] Hence John Betjeman's description of him as 'the Boucher of the boy scouts'.[58]

Whatever the eventual failings of Tuke's art, however, the role of Cornwall as the perfect setting for ideal physical bodies continued. By the turn of the century, the word 'degeneracy', as we have seen, had become a general term of abuse, extending from descriptions of the body outwards into modern culture, modern civilization.[59] All contrast with perceptions of the landscape in Cornwall and the figures posed on its sun-filled beaches. The more remote from the centre of modernity's degradations, the more that artistic ideals of health and wholesomeness could flourish, as contemporary descriptions confirm. Arthur Reddie, for instance, felt that through 'living and working in close communion with nature', artists there were producing works of 'truth, unaffectedness, freedom from pose and extravagance'.[60]

Like Tuke, Laura Knight's own development had led her away from the lives of the working inhabitants of the fishing community she had depicted at Staithes. According to Garstin, her 'youth and strength demanded a wider horizon than was to be found in the poetic sadness of their low-toned realizations of the grave, serious lives of the poor'. But on arrival at Newlyn

she had been disappointed by the appearance of the local women: 'They were not so magnificently upright, they carried no weights on their heads nor did they work among the fishing … slippers slopped from house to house.'[61] This un-picturesqueness was a general complaint about Cornish women. As the painter W. H. Bartlett commented in 1897, 'a fine buxom-looking woman is not a common sight among the fisher class'. The answer, he felt, might lie in 'the large quantities of tea the women take'.[62]

Finding no appropriate material there, Knight turned first to carefree scenes of small children playing on the sands, like *The Beach*. For a time she worked on several slightly stilted symbolist pictures of girls with their unpinned hair streaming in the breeze, their faces turned to the sun, gazing out across brilliantly lit expanses of sand and sea, as in *Untrodden Sand* shown at the Royal Academy in 1912. This theme was also taken up in *Wind and Sun* but at the same time a growing interest in the possibilities of placing the nude in such a setting emerged. With no chance of hiring local girls for these pictures, Knight's imagery was further divorced from the depiction of the real life of the Cornish coast around Newlyn and Lamorna Cove. The reaction of the Londoners she employed to the strangeness of their new environment clearly impressed the painter: 'They had never been in the country before, scarcely knew a sheep from a cow and thought cabbages grew on trees. It was pandemonium.'[63]

Knight's new subjects intersect closely with the culture surrounding the specific type of tourism in which Cornwall was compared with the landscapes of the classical south. Kains Jackson, as one might expect, was complicit in this: 'Cornwall … remains the painters elect haunt, nor can the wine dark Aegean itself surpass the beauty and colour of the south Cornish sea.'[64] Not only was Cornwall like the Mediterranean, it was better. Similarly Arthur Symons, walking along the Cornish coast 'could have fancied myself in Naples … And the air was as mild as the air of Naples, and the sea as blue as the sea in the Bay of Naples'.[65]

In pictures like *Bathing*, 1913 and *Daughters of the Sun* (Figure 5.6) Knight's models are unclothed and, unmoved by breeze and atmosphere, are arranged on the rocks like statues in timeless compositions of two and three, the sea swirling below. If the real women of Newlyn were unsatisfactory as models, then certain London girls, like the ex-Tiller girl Dolly Snell, suited her ideals admirably and they posed day after day as she worked from life on her six-foot canvas. Her intention was to give as full an impression as possible of brilliant sunlight and this she achieved in the latter work by reversing her usual methods of painting sunlight, making the direct light almost colourless, with intense warmth and colour in the reflections from the rocks.[66] But her concerns now took her beyond mere impressions of sunlight and atmosphere and Knight could perceive classical lines in the forms of those she placed on the rocks around Lamorna Cove. One she likened to a 'Tanagra Greek statuette come to life. I could not take my eyes off her.'[67] As for Tuke, it was important that the model was a conceivably real figure – she should not be presented, as in George Wetherbee's *Circe*, shown at the Royal Academy in 1911, as the

5.6
Laura Knight,
*Daughters of the
Sun*, 1911

mythological demi-goddess luring men to their death on the rocks. Knight's female nudes, often in classicizing postures, simply contemplate the immensity of nature from rocky cliff-tops that form a *repoussoir*, leading the eye out to sea and the horizon. Like Arthur Symons, they 'are content to sit on the rocks … and watch a few feet of sea for an hour altogether … its recurrent and changing violence and stealthiness of approach … Form and colour changes at every instant'.[68] The experience, alternatively, of the long, steady view, of being able to see across vast distances, a watery panorama, contrasts with the real experience of the urban spectator whose view in daily life is constantly impeded, whose space is endlessly crowded. In this way the very act of looking at, as much as the actual content of the view in Cornwall, ran counter to modern life.

At the same time Knight's paintings are exactly about the experience of modern life. They belong in the aftermath of the 'New Woman' phenomenon, when the Physical Culture Movement was reshaping notions of femininity. As Gail Cunningham writes, after the turn of the century 'the feminist fervour of the nineties appears to have spread sufficiently widely into the popular consciousness to make potted versions of the New Woman's ideas a common part of a girl's youthful rebellion, a cheerful fling at old fashioned convention

before she settles down to become a thoroughly modern housewife'.[69] The New Woman had been subsumed into the prevailing modern spirit, an 'amused indulgence of modernity'.[70] Popular magazines for women were developing a familiar consensus on femininity, in which healthy outdoor activities, fitness, diet and a certain measure of independence played an important part.[71] Knight's modern woman was quite unlike the ideal of much contemporary portraiture, in many cases still operating on the level of nostalgic eighteenth-century revival notions of femininity, traditional gender stereotypes and long approved sexual relationships, all of which from Freud through to Havelock Ellis were being called into question.[72] Lawrence is of interest again here. One of his reasons, in 1913, when he declared that 'I don't like England very much', was because of the young women, 'they all seem such sensationalists, with half a desire to expose themselves. Good God, where is there a woman for a really decent earnest man to marry. They don't want husbands and marriage any more – only sensation.'[73]

In the context of all of this, the existence, or not, of a native hardy type of Cornish fisher-woman was irrelevant. These paintings were only really meaningful in terms of the perceptions of a modern urban middle-class womanhood – a potential market for Knight's pictures in London galleries. Female spectators could imagine themselves inside the spaces of her paintings. They themselves might be the sturdy heroines posing heroically on the rocks, perilously perched at the point where culture meets nature, literally at the edges of the island. They might take up similar positions themselves on holiday visits to Cornwall and perhaps even find themselves decorating a postcard for sale to other tourists (Figure 5.7).

Nature and fresh air were as morally and physically improving for women as for men. Sunbathing was as much a cult for women as it was for the Neo-Pagans, hence the title of Knight's *Daughters of the Sun*, and hence the character of her models. Recalling bathing with them in the deep pools and lying on the rocks in the sun, Knight expressed the same solarism that Joseph Kestner associates with Tuke's circle, 'How holy is the human body when bare of other than the sun.'[74] The classical postures of some of Knight's figures were at the same time being emulated by followers of Charles Wesley Emerson and his system of 'vital exercises' based on correspondences between inner and outer beauty. Emerson was drawn to Greek beliefs in the co-equal development of mind and body. 'The Greeks knew that God joins beauty and health in an indissoluble union … a unity – a oneness of expression of all parts of the body.'[75] Greek dancing lessons were also being given to young Cornish girls and Isadora Duncan's methods were being eulogized in women's journals – all of which connect to the professional concerns of Fergusson's partner, Margaret Morris. The appearance of contemporary handbooks of health for women at this time is also of interest.

The crucial 'outside-ness' of this broad culture helps account for the successful reception of Knight's pictures, described by Laurence Binyon as 'modern idylls' and possessing a 'graceful vigour'.[76] Knight's healthy young women embodied a prevailing modern spirit, a measure of youthful

F_43115. ST. IVES: CLODGY, FIVE POINTS.

5.7 Postcard from Cornwall, figure on the cliffs

independence, a zest for the physically and morally improving aspects of life, the sun, fresh air, etc. In these respects they were modern women, but they were also essentially safe and in the appropriate place – they had been 'subsumed into an amused indulgence of modernity'. Beyond that indulgence, however, Knight's models played an important role. They represented an acceptable modernity that might just be identified, falsely but reassuringly, with the real inhabitants of this remote corner of the island.

There are connections between the cultural meanings of Laura Knight's imagery and her methods of painting. For the most part she worked on the spot, as in *Daughters of the Sun*, often having struggled across slippery rocks with the six-foot canvas on her back. The local landowner cleared areas of the cove for her subjects and had a hut built for her on the cliffs, but apparently she preferred to work outside, whatever the conditions. The potency of her subjects and of her own handling was recorded by S. B. Mais, writing in the 1920s: 'Her facility and energy were overpowering, she placed her nude and lovely models in the open air, down on the rocks at Lamorna. She spread upon her enormous canvases white and yellow dollops of creamy sunshine with a palette knife.'[77] The conditions of production, the very handling itself and the quality of those dollops of paint all signify vibrancy and a reassuring physical well-being – a form of modernism that was very far from disconcerting.

In the context of an article on Harold and Laura Knight in 1912, Norman Garstin termed those Futurist and Post-Impressionist painters who wanted to destroy tradition, 'artistic nihilists'. 'The Prison House' he said, 'has been opened and small wonder that the prisoners should make first use of their

freedom to plunge into unlicensed orgies.' By contrast, the Knights' work, 'avoids all suspicion of abnormality. Sanity of outlook and lucidity of statement are the dominating factors of their work'.[78] This sanity could only be attained in a specifically constructed, suitably remote, timeless and healthy locality, recalling a classical paradise that could only, really, have existed in the minds of a beleaguered Edwardian middle class. For 'Cornwall', as John described it to John Quinn, was 'a most sympathetic country'.[79]

An ideal modernity: Spencer Gore at Letchworth

In 1912 the newly married Spencer Gore and his wife, Mollie Kerr, temporarily left London for Harold Gilman's house in Wilbury Road, Letchworth, to await the birth of their first child. In the few months he spent there Gore produced seventeen pictures, a significant body of work in terms of his own development, which reflect the cultural preoccupation with the city and the country and comprise a mediation of Englishness and modernity.

This chapter further explores the sense of opposition between Englishness as an ideal of cultural unity identified with the rural, and the negative perceptions of urban modernity as either a fragmented and chaotic experience or as an overly regulated and systematized one. In both perceptions, the foundations of a unified national identity are perceived to be at risk. However Letchworth as pictured by Spencer Gore appears, initially at least, as a place where both the romantic illusions of individual freedom and of collective progress could apparently co-exist and where the sharp divisions between town and country could be dissolved. In that sense the artist presents the possibility of what, in another context, has been described as 'an ideal modernity'.[1] There was, however, a significant cost and sacrifice attached to this process.

As previous chapters have shown, the period from the end of the century up to the Great War is often marked both by a resistance to European modernism or a struggle to reach an accommodation with what was commonly regarded by contemporary critics as threatening to the national tradition. Ways in which this accommodation took place around 1912 offered an apparent resolution to the polarities of Englishness and modernity but, at the same time, uncovered fundamentally conservative tendencies within modernism itself. My contention is that Gore's representations of the new Garden City of Letchworth, predicated on urban middle-class fantasies about the natural continuity and essential Englishness of rural life, successfully displaced anxieties about modernity and the urban, through the artist's own interpretation of current aesthetic theory and of the European paintings to be seen at London exhibitions. As Jack Wood Palmer declared, at this point: 'Gore was the first to seize on the new movements from France, to examine and assimilate them.'[2]

William Ratcliffe, fellow member of the Camden Town Group, first introduced his colleagues to Letchworth. He had moved there in 1906, three years after its foundation. Gilman and his own young family followed in 1909. Ratcliffe, Gilman and later Gore embraced Ebenezer Howard's wholesome new environment in the Hertfordshire countryside and in so doing affirmed that, although the spectacle of London was a powerful artistic stimulus, it was also the unhealthy, disease-ridden home to an enfeebled race. Statistics of 1912 proved the efficacy of the Garden City and revealed a significantly lower child mortality rate than in major cities in England. Letchworth was 'the healthiest English city' as Ebenezer Howard had promised, and life within it might 'become an abiding joy and delight'.[3] For resident accountant and historian C. B. Purdom: 'The new town, instead of draining the vitality of the race – may maintain it.'[4] His view was underpinned by class prejudice and that illusory belief in the sturdy vigour of the country-dweller, contrasted with the 'unkempt humanity' the 'massed and unheeded populations' of the labouring classes in their crowded metropolitan quarters.[5]

Howard's solution to the deteriorating inner-city conditions, building on widespread anti-urbanism and endemic rural nostalgia, first appeared in 1898. His proposal, traceable to William Morris's *News from Nowhere*, and to American 'city beautiful' plans, was intended to resolve the traditional town or country dilemma. The first Garden City, originally to be named 'Rurisville', would combine 'the most energetic and active town life, with all the beauty and delight of the country'. The resources of modern science would facilitate 'the spontaneous movement of the people from our crowded cities to the bosom of our kindly mother earth'. Areas like Camden Town would be transformed. 'Families, now compelled to huddle together in one room, will be able to rent five or six.' Wretched slums would be pulled down, their sites occupied by parks, recreation grounds and allotment gardens.[6]

Although Garden Cities were intended to provide good, working-class accommodation of a type proposed in endless *Studio* magazine competitions, Letchworth's initial reputation was as a perfect site for wealthy Londoners seeking inexpensive weekend cottages, their attention perhaps drawn by picturesque postcard sets like those produced by Frank Dean and William Ratcliffe.[7] More specifically, Letchworth was renowned, in its early days, as a centre for eccentric middle-class vegetarians and sandal-wearing potters and weavers, hence perhaps the low mortality rate. Unlike Port Sunlight, or indeed Robert Owen's New Lanark of the 1830s, Letchworth had no indigenous industrial base. The initial lack of industry, coupled with an emphasis on cottage crafts, encouraged the view that Letchworth was another Chipping Campden without the guiding spirit of C. R. Ashbee.[8] Many early inhabitants, Gore amongst them, were interested in Madame Blavatsky's theosophy, believing it could produce a utopian society of individuals united by some higher state of consciousness: 'a body of strong and joyous men – to preach and practise among the masses of the people a wholesome – emancipating – and a saner mode of living'.[9] While the ideology of social hygiene was implicit, this utopianism was essentially redemptive, conscience-

salving and hardly a catalyst for real change.[10] But by this date country life was being presented not simply as a recourse for the well-fed middle classes, it was being advocated as an essential state for a wider public.[11]

By the time he arrived in Letchworth, Gore had abandoned the loose, spontaneous handling of his Slade mentor, Philip Wilson Steer. The style and composition of Steer's late-1890s works were overhauled in the years after 1907 and Gore initially revealed the growing importance of Lucien Pissarro in his approach to the intimate, secure gardens and wooded countryside around his mother's home, Garth House at Hertingfordbury.[12] This contrasts, however, with the high-horizoned panoramas, the broad swathes of mature trees and field patterns which he produced at Applehayes in Devon on three occasions between 1909 and 1913.[13] That was a landscape without personal connotations for Gore but one which, though wide and unpeopled, was nevertheless accessible and, neatly hedged, on a human scale.

In *The Garden*, 1909 Gore came close to compositions by Monet, like *Path in Monet's Garden*, 1901–1902 and the technique of the Pissarros, all committed garden painters.[14] Here, cultivated flower-beds, the intimate natural view-point, and brightly coloured shadows create a harmonious and controlled atmosphere, and the sun-dappled, well-tended, narrow footpath suggests a human presence without the use of figures. The sense of real distance is suppressed by the rising footpath that flattens the picture plane, drawing the spectator into the scene. Nature allows for a solitary contemplation, but it is a regulated and structured experience. It was inevitable that the garden should become a favoured subject for Gore in the Garden City.

A garden was also a safe subject commercially in this era and a staple ingredient of gallery stock and exhibitions. Gore's own garden paintings were described by Jack Wood Palmer in the mid-1950s as 'among the most exquisite evocations of the Edwardian era'.[15] In works like *The Garden, Garth House* (Figure 6.1) the artist had demonstrated his skill at suppressing conflict, a talent which led to his role in so many of the pre-war groups and exhibiting societies. Tensions and insecurities, the reality of that era and of his own family circumstances, have been typically and successfully concealed.[16] A comparison here with certain pictures by Camille Pissarro, like *Kew Gardens* of 1892, is interesting; the arrangement of the canvas, the repeated lines of the formally laid-out gardens suggest an idea of nature as pure, tame and unintimidating. The London park, like Gore's mother's garden, resists the chaos of modernity. Something of the same quality occurs throughout Gore's practice as a painter, accounting for his appeal as an individual, his personal history and motivations, and his success as an artist.[17]

Gardens have been perceived as sites halfway between the unplanned wilderness and the man-made world of the city – the best of all worlds, they balance human organization and the unexpected delight of nature. As MacCannell puts it, the garden fills a space between the opposites of nature and culture, where conflict and anxiety might be wished away.[18] A middle-class passion for garden design reached a high point during the Edwardian era, and was supported by articles in numerous journals like *The Studio*

6.1
Spencer Gore,
*The Garden, Garth
House*, 1908

where it was argued that: 'almost every little suburban villa, in its tiny front plot, shows the desire to bring nature into a pattern'.[19] The significance of suburban and modest country gardens developed as the complexities of urban life seemed increasingly threatening to the preservation of bourgeois individualism. Although they can be seen as 'representations of nature – purified and refined – enjoyed passively – without exertion', gardens also demonstrate a need to achieve autonomy and a control less attainable in urban centres.[20] This was their significance for Garden City planners and also, I would argue, for Gore.

After 1910, however, Gore was increasingly preoccupied with the art of Cézanne, which he thought possessed a 'wonderful gravity'.[21] His paintings of Letchworth were therefore to concentrate on formal, structural relationships and simplified planes and outlines, rather than a field of unmodulated colour. The shift registers that movement in avant-garde circles from the late 1890s away from the perceived, dispassionate superficiality of Monet, towards the meditative, empathetic contemplation of the essential spirit of a scene. By 1912, Gore was often in attendance at T. E. Hulme's weekly gatherings at Frith Street, where enthusiasm for Bergson was rife. Hulme, at this point,

was still impressed by Bergson's insistence on the rhythmic flux and vital energies underlying material existence. Underpinning this notion is what has been described as the 'romantic evolutionism' supporting Frederick Goodyear's assertion in the first edition of *Rhythm*, that the ideal society, formerly distanced either historically, geographically or metaphysically, was now about to be realized. Thanks to Bergson, utopia had turned up on the very doorstep: 'Thelema, the soul's ideal home, has become a plain practical issue;' it lies simply in the 'ordinary human future'.[22]

Much of this echoes the sentiments of the Blavatsky followers at Letchworth. The sense of this trajectory is equally evident in Gore's desire, in 1910, to reconcile both the decorative and the naturalistic elements in his art and to produce an imaginative transformation of existing nature. The artist is no longer simply a passive recorder of outer appearances. Modernism shapes and reorganizes. In his enthusiastic response to the Cézannes, Gauguins and Van Goghs at Fry's first Post-Impressionist exhibition, Gore wrote:

The attempt to separate the decorative side of painting from the naturalistic seems to me a mistake … Simplification of nature necessitates an exact knowledge of the complications of the forms simplified. This may be done to produce a greater truth to nature as well as for decorative effect … Gauguin gives his idea of Tahiti just as Goya gives his of Spain … If the emotional significance which lies in things can be expressed in painting, the way to it must lie through the outward character of the object painted.[23]

Gore in fact echoes Desmond MacCarthy's position in the introduction to the first Grafton Post-Impressionist show – that the artist must aim at synthesis in design: 'that is to say that he is prepared to subordinate consciously his power of representing the parts of his picture as plausibly as possible, to the expressiveness of his whole design'.[24]

By this stage, acutely aware of the potential of modern French painting, Gore would probably have empathized with Matisse's reference to composition as 'the art of arranging in a decorative manner the various elements at the painter's disposal for the expression of his feelings'.[25] The idea that the wholeness of a picture was essentially the by-product of design, led Gore to stand back from what he was doing and to attempt to see a given subject in its entirety.[26] Unstable light effects, causing movement of tone in local colour, were now to be generalized within a heightened consciousness of the marquetry of shapes. Increasingly the picture plane was emphasized, objects treated in a slab-like way and clumps of foliage left without surface modulation. This pace of development quickened in August 1912, by which time Gore had been encouraged towards a greater flattening of planes and non-naturalistic colour by the moderate *Rhythm*-favoured followers of Cézanne, artists like André Lhote, Othon Friesz, Derain and Herbin.[27]

In *Letchworth, The Road* (Plate XII) Gore demonstrated the effects of aesthetic ideals such as these. Characteristically, the viewpoint is down onto a broad sweep of landscape. Red-roofed and tall-chimneyed houses nestle behind the hedges to the right of the canvas, counterbalanced by a tall tree on the far left. The diagonal stripe of the footpath recedes into the

6.2
Spencer Gore,
*Letchworth, The
Road*, 1912

distance, its direction taken up by the ploughed fields in the background. Land and sky are equally divided. Overall recession on the ground is balanced by the pale pinks and greens of the blocky clouds above; the effect brings the eye back to the front of the picture plane. Spatial depth is further reduced by implying undulations in the landscape which are not actually there. It is as if the painter's eye levitates above the landscape in order to find an aerial viewpoint. Smoother surfaces and a dynamic, rhythmic organization of forms help to achieve compositional equilibrium. Basic forms are found in nature, then abstracted or emphasized according to the desired expression, in this case of a harmonious and regulated natural environment.

In this way Gore's paintings, like many contemporary travel posters, 'give, by means of flat colours and outlines, something of the joy of sunny country lanes, red tiled roofs and bright skies, using colour and tone values quite

arbitrarily'.[28] The designs of individuals like Walter Spradbery and F. Gregory Brown were commissioned by London Transport, who were keen to impress on city dwellers the benefits of healthy sunlight and fresh air. While their posters were consciously more explicit than Gore's paintings, both cast in visual terms the new relationship of the middle classes towards the countryside in which it appeared to be what it signally was not, free from conflict and complexity. The process of sub-urbanization, whereby rural areas were effectively colonized, could now, having found pictorial expression, become legitimized within Edwardian bourgeois ideology.

Although he stalked the periphery of Letchworth, Gore was acutely conscious that this was a 'garden' city. He was already a painter of gardens and in this case individual cottage gardens were subject to the idea of Letchworth in its totality. An early Letchworth planning directive bound tenants to keep their gardens in good condition. 'A garden', it was believed, 'is irresistible to the man of wholesome mind (the complete citizen). He cannot suffer it to fall into neglect.'[29] Such idealism was rewarded by the Howard Cottage Society prize of a week rent-free for the best garden on each estate. The garden's value lay not only in the expression of middle-class individualism, but in terms of a wider mechanism of social control. Gardening conflated conventional aspects of Englishness with modern social organization and collectivism. At this moment, the two were not antagonistic and seemed mutually compatible.

Planned like a traditional village, with greens and cul de sacs, Letchworth had little urban character. Such planning resonates with contemporary preconceptions about the countryside, which inevitably came into conflict with the very idea of the 'new' at Letchworth. Unwin wanted a design that would retain the 'outward expression of an orderly community of people ... undoubtedly given in an old English village'.[30] This emphasis, also a strong feature of Gore's imagery, contrasted with perceptions of disorder in the city which, in his depiction of London parks and backyard gardens, the painter had consistently managed to avoid. Like others, Unwin fantasized about earlier times when 'clearly defined classes [were] held together by a common religion or common patriotism'. Similarly, in 1901, Masterman had spoken of an erstwhile 'England of reserved, silent men, dispersed in small towns, villages and country homes'.[31] Implicit once more is that notion of order in historical Englishness, of organic hierarchies of quiet, well-behaved men and women. But order is also a defining characteristic of modernism. To quote again from Purdom:

The idea of a complete and perfect city, despite its irreproachable sanitation, freedom from slums, and splendid regularity, was not altogether attractive to many reflective minds. Its formality, order and completeness, its fearful up to dateness were, however desirable in theory, more than a little repellent in prospect – men would not consent to live under the perfect conditions ... Would Mr Howard himself enjoy his Garden City, any more than Mr Wells could be expected to be satisfied with his Utopia? The ideal cities are good in books, but none but mad men and dull persons would ever inhabit them.[32]

6.3 Photograph
of Letchworth Order needed to be attained almost surreptitiously, so that modernity and
progress could be achieved without sacrificing traditions of Englishness
(Figure 6.3).

 Borrowing the term used by Alex Potts, it is possible also to regard the pre-
war Garden City and Gore's representations as groping towards an 'ideal
modernity'. Letchworth, as a perfectly ordered new city set down in nature in
the rolling English countryside, might be a forerunner in Potts's account of the
inter-war period's optimistic ruralism, to the 'ideal image of what a modern
Britain emerging from the unsightly ravages of Victorianism might become'.[33]
Stephen Daniels extended Potts's argument in relation to his own discussion
of A. L. Parkington's inter-war 'homes for heroes', with their aesthetic of 'clear
order and truth to materials'. For Daniels this aesthetic signified what Potts
had termed 'ideas of order and health appropriate to a rationally modernised
society – both new and organically related to the past at the same time'.[34]

 If we look at Gore's depiction of Gilman's house (Figure 6.4) in Wilbury
Road, we see a building which, while a vernacular cottage type, is also as
simply formed and clean-lined, or as modern, as Gore's style of painting. A
lack of unnecessary detail and even the use of new materials already defined
the building style at Letchworth from around 1905, when one of the cheap
cottage designs was of pre-cast concrete. Stephen Daniels reproduces a line
drawing of Willy Lott's newly restored cottage in the 1920s.[35] It looks
remarkably like Gilman's house, painted by Gore in 1912, with tall sunflowers
outside, signifying the new and the old, health and light at the same time. In
other words, what is conventionally interpreted as formal and aesthetic
progress is, on another level, almost completely subsumed within a quite
different social and cultural rhetoric.

 Most of Gore's Letchworth pictures are not of the town itself but of its
margins on the edge of the countryside, corresponding with Howard's stress

6.4
Spencer Gore,
*Harold Gilman's
House,
Letchworth,* 1912

that 'the free gifts of nature … fresh air, sunlight [and] breathing room … shall be retained in all needed abundance'. For Purdom this was fundamental: 'In all the modern utopias town and country are pictured as being in happy relation.' At this period, Letchworth was spreading rapidly over that surrounding countryside, but the village concept was uppermost in Garden City propaganda, creating an archetype modelled, for instance, on the sentimental perceptions of G. M. Trevelyan: where 'the darkest lane was never a mile from the orchards around the town'.[36] Gore's paintings reveal the same double standards, emphasizing ultimately that romantic ideal over a planned twentieth-century solution to inner-city problems. It is notable too that in the huge debate that Garden Cities generated, there was little comment on their effect on existing rural communities, then in serious decline. Just as Gore's landscape paintings ignore the agricultural worker, so Letchworth was developed primarily from the perspective of sections of city populations, largely ignoring rural experience. Although the original plan was that two thirds of the acreage of Letchworth be divided into allotments and small farms, this scheme was soon curtailed.

6.5
Spencer Gore,
The Beanfield,
1912

The formal elements of *The Beanfield* (Figure 6.5) are organized into stripes and bands of intense colour, all drawn from the natural scene but separated and reformed in interlocking patterns across the canvas.[37] None of these Letchworth pictures were completed in front of the motif, though in few cases did Gore significantly alter the physical reality of the landscape. At all times the artist was preoccupied with striking the balance between naturalism and the decorative. The object of all the great imaginative painters, he wrote, was 'to reconcile their ideas with the things they saw'.[38] His approach was similar to that of the architects of the new town itself. Unwin remarked: 'We tried to combine a certain amount of formality in the lines of the plan with a great deal of regard for the natural features of the site, which is undulating and wooded.' Gore similarly grouped and composed the elements as they existed out there and, contrary to the more descriptive panoramic views of Applehayes, allowed a new awareness of what Kandinsky termed the spiritual significance of form and colour to strengthen his powers of expression.

On the horizon of *The Beanfield* we see the tall chimneys of the brickworks at Baldock. They are patently out there in the scene the painter chose to paint, defining the horizon compositionally. They also point to a co-existence between the timeless world of nature, the flourishing bean crop and a modern world of industry.[39] Both elements, the brickworks and the landscape, are

unified in Gore's rhythmic interplay of brightly coloured forms, underscoring Howard's conviction that Letchworth would produce a 'happy unity of art, science and nature' and reconfirming a Wellsian notion of the modern utopia. Significant here is the fact that this is a happy unity without the presence of any figures. Gore was attempting a rendering of the three-dimensional forms found in nature onto a two-dimensional surface, in such a way that the integrity of the picture surface and the initial individual response to the natural scene cohere. Hence the rhythmical distribution of blocky forms and the expressive use of intense colour.

Typically for Gore, a number of the Letchworth pictures base their composition on roads and footpaths, often of the path from Works Road that wound its way from the new town towards nearby Baldock. Roads and pathways were always attractive to Gore because of their ordering effect: they 'suggest' a human presence and they provide both a formal and a psychological stability. For Purdom, footpaths across the common and rural belt were vital to the Garden City: 'The invitation of the open road, of the little path across the fields, is always there for those who live in the new town.'[40]

As Letchworth was deliberately designed to preserve natural and historical features, the central square and roads were planned to allow views like that of the ancient Icknield Way, just north of the railway station. In 1911 Edward Thomas had made a journey along the walkway, which he described in 1913. This pre-Roman route, on which Boadicea and the Iceni rode from battle, was originally a broad green strip following a watershed between rivers. As time passed and villages multiplied, the land that the footpath covered was gradually enclosed, causing much speculation as to the original path. Gore was perhaps particularly absorbed by the historical reality of the forms and structures which he knew lay beneath the surface of this pathway on the outskirts of Letchworth. He used *The Icknield Way* (Figure 6.6) as the site for a picture that was clearly a turning point in his career, when he came closest to the Cubo-Futurist forms of Lewis and Bomberg. In his treatment and in the very nature of his subject, a correspondence between ancient landscapes and concepts of the modern is emphasized.

It is quite in character that Gore could produce a series of paintings based around a Garden City which hardly ever included the figure as a focus of interest, and my argument is that this absence accounts considerably for their success with contemporaries. The remoteness of the figures in the earlier *Garden, Garth House* is instructive here. These are not real individuals; their distance prevents recognition and crucially maintains the artist's control. An affinity between people and nature can only be achieved through distancing and integration into a highly structured composition. Here the sweeping footpath provides both formal and metaphorical stability.

Gore's garden-scapes, marked either by the absence of figures or of interaction between them, are concerned above all with people and their problematic relations. In one of the few instances in which a figure is brought closer to the foreground of the picture, *Sunset, Letchworth with Man and Dog*

6.6
Spencer Gore,
The Icknield Way,
1912

(Figure 6.7), the 'happy unity' of a modernist handling and an ideal modernity is jeopardized. Here the solitary grey figure, trudging the footpath, is out of place against the background sunset and the deep foliage. Far from being a natural accessory to a vibrant, dynamic environment, this is an isolated, suburban man walking his dog off the lead, strangely disassociated from all around him, unable to adapt properly to the overall design. He seems to stand rather for the conventionally alienated result of urban anomie and he illustrates the extent to which the inclusion of the figure disrupts the pure integrity of the modernist landscape. Was the effect of this representation intentional? Are we to assume a degree of social critique here on the part of the artist, as Charles Harrison has suggested in his description of the trudging peasant in Camille Pissarro's *Hoar Frost*?[41] It would seem unlikely in this instance, and in terms of brushwork and handling the figure is quite consistent with his surroundings. It was simply impossible to introduce into such a scene a figure who is neither an appreciative spectator nor engaged in any symbolic, though safely distanced rural (or semi-rural) activity. The grey man is both compliant and awkward and he can never, given the formal

6.7
Spencer Gore,
Sunset,
Letchworth with
Man and Dog,
1912

qualities of such a work, emerge as a distinct individual with either a 'felt life' or a grudge to bear. He is effectively tidied away. The conservative effects of this type of modernist handling equate in interesting ways with the broader experience of modernity and with the eventual results of the interaction between town and country during this period.

Although utopian town-planners might have envisaged cooperative, organized societies arising from their schemes, what often resulted was the isolation of individuals removed from urban communities that were not always as alienating as middle-class critics depicted them. It has been observed that the social classes at Letchworth simply did not mix; 'social disharmonies would not disappear by offering the working classes scaled down versions of middle-class communities.'[42] Somewhat ironically, the effect of Gore's predisposition to avoid painting the interactions between people resulted in representations of exactly those disconnected, lone figures. His are just the 'reserved', 'silent' and 'dispersed' men Masterman had idealized – men unlikely to cause any disturbance. The modern landscape could only ever be an ideal landscape once it had been pictorially and metaphorically emptied out; only then could order, harmony and control be attained.

6.8
Spencer Gore,
*Letchworth
Station*, 1912

Letchworth Station (Figure 6.8) which was included in the second Post-Impressionist exhibition, is possibly Gore's only Garden City painting to deal with a subject based on the town itself and to involve a number of people. Gore's station, a temporary structure replaced the following year, is far from threatening to the green countryside, as one contemporary critic assumed:

> It is about the last subject that any artist with the old fashioned sense of the 'picturesque' would have chosen for representation. But this is far more than a representation of uninviting facts. It may or may not be a 'portrait' of Letchworth railway station. What it suggests is the silent protest of a lover of the green countryside against the intrusion of unbending iron and black smoke. An almost cruel stress is laid on all that is hard and stiff and graceless, dingy and unpleasant in and around a railway station; everything is concentrated on that 'spiritual significance' that has entered so largely into the jargon of Post-Impressionist criticism.[43]

Konody's interpretation says more about his own prejudices than it does about Gore's, but also demonstrates the tensions between progress and preservation implicit in all representations of the English countryside.[44] Gore's

Letchworth Station is in no sense an image of grimy unpleasantness. A contemporary photograph reveals the extent to which the artist made slight compositional changes, with the result that the temporary wooden station appears in greater harmony with the surrounding countryside and signs of development, like the new housing to one side of the left-hand platform, are conveniently out of view. Set amidst open fields under clear blue skies Gore's station and its waiting passengers are a model of tidy respectability. Preliminary drawings squared up for transfer also show that those passengers were a later addition.[45] When they appear in the final painting, they are disconnected from each other, ordered rather than vital. If the railway was a symbol of progress, of the developing unity between large cities and the outlying countryside, then the painter here presents us with an ideal vision of a new, civilized, neatly functioning and untroubled England, that was essentially middle-class and of which any corporate designer would have been proud.

The painting of another Camden Town Group member, Malcolm Drummond – *In the Park (St James' Park)* 1912 – might be seen as an English urban response to Seurat's *A Sunday Afternoon on the Island of La Grande Jatte*, 1884–1886, and to an extent Gore's is a semi-rural version. As Charles Harrison has pointed out in relation to Seurat, the visual unification of a painting style which is both highly figurative and highly coloured, results in the 'petrification' of the figures. Harrison's argument, relevant here, is that the 'technical interests of modernism may be reconciled with the appearances of social life, but only to the extent that one or other is allowed to be inhuman'. As he continues, such a problem is not likely to occur in a pure landscape, 'where the absence of human animation goes unnoticed and where the sense of stillness generated by the assiduous technique appears appropriate and highly expressive'.[46] In another instance the anonymity and the seeming isolation of Seurat's figures have also been related to the anonymity of life in a modern city or suburb, where 'human beings remain … without reference, as faceless as the factory and suburban landscapes they have created, and must inhabit'.[47]

Gore's own motivations, that celebrated diplomacy or, more specifically, the drive to suppress any kind of genuine conflict, significantly influenced his reactions to his subject. These factors, allied with his class position and the effects of shared cultural and political experience – anxieties about inner-city disorder and the breakdown of established order – fundamentally helped to shape his representations. Assimilation of modernist forms of art ultimately, here, exemplified a kind of cultural conservatism and supported a wider reluctance to address certain social realities. For instance, privileging the imagination and/or formal innovation made it possible to avoid nagging details like actual individuals. The artist's disingenuous manner of suppressing, avoiding or denying conflict, while successfully forging an 'ideal modernity', resonated strongly with both the broader programmes of modernism, and at the same time with contemporary social and political anxieties and agendas.

Those broader programmes which necessitated the steady colonization of the country from the city, whether by the urban middle classes, artists, back-

to-the-landers, country-retreaters, week-day commuters or suburbanites, all resulted in processes of denial, purification and the displacement of native, rural populations observable in much painting throughout this period. On-going developments in economic and political spheres were therefore successfully shaped into cultural and aesthetic expression, as Gore's paintings demonstrate. These Letchworth pictures were, for Gore, a perfect site upon which to construct imaginative solutions to the problems of modern city life. As such, the concept of the rural as fundamentally empty of its existing inhabitants is crucial, for only then could representations like these be effective for their urban audiences.

Dwellers in the innermost: mystery and vision

The period from 1910 to the outbreak of war has frequently been described in terms of artistic and cultural synchronicity, a sustained revolt against standards of civilized good taste, conservatism and tradition. With the benefit of hindsight, Robert Ross described an initially 'united front of reaction against the dead hand of Academicism amongst all the arts'.[1] But this revolution was short-lived, common ground was soon lost and the movement towards modernism took divergent paths. We have seen in previous chapters how the image of the English landscape was remade in the Edwardian era, that the initial search for its elemental forces in Steer led to a dramatic reshaping along modernist lines in Gore. We have seen the English peasant, the landscape's inhabitant, at first invested with mythic qualities in Clausen and Stott, then physically and racially transformed by John and by those painters working along the Cornish coast. In the present chapter, these considerations take a new form. The landscape adopts a mystical, spiritual force in which it is contained and intensified, and in which its mythic inhabitants are given meaning derived from ancient, mystical, often religious sources.

When Ross spoke of a divergent modernism he referred explicitly to the schism which took place in literature, but there are interesting parallels to be drawn between painters like Mark Gertler and Spencer and the poets of the Georgian Circle.[2] John Masefield, John Drinkwater and W. H. Davies were first regarded, by supporters and critics alike, as bold, uncompromising literary experimentalists, reacting against the extravagantly poetic language of the 'Blah Blah School of Verse' of Tennyson, and the maudlin nostalgia of the Poet Laureate, Alfred Austin.[3] By contrast the Georgians were assumed to have abandoned self-indulgent melancholy and were forging a new, direct and modern poetic renaissance. The difference, as Ross had it, was between 'old men dreaming dreams and young men seeing visions'.[4] A positive content rather than false sentiments is implied here for, as Edward Thomas commented on publication of the first Georgian anthology in 1912: 'It brings out with great cleverness many sides of the modern love of the simple and the primitive, as seen in children, peasants, savages, early man, animals and Nature in general.'[5] This 'modern love' is clearly a love

expressed by those urban sophisticates who saw themselves as definitely not simple, not primitive.

The writings of Binyon have a special importance here.[6] As we have seen, as an early and consistent supporter of Augustus John, he had now dismissed the 'picnic landscapes' of the New English Art Club, arguing that they were 'too much a covered surface', too engaged in a search for 'sensations of well being' and realistic imitation.[7] 'How long', he asked, 'have we been sitting down before Nature and letting her impose herself upon us? Our imaginations have been schooled into passivity.' By contrast, in his studies of Chinese and Japanese painting he had discovered a 'refreshing abstinence from our materialism and mental voracity', a rendering of the dynamic forces of life and energy through simplified forms and linear rhythms. Binyon sought in contemporary art the spiritual and emotional qualities he had discerned in those ink paintings and was ill-disposed to Impressionism, a purely scientific and objective practice. The business of the landscape painter was not mimesis of its surfaces or of the fleeting effects of nature, 'purveying correct information', but was rather a meditation on those dynamic forces behind superficial appearances.[8] 'We crave', he wrote, 'for an art which shall be more profound, more intense, more charged with essential spirit, more direct a communication between mind and mind'.[9]

Binyon, like other writers before him, pinpointed in Western art generally a tendency towards the transcription of mere fact, the 'constant endeavour to realize the material significance of objects'.[10] In Oriental art, linear outlines were 'so charged with life that they suggest, as no other art has done, rhythms of movement and forms so buoyant and dematerialized as to come close to the utmost limits of what visual art can do to evoke spirit'. Notable exceptions in European art were the Italian Primitives and William Blake, whose instinct for line Binyon praised. In none of these cases was energy expended on material representation, which would have hampered the original impulse, obliging a filling up of all the spaces in a composition. Space, in his view, had a positive value, it was 'an outlet to infinity'. The artist should aim for a more direct expression, '[we should] toil less with our fingers and concentrate more in our minds'.[11] Conscientious, freezing labour, he saw simply as a kind of worldliness. The point was not to mimic the real world, but to establish another one, quite independently, with its own order and unity. As Roger Fry also argued, this was to be a world related not to an actual, but to an imaginative life.[12] To abandon illusionistic space, as was the case in Primitive and Oriental art, was a crucial step in that direction. It might be argued that a by-product of these aesthetic theories – prioritizing boldness, rhythm and non-illusionistic space – gave an added impetus to representations of the rural which were nothing to do with reality, but which existed entirely in the imaginative lives of their creators.

Assertions of a surviving and innately English visionary tradition linking back through the Pre-Raphaelites – also conscious distorters of space – to Samuel Palmer and to Blake were especially significant.[13] While unconcerned with native traditions, Roger Fry perceived a quality in Blake that was also

7.1
Stanley Spencer,
Nativity, 1912

essential in terms of his own account of modernism. All art, he argued, gives an experience freed from actual life, but Blake's art is more concentrated than most, he creates an experience with 'the purity, the intensity, and the abstraction of a dream'.[14] The pastoral idylls of Samuel Palmer are equally important. As Samuel Smiles showed, Palmer eschewed naturalism in order to express a more visionary experience of an innocent, God-given and 'unblemished' nature that could only be glimpsed once worldly, superficial appearances were abandoned, or at least disrupted. In *The Valley Thick with Corn*, 1825, conventional space is rejected, scale distorted and the eye continually distracted by discrete areas of intense detail. Coherence and unity are therefore established within the totality of the image itself, comparable to the subject of the work – a golden age, a complete idyll.[15]

With these ingredients an alternative account of modern art could be told. It was not so much that it connected to the tropes of Englishness, or that it was explicitly anti-French, but that it brought the significance of the artist's vision to the forefront. As with the Georgian poets, the rhetoric of primitivism pervaded the discussions of Slade school 'Neo-Primitive' painters from 1911 like Spencer, Allinson, Rosenberg and Gertler.[16] They shared Binyon's aversion to Impressionism, renouncing all desire simply to render the fleeting moment. So Spencer's *Nativity* (Figure 7.1) and Isaac Rosenberg's *Sacred Love*, 1911–1912 struggled for an intensity of vision through non-naturalistic colour, un-conventional handling of space and scale and the decorative quality of Gauguin, Puvis de Chavannes, the naive simplicity of Piero della Francesca and Giotto,

Blake's drawings and elements of Pre-Raphaelitism.[17] Like the Neo-Primitives, Binyon approved Post-Impressionism's insistence on the qualities of rhythmic design.[18] But beyond this he was doubtful, finding closer sympathy with the views of an artist whose work he approved, Charles Ricketts.[19] Both were engaged, to varying degrees, in constructing an acceptable hierarchy of influences which ultimately had the effect of playing down the significance of modern French art on English artists.[20] Ricketts was especially antagonistic to Fry's first Post-Impressionist show, believing that, with the exception of Maurice Denis, their fundamental concern was with novelty – a valueless and anarchic preoccupation.[21] Like Binyon, Ricketts also preferred the Japanese painting and sculpture to be seen at the Anglo-Japanese Exhibition, where he discovered a far greater rhythmic sense and a conscious will for design than in any of the artists being promoted by Fry and Clive Bell.[22]

Alongside these shared predilections, Binyon and Ricketts were both anxious to distinguish between the character and artistic tendencies of the French and the English. The English were slower to grasp formal innovations and yet they possessed a greater imaginative force: 'It is on the imaginative side that English painting ought to excel, if ever our race finds as free pictorial expression as it has found poetic expression for its deepest thoughts and emotions.'[23] Although the Post-Impressionists were, he acknowledged, in pursuit of those very same qualities, ultimately they failed, for instead of the 'recovery of profound and strenuous moods' they produced what was little more than childish rubbish and an ideal was 'corrupted into a formula'. None of the artists seemed able enough to carry out their programme. Van Gogh may have been a colourist with a strong, personal way of seeing things but, referring to *Bles d'Or*, Binyon wrote, 'think what Blake would have made of such a vision of the waving corn'.[24] While Gauguin's paintings had sinister, exotic and bizarre qualities, revealing a gift for 'strange and sullen colour', and demonstrating hints of primitive grandeur through simplified forms, fundamentally there was more 'struggle than mastery' and the artist 'couldn't hold a candle to Mr John'.[25]

It was crucial to Binyon that young English painters should not jeopardize their own native characteristics – their 'Englishness' – by emulating the art of another race. Here he narrowed the terms of reference, English artists were 'a bucolic crew', sailing a 'drowsy barge on semi-stagnant water, unaware of the grand commotion on the wide seas of living art', and this was a good thing. Any real engagement with European modernism was unthinkable.[26] A national tradition was crucial but, and here lies Binyon's own critical significance, this tradition needed to be constantly reformed in the context of changing times: 'We cannot discard the past; we cannot throw away our heritage, but we must remould it in the force of our necessities, we must make it new and make it our own.'[27] Complete abstraction was therefore not an option and innate, racial instincts should be preserved and reinvigorated – not simply rejected. It was this, plus his insistence on the continued importance of subject and emotional appeal in art, that distinguished his criticism from that of Fry and Clive Bell.

It is significant that the Slade students' taste for and knowledge of the Italian Primitives should have been derived partly through the writings of John Ruskin. Stanley Spencer's reading of Ruskin's *Giotto and His Works at Padua* (1853–1860), has frequently been cited.[28] In places the critic's language would have appealed to both Fry and Binyon. For Ruskin:

> [the early Italians] never show the slightest attempt at imitative realization, [their pictures] are simple suggestions of ideas, claiming no regard except for the inherent value of the thoughts. There is no filling in of the background with variety of scenery ... the whole power of the picture is rested on the three simple essentials of painting, pure Colour, noble Form, noble Thought.[29]

Ruskin believed that Italian painting could redress the disproportionate influence of the Dutch masters, replacing their materialistic culture with the religious symbolism and imaginative power of the *quattrocento*. Italian painting contrasted with the 'feverish and feeble' sentiment of his own period. The masters of the fourteenth century produced 'simple scenes filled with prophetic power and mystery'. Most importantly in terms of the creation of traditions, Ruskin traced a clear trajectory between the art of Giotto and his followers, and the Pre-Raphaelite movement in this country.[30] The French could not equal this trajectory. Its force, acting through modern British painting, was clear. For a critic like Robert Ross in 1910, modern French artists were racially incapable of understanding the true significance of Primitive painting: 'The French are too progressive, too curious for new experiments ever to succeed in the archaistic rehandling of archaic formulas. M. Denis ... illustrates the impossibility of a Frenchman assimilating the sentiment of the Primitives.'[31]

Binyon emphasized the links between Botticelli and the Pre-Raphaelite tradition, praising an artist who was 'never quite one of the modern movement, yet never quite able or willing to turn his back on it'.[32] He, like Ricketts, would have dismissed Fry's attempts to prove the French Post-Impressionists' links to tradition, alongside his claim that in rejecting the pictorial conventions of the Renaissance they were 'the true Pre-Raphaelites'.[33] For Binyon, as for Spencer and Paul Nash, the value of the Pre-Raphaelite tradition went far beyond formal considerations and lay in its poetic evocation of subject and in the sense that their works conveyed a complete, controlled and self-contained world. In early paintings by Spencer, like *Zacharias and Elizabeth* (Figure 7.2), early Italian sources, plus what has been seen as the Pre-Raphaelite tendency to enact religious events in the English countryside, or in what, by the turn of the century, remained of village England, are plainly in evidence. In the 1930s the artist commented that in this picture he had wished to 'absorb and finally to express the atmosphere and meaning the place had for me ... it was to be a painting characterizing and exactly expressing the life I was, at that time living and seeing about me'.[34] Cookham, for Spencer, was very nearly paradise; it was the new Jerusalem: 'It struck me that it only needed a very little changing in one's ordinary surroundings to at once reveal the more magnificent and beautiful way of life as is suggested in St Luke.'[35] Just as the composition of Samuel Palmer's images of Shoreham are constructed so as to prevent any

7.2
Stanley Spencer,
Zacharias and
Elizabeth, 1912,
private collection

easy assimilation, through crowded detail and cramped spaces that offer no
simple passage to the spectator's eye, so Spencer produces an enclosed and
claustrophobic space, where conventional space is confused and confounded
by the curving 'bath-tub' wall that divides the composition in two parts. This
is a world that is strangely unlike our own, a world that is distinctly 'other',
but which surrounds us and draws us in – as it does the small child peeping
over the wall, straining to see the vision of Zacharias making his sacrifice. The
contrast between Spencer's work and the bird's eye, 'august site', panoramic
topographies of Steer is intense. The spectator is drawn instead into an enclosed
and secure fantasy of the imagination – a complete idyll.[36]

Immediately before the Great War, overshadowed in hindsight by Fry's
Post-Impressionist shows, were a series of equally powerful exhibitions

charting the Binyon path to modernism. Pre-Raphaelite painters were shown at the Tate Gallery in 1911–1912. William Blake was exhibited in 1913 and there were shows at the Royal Academy of Botticelli, Mantegna and Giorgione in 1908, 1910 and 1912.[37] While in the same period, elements of Pre-Raphaelitism were still in evidence in works by respected artists like Charles Gere, Reginald Frampton and J. M. Strudwick, its wider renaissance could be perceived, as in a review of Percy Bate's study in 1900, as a possible reaction against the 'extravagances of impressionism', again, by implication, supporting racial distinctions.[38] Isaac Rosenberg, in his notes for an article on the Tate Pre-Raphaelite exhibition, praised those artists' 'ingenuity of imagination'. Singling out Rossetti's pen-and-ink drawings for Tennyson and early Millais paintings like *Mariana at the Moated Grange*, 1851, Rosenberg described the richness and daring of the Pre-Raphaelites, and the fact that, unlike the French Impressionist painters: 'They imagined nature, they designed nature … we are projected into an absolutely new atmosphere that is real in its unreality.'[39]

Paul Nash underlined what was perceived to be a more subjective English approach in a letter to his friend, the poet Gordon Bottomley, 'I turned to landscape, not for the landscape's sake, but for "the things behind" the dweller in the innermost: whose light shines through sometimes.'[40] The inclusion of the figure was almost a prerequisite for his poetic form of representation at this stage. Occasionally he attempted to invest the same enigmatic qualities in his pictures simply through his depiction of trees with their own special 'treeness', as for example in *Wittenham Clumps* (Plate XIII), or with flights of suddenly unnerved birds, as in *Under the Hill* (Figure 7.3), but in several works like *Barbara in the Garden*, 1911 Rossetti-type figures were required in order to heighten the mysterious sense of place. C. H. Collins Baker's review of his exhibition at the Carfax Gallery in the winter of 1912 observed the artist's dilemma:

Mr Nash at present is occupied with the pattern material of Nature; he has not yet got into touch with the life and character of trees. They give him clues and motifs, material for spacing and silhouettes. In time he probably will have converted this very proper preoccupation into instinctive knowledge, and have gone on to the meaning within the shapes and patterns.[41]

Similarly, although Spencer painted the occasional pure landscape, like *A View of Cookham*, 1914, most often his images contained the figure.[42] Insistence on a uniquely human, subjective relationship to the natural world is crucial and forms further connection with the poetry of the Georgians, in which mysterious nature and a 'felt life' are an essential counterbalance to an increasingly regulated and systematized social existence. In order to preserve the sense of an individual 'felt life' in a collectivized modern society and amidst what has been characterized as a 'crisis of subjectivity', nature needed to be mystified or rendered exotic.[43]

Writing in later years about *The Apple Gatherers* (Figure 7.4), by then such a popular theme that it had become a set subject at the Slade, Spencer made clear that this expression of spirit was all important, and he had:

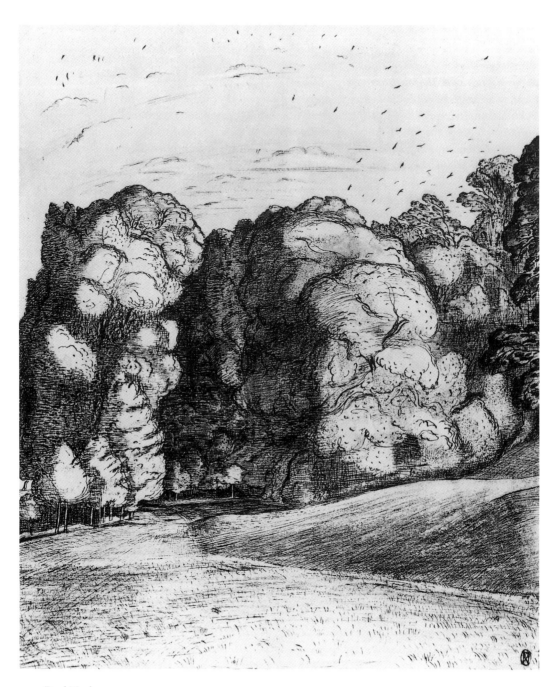

7.3 Paul Nash,
Under the Hill,
1912

… felt moved to some utterance, a sense of almost miraculous power, … arising from the joy of my own circumstances and surroundings. Nothing particularised but all held and living in glory … The Apple Gatherers is an earnest request from whence what is marvellous in themselves (God given) can be revealed and expressed.[44]

The distortions of form, scale and perspective, the massive arms of the fruit-pickers and the immense apples themselves combine to emphasize an ideal,

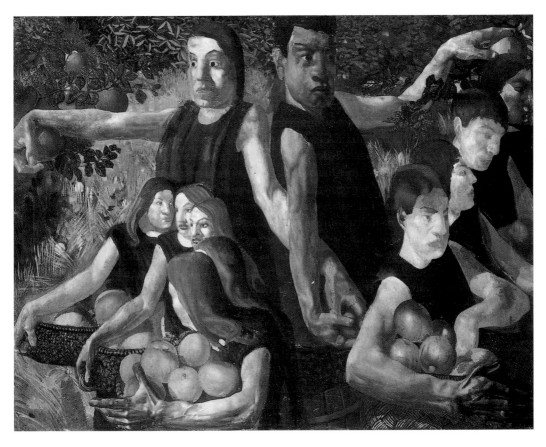

7.4
Stanley Spencer,
*The Apple
Gatherers*, 1912–
1913

organic relationship between man, woman and a fertile, natural world. Similar
expression of a kind of bountiful, Virgilian Golden Age emerges from Mark
Gertler's *The Fruit Sorters* (Figure 7.5), shown at the New English Art Club in
1914, in which Spencer and Augustus John are allied with the more geometric,
hieratic influences of the Egyptian art seen at the British Museum, and the
works of Cézanne.[45] For Walter Sickert, Gertler's painting was an improvement
on those countless, rather languid Ecole de John compositions, the work was
'justified by a sort of intensity and raciness'. It was an exemplary piece of
painting.[46] Duncan Grant's two paintings, *The Lemon Gatherers* (Figure 7.6) and
Adam and Eve, 1913 clearly relate here too. The first of these adopts an extremely
low viewpoint; as a result we look up at the rather awkward and stiff,
monumental figures of the women who appear as relatively dark silhouettes,
looming close to the front of the picture plane and excluding the spectator
from the background view. The tall baskets they carry poised on their heads
contribute to their rather forbidding aspect and seemingly refer to the
headdresses of figures in Piero della Francesca's *Heraclitus Restoring the Cross
to Jerusalem in Arezzo*.[47] In *Adam and Eve* a greater degree of conscious distortion
occurs, to the extent that popular opinion – apart from his Bloomsbury friends
– was generally hostile.[48] In both cases however, the depiction of an earthly

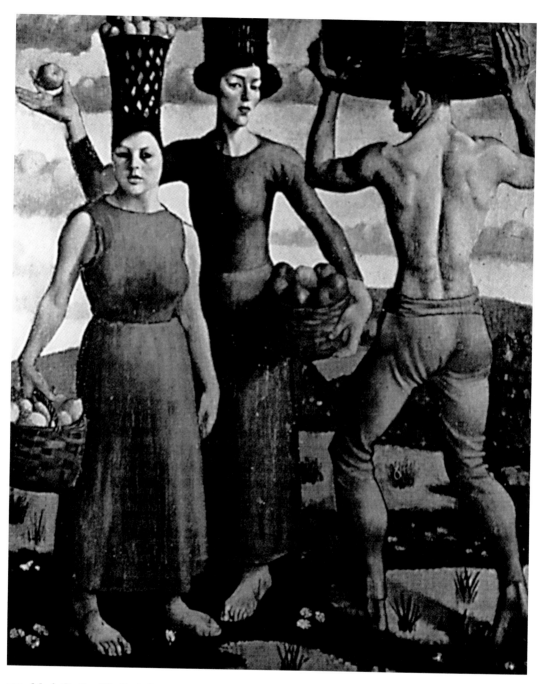

7.5 Mark Gertler, *The Fruit Sorters*, 1914

7.6
Duncan Grant,
*The Lemon
Gatherers*, 1910

paradise required a considerable degree of abstraction from conventional perspective – in art and life.

While connections between both Gauguin's Tahitian idylls and Spencer's Cookham paintings have been drawn, the artist himself and numerous supporters favoured links with the symbolic, semi-religious pastorals of Samuel Palmer. John Rothenstein was characteristically eager to dismiss French influence and to place Spencer in 'the tradition in which Milton and, more militantly, Blake, were sharers, according to which the British Isles were the centre of all primitive and patriarchal goodness'.[49] Similar notions were expressed in letters from Gordon Bottomley to Nash, advising the painter against unsuitable foreign infections. Just after the Great War, the poet warned:

Think, my Paul: in spite of what all the lying art histories (mostly written on the continent) say, modern [ie 19th Century] art was at root an English impulse … And all the time our young artists turn humbly to France … And now it seems to me that you and your companions are finding again the English secret, the English soul that the Pre-Raphaelites found and lost: so I am sad and sorry when I see you doing even the most surface service to the artistic internationalism that was springing up before the war.[50]

With some exceptions, the rural idylls to emerge in the art and literature of this period could only be constructed after a period of separation and experience, in the city or abroad. Gordon Bottomley told Nash that 'every

artist especially needs ten years of London life in his youth, before isolation in even the most beautiful country can be fruitful for him'.[51] Spencer's though was a fascination with a sense of place that could only be maintained through constant familiarity. Going away from Cookham, that 'holy suburb of heaven', meant that 'when I come back, I feel strange and it takes me some time to recover'.[52] Too much exposure to the real world diminished its magic. This experience was shared by the central character in D. H. Lawrence's *The White Peacock*, 1911, who, on his return to Nethermere after a year in the south found, 'no longer a complete wonderful little world that held us charmed inhabitants. It was a small, insignificant valley lost in the spaces of the earth … The old symbols were trite and foolish.'[53] The 'wonderful little world' both men tried to hang on to was an important fantasy, for Lawrence's novel was filled with conventional anxiety over the spread of industrialism and the effects of modernity on the organic community of his own Derbyshire. The threat of war, the experience of the rapidly expanding urban centres and the continued dissolution of rural communities all heightened the value of safely integrated rural places where, in lines from Rupert Brooke's 'Grantchester', 1912, 'the cool lapse of hours pass, Until the centuries blend and blur'.[54]

Retrospective views of the Georgian poets – Brooke, Edward Thomas, W. H. Davies and Robert Bridges – reveal that while their work may have been initially portrayed as modern, as part of the so-called revolt of the period, it was in fact of the past: 'Georgian poetry was to be English but not aggressively imperialistic; pantheistic rather than atheistic; and as simple as a child's reading book.'[55] Although sometimes more ironic, and usually less sentimental than the work of Newbolt and Tennyson, there is clearly still a preservative and conservative strain in this aspect of the literary culture of the immediate pre-war period. It was this that would ultimately account for its acceptability to liberal patriotic sensibilities. Any radicalism was only skin deep and the ultimate relationship was with Wordsworth who, as Binyon had written, was also the real founder of Post-Impressionism in his wish to get back 'to primary things, elemental emotions, and to express these in the very simplest manner'.[56]

A bent towards visionary experience paralleled perceptions of the monotony, the stifling homogeneity of mundane, modern existence. As Edward Thomas put it in his book, *The Country*, 'There is nothing left for us to rest upon, nothing great, venerable or mysterious, which can take us out of ourselves.'[57] It was only in a heightened, partly imagined world of nature that the individual could retain subjectivity. The art of these painters and poets represented an insistence on the individual's connection to a world that might still retain emotional significance. To this end Nash left Chelsea and went purposefully to Iver Heath in order to seek individualism in his art, to 'find himself' in landscape drawings. The symbolic significance of a locality was crucial – Spencer spoke of rendering the spiritual atmosphere of Cookham, whereas for Nash the desire was to capture through imagery the genius loci, the spirit of places (tree-lined gardens, initially), in which he perceived a sense of both sanctuary and disquiet:

The Country is in a very romantic mood just at this time, something about the trees and the light across shorn fields is always making me wonder. Then the garden is full of birds; the nights are mysteriously lit and rain in the night holds me listening spell-bound. In fact I do nothing but walk around marvelling at the wonder of the world in general.[58]

From this perspective nature is a dream-like, even an ecstatic place where the unaccountable might easily occur. This sense underpins Nash's illustrations to Bottomley's *The Crier by Night* and his drawings *Our Lady of Inspiration*, 1910 and *A Vision at Evening* (Figure 7.7), where, over a gently rolling landscape of hills and valleys, a young woman's head, with the flowing hair of a Rossetti model, hovers mysteriously in place of the moon. There is a sense here of the Georgian poets' preoccupation with the atmospheric, unknowable enigmas of the night.[59] Sexual symbolism is evident too. Raymond Williams stated that there are many cases in the literary culture of these years where 'land and countryside are metaphors for sublimated sexual feeling'.[60] Similarly Roger Cardinal argued that the girl's face in Nash's 'anthropomorphic' landscape is metaphorical, and that her absent body is present in the contours of the hills below. These landscapes he sees as 'agile symbolic surfaces across which are inscribed a gamut of human feelings'.[61] What is absolutely the case is that these have become mental landscapes, arguably landscapes of the unconscious mind, paving the way for the artist's transition through to Surrealism in the 1930s. The anthropomorphizing of the objects of nature, a characteristic device for Surrealism, was an early feature of Nash's work. He had described to Bottomley how, 'I love and sincerely worship trees and know that they are people.'[62] In similar vein Isaac Rosenberg described in his 'Uncle's Impressions in the Woods at Night', the silence of the night, when the 'trees around me stood in ghostly array [and] The Lady of the Moon showed me a study in silver and black … everything was still: a prolonged silence, an unearthly stillness'.[63]

Much of Spencer's and Nash's work at this date witnesses the desire to express a moment of revelation, an epiphany, where nature suddenly reveals the inexplicable with intense clarity. Nash remembered in 1922 that he had at one time thought Spencer's works were 'the real thing with all the right inheritance of the fine qualities of the mighty … which caught one by a strange enchantment'.[64] The significance of this imagery to many of its supporters lay in its contrast, as they chose to believe, both to developments within modernism in art and modernity in life. For Binyon, in a modern continental spirit there were to be 'no more old romantic sorrows, no more stale subjects from the past! We are to celebrate the sublime geometry of gasworks, the hubbub of arsenals, the intoxicating swiftness of aeroplanes.'[65] None of this was the true business of art for, to re-quote him, 'We feel intuitively that art exists not for a temporary and ever shifting set of conditions, but for an ideal order. Its relation to life is to the ideal life.'[66] It was this ideal life, set in an English rural location – Widbrook Common – that Spencer represented in *John Donne Arriving in Heaven*, 1911. In such a setting, and through his own interpretation, God was literally all around, and the figures, derived from those of the Italian Primitives, 'like clumsy marionettes', are therefore praying in all directions.[67] Rural Berkshire had become the counterpart of Ruskin's fourteenth-century Padua.

Like Ruskin before him, Binyon found himself 'haunted by a sense of art's irrelevance for the vast majority, when life for so much of our population has been so joylessly dehumanized by modern industrial conditions'.[68] For the educated liberal wing of the upper middle classes, Spencer's vivid evocations of an ancient paradise, and Nash's natural world of imagined experience, were magical and endlessly consoling. Ironically many in this audience were the same people who were responsible for the new bureaucracies. So, Edward Marsh, the consolidating force behind the Georgian poets literary renaissance and patron of all these artists, was at the time Private Secretary to Winston Churchill at the Admiralty.[69]

Speaking in 1914 on behalf of Lewis et al., T. E. Hulme, not long sent down from Cambridge, railed against what he perceived to be the 'feeble romanticism' of painters of this ilk.[70] For Hulme this kind of art represented nothing more than a 'new disguise of English aestheticism', appealing primarily to the cultured liberal humanists, presumably like Marsh, who he himself despised. Especially irritating to Hulme was the way in which Duncan Grant's *Adam and Eve* adopted the qualities of an archaic and intense Byzantine art to apparently meaningless ends. He had been much amused by one writer's description of Roger Fry's own landscapes as having 'the fascination of reality seen through a cultured mind'.[71] Hulme regarded this as the cultured atmosphere of Cambridge and he could identify exactly the kind of dons who were drawn to collect such pictures and the 'dilettante appreciation' they felt towards them. He continued: 'A sophisticated Cambridge sense of humour would relish the clever, paradoxical way in which Grant has his Adam standing on his head and his donkey's ear continuing on into the hills beyond.' Its links to Pre-Raphaelitism soon revealed themselves in its quaint

playfulness, a similar if not identical 'queerness', which gave the spectator the same reminiscent pleasure. Just as Pre-Raphaelitism declined into Liberty's so, Hulme felt, this art of Grant's, those fascinating and cultured landscapes of Fry's, would end up in some emporium, providing suitable house decoration for the wives of 'young and advanced dons'.

By 1911 Edward Marsh had tired of his endless round of social engagements and was looking for a more worthwhile activity for his spare time. To this end he began his role as a benevolent patron in the gentlemanly tradition to young painters like Duncan Grant, to the three relatively impoverished Slade painters, Gertler, Currie and Spencer and, from 1914, to John and Paul Nash. Marsh gave up his earlier practice of buying pictures by Richard Wilson and Girtin, believing that it smacked too much of 'sheep-like conventionalism' to buy old masters in shops. Instead he remembered in later years, 'how much more exciting to purchase wet from the brush, the possible masterpieces of the possible masters of the future'.[72]

Like Binyon, Ricketts and Bottomley, Marsh was averse to 'foreign' theorizing and aesthetic doctrines and maintained a cordial distance from Roger Fry. His literary tastes reflected his tastes in contemporary painting. In poetry he looked for three attributes: 1. intelligibility, 2. music – a singing quality, and 3. raciness, by which he meant an intensity of thought and feeling … to rule out the vapidity which is often to be found.[73] His artistic preferences were largely for paintings of nature, just as the Georgians' poetry was primarily pastoral. Marsh developed his collection beginning with Richard Wilson's *Summit of Cader Idris*, purchased because 'I like things to have their roots in the past.' Wilson's arcadia was of course not unrelated to the later purchases, and artists like Innes, for example, had been clearly drawn to Wilson's bold reductivist masses and crystalline stillness in his own pictures of the mountains and lake around Bala. Marsh's overcrowded rooms in Raymond Buildings included Steer's *Poole Harbour* and Grant's *Lemon Gatherers* alongside Spencer's *Apple Gatherers* and *A View of Cookham*, all pictures which had aroused in him an irrepressible 'lust of possession'. Abstract pictures Marsh shunned, looking upon them with 'a deep but chilly respect'.

Part of the joy of patronizing artists like Spencer and Gertler was, surely, the fascinating glimpses allowed into the vastly different lives of the painters themselves, the opportunities for trips down to the Spencer household in Cookham and into the alien world of the Jewish community in Whitechapel. As for Ottoline and Philip Morrell, who made the same visits, these in themselves were journeys into curious, seemingly innocent and authentic worlds.[74] According to Marsh, who had already befriended another Jew from the East End, Isaac Rosenberg, Gertler was a 'beautiful little Jew, like a Lippo Lippi cherub … an absolute little East End Jew … his mind is deep and simple, and I think he has got the feu sacré.'[75]

Despite this taste for the exotic, it is clear that in both the poems and the paintings that Marsh admired, a decorative primitivism and 'raciness' lent a superficial intensity to images of nature which were intrinsically sentimental

and picturesque. In this a deeply patriotic sensibility was expressed and it has been argued that in this period, 'the romantic and oppositional literary culture of the early nineteenth century was appropriated by a twentieth-century nationalism'.[76] Ultimately, the nature of the audience for this art is an important key to its comprehension. Patrons like Michael Sadleir and Marsh had, through their classical education and class backgrounds, developed a particular, literary view of rural history which incorporated pagan myths and fantasies about a Golden Age and which made them especially susceptible to imagery like *The Apple Gatherers* (Figure 7.4). A consequence of this taste for the unusual, the exotic, the mysterious, the pure and the unsullied was that actual rural life and its history was subordinate to artists' and their public's own idealized perceptions of a secure, harmonious order set in some distant past or special place.

The popular appeal of these perceptions, and of Marsh's critical judgements, was made clear by the enormous circulation of the Georgian Poetry anthologies before the Great War and, in his personal collection of pictures, by a writer in *The Studio* in 1929. T. W. Earp believed that, 'Nearly every artist whose work has real vitality and whose appearance may in some way, during the present century, have contributed to the development of our national tradition, is represented.' The work of 'Messrs Innes, Spencer, Nash and Currie', which is 'tinged by a strong romanticism', is 'consciously national'; they are all 'acknowledged masters in a noble line', and furthermore 'have all gone far beyond the distressing, ephemeral triumphs of sensation with no power of continuity, so characteristic of much modern French production'.[77]

T. E. Hulme's criticism, clearly partisan, in many ways explains the lure of the simplicity, ruralism and subjectivity of the pictures discussed here. It aptly describes the appeal of those illusions of a seemingly far-off and contrasting world, constructed in terms of ideal relationships between men, women, nature and a perceived cultural identity, in the face of a contemporary social fragmentation. In this regard, Nash and Spencer's paintings take their place alongside the country-based fantasies of Kenneth Grahame and J. M. Barrie in which, as Raymond Williams described it: a 'real land and its people were falsified; a traditional and surviving rural England was scribbled over and almost hidden from sight'.[78] In an exchange of identities the rustic is certainly swept aside, but the result here is much more than a mere falsification. In empty pastures and mysterious ancient places, those urban sophisticates who looked and listened hard enough just might encounter still the 'dweller in the innermost'. To achieve this all the distractions of reality had to be disregarded. Only then could the visions commence.

Such a vision preoccupied Augustus John in his monumental, decorative composition, *Lyric Fantasy* (Figure 7.8) depicting once again his extended family, now posed around the site of an old clay pit near Wareham Heath in Dorset. In its shallow space, stylized figures and harsh background, all bound together by the compositional device of the stretch of water and the wicket fence, something of a musical analogy is struck and the placing of the

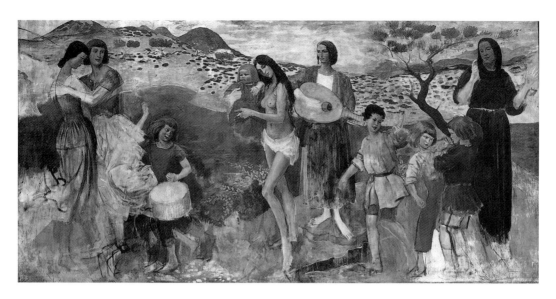

7.8
Augustus John,
Lyric Fantasy,
1911–1914

figures corresponds to the position of notes on a stave. Rather like the art of music suggested by the title, so the spirit of John's painting is of an enclosed, self-sufficient and self-referential world – some remote Eden – that bears no real correspondence to the world outside. And it was a timeless, ancient world, in which the writer Sacheverell Sitwell later perceived a 'static slowness', it is a 'morning in endless time, and there is no thought of change'. To observe it 'We must be as travellers who have come out of the desert; and for many months, or thirty centuries, they are the first human beings we have seen – If we listened we would catch their voices and the bleating of their flocks.'[79]

So we return, in the end, to the appeal of remote Golden Ages and of course this was never simply an English phenomenon – the links are clearly there to Baudelaire's *L'Invitation au Voyage* and *Parfum Exotique*, to the utopian ideals of Fourier and Walt Whitman. The search for a moral and aesthetic counter to modern life took place across Europe and North America and it was a fundamental feature of modernism. But still English critics appeared bent on establishing national distinctions. James Bone, for example, ended his personal panegyric on John and 'English' national and artistic traditions, by assuring his readers that: 'Our innate charm never altogether fails, and is springing up under the most unlikely hedgerows and in queer company to carry us through seasons when professional crops on the Continent have perished in the drought.'[80]

Leaving the landscape

Previous chapters have explored the effects of the social and cultural contexts in which painters produced images of landscape and rural scenery in the early years of the twentieth century. The urban experience of modernity worked through a wide range of contemporary concerns about class, race, gender and social mobility and surfaced in different forms in the images that have been considered here. The search for archetypes that express some fundamental essence, whether in the land or in its people, runs throughout the diverse strands of painting I have described, leading to bold assertions of ideal relationships between the natural world and its inhabitants. It was the stripping away of the cottage landscape clichés to reveal the great masses of soil and sky that created the space for British modernism before the Great War. Essential for its construction was the real (and imagined) socio-economic and cultural divide between the city and the country. So, the concept of the rural as somehow empty, as a potentially vacant site, has been crucial and our observations of a process of reduction – a dominant feature of the modernist aesthetic – link inextricably to an elemental topography. Issues to do with racial type and national origins have underpinned many of the representations surveyed in these pages. These were also, by their very nature, essentially by-products of the discourse of imperialism itself. The vocabulary used typically to describe the activities of imperialist adventurers at the height of Empire – observe, know, describe, all in an anthropological sense, but then also mystify, control, bring order and, finally, obliterate and replace – resonates throughout international modernism. What emerges is a defoliation of landscape, something beyond the sublime and picturesque models of the first generation of British 'grand tourists'. The impetus for artists in the period discussed here was to reveal a world at the edge of an immensity, over which ideal figures or communities might preside.

A seal had already been placed upon imperialist debates when, in 1905, the young writer Elliott Mills equated a contemporary experience of imperial decline with that of Rome in *The Decline and Fall of the British Empire*.[1] Despite the impression that this was in fact a high point of imperial strength, a growing lack of confidence was clearly generated from the bitter conflicts of the Boer War, the increase in German naval strength and the foreign policy

clashes with Russia and France. Just as the rural territories at home seemed insecure and under threat, so too did the overseas colonies and dominions. In situations like these a general heightening of rhetoric is only to be expected.[2] Desperate assertions of one kind tend to belie deep anxieties of another and, in all instances, primary fears focused around concepts of degeneration. Mills listed amongst the seven main causes of imperial decline the disastrous effects on health and faith of the prevalence of town life over country life, the growing English tendency to 'forsake the sea except as a health resort', and the gradual decline of the national physique. The outcome was surely to be the physical and moral decadence and degeneracy which, for the Tory pamphleteer, compared precisely to the conditions in Rome.

The accessory to imperialism, colonization is an entirely apt description of occurrences in the countryside during the period of this investigation. As the flow of indigenous rural populations from the country to the city was maintained in the years up to World War I so, in the other direction, the flow of urban, predominantly middle-class populations increased, at least in the southern counties. This took the form of those holiday-makers and tourists, back-to-the-landers, neo-pagans, artist colonizers, country retreaters, weekday commuters and suburbanites, all of whom, to varying degrees, were attracted by the prospect of an outright rejection of the modern, or by the potential for forging an ideal alternative modernity. The rural was eventually made to accommodate a number of idyllic, prelapsarian golden ages or imaginary future utopias. For those populations, painters such as John, Innes and Knight expressed, ultimately, the new shared values.[3]

The culture of ruralism, as we have seen, began this process and resulted in acts of both colonization and commodification.[4] The final outcome in this case was a representation of rural life that was, largely, labour-free. Emerson's remark that 'you cannot freely admire a noble landscape, if labourers are digging hard near by', has been quoted to account for the important perceptual shift in which 'landscape' was progressively replaced by 'terrain'.[5] As a consequence, the figure became timeless, languid, detached and contemplative or, in some cases, disappeared altogether. So the land, if it is at all productive, is rendered so almost magically and without visible evidence in the form of workers.[6] There is an important distinction here between nineteenth-century paintings of colonial settler societies like those of South Africa and New Zealand, and Empire Marketing Board posters of the 1930s in which the land is cleared of non-Europeans. A productive land is pictured in those cases, i.e. one that has been rendered so by European colonization. These are very different acts of colonization – or ownership – and in John's case, for instance, the impulse derives from a concentrated projection of his own individual (but class-based) fantasies and desires; the empty land is a place where these drives can be indulged, so it is unnecessary to cultivate any crops – or perhaps there is just no space and no time.

Discussion of paintings of the 'peasant' observed the beginnings of the displacement of the real working class from their own territory. In true imperialist fashion the rural worker was first observed and documented

according to the dictates of Naturalism, and then idealized as a noble type, distanced and rendered safe, through a poetic, selective interpretation which valued aesthetic ideals of a unity of impression and atmospheric envelopment, as witnessed for example in the handling of Edward Stott. As a result all individuality and direct recognition is lost. Handling and technique disallowed real interest in workers, signalling avoidance of the reality of rural conditions. The labourer is now both powerless and picturesque, aesthetically and materially he is in the right place. Being timeless and essentially 'not modern', he is not threatening. Again in terms of an imperialist discourse, this representation could be seen as underpinned by distrust and ridicule of the rural poor, and a need to control, both socially and pictorially. In strikingly similar fashion, Said described Orientalism as a 'culturally sanctioned habit of deploying large generalizations by which reality is divided into various collectives – language, race, type … (of us and them), all reinforced by anthropology, linguistics etc. and Darwinist theses on survival and natural selection'.[7] At the turn of the century colonial administrators were commonly describing 'the backward races' of the overseas territories as 'lower', 'less-gifted' and 'less-developed'.[8] Much the same terminology was employed in relation to the English labourer, but in order to justify ideological fantasies that he was exactly the opposite, that he was at once both a dying breed and a wellspring of racial purity, he needed to be removed from scrutiny. He and his decaying villages were therefore transformed into ideal, spiritual communities with which to contrast real urban conditions and urban types. Safe ahistorical ideals of rudimentary and seasonal existences therefore predominate. Atmospheric envelopment becomes all pervading and the individual worker, now almost an abstraction, vanishes, symbolically, into the ether.

While the figure in the landscape has largely dominated this book, the unpopulated, pure landscapes of Steer, in the eyes of contemporaries, weighed modern French influences against the reworking of authorized national aesthetic traditions, most notably of the, by then, nationally acclaimed Turner and Constable. Such a transformation resulted in the emergence of a popular series of panoramic vistas, of commanding prospects of the rolling English countryside, where once again a relationship with the expansionist character of imperialism and the 'imperial prospect' might be discerned.[9] There was no space, literally, for the working figure, beyond merely a fictional adjunct – an accessory to sites which were important because of their established literary and visual associations, often because they evoked an idealized eighteenth century, or because of the picturesque, ruined castles they contained and the delicious melancholy that they induced. Such figures that are present, and the same applies to what remains of the rural worker in Clausen's pictures, are reduced to the function of both being and purveying commodities.

Augustus John and his circle changed the emphasis in adopting modernist notions of the artist as bohemian outsider, a supposedly 'free spirit'. An engagement with the decorative primitivist forms of Post-Impressionism

might be seen ultimately to have supported bourgeois preoccupations with the bland vulgarity of modern urban society. To project their ideal, which was fundamentally in accord with an imperialist ideal of a hardy and resilient race, who would artists choose to depict in remote, rugged and unfurnished landscapes, but themselves and their own kind? In the process, John depicted an imaginary race that could assuage the anxieties of all the urban middle classes concerned with the debates emerging out of social Darwinism, women's suffrage and the critiques of mass society. The inevitable result was the depiction of those timeless Golden Ages that were utterly and reassuringly devoid of real people.

In a quest for these idylls, John and Henry Lamb had initially been led to explore the rugged coastlines and fishing communities of Brittany, with visions of Gauguin's primitive ideals implanted in their memories. But the allure of the Midi prevailed, and in the case of Innes and Derwent Lees, a quintessential 'southern-ness', signified by the intense blue sea and scorched, arid landscapes – simply furnished with olive trees and cacti – produced the archetypal decorative landscape. For John, this was the quintessential setting for his dislocalized Arcadias, populated mainly by earth-mother Madonnas and their sturdy offspring. The Mediterranean was the inevitable destination for devotees of Cézanne, like Roger Fry, but also for those like Fergusson, Peploe and Rice who were seeking the Bergsonian essential life force. The regenerative energy and rhythm that they could intuit beneath the superficial appearances of nature was best expressed away from the centres of modernity, in the liberation and essential purity of the south.

In what was to be hailed the 'Cornish Riviera' this esoteric purification process achieved a wider base, again in part through the modern culture of tourism itself, shaped by the middle-class repudiation of its own conditions. The initial attraction of Cornwall, for painters and visitors alike, lay in its remoteness and the supposed authenticity of its native inhabitants, its fisherfolk. Arthur Symons's comments are particularly telling in this case; 'You will find, often enough, that very English quality of vulgarity in the peasant who lives inland; only the sea seems to cleanse vulgarity out of the English peasant, and to brace him into a really simple and refined dignity.'[10] But in the process of selling the location through urban ideals of physical health, racial and moral purity, Cornwall's Celtic origins led to spiritual longings for the pre-modern and the pre-Christian. The real Cornish fisherman, in spite of Symons's projection, is inevitably displaced. The imaginary geography of the county is much more seductive. Fisherfolk had to be replaced by physically perfect and ideal specimens, inactive, and contemplative, gazing out from the cliff-tops and as far from the vulgar crowd as was possible. To be busily gutting fish would have destroyed the fantasy afforded by Knight and Tuke.

In Spencer Gore's representations of Letchworth, modernist forms of painting provide an imaginary solution to existing conflicts in the city, and cultural expression is given to developments that were already taking place in political and economic spheres. The garden city programme was essentially

a bureaucratic ideal for a planned countryside. A practical and organized approach, it also, of necessity, entailed the clearing out of indigenous populations in its programme of tidying up, of re-cultivating in order to extend the garden metaphor – an ideal modernity. Like Gore's form of modernism, suburbanization was a force for social and cultural conservatism. If imperialism was an agent for the creation of order and control, then so in this regard are these particular formulations of Englishness and modernism. Hence the docile, unindividuated commuters dotted around the railway station in sunny Letchworth.

Gore highlights the dilemma of those painters identified with the literary circle around Edward Marsh, concerned with efforts towards a re-assertion of individualism and subjectivity in the context of collectivity and centraliz-ation – the Letchworth paradigm. From this emerged a taste for simple, mystical, rhythmic forms celebrating an intensity of vision, animism and moments of epiphany. An assimilation of decorative Post-Impressionism and Italian primitivism could support the religious or spiritual expression of an inner life. There were, as we have seen, English precedents for this in Blake, Palmer and the Pre-Raphaelites, capable of taking on the enigmatic mysteries of specific, invariably rural, places. Hence Paul Nash's yearning to depict landscape, 'not for the landscape's sake, but for the things behind it'.[11] The value placed upon this 'felt life' is perhaps best expressed in Spencer's *Zacharius* amongst the garden trellises of Cookham. And the sense that the innermost revealed itself in odd flashes, as through the trellis, is clearly conveyed by Edward Thomas in his description of a tract of country rarely visited by outsiders:

The few people whom we see, the mower, the man hoeing his onion bed in a spare half hour at mid-day, the children playing 'Jar-Jar-winkle' against a wall, the women hanging out clothes, – these the very loneliness of the road has prepared us for turning into creatures of a dream; it costs an effort to pass the time of day with them, and they being equally unused to strange faces are not loquacious, and so the moment they are passed, they are no more real than the men and women of pastoral … The most credible inhabitants are Mertilla, Florimel, Corin, Amaryllis.[12]

In advance of the Great War then, the English landscape had already undergone a consistent process of purification. In this sense painting had played an active role in the wider political and economic processes of reshaping the countryside. Rural England had, by 1914, already been safely and effectively emptied out and then resettled and the rural poor, if they were allowed to appear at all, took the form of the quaint rustic types depicted by Alfred Munnings. The country was therefore prepared to be that place of intimate, solitary contemplation to which wounded soldiers would return.

One damaging effect, I think, of the dominant periodization of art history has been to over-determine the significance of the Great War in relation to perceptions of the rural, and to underestimate the force of British landscape modernism prior to its outbreak – alongside the wider social, cultural and political developments associated with an expanding pre-war middle class.

Masterman's sense of a dramatic cultural shift after 1918 has perhaps been too liberally quoted.[13] Although the Edwardian 'garden party' may well have suffered a lethal blow, the seeds of its destruction were clearly already there in European culture long before. Indeed virtually the whole of Masterman's 1909 *Condition of England* took the form of a lament, with the underlying conviction that civilized standards were irredeemably slipping away. That 'garden party' was, as we have seen, laid consumptive on the shores of the Mediterranean at Nice and Monte Carlo, the very sites that John, Innes and Fergusson knew to avoid. So the war simply concentrated attitudes and developments already in place by 1914. The familiar landscapes of the south of England were re-valued for their accessibility, their order and cultivation – all the more emphatically because the disorder and chaos of war added to the more general notions of the disorder of modernity. Nature in the 1920s, as it has long been argued, was to be appreciated as a solitary and intimate place where the individual went for solace and spiritual recuperation, as seen in the untroubling landscapes by painters of the 7&5 Society.[14] This type of English landscape was regarded as an important symbol during the Great War. It represented, and this was positively encouraged, the bedrock of nationality that needed to be protected from alien outsiders.[15] But it was the very fact that in previous decades rural areas had been both represented and colonized in this way that made that ideological process possible.[16] The post-war economy and various social and technological developments simply extended and made more overt the system of commodification. Ultimately, then, we find that modernization and modernism in the early part of the twentieth century continue many of the impulses and processes involved in the picturing of the countryside that have been identified in studies of landscape at the end of the eighteenth century.[17] At the very moment of industrialization, the spread of capitalism and its emergent social relations, the depiction of an ideal and harmonious rural life became, and has since remained, an urgent and significant pressure.

Notes

Landscape and modernity

1. *The Connoisseur*, vol. IX, 1904, pp. 135–43. Alfred East trained in Paris and painted at Barbizon in the early 1880s, subsequently travelling to Japan. By the 1890s however, East had become a favourite at the Royal Academy for what Palgrave termed his 'grand and imposing' English landscapes. For more discussion of East and also of the American expatriate painter, Mark Fisher, who showed at the New English Art Club and at the Royal Academy in the 1880s and 1890s, see Kenneth McConkey, *Impressionism in Britain*, exhibition catalogue, Barbican Art Gallery and Yale University Press, 1995. For Waterlow, see 'Sir E. A. Waterlow RA, PRWS', *The Art Journal*, 1906. For Leader, see Peter Hood, *B. W. Leader, Life and Work*, Antique Collectors' Club, 1990. For a study of these earlier Academy painters in the context of landscape theory derived from Ruskin and Stokes, see Kenneth McConkey, 'Haunts of Ancient Peace', in David Peters Corbett, Ysanne Holt and Fiona Russell, eds, *Geographies of Englishness, Landscape and the National Past, 1880–1940*, London and New Haven: Yale University Press, 2002. On Stanhope Forbes and Frank Bramley, see especially Caroline Fox and Francis Greenacre, *Painting in Newlyn, 1880–1930*, exhibition catalogue, Barbican Art Gallery, 1985.

2. A typical review of 'A Society of Landscape Painters', stated that the 'steady advance of landscape painting during the last few years has been, and still is, one of the most interesting movements of English art. We now have a brilliant band of comparatively young men producing works which worthily sustain the best traditions of English landscape art', Arthur Fish, *The Magazine of Art*, 1899, pp. 218–21. A survey of the pages of *Royal Academy Illustrated* magazines during the period of this study reveal that consistently over a third of the works were of landscape or rustic scenes. At the same time treatises on landscape painting technique, like for instance, Alfred East's *Landscape Painting in Oil Colour*, 1906, (Cassell & Co.) were published.

3. Adam Nicholson, introduction to *Towards a New Landscape*, London: Bernard Jacobson Ltd, 1993, pp. 9–10.

4. W. J. T. Mitchell, ed., *Landscape and Power*, Chicago: University of Chicago Press, 1994, p. 2.

5. Ibid., p. 1.

6. See Raymond Williams' essay, 'Between Country and City', in Simon Pugh, ed., *Reading Landscape, Country, City, Capital*, Manchester: Manchester University Press, 1990, p. 5. As Peter Howard pointed out, Williams' studies have maintained a powerful impact on those rural, cultural and art historians who accepted his assertion that the social relations and the means of production associated with capitalism should be the rationale behind all histories of the city and the country, see 'That Arty Stuff', *Landscape Research*, vol. 18, 1993, pp. 55–6. Such thinking has already informed important works like John Barrell's, *The Dark Side of the Landscape*, Cambridge, 1980 and Ann Bermingham's *Landscape and Ideology – The English Rustic Tradition, 1740–1860*, Thames & Hudson, 1987, and reflects the development away from the deeply embedded formalist readings of art history to take place in the 1970s.

7. Charles Harrison, 'The Effects of Landscape', in W. J. T. Mitchell, ed., (see note 4, p. 205).

8. The Homeland Association was founded in 1896. Its aim: to foster greater knowledge and appreciation of British towns and the countryside. In the 1890s the Association began to publish guide books and practical information for those anxious to move out of inner-city areas, an activity that was greatly extended in the inter-war period.

9. Mary Stratton, ed., *The Country*, Fellowship Books, c.1912, pp. 36–9.

10. Published by MacMillan, 1906, p. 93.

11. Much of the impetus of the Back-to-the-Land Movement derived from the rural utopia envisaged in William Morris's *News from Nowhere*, of the early 1890s, and this was an influence on many, from the Purleigh Tolstoyans to Rider Haggard. For discussion see Alun Howkins, *Reshaping Rural England: A Social History, 1850 to 1925*, London: Harper Collins, 1991.

12. 'The Formation of London Suburbs', *The Times*, 25 June 1904. Cited in Donald Read, ed., *Documents from Edwardian London, 1901–1915*, London: Harrap, 1973, p. 25.

13. For an account of the extent to which ruralism was cross-class and appealed to both left and right politically, see Peter Gould, *Early Green Politics: Back to Nature, Back to the Land, and Socialism in Britain, 1880–1900*, Brighton: The Harvester Press, 1988.

14. The Trust was registered with the Board of Trade in 1895 as 'The National Trust for Places of Historic Interest or Natural Beauty'. For discussion of its founding and subsequent role, see Robert Hewison, *The Heritage Industry: Britain in a Climate of Decline*, London: Methuen, 1987, esp. pp. 56–8.

15. *The Art Journal*, 1885, pp. 267–7. Leader's success is here accredited to his ability to please the 'English picture seer, who likes his landscape with an addition of allusions not difficult to catch and allegories not hard to understand'.

16. David Lowenthall, 'British National Identity and the English Landscape', *Rural History*, vol. 2, 1991, p. 213. As Andrew Hemingway notes, the belief that the relationship between landscape imagery and national identity is strongest in this country needs close questioning. See Hemingway's review 'National Icons and the Consolations of Imagery', *Oxford Art Journal*, vol. 17, no. 2, 1994, p. 114.

17. David Cannadine, *Ornamentalism, How the British saw their Empire*, London: Allen Lane, The Penguin Press, 2001, pp. 12–13.

18. Cannadine quotes here from John Mackenzie, *Orientalism: History, Theory and the Arts*, Manchester: Manchester University Press, 1995.

19. Martin Wiener, *English Culture and the Decline of the Industrial Spirit, 1850–1980*, Cambridge University Press, 1981 (this edn Pelican 1987).

20. Alun Howkins discusses the origins of this metaphor in Hilaire Belloc's poem, *The South Country*, and in Edward Thomas's prose collection, *The South Country*, of 1908. See 'The Discovery of Rural England' in Robert Colls and Philip Dodd, eds, *Englishness, Politics and Culture, 1880–1920*, London and Sydney: Croom Helm, 1987.

21. Cannadine refers to Evelyn Waugh's account (*Remote People*, 1931) of colonials' efforts 'to transplant and perpetuate a habit of life traditional to themselves which England had ceased to accommodate – the traditional life of the squirearchy', (see note 17), p. 39.

22. Recent research into ideals of Englishness and the countryside around 1900 has been largely general or, where particular, concerned with rural, social and cultural history. Perhaps most influential in recent years have been the essays contained in Robert Colls and Philip Dodd, eds (see note 20). None of these essays refers to the visual arts, but all, in various ways, expand on the particular discourses in which the paintings I discuss acquired their meaning.

23. In 1909 Alfred East edited a special number of *The Studio* containing an essay on 'Sussex, as a Sketching Ground'.

24. William Vaughan has argued that although the qualities of painters like Hogarth and Constable had, earlier in the nineteenth century, been regarded as innately English (i.e. in the earlier sense of naturalistic), it was at the close of the century that the term 'Englishness' was used to subsume all other British identities – thereby fostering a greater, though clearly false, sense of national unity. But it is also clear that it was specifically the south of England that was most commonly identified by writers and artists in this respect. See 'The Englishness of British Art', *Oxford Art Journal*, vol. 13, no. 2, 1990, pp. 11–23. David Lowenthall also discusses the conflation of Englishness and Britishness in 'British National Identity and the English Landscape', *Rural History*, vol. 2, 1991, pp. 205–30.

25. Depression had a number of causes, all dating from the early 1870s, including such factors as bad harvests, cheaper foreign food and grain imports, continually declining areas of agriculture, wage competition from industries and a series of education acts which reduced available labour forces. The result was the continued exodus of the rural population to the cities, which caused such constant concern throughout the period of the present study.

26. Montague Fordham, *Mother Earth*, London: Simpkin, Marshall, Hamilton, Kent & Co., 1908, p. 6.

27. After Cambridge, C. F. G. Masterman had been engaged in social work in south London and as editor of the journal of the Christian Social Union. He was a member of the Liberal government from 1906 and of Asquith's cabinet in 1914. For an account of Masterman's general tone of apprehension and nostalgia as opposed to any positive programme of action, and of the way in which this coincided with Tory perceptions of the time, see Samuel Hynes, *The Edwardian Turn of Mind*, Princeton: Princeton University Press, 1968, pp. 57–73.

28. Brian Doyle, *English and Englishness*, London: Routledge, 1989, p. 19.

29. For a very interesting discussion of Rider Haggard's writings in relation to late Victorian imperialism and a culture of masculinity, see Gail Ching-Liang Low, 'His Stories?: Narratives and Images of Imperialism', in Erica Carter, James Donald and Judith Squires, eds, *Space and Place: Theories of Identity and Location*, London: Lawrence and Wishart, 1993. Ching-Liang makes the connection, important here, between Empire, Eugenics and the discourse surrounding the body; 'Eugenics located progress in the physical health of whole races; the body became a site where anxieties about urban poverty, degeneration and national decline were represented', p. 189.

30. C. F. G. Masterman, *The Condition of England*, London: Shenval Press, 1909, p. 12.

31. In terms of the urban experience, Jack London's *The People of the Abyss*, 1903, is a most classic example. Further instances of this 'Into Unknown England' writing which, as described by Philip Dodd, blended personal exploration with emerging sociological analysis, include Charles Booth's *Life and Labour of the People in London* (1889–1903) and Rider Haggard's *Rural England* (1902). See Philip Dodd, 'Englishness and the National Culture', in Robert Colls and Philip Dodd, eds, (see note 20), p. 8. As Gareth Stedman Jones observed, the theory of urban degeneration derived its real significance, not from actual conditions, 'but from the mental landscape within which the middle class could recognize and articulate their own anxieties about urban existence', see *Outcast London*, Oxford: Oxford University Press, 1971, p. 151.

32. In its 1904 report, the Committee advocated, amongst other remedies, the setting up of enforced labour colonies to relieve overcrowding in certain districts. See Read (see note 12), p. 213.

33. For discussion of representations of Cornish fisher women around the close of the nineteenth century, see Nina Lübbren's essay 'Toilers of the Sea: Fisherfolk and the Geographies of Tourism in England, 1880–1900', in Corbett, Holt and Russell, eds, (see note 1).

34. Raymond Williams, *The Country and the City*, London: Chatto and Windus, 1973, p. 248.

35. I draw in particular here on the work of Christopher Shaw and Malcolm Chase, eds, *The Imagined Past: History and Nostalgia*, Manchester: Manchester University Press, 1989, pp. 2–5.

36. Clausen's *The Ploughman's Breakfast*, 1905, was acquired for the National Gallery of Victoria, Melbourne in 1906; *The End of a Long Day*, 1897, by the Art Gallery of Western Australia, Perth in 1898; *The Haymakers*, 1903, by the Museum of New Zealand, Wellington in 1912; and *Propping the Rick, a Stormy Day*, 1911 by the Art Gallery of New South Wales, Sydney in 1912. Sir Hugh Lane, who bought for Johannesburg Art Gallery, purchased works from Steer's solo Goupil Gallery exhibition in 1909, including *The Limekiln (Corfe)* and *Corfe Castle and the Isle of Purbeck*.

37. Stephen Daniels, *Fields of Vision, Landscape Imagery and National Identity in England and the United States*, Oxford: Polity Press, 1993, p. 5. This condition clearly does not apply solely to landscape painting in Britain. Daniels', own work on nineteenth-century American painting demonstrates this. See also, for example, Richard Brettell's chapter 'The Impressionist Landscape and the Image of France', in *A Day in the Country – Impressionism and the French Landscape*, Los Angeles County Museum of Art, 1984, and Richard Thomson's, *Monet to Matisse, Landscape Painting in France, 1874–1914*, National Gallery of Scotland, exhibition catalogue, 1994, which deals with the extent to which landscape paintings could be interpreted as constructions of Frenchness.

38. The Bloomsbury Group's paintings are not a substantial focus for my interests here, although Fry's aesthetic theories and the effects of his Post-Impressionist exhibitions are of course important.

39. Ferdinand Tonnies' *Community and Society* was published in 1887, Emile Durkheim's *Suicide* in 1897 and Georg Simmel's *The Metropolis and Mental Life* in 1911. One of the few exceptions to what became the traditional critique of modernity, appealing to writers across the political spectrum, was Marshall Berman's book, *All that is Solid Melts into Air*, Verso, 1983. See esp. p. 60, where he writes about the prolific extent to which in the 20th century we have 'constructed idealised fantasies of life in tradition bound small towns', in defiance of 'the cruelty and brutality of so many of the forms of life that modernization has wiped out'. As Chase and Shaw pointed out (see note 35, p. 8), for Berman, nostalgia is something like a failing of our collective cultural confidence in the modernizing impulse – like it or not, change is the only constant in our lives.

40. Arthur Symons, *London: A Book of Aspects*, 1909 (New York: Garland Publishing, facsimile edition, in Ian Fletcher and John Stokes, eds, 'Degeneration and Regeneration: Texts of a Premodern Era'), p. 36.

41. For interesting general discussion of the function of landscape in this respect, see Fred Inglis, 'Landscape as Popular Culture', *Landscape Research*, vol. 12, no. 3, 1987, pp. 20–4.

42. On the notion of Englishness as being constantly attended by definition of what is 'unenglish and alien', see 'An Open Letter from Philip Dodd: Art, History and Englishness', *Modern Painters*, no. 1, vol. 4, 1988–9, p. 40. Also, Patrick Wright's account of the appeal of the countryside in the context of modernity has drawn on the writings of Agnes Heller (*A Theory of Feelings*, Assen, 1979) and describes the importance of the rural past in opposition to the rationalization and the bureaucratization of everyday life, *On Living in an Old Country, The National Past in Contemporary Britain*, London: Verso, 1985, p. 22.

43. The Trade Union Movement had expanded significantly from the beginning of the 1890s and continued to do so up until 1914, as the Labour challenge to Liberal rule continued to escalate along with increasing levels of industrial militancy – threatened rail strikes in 1907, ship-builders and engineers' strikes in 1908, miners' strikes in 1910 and 1912 and the 'triple alliance' strike of 1914. The challenge of women to the status quo was marked by the formation of the Women's Social and Political Union in 1903 and a steady growth in suffrage activity from that date. Further unsettling conditions developed in Ireland, culminating around the Lords' rejection of the Third Home Rule Bill in 1913. For general discussion see, for example, David Powell, *The Edwardian Crisis, 1901–1914*, Basingstoke: Macmillan, 1996.

44. Recent critical approaches to the British landscape in these years can be found in Corbett, Holt and Russell, eds, 2002, (see note 1).

45. For example, general surveys like Dennis Farr's, *English Art, 1870–1949*, Oxford: Oxford University Press, 1978; Charles Harrison's *English Art and Modernism, 1900–1939*, London and Bloomington: Indiana, 1981; Frances Spalding's, *British Art Since 1900*, London: Thames & Hudson, 1986; Royal Academy of Arts, catalogue of an exhibition, *British Art in the Twentieth Century*, 1987.

46. By radical modernists I mean those artists, like the Vorticists, who perceived as their role a critical engagement with the experience of modernity itself. For discussion of the term in the inter-war context, see David Peters Corbett, *The Modernity of English Art, 1914–30*, Manchester: Manchester University Press, 1997, pp. 25–56.

47. See *Blast*, vol. II, 1914, pp. 129–31. For Lewis 'Life, not nature, is the important thing'.

48. Worringer's essay *Abstraction and Empathy* is reprinted in Charles Harrison and Paul Wood, eds, *Art in Theory, 1900–1990, An Anthology of Changing Ideas*, Oxford, UK and Cambridge, USA: Blackwells, 1996 (1st pub. 1992), pp. 68–72.

1 Poetry of the peasant

1. C. F. G. Masterman, ed., *The Heart of the Empire, Discussions of Modern City Life in England*, London: Fisher Unwin, 1902, p. 7.

2. Recent historians have pointed out that in fact rural depopulation was slowing down relatively in the twenty years leading up to the Great War. W. A. Armstrong makes clear that there was a slight rise in the national number of agricultural labourers between 1901 and 1911. See Armstrong, 'The Workfolk', in G. Mingay, ed., *The Victorian Countryside*, vol. 2, London: Routledge & Kegan Paul, 1981, p. 132. It is clear though that the economic importance of agriculture was in decline during these years, due mainly to three factors: the decrease in the area of agricultural land, the expansion of other areas of the economy and especially the increased dependence on foreign production. Between 1909 and 1913, 60% of all British food consumption was imported. See P. Holderness, 'The Victorian Farmer' in Mingay, op. cit., p. 243.

3. Wages were low and, even in the north where they were highest, did not compete with those in industry. Also, as Jan Marsh stated, while industrial employment offered more security, just as importantly it was relatively impersonal, whereas in the village 'quasi-feudal attitudes persisted'. See *Back to the Land, The Pastoral Impulse in England from 1880–1914*, London: Quartet Books, 1982, p. 61. Further dissatisfaction was caused by appalling living conditions in tied housing, giving the lie to the 'cottager by the door' genre of painters like Birket Foster and Helen Allingham. One commentator, cited in 1913, spoke of the 'burning question' of country people living in houses desperately unfit for human habitation, cramped, squalid and without clean water. Cited in Mrs Cobden Unwin, *The Land Hunger, Life under Monopoly, Descriptive Letters and Other Testimonies from Those Who Have Suffered*, London: Fisher Unwin, 1913, pp. 68–71. As Enid Gauldie notes, by the time the importance of building sound homes for the rural labourer was recognized, the fading profitability of the land had reduced the incentive, see 'Country Homes', in Mingay (see note 2), p. 540.

4. Milner is cited by Alun Howkins, 'The Discovery of Rural England', in Robert Colls and Philip Dodd, eds, *Englishness, Politics and Culture, 1880–1920*, London: Croom Helm, 1986, p. 68.

5. In the context of the earlier period and on the ways in which the late paintings of John Linnell from the 1850s and 1860s functioned to resolve bourgeois anxieties about change in rural society through the perpetuation of myth about a natural and organic society, see Paul Street, 'Painting deepest England' in C. Shaw and M. Chase, eds, *The Imagined Past: History and Nostalgia*, Manchester: Manchester University Press, 1989, pp. 68–79.

6. E. P. Thompson's comments about the earlier part of the nineteenth century, from *The Making of the English Working Class*, are also discussed in Ann Bermingham, *Landscape and Ideology – The English Rustic Tradition, 1740–1860*, Thames & Hudson, 1987, p. 4. For a discussion of Hardy, Clausen and La Thangue's representations of country-women amidst contemporary anxieties over a 'lost femininity', see Karen Sayer, 'Unstrained dialect a speciality', in *Women of the Fields*,

Representations of Rural Women in the Nineteenth Century, Manchester: Manchester University Press, 1995.

7. Edward Thomas, *The Country*, London: Batsford, 1913, pp. 19–22.

8. George Thomson, 'Henry Herbert La Thangue and His Work', *The Studio*, vol. IX, 1896, p. 176.

9. For reference to *Ploughing*, 1889, see Kenneth McConkey, *Sir George Clausen, R.A., 1852–1944*, Bradford and Tyne & Wear Galleries & Museums, 1980, p. 50. McConkey states that the artist first began to treat the subject in 1884. This work he cites as 'the summit of his admiration' for Bastien Lepage. The obvious symbolism of the theme of youth and age is here less important than the literal depiction of the task itself.

10. Flora Thompson, *Lark Rise to Candleford* (1st edition 1939), Oxford: Oxford University Press, 1969, pp. 43–4.

11. Thomas's description is contained in his 1906 *The Heart of England*. This passage, from 'The Ship, Chariot and Plough', is cited in Jan Marsh, *Edward Thomas, A Poet for His Country*, London: Elek Books, 1978, p. 51.

12. H. Rider Haggard, *Rural England, Being an Account of Agricultural and Social Researches Carried Out in the Years 1901 & 1902*, vol. II, London: Longman, 1902, p. 540. For full discussion of Haggard's belief in the importance of rural society as the key to the reversal of racial decline and as a depository of the true essence of Englishness, see Alun Howkins, 'Rider Haggard and Rural England', in C. Shaw and M. Chase, eds, (see note 5), pp. 81–92.

13. Clausen's first encounter with Bastien-Lepage occurred around 1882 while he was in attendance at Bouguereau's atelier in Paris. At this time Bastien's *Les Foins* was on display at the Louvre. For full discussion of the importance of Bastien-Lepage, see Kenneth McConkey, 'The Bouguereau of the Naturalists; Bastien-Lepage and British Art', *Art History*, vol. 1, no. 3, 1978, pp. 371–82 and on the term 'Rustic Naturalism', see Kenneth McConkey, 'Rustic Naturalism in Britain', in G. P. Weisberg, ed., *The European Realist Tradition*, Bloomington: Indiana University Press, 1983. See also, Kenneth McConkey, *Sir George Clausen RA 1852–1944*, catalogue of an exhibition, Bradford Museums and Art Galleries, 1980. For a discussion of Clausen's practice in the Essex countryside around 1881, see also Anna Greutzner Robins's essay 'Living the Simple Life: George Clausen at Childwick Green, St Albans', in Corbett, Holt and Russell, eds, *Geographies of Englishness, Landscape and the National Past, 1880–1940*, London and New Haven: Yale University Press, 2002.

14. D. S. MacColl, 'Professor Brown: Teacher and Painter', *The Magazine of Art*, 1894, pp. 407–8. The 'new critics' are substantially discussed in chapter 2.

15. For discussion of the consequences of MacColl's term 'congruous beauty', see chapter 2.

16. *The Saturday Review*, 22 May 1897, 'Painting at the Academy', p. 572. There is constant reference to the British peasant throughout this period although, of course, he no longer really existed. As writers like Christopher Hill and Eric Hobsbawm have established, the process of capitalist agriculture since the sixteenth century had converted the majority of rural labourers into landless proletarians. Hobsbawm states that 'unlike peasant countries, Britain possessed no great reservoir of land-hungry small cultivators working smallholdings with family labour. The farm labourers wanted good wages, not land', see *Industry and Empire, From 1750 to the Present Day*, Harmondsworth: Pelican, 1981, p. 200 (1st edn, Weidenfeld & Nicholson, 1968). All of this has interesting implications for the agricultural and political propaganda, as well as for the increased reference in paintings from the 1880s to the ideal vision of 'three acres and a cow'. For George Bourne (Sturt), in 1912, the 'peasant tradition in its vigour amounted to nothing less than a form of civilization – the home made civilization of the rural English', see *Change in the Village*, New York, 1969, p. 76.

17. Clausen, *Six Lectures on Painting*, London, 1904, p. 106.

18. Julia Cartwright's *Jean François Millet, His life and Letters*, continued the wave of interest in the artist generated in 1881 by the publication (and translation) of Alfred Sensier's biography *Jean-François Millet, Peasant and Painter*, Macmillan & Co., 1881.

19. Breton was, for example, eulogized by Garnet Smith in 'Jules Breton: Painter of Peasants', *The Magazine of Art*, 1893, pp. 409–16.

20. Walker had seen Breton's *La Fin de la Journée* on a visit to the Salon in 1863. Breton was also shown in London at the French Gallery in 1870. See H. S. Marks, *Frederick Walker*, ARA, London, 1896, p. 37. Millet's *The Angelus* was shown at Durand-Ruel's in London in 1872. For more discussion, see McConkey, (see note 13), 1980.

21. Claude Philips, *Frederick Walker and his Works*, (Portfolio Monograph), Seeley & Co., 1905. For more recent discussion of Walker see Christiana Payne, *Toil and Plenty, Images of the Agricultural Landscape in England, 1780–1890*, New Haven and London: Yale University Press, 1993.

22. Anon., 'The Royal Academy', *The Magazine of Art*, 1899, p. 388.

23. Haldane MacFall, 'The Art of Mr Clausen', *The Academy and Literature*, 3 December 1904, p. 569.

24. Dewey Bates, 'About Market Gardens', *The English Illustrated Magazine*, February 1885, pp. 551–9.

25. 'The Royal Academy', *The Art Journal*, 1901, p. 166.

26. A. L. Baldry, 'William Lee Hankey, RI', *The Studio*, January 1906, p. 294. Sarah Knight's interesting study of the photographer Emerson has dealt with the importance of late-nineteenth-century attitudes towards the 'peasant' in relation to ideas about a natural social order. Knights shows how Emerson's writings and his photographs of East Anglian labourers were a criticism of the effects of economic and social change and the gradual spread of urban influences on the traditional rural hierarchy. His counter to this was to present the peasant as a 'type' and a passive individual ruled by the order of the seasons and he instructed his followers to 'choose your models most carefully', for they must 'without fail be picturesque and typical', 'Change and Decay: Emerson's Social Order', in Neil McWilliam and Veronica Sekules, eds, *Life and Landscape, P. H. Emerson, Art and Photography in East Anglia, 1885–1900*, Sainsbury Centre for Visual Arts, 1986, pp. 12–20.

27. See 'The Collection of Sharpley Bainbridge Esq., J. P. Lincoln', *The Art Journal*, 1898, p. 228. Sharpley Bainbridge's collection included also Clausen's *Mowers* as well as works by Samuel Palmer, Pinwell's *The Princess and the Ploughman*, and pictures by Birket Foster, pp. 225–9 and 272–4.

28. J. Stanley Little, 'On the Work of Edward Stott', *The Studio*, vol. 6, November 1895, p. 78.

29. See Lucas, *Highways and By Ways of Sussex*, quoted in P. H. Ditchfield, *Cottage and Village Life*, illustrated by A. R. Quinton, first pub. Dent, 1912, this facsimile edition, Bracken Books, 1993, pp. 67–8.

30. H. G. Wells, 'Anticipation of the Reaction of Mechanical and Scientific Progress upon Human Life and Thought', London: Chapman and Hall, 1904, cited in Donald Read, ed., *Documents from Edwardian England, 1901–1915*, Harrap, 1973, p. 33.

31. Qualities, in fact, that English painters had associated in the early 1880s with the French village of Grez-sur-Loing.

32. J. Stanley Little (see note 28).

33. Processes like these have been described in Ann Janowitz, *English Ruins: Poetic Purpose and the National Landscape*, Cambridge: Cambridge University Press, 1990.

34. J. Stanley Little (see note 28).

35. See, for instance, *To Colonise England, A Plea for a Policy*, C. F. G. Masterman, W. B. Hodgson and Others, London: Fisher Unwin, 1907, p. 189.

36. For important discussion of the functions of the picturesque and the pastoral see e.g. Ann Bermingham (see note 6), 1987, and see also Brian Short's essay 'Images and Realities in the Rural Community: An Introduction', in Brian Short, ed., *The English Rural Community, Image and Analysis*, Cambridge: Cambridge University Press, 1992.

37. Ditchfield states that his book is partly intended for 'our countrymen across the seas'. Those now living in America and Australia, will recall happy memories of 'the Old Country, its rural scenes and associations', (see note 29), n.p.

38. Ibid., p. 163.

39. Bourne, (see note 16), pp. 121–2.

40. Ditchfield, (see note 29), p. 177.

41. For discussion of British Empire exhibitions, see John M. Mackenzie, *Propaganda and Empire, The Manipulation of British Public Opinion, 1880–1960*, Manchester: Manchester University Press, 1984, pp. 97–120.

42. Ditchfield, (see note 29), p. 3.

43. All this the author identifies since the collapse of taste in the nineteenth century and the trend for classical and gothic architecture. By 1912 he could discern the emergence of a sounder taste, and 'it would be hard to exaggerate the value of these little English cottages from this aspect of beauty alone', 'Cottage building is neither Gothic nor Classic; it is just good, sound, genuine and instructive English work', ibid., p. 16.

44. Ibid., p. 80.

45. Gabriel Mourey, 'The Art of M. Le Sidaner', *The Studio*, vol. 24, 1901, p. 30. Works by Le Sidaner were included in the Grafton Galleries 'Modern French Art' exhibition at the end of 1899, at the International Society exhibition of 1901, at the Hanover Gallery in 1902 and at the Goupil Gallery in 1905, 1907, 1908 and 1910. Ref. see chronology by Anna Greutzner Robins – *Post Impressionism*, catalogue of an exhibition, Royal Academy of Arts, 1979–1980.

46. 'The Royal Academy', *The Art Journal*, 1898, p. 164.

47. For a discussion of the term 'enchantment' in relation to George Moore's appreciation of the

special qualities, the allure and charm of Boucher and Watteau, see Kenneth McConkey, 'A Walk in the Park', in David Peters Corbett and Lara Perry, eds, *English Art, 1860–1914, Modern Artists and Identity*, Manchester: Manchester University Press, 2000, pp. 102–3.

48. Haldane MacFall was here describing Clausen's *A Village Street*, seen at the Goupil Gallery, in 'The Art of Mr Clausen', *Academy and Literature*, 3 December 1904, p. 569. Also see pictures like Lucy Kemp Welch's *The Village Street* at the Royal Academy in 1903 and Yeend King, *A Peaceful Village*, shown at the Royal Academy in 1911. These are just random examples.

49. D. S. MacColl, *The Saturday Review*, 28 January 1899, pp. 110–11. The previous year Jack Nettleship published a monograph on Morland (J. T. Nettleship, *George Morland*, Seeley & Co., 1898), making connections between his art and that of Millet and drawing on Clausen's essay 'Bastien-Lepage as Artist', in André Theuriet, *Jules Bastien-Lepage and his Art*, London: Fisher Unwin, 1892. In all cases it was asserted that the realism of Lepage had led to an impasse; literal truth was achieved at the expense of beauty. This was Clausen's position in the 1890s, but MacColl clearly felt the latter had gone too far in his pursuit of selection and faithfulness of representation had suffered.

50. 'The Royal Academy of 1899', *The Art Journal*, p. 168.

51. D. S. MacColl, *The Saturday Review*, 6 May 1899, pp. 556–7. Millet's peasants were not of course 'Breton'.

52. See George Moore review in *The Speaker*, 1892, cited in *Modern Painting*, Walter Scott Ltd, 1898, p. 122.

53. Claude Phillips, 'The Royal Academy', *The Art Journal*, 1892, p. 220.

54. For more discussion of mechanization in agriculture and the social and moral debate around gang labour see Alun Howkins, 'The Problems of Consensus: The Contradictions of the System', in *Reshaping Rural England, A Social History, 1850–1925*, London and New York: Harper Collins, 1991, pp. 93–116.

55. 'The Mower's Scythe', *The Saturday Review*, 9 July 1904, pp. 46–7.

56. Ibid.

57. For further discussion, see J. Patrick, 'Agricultural Gangs', *History Today*, March 1986, pp. 21–6. The Agricultural Gangs Act first forbade the employment of children under eight and also of men and women working in the same gang. More reforms were effected through the spread of compulsory education through to the end of the 1890s. But as Patrick points out, the use of casual gangs of labour persisted in certain areas, until at least the post-war period in the example of potato harvesting alone.

58. Howkins (see note 54), 1991.

59. Ibid., p. 226.

60. Quoted by H. R. Mansfield, 'The Rural Exodus', in *To Colonise England* (see note 35), p. 186.

61. La Thangue had already evolved the prototype for his picture in the earlier work *In the Dauphiné*, shown at the first New English Art Club exhibition. The composition is virtually identical but the position of the two figures in relation to the picture frame has been reversed.

62. The popularity of Greiffenhagen's picture is referred to by lovers in D. H. Lawrence's *The White Peacock*, Harmondsworth: Penguin, 1954, p. 48 (1st ed., 1911).

63. 'The Royal Academy', *The Art Journal*, 1899, p. 166.

64. Ibid.

65. 'The Academy', *The Saturday Review*, 6 May 1899, pp. 556–7.

66. Laurence Binyon, 'The Academy Again', *The Saturday Review*, 22 May 1909, p. 655.

67. MacColl (see note 51).

68. George Thomson, (see note 8), La Thangue showed his own version of *Travelling Harvesters*, at the Royal Academy in 1897. Illustrated in McConkey, *A Painter's Harvest, 1859–1929*, Oldham Art Galleries & Museum, 1978.

69. Rider Haggard (see note 12), vol. 1, p. 130. The 'Three Acres and a Cow' campaign, led by Jesse Collings and Joseph Chamberlain, was identified in the public mind with the Back-to-the-Land Movement and is discussed in Peter C. Gould, *Early Green Politics, Back to Nature, Back to the Land, and Socialism in Britain, 1880–1900*, Harvester Press, 1988, pp. 104–23.

70. See George Bunyard, *Fruit Farming for Profit*, Royal Nurseries, Maidstone, 1899.

71. Ditchfield (see note 29), p. 84.

72. P. J. Waller discusses the intricate links and interwoven economies that continued between town and country dwellers and mentions also the use of West Midlands townsfolk in the cider and beer-making industries of Herefordshire and Worcestershire, in *Town, City and Nation, 1850–1914*, 1983, Oxford: Oxford University Press, p. 193.

73. Review of *Sussex*, illustrated by Wilfred Ball, in vol. 39, p. 89.

74. Stuart Laing, 'The Rural in Popular Culture', in Brian Short (see note 36), p. 141. The coster featured regularly in paintings of the period, as for instance in William Rothenstein's *The Coster Girls*, 1894.

75. For a discussion of imagery of Cockney coster women in the period, see my essay 'London Types' in *The London Journal*, vol. 25, no. 1, 2000, pp. 34–51.

76. John Masefield, 'The Land Workers', in *Collected Poems*, London: Heinemann, 1923, p. 12.

77. The living conditions pickers endured while working were well known. One commented in 1909 that 'a hop garden is a hell'. Urban reformers, clergy and educationalists all debated the problem which, by 1908, had taken on political implications resulting in demonstrations in London against the importation of foreign hops and the slogan 'England expects every foreign hop to pay its duty'. By September, summer storms in Kent had led to national press reports and to an aid appeal for the 30,000 starving hop-pickers stranded there in over-crowded workhouses, at which point the socialist editor of *The Clarion*, Robert Blatchford, went on a tour of the county in an attempt to stir even greater unrest. See J. G. W. Farley, *Pull No More Poles, An Account of a Venture among Hop-Pickers*, London: Faith Press, 1962, p. 11.

78. Another painting, *Hop Binding* by Edgar Barclay (untraced, ill. in *Pall Mall Gazette 'Extra'*, 1897, p. 92), was shown at the New Gallery in 1897. The real interest here is in the children playing contentedly by the stream rather than in the activity of the solitary hop-binder. *A Worcestershire Hop Garden* (untraced, ill. in *Pall Mall Gazette 'Extra'*, 1890, p. 48), by Walter Urwick, hung at the Academy in 1890, shows a distanced view of the activity of the pickers, the regulated composition is framed by a young labourer, his wife with babe in arms, leading our eye into what appears to be a carefree picnic atmosphere.

79. 'The Academy: and Mr Fry's Drawings', *The Saturday Review*, 8 May 1909, p. 590.

80. Masefield, (see note 76), p. 11.

81. Allotments were regarded positively by Socialists in the 1890s as well, for both their economic and moral benefits. In northern areas allotments were seen as a healthy open-air experience for the industrial workforce. For more discussion, see Peter C. Gould (note 69), p. 121.

82. C. F. G. Masterman, *The Condition of England*, London: Shenval Press, 1909, p. 149.

83. Dewey Bates (see note 24).

84. Mingay (see note 2), pp. 196–7.

85. See *To Colonise England*, (note 35), p. 132.

86. On this see Mingay (as in note 2).

87. P. J. Waller (see note 72), p. 190.

88. For more discussion see W. A. Armstrong in Mingay (see note 2), p. 123.

89. Rider Haggard (see note 12), p. 540.

90. Dewey Bates (see note 24), p. 555.

91. George Bourne also comments on 'the jealousy, suspicion, some fear (and) the elements of bitter class war in fact, (which) frequently mark the attitude of middle class people towards the labouring class' (see note 16), p. 108.

92. Laurence Houseman, 'Edward Stott: Painter of the Field and Twilight', *The Magazine of Art*, 1900, p. 531.

93. Rider Haggard (see note 12)

94. For Ditchfield, urban types were quite simply, 'feckless folk', and so it was foolish ignorance to speak of taking these people back to the land. This was just the 'noisy talk of agitators and Socialists'. Change for this writer could only be for the worse, 'we love to keep in the old ways and follow in the footsteps of our sires', (see note 29), pp. 178–9.

95. *The Connoisseur*, vol. IX, 1904, p. 142.

96. Dyneley Hussey, *George Clausen*, Contemporary British Artists, London: Ernest Benn, 1923.

97. Clausen (see note 17), p. 96.

2 The joys of sight

1. *Saturday Review*, 1 May 1909, pp. 556–7. Binyon was reviewing Steer's Goupil Gallery exhibition of that year.

2. Surveying Steer's career in 1952, Rothenstein, responsible for buying the bulk of the Tate

Gallery's collection of early Steers, wondered at the radical differences between paintings like *Girls Running, Walberswick Pier*, begun in 1890, and works such as *A Classic Landscape*, 1893. Unsure of the merits of these later works, he could nevertheless discern the legacy of Impressionism in their loose handling and atmospheric qualities. Nevertheless, he wrote, 'this almost total transformation in Steer's outlook, which appears to me to be the most important event in his life, has remained, so far as I am aware, unnoticed or ignored by all those who have written on his work'. For Rothenstein, adopting the classic Modernist position on Steer, the 'deterioration' of his creative faculties was difficult to explain given his sporadic development and famous silences. The writer ended by speculating on the effects of lethargy, debilitating middle age and even the end of his relationship with his young model Rose Pettigrew. See John Rothenstein, *Modern English Painter*, vol. 1, *Sickert to Smith*, London: Eyre & Spottiswoode, 1952, p. 73.

3. For discussion of these processes, see catalogue essay by Kenneth McConkey in *Impressionism in Britain*, Yale University Press and Barbican Art Gallery, 1995. See also a different version of this chapter in Ysanne Holt, 'Nature and Nostalgia, Philip Wilson Steer and the Edwardian Landscape', *Oxford Art Journal*, vol. 19, no. 2, 1996, pp. 28–45, see also Ysanne Holt, *Philip Wilson Steer*, Bridgend: Seren Press, 1992. My own two previous studies, I now feel, significantly undervalued Steer's continued relationship with Modernism after the mid-1890s – an issue re-addressed here.

4. For later critics this situation was more likely a cause for criticism. Such was the view of Douglas Cooper who, writing in 1945, rejected English painting for exactly those qualities that it was valued earlier. By the late 1940s, Cooper was building up his collection of Picasso, Braque and Léger and was highly critical of those characteristics of Englishness in British art, which excluded it from what he regarded as the onward progression of modernism. Following his death in 1942, Steer had been fêted as the epitome of an English painter and so it was natural that he should become the target of Cooper's invective. In 'The Problem of Wilson Steer', the painter was condemned for his eclecticism, the lack of logical advancement in his art or of any individual formal language; see *The Burlington Magazine*, vol. 84, 1944, pp. 66–71. So while the reception of Steer's paintings reveals interesting assumptions about the nature of Englishness as a unifying ideal at the turn of the twentieth century, it also provokes consideration of the Modernist traditions of thinking about British art.

5. William Rothenstein, *Men and Memories, Recollections of William Rothenstein; 1872–1900*, vol. 1, London: Faber & Faber, 1932, p. 170.

6. William Gerdts, *John Singer Sargent*, exhibition catalogue, Whitney Museum of American Art, New York, 1986, p. 118.

7. This review was discovered by Laughton in the British Museum cutting book, but with no identification. He was of the opinion that it may have been written by the critic of the *Telegraph*, Bruce Laughton, *Philip Wilson Steer, 1860–1942*, Oxford: Clarendon Press, 1971, p. 14.

8. Like most of his peers, Steer did not become completely familiar with Impressionism until, ironically, he returned from his training in Paris and saw exhibitions in London, like for example in 1889, when 20 Monets were displayed at the Goupil Gallery.

9. The retrenchment that occurred at the Slade School in the early 1890s was paralleled by increased social and political introspection. This had reverberations in the stamping out of the last traces of decadent aestheticism as the decade progressed. For further discussion, see Holbrook Jackson, *The 1890s: A Review of Art and Ideas at the Close of The Nineteenth Century*, London, 1913. Jackson cites in support of his view the sobering effect of Oscar Wilde's imprisonment in 1895.

10. Steer also showed eight pictures at the 1889 London Impressionists exhibition at the Goupil Gallery, which provided further evidence of the influence of Monet. By the time this Sickert-led splinter group had formed within the New English, the original Rustic-Naturalist contingent were already gravitating towards the Royal Academy.

11. George Moore, *Modern Painting – II*, 1898, p. 99. First published as 'The Royal Academy', *The Fortnightly Review*, January–June 1892.

12. Ibid., p. 243.

13. C. F. G. Masterman, *The Condition of England*, London: Shenval Press, 1909, p. 156.

14. *The Studio*, vol. 33, 1904, p. 96.

15. Mark Pattison was Head of Lincoln College and believed that a 'liberal' or 'higher' education would inculcate in the individual a higher sensibility which would transcend mindless routines. See Brian Doyle, 'The Invention of English' in Robert Colls and Philip Dodd, eds, *Englishness, Politics and Culture*, London: Croom Helm, 1986, op. cit., p. 94. It was Pattison who offered MacColl his scholarship at Oxford in 1881. For an account of MacColl's association with Oxford, see Maureen Borland, *D. S. MacColl: Painter, Poet, Art Critic*, Harpenden, Herts: Lennard Publishing, 1995.

16. Brian Doyle (in Colls & Dodd, op. cit., p. 99) describes the role of the Oxford Extension Movement in the context of efforts to encourage national character and culture from the late

1880s. In the universities this developed alongside a gradual eclipse of Latin and Greek, in favour of the study of English language and literature. The Extension Movement itself was an attempt for those universities to take on a national role. According to the Oxford Vice Chancellor in 1887, 'the lecturers whom we send through the country are a kind of missionary … To a great majority of those persons with whom they come into contact it is the only opportunity afforded of learning what Oxford means and what is meant by the powers of all Oxford education.'

17. *The Spectator*, 11 May 1895.

18. Charles Harrison, *English Art and Modernism, 1900–1939*, Allen Lane/Indiana University Press, 1981, 2nd edn Yale University Press, 1994, p. 17 (in both editions). Harrison's definition aptly describes MacColl's position by the 1890s: 'purity entailed the pursuit of technical autonomy, a manifest if highly mediated interest in recent French art, and the avoidance of subjects which might conceivably be taken as moral exhortations'.

19. D. S. MacColl, *Life, Work and Setting of Philip Wilson Steer*, London: Faber & Faber, 1945, p. 31.

20. For discussion of the extent to which Modernist writing misrepresented the aims of French Impressionism, downplaying subjective, symbolic preoccupation, see Richard Schiff, *Cézanne and the End of Impressionism, A Study of the Theory, Technique and Critical Evaluation of Modern Art*, Chicago: University of Chicago, 1984.

21. For Denis, Cézanne's art was related to Symbolism more than to Impressionism. It 'implied the belief in a correspondence between external forms and subjective states. Instead of evoking our moods by means of the subject represented, it was the work of art itself which was to transmit the initial sensation and perpetuate its emotions.' Fry translated Denis's article for *The Burlington Magazine* in January 1910. Passage here cited from J. B. Bullen, ed. *Post Impressionists in England: The Critical Reception*, London: Routledge, 1988, p. 69.

22. D. S. MacColl, 'Theoretical Precedents for Impressionism', *The Spectator*, 12 December 1891, p. 846.

23. Cited in D. S. MacColl, (see note 19), pp. 177–8.

24. This attitude persisted with only few exceptions of whom Camille Mauclair was one; he described Monet as a poet-painter, his water-lilies as a 'pantheistic evocation' and his approach one of 'idealism and lyric dreaming', cited in Kate Flint, ed., *Impressionists in England, The Critical Reception*, London: Routledge & Kegan Paul, 1984, p. 322.

25. *The Art Journal*, 1905, p. 166.

26. These complaints continued throughout the whole period of this study. A. L. Baldry, for instance, commented, 'The Academy is contented to plod on year by year in the same path, to hang what are to all appearances the same pictures, and to do things exactly as they were done in that remote period when its ideals were fresh and its principles were first formulated', *The Studio*, 1905, vol. 35, p. 37.

27. Denis (see note 21).

28. *Pall Mall Gazette*, 27 February 1894, cited in Laughton, (see note 7), p. 56.

29. Review in *The Spectator*, cited in MacColl, (see note 19), p. 48. *A Procession of Yachts* is in the Tate Gallery.

30. This of course ignored the fact that Monet often painted in his studio away from nature and would at times re-order his compositions. Musical analogies may be equally appropriate to a discussion of Monet's art, to his *Poplars* for example. MacColl, however, was set in his pursuit of distinctions.

31. William Rothenstein, (see note 1), p. 171.

32. D. S. MacColl, (see note 19), pp. 48–9.

33. Douglas Cooper (see note 4).

34. Cited in Osbert Sitwell, ed., *A Free House, The Writings of W. R. Sickert*, London: Macmillan, 1947, p. 57.

35. Frank Rutter, *Art in My Time*, London: Rich & Cowan, 1933, p. 65.

36. *The Studio*, vol. 20, 1900, pp. 213–16. A brief survey of the titles of Academy pictures of this period indicates just how much this sense of a lost world preoccupied painters. Such titles as David Murray's *Farewell to the Forest*, 1906, C. E. Johnson's *The Sunset of his Days* and Benjamin Leader's *Evening Glow*, 1906 are typical.

37. Some connections might be made here to the market for landscape painting in France in the 1850s and 1860s. See, for example, Anne Wagner's discussion of the appeal of Courbet's landscapes to their bourgeois purchasers who often commissioned exact size, motif and weather effect. The simplicity and predictability of Courbet's works, the ordering of their elements, was a crucial part of their appeal – 'Courbet's Landscapes and their Market', *Art History*, vol. 4, no. 4, December 1981, pp. 410–29.

38. Somewhat ironically, given the prejudice of Steer's supporters, but this was of course Cézanne's concern too – as reported by Denis (see note 21).

39. Turner's *Walton Bridges* is now at the National Gallery of Victoria, Melbourne. Steer would have been able to study the composition of other Thames pictures through Turner's *Liber Studiorum*, 1878, Macmillan & Co. In particular he would have seen there the 1840–1845 *Landscape with Walton Bridges*, which is particularly close to *A Classic Landscape*. Steer's friend and Slade colleague Fred Brown also painted views of the Thames at this date. There is a possibility that *The Thames at Richmond*, of 1893, cited in the Barbican *Impressionism in Britain* exhibition catalogue (no. 214, see note 3), as Steer's study for *A Classic Landscape*, is actually by Brown.

40. Andrew Hemingway, *Landscape Imagery and Urban Culture in early Nineteenth Century Britain*, Cambridge: Cambridge University Press, 1992, pp. 216–38.

41. For these readings of Monet see especially T. J. Clark, *The Painting of Modern Life: Paris in the Art of Manet and his Followers*, London: Thames & Hudson, 1985.

42. Frederick Wedmore was one of the first British critics to attend seriously to Impressionism, e.g. 'The Impressionists', *Fortnightly Review*, Vol. XXXIII, 1883, pp. 75–82. See Flint, (as in note 24), pp. 46–55. On the terms of Dewhurst's appreciation see Kenneth McConkey, *Impressionism in Britain*, Yale University Press and Barbican Art Gallery, 1995, pp. 82–3.

43. Wynford Dewhurst, *Impressionist Painting, Its Origin and Development*, 1904.

44. Andrew Forge, *Philip Wilson Steer*, London: Arts Council of Great Britain, 1960, p. 7.

45. Although Bruce Laughton has cast doubt on MacColl's assertion, (see note 7, p. 89). Firstly, as he says, the *Liber* was not an authorized version of the 'English' landscape, but of generic landscape compositions; secondly it seems that no pocket edition of the kind MacColl describes was yet in evidence. Steer did of course know the contents of the *Liber* and the anecdote does also reveal the extent to which MacColl was concerned to emphasize the nationalist associations of Steer's art.

46. D. S. MacColl, (see note 19), p. 125.

47. Ibid., p. 81.

48. Steer's patrons were not the newly monied, northern industrialists buying from La Thangue and Clausen. They were drawn from the traditional professions rather than from trade, including a solicitor, Augustus Daniel, a publisher, Geoffrey Blackwell, Judge Evans and Michael Sadler, the Vice Chancellor of Leeds University. From the gentry, he sold to the de Walden family at Chirk Castle – later supporters of Augustus John.

49. Cal Clothier, 'Philip Wilson Steer: Some Watercolours from the Leeds Collection', *Leeds Art Calender*, no. 97, 1985, p. 27.

50. The turn of the twentieth century saw the development of various efforts to both encourage these 'trippers' on the one hand and to preserve rural areas from them on the other. For the more discerning, art magazines were constantly reviewing and recommending new guidebooks to counties like Sussex and Dorset as well as publishing periodic notes on rural sketching grounds.

51. D. S. MacColl, (see note 19), p. 168.

52. Ibid.

53. Ibid., p. 82.

54. Chepstow Castle was of course painted by both Turner and Girtin, and they were influenced in their choice by the elaboration of the picturesque theory which had resulted from the Reverend Gilpin's travels around the Wye Valley in the late eighteenth century. Gilpin had urged painters to depict the roughness and irregularity of their chosen sites, to look for character, not perfection. Bruce Laughton illustrates Turner's engraving of Chepstow from the *Liber Studiorum*, (see note 39), plate 48. For more discussion of Steer at Chepstow, see my earlier study, *Philip Wilson Steer*, (as in note 3), pp. 94–5. The painting is in the Tate Gallery.

55. 'The Work of Herbert Alexander', *The Studio*, vol. 31, 1904, p. 306. It is this national hankering after the past identified here by Houseman which Martin Wiener blamed for the country's failure to ever come to terms either with modernism in art or modernity in life. See M. Wiener, *English Culture and the Decline of the Industrial Spirit, 1850–1950*, Cambridge: Cambridge University Press, 1981.

56. George Clausen, intro. to *Mark Fisher*, Leicester Galleries Exhibition, 1924.

57. Works by Monticelli, owned by Alexander Reid, were shown in Arthur Collie's Bond Street gallery that year. Symons's discussion of the painter appears in the midst of his review of MacColl's book *Nineteenth Century Art*, in *Fortnightly Review*, January–June, 1903, pp. 520–34.

58. For excellent discussion of Constable's significance at the end of the nineteenth century see Stephen Daniels, 'John Constable and the making of Constable Country, 1880–1940' in *Landscape Research*, Summer 1991, vol. 16, no. 2. Daniels attends to Holmes's book and deals also with the extent to which the burgeoning market for Constable paintings provoked debate on 'commodity

patriotism' from the late 1880s. See also, Ian Fleming Williams and Leslie Parris, *The Discovery of Constable Country*, London: Hamish Hamilton, 1984.

59. A new edition of C. R. Leslie's 1845 biography was edited by G. D. Leslie in 1896. At the same time there was an increasing trade in Constable pictures, in particular to America. As Daniels points out (Ibid., p. 11), Holmes's book was a systematic attempt to catalogue his work in the face of a flood of Constable pictures being released on to the market, both real and fake.

60. C. J. Holmes, *The Times*, 22 April 1909. Holmes was here happy to perpetuate the idea of Steer as Constable's successor.

61. Sir James Linton, 'The Sketches of John Constable, R.A.', *The Magazine of Fine Arts*, 1906, pp. 16–21.

62. For a chronological list of Steer's painting locations see Laughton, (see note 7), pp. 125–6. Steer did return to North Yorkshire on several occasions up to 1904.

63. Cited in Robin Ironside, *Wilson Steer*, London: Phaidon Press, 1943, p. 6.

64. *The Art Journal*, 1905, p. 170.

65. 'Mr Geoffrey Blackwell's Collection of Modern Pictures', *The Studio*, vol. 61, pp. 271–82. Blackwell was an important patron for Steer and also for Lucien Pissarro, Henry Tonks and C. J. Holmes. According to Manson, 'He responded to the call of nature', as expressed in Steer's pictures. 'He felt in them an intenser quality of light and air than he had previously experienced in any of the ordinary paintings which are commonly to be met with in the social world, decorating the drawing rooms of Mayfair with their empty triviality.'

66. Ibid.

67. On the potential relation between Cézanne's technique and Steer's paintings of the Square at Montreuil, painted just after his visit to the Salon – and also on his first visit to France for thirteen years – see Laughton, (as in note 7), p. 97.

3 Seeking classic lands

1. Laurence Binyon, *The Saturday Review*, 6 June 1908, p. 720. In his survey of the pioneering years of the Slade School between 1893 and 1907, D. S. MacColl had summed up the potential of Augustus John, regarded by him as the most promising young painter of that era in similar terms: 'The temper of Mr John is rebellious against the ordinary and scornful of the pretty, and the anarchic young has not yet controlled or concentrated his passion to the creation of great pictures; but he has given us some measure of his powers and indication of their quality', John Fothergill, ed., *The Slade, A Collection of Drawings and Some Pictures Done by Past and Present Students of the London Slade School of Art, MDCCCXCIII–MDCCCCVII*, 1907, p. 9.

2. Arthur Symons, 'The New English Art Club', *The Saturday Review*, 1 December 1906, p. 673.

3. The quote is from Binyon (June 1908) (see note 1), p. 720.

4. For interesting recent discussions of shifting constructions of masculinity amongst British artists from the close of the nineteenth century, see Lisa Tickner, 'English modernism in the cultural field' and Andrew Stephenson, 'Refashioning modern masculinity: Whistler, aestheticism and national identity', both in David Peters Corbett and Lara Perry, eds, *English Art, 1860–1914, Modern Artists and Identity*, Manchester: Manchester University Press, 2000.

5. Anthony M. Ludovici, *Nietzsche and Art*, New York, 1911. The author blamed what he saw as the debased condition of contemporary art on the lack of consistent aesthetic canons, and 'when there is no longer anybody strong enough to command or to lead', p. 8. Taking a range of artists from Monet to Alfred East, Ludovici questioned their 'plebeian embarrassment, this democratic desire to please', and 'their democratic disinclination to assume a position of authority' and asked, 'Why are their voices so obsequiously servile and faint?', p. 16. Finding no worthy successor to the 'bright missiles' fired by Whistler, the world now seemed to be one of decomposition and decay, p. 17.

6. Wallace Martin, ed., *Orage as Critic*, London: Routledge & Kegan Paul, 1974, p. 11.

7. John's friend Wyndham Lewis commented on what he termed, the 'biblical course of this patriarch'. Cited in Michael Holroyd, *Augustus John*, vol. 2, *The Years of Experience*, London: Heinemann, 1975, p. 139.

8. John's essays for the Gypsy Lore Society can be seen in the context of the national dictionaries and collections of folk tales and songs to appear during these years. As such this was a respectable academic pursuit, 'gypsiology', requiring a degree of the professionalism that he chose to play down in his artistic career. He felt himself possessed of Romany characteristics like pride, suspicion and sensitivity, revealing a degree of both racial stereotyping and aesthetic snobbery. Not all distinct cultures were so attractive to him however; William

Rothenstein he once described as 'Le sale juif par excellence', see Michael Holroyd, *Augustus John*, vol. 1, *The Years of Innocence*, London: Heinemann, 1974, p. 186, revealing an anti-Semitism that was typical of the time.

9. Lisa Tickner has studied John and the vogue for gypsy life in the context of her close reading of 'The Smiling Woman' and 'A Lyric Fantasy', in *Modern Life and Modern Subjects; British Art in the Early Twentieth Century*, New Haven and London: Yale University Press, 2000. My approach derives from a broader discussion of John's place within modernist landscape painting and the culture of ruralism as developed in my unpublished PhD thesis, 1998.

10. Marilyn R. Brown, *Gypsies and other Bohemians. The Myth of the Artist in Nineteenth Century France*, UMI Research Press, Studies in the Fine Arts: The Avant-Garde, no. 51, 1985, p. 6.

11. Arthur Symons, 'In Praise of Gypsies', *Gypsy Lore Society Journal*, vol. 1, July 1907–April 1908, pp. 294–8. Malcolm Easton and Michael Holroyd recorded that after their meeting in 1902, Symons 'found a hero of the new century in John'. John painted Symons's portrait in 1917. See M. Holroyd and M. Easton, *The Art of Augustus John*, London: Secker & Warburg, 1974, pp. 160–1.

12. On this see especially Lisa Tickner's discussion of *The Smiling Woman* in *Modern Life and Modern Subjects* (see note 9).

13. Macfie and Sampson were both gypsy scholars.

14. For an extended discussion of Munnings's gypsy paintings, see my essay 'Gypsy Life', in Kenneth McConkey, *An English Idyll, A loan exhibition of works by Sir Alfred Munnings*, Sotheby's, January 2001.

15. Illustrated in John Rothenstein, *Augustus John*, Oxford: Phaidon, 1946 (3rd edn), plate 6.

16. It is likely that John saw the 1899 Puvis exhibition in Paris. He certainly saw his paintings in the Louvre on that visit and he had already seen reproductions of the artist's works by that date. There were also a number of articles in British periodicals, including Gabriel Mourey's in *The Studio*, vol. 18, no. 79, 1899, pp. 12–18. Amongst the illustrations was Puvis's *Marseilles, Colonie Greque*, a composition of two seated women and a child at the edge of the Mediterranean – a most likely influence for John's Martigues compositions. An English translation of Arsène Alexandre's copiously illustrated *Puvis de Chavannes*, London: George Newnes, appeared undated but almost certainly around 1905.

17. Cited in Holroyd, vol. 1, (see note 8), p. 253.

18. Mourey, (see note 16), p. 18.

19. Charles Ricketts, 'Puvis de Chavannes; A Chapter from "Modern Painters"', *The Burlington Magazine*, vol. XIII, April–September, 1908, pp. 9–12.

20. The dress worn by Dorelia aroused considerable comment and a number of copyists. One critic remarked, 'and if the woman of Mr John's feminine type is, as we are told, in advance of our present time, it is not enough for everyone to find this out: for though designing most of her own dresses, she has not quite abandoned the Victorian mode'. In this sense the critic pinpointed the ambivalence in John's work in general concerning works, which appeared modern and yet related to gender ideals of the previous century. See review of the NEAC Summer Exhibition, *The Studio*, vol. 47, 1909, p. 178.

21. Quoted in Janet Dunbar, *Dame Laura Knight*, London: Collins, 1975, p. 98. This was a review of Knight's 1916 exhibition at the Leicester Galleries.

22. Review of New English Art Club, *The Art Journal*, 1905, p. 32.

23. Thomas Hardy, *The Return of the Native*, Book 1, VI, 'The Figure against the Sky' (1st edn, 1878), London: Penguin, 1978, pp. 104–8.

24. James Bone, 'The Tendencies of Modern Art', *Edinburgh Review*, April 1913, reprinted in J. B. Bullen, ed., *Post Impressionists in England: The Critical Reception*, London: Routledge, 1988, p. 440.

25. 'Night is on the downland', from 'Lollingdon Downs', in *Poems by John Masefield*, London: Heinemann, 1954, xvii (1st edn, 1923), pp. 323–4.

26. For example, see Ivor Gurney, 'Your hills not only hills, but friends of mine and kindly, your tiny orchard knolls hidden beside the river.' Cited in R. K. R. Thornton, ed, *Ivor Gurney, War Letters*, London: Hogarth Press, 1984, p. 87 (1st edn, 1983).

27. Excerpts from these letters appear in Holroyd, vol. 1, (see note 8), pp. 258–9.

28. On these sketches and their derivation see A. D. Fraser Jenkins, *Augustus John, Studies for Compositions*, exhibition catalogue, National Museum of Wales, Cardiff, 1978. John would have seen Puvis's *Pauvre Pêcheur* in the Musée de Luxembourg. The Pantheon cycle was also on public view in Paris and this included *St Genevieve Bringing Food To Besieged Paris, II* which, with its descending row of figures, seems a most likely influence on John – most particularly on *The Way Down to the Sea*.

29. Gauguin was shown at Frank Rutter's first Allied Artists Association exhibition in London in July 1908 and at Robert Dell's 'Modern French Art' exhibition in Brighton in June 1910.

30. However, as Stephen Eisenmann points out, Gauguin himself was at pains to distinguish his own primitive instinct from Puvis's conventional use of allegory. Writing to Charles Morice in 1901 he stated 'He [Puvis] is Greek whereas I am a savage, a wolf in the woods without a collar', *Gauguin's Skirt*, London: Thames & Hudson, 1997, p. 142.

31. *The Sunday Times*, 18 June 1911. Cited in Keith Clements and Sandra Martin, *Henry Lamb, 1883–1960*, catalogue of an exhibition, City of Manchester Art Galleries, 1984.

32. J. B. Manson – another later member of the Camden Town Group – painted the scenery around Douélan after 1905 in works which still revealed vestiges of Impressionism, but his example is untypical in this respect. For an example from Manson's Brittany period see *Summer Day, Douélan, Brittany*, 1907 reproduced in Wendy Baron, *The Camden Town Group*, Aldershot: Scolar Press, 1979.

33. The review is of 'Mrs Gosling's charmingly illustrated book "The Bretons at Home"' with an introduction by the French 'student of folk-lore', Anatole le Braz, *The Nation*, 22 May 1909, pp. 273–4.

34. Ibid.

35. On 'place myths' see Rob Shields, *Places on the Margin, Alternative Geographies of Modernity*, London: Routledge, 1991. For discussion of Shields's concept in relation to artists' colonies see Nina Lübbren, *Rural Artists' Colonies in Europe, 1870–1910*, Manchester: Manchester University Press, 2001.

36. David Fraser Jenkins provides a detailed account of the stages in development of the work up to its purchase by John Quinn in 1912, (see note 28), n.p. He identifies the composition as similar to Puvis's *Le Paix*.

37. For discussion of *A Lyric Fantasy*, see chapter 8. For fascinating, but differently focused discussion, see also Lisa Tickner's chapter on John in *Modern Life and Modern Subjects*, (note 9).

38. Holroyd, vol. 1, (see note 8), p. 292.

39. Ibid., p. 293.

40. John's description of Innes appears in 'Fragment of an Autobiography', *Horizon*, vol. XI, no. 64, April 1945, p. 25.

41. A year later Fothergill was to accompany John on a caravan expedition that took in Roger Fry's house in Guildford and ended on Ranmore Common. For an account, see Holroyd, vol. 1, (note 8), p. 295.

42. John Fothergill, *James Dickson Innes*, London: Faber & Faber, 1946, pp. 7–11.

43. *The Wye Near Chepstow* is in a private collection but illustrated in ibid. *Bozouls Near Rodez* is in the Tate Gallery. Steer's influence can also be seen on Innes' Slade contemporary Maxwell Lightfoot's *View of Conway*, c.1910, now in the Walker Art Gallery, Liverpool.

44. Fothergill, (see note 42), p. 8.

45. Ibid.

46. For an account of Löwy's principles see Meyer Schapiro's collected essays in *Theory and Philosophy of Art, Style, Artist and Society*, New York: George Brazilier, 1994, pp. 77–8.

47. 'Norman Shaw and the New English Art Club', *Saturday Review*, 1912, p. 708.

48. John Rothenstein, 'James Dickson Innes, 1887–1914', *Modern English Painters, Lewis to Moore*, London: Eyre & Spottiswoode, 1956, p. 66.

49. The portrait of 1913 is in the National Museum of Wales, Cardiff.

50. Augustus John, *Chiaroscuro, Fragments of an Autobiography*, London: Jonathan Cape, 1962, p. 65. This last remark is faintly ironic given that, from the early 1900s, artists quite commonly illustrated guide books for the tourist, which were then frequently reviewed in art magazines like *The Studio*.

51. For Lane's Lindsay House project, see Robert O. Byrne, *Hugh Lane, 1875–1915*, Dublin: The Lilliput Press, 2000, pp. 116–28.

52. See Holroyd, vol. 1, (see note 8), p. 324. Cited from a letter to Ottoline, December 1909.

53. *Chiaroscuro: Fragments of an Autobiography*, London: Grey Arrow, 1962 (1st edn, Jonathan Cape, 1962), pp. 92–3.

54. Ibid.

55. See for example, Richard Thomson, *Monet to Matisse, Landscape Painting in France, 1874–1914*, Edinburgh: National Gallery of Scotland, 1994, James Herbert, *Fauve Painting: the Making of Cultural Politics*, New Haven: Yale University Press, 1992 and Judi Freeman, ed., *The Fauve Landscape*, London and New York: Guild Publishing, 1900.

56. *Chiaroscuro*, (see note 53), p. 94. The Pellegrin painting of Martigues is in the Musée de La Castre, Cannes.

57. Derain first stayed in Martigues between May and November in 1908. An example from that period, *Martigues* (previously known as *Le Havre*) is reproduced in Freeman, (see note 55), plate 125. In this and subsequent views the artist was drawn to depictions of the port itself to a far greater extent than John was, although his paintings are also largely unpeopled. Derain stayed again in Martigues in 1913 and so he and John would not have met.

58. *Chiaroscuro*, (see note 53).

59. John Urry, *The Tourist Gaze, Leisure and Travel in Contemporary Societies*, London: Sage, 1990, pp. 88–9. Urry is restating Bourdieu. Working-class tourists, 'seek to be a king or queen for a day' and so intellectuals demonstrate 'ostentatious poverty'.

60. Pierre Bourdieu, 'Class, Taste and Life-Styles', *Distinction. A Social Critique of the Judgement of Taste*, London: Routledge, 1989, pp. 266–70 (1st edn, 1979).

61. Charles Marriott, 'Masters of Modern Art: Augustus John', *Colour Magazine*, 1918, p. 6.

62. On dignified, composed and fit, moral landscapes, see David Matless, *Landscape and Englishness*, London: Reaktion Books, 1998, p. 39. Matless writes about the preservationist discourse in England in the inter-war period.

63. Ford Madox Ford, *Provence*, New York: The Ecco Press, 1979, (1st edn, 1935), p. 69.

64. Eisenmann, (see note 30), pp. 55, 62.

65. *Chiaroscuro*, (see note 53), pp. 95–6.

66. Ibid.

67. Marriott, (see note 61). Marriott is paraphrasing William James.

68. Urry, (see note 59), p. 2.

69. Denys Sutton, 'The Significance of Augustus John', *Country Life*, 25 March 1954, p. 866.

70. James Bone, 'The Tendencies of Modern Art' in J. B. Bullen, (see note 24), p. 438.

71. For discussion of the Marseilles murals, see Brian Petrie, *Puvis de Chavannes*, Aldershot: Ashgate Publishing, 1997.

72. Michael Holroyd, *Augustus John*, vol. 1, (see note 8), refers to a letter written by John early in 1908 where he describes having seen some 'reproductions of wonderful pictures by Gauguin' (p. 275). Holroyd also refers to a review written by Binyon of John's 'Provençal Studies' exhibition where the critic compared the 'simplicity of his technique to that of Gauguin' (p. 361). John himself wrote to John Quinn in January 1911 praising the late addition to the show of Gauguin's picture of 'two Maori women in a landscape', cited p. 362.

73. Describing the encounter in 1941, John recalled seeing what may well have been *Les Demoiselles d'Avignon* in Picasso's studio: 'an immense canvas containing a number of figures based, it would seem, on a recent acquaintance with the monstrous images of the Easter Island. ... Anything but primitive himself, he has found in Primitive art a means of escape from the boredom which overcomes the sophisticated in the face of objective nature.' See 'Fragment of an Autobiography', *Horizon*, vol. IV, no. 20, August 1941, p. 127.

74. Ibid., p. 130.

75. This picture is unlocated but reproduced in Denys Sutton, (see note 69).

76. Eisenmann, (see note 30), p. 77.

77. Letter from Derain to Matisse from London in 1906, cited in Judi Freeman, *The Fauve Landscape*, (see note 55), p. 201.

78. Letter quoted in Holroyd, vol. 1, (see note 8), p. 362.

79. For Denis reviews in England, see *The Graphic*, 26 November 1910, p. 838 and *The Illustrated London News*, 26 November, pp. 824–5. These are cited in Anna Greutzner Robins, *Modern Art in Britain*, 1910–1914, exhibition catalogue, Barbican Art Gallery and Merrill Holberton, 1998.

80. Ford Madox Ford, (see note 63), p. 110.

81. Ibid., p. 120.

82. Ibid., p. 225.

83. Ibid., p. 293.

84. See Kenneth McConkey, *A Painter's Harvest, H. H. La Thangue, 1859–1929*, exhibition catalogue, Oldham Art Gallery, 1978.

85. John Pemble, *The Mediterranean Passion, Victorians and Edwardians in the South*, Oxford: Clarendon Press, 1987, p. 96.

86. Ibid., p. 8.

87. Pemble quotes from Norman Douglas, *Siren Land*, 1911, ibid., p. 12.

88. Robert Gathorne-Hardy, ed., *Ottoline: The Early Memoirs of Ottoline Morrell*, London: Faber, 1963, pp. 198–200.

89. F. R. Aflalo, 'Winter Travel', *Fortnightly Review*, January–June 1913, p. 155.

90. *The Riviera, Painted and Described by W. S. Scott*, London: A. & C. Black, 1907, pp. 86, 88, 121, 99.

91. See Carol Crawshaw and John Urry, 'Tourism and the Photographic Eye', in Chris Rojek and John Urry, eds, *Touring Cultures, Transformations of Travel and Theory*, London and New York: Routledge, 1997, pp. 176–7.

92. *Cook's Traveller's Gazette*, 10 December 1910, p. 5.

93. Chris Rojek, *Ways of Escape: Modern Transformations in Leisure and Travel*, London: Macmillan, 1993, p. 120.

94. Letter from John to Dorelia, cited in Michael Holroyd, *Augustus John, The New Biography*, London: Chatto & Windus, 1996, p. 321.

95. Cited in Eric Rowan, *Some Miraculous Promised Land, J. D. Innes, Augustus John and Derwent Lees in North Wales, 1910–13*, exhibition catalogue, Mostyn Art Gallery, 1982.

96. For example see Susan Sontag, *Illness as Metaphor*, London: Allen Lane, 1978, p. 34. It is interesting that none of this 'romantic cult' attends to the vast majority of the lower classes who suffered and died from the disease in conditions of poverty and overcrowding – another example of colonialism perhaps.

97. See note 90, p. 34.

98. See Pemble, (note 85), p. 90.

99. Bone, (see note 70).

100. In 'Fragment of an Autobiography', *Horizon*, vol. IV, August 1941, p. 124.

101. Sontag, (see note 96), pp. 74–6.

102. In relation to French artists, classical ideals and issues of health are discussed in James Herbert, *Fauve Painting: The Making of Cultural Politics* (see note 55).

103. On shifts in the social and scientific understanding of the disease, see David Armstrong, 'From clinical gaze to regime of total health', in A. Beattie, M. Gott, L. Jones and M. Sidell, eds, *Health and Wellbeing, a Reader*, Basingstoke: Macmillan and Milton Keynes: Open University, 1993.

104. *Saturday Review*, 10 December 1910, p. 747

105. Ibid.

106. Ibid., 29 May 1909, p. 684.

107. For discussion see Kate Flint, 'Moral Judgment and the Language of English Art Criticism, 1870–1910', *Oxford Art Journal*, 1983, vol. 6, no. 2, p. 8.

108. *Pall Mall Gazette*, 14 December 1910, p. 5.

109. 'Post-Impressionism at the Grafton Galleries', *The Builder*, 12 November 1910, p. 578.

110. Eisenmann, (see note 30), p. 39.

111. John Rothenstein, *Augustus John*, London: Phaidon, 1944, p. 8.

112. A new edition of Percy Bate's *The Pre-Raphaelite Painters* appeared in 1910 and a Pre-Raphaelite exhibition was staged at the Tate Gallery that year.

113. Currie was invited in that year to produce the design for a mural, *The Inspiration of Monastic Labour* for the Cistercian College, Roscrea in County Tipperary at which time he was employed as an academic art inspector in Dublin. See Sarah Griffiths, *John Currie, Paintings and Drawings, 1905–14*, exhibition catalogue, City Museum and Art Gallery, Bethesda St Hanley, Stoke-on-Trent, 1980. Currie's interest in Irish subjects arose in part from his own family connections.

114. The phrase belongs to Louis Macneice, see his *The Poetry of W. B. Yeats*, London: Faber & Faber, 1967, (1st edn, Oxford University Press, 1941), p. 83.

115. See 'Fragments of an Autobiography', *Horizon*, vol. VIII, no. 44, August 1943, p. 140. The accumulation of his observations in Ireland resulted in the vast canvas, *Galway*, 1915, in the Tate Gallery.

116. See Keith Clements, *Henry Lamb, The Artist and his Friends*, Bristol: Redcliffe Press, 1985, p. 115.

117. An interesting silence for, as Keith Clements records, Lamb found the Irish a great contrast to the Breton peasants, 'he was overwhelmed with their volubility: "heavens", he declared "how these Irish gabble!"' Ibid.

118. Bone, (see note 70), p. 440.

4 Landscapes and rhythm

1. James Bone, 'The Tendencies of Modern Art', *Edinburgh Review*, April 1913, reprinted in J. B. Bullen, ed., *Post Impressionists in England: The Critical Reception*, London: Routledge, 1988, p. 444.

2. *Rhythm* – a quarterly and then monthly journal published by Stephen Swift and Co., London – was begun in the summer of 1911 by the literary critics, Michael T. H. Sadler (later Sadleir) and John Middleton Murry, with close involvement from the writer Katherine Mansfield. The journal was funded in its early stages by Sadler's father (also Michael), then Vice Chancellor of Leeds University and a devoted art collector. *Rhythm* ran until March 1913, temporarily revived as *The Blue Review* in the summer of that year. Fergusson was the journal's art editor and regularly commissioned illustrations from Jessica Dismorr (who trained at the Académie de La Palette and was later a member of the Vorticist Group), the American, Anne Estelle Rice and, on several occasions his Scottish compatriot, Samuel Peploe. These last two are considered in this chapter. Reproductions of Picasso, Derain, Marquet, Friesz and, in vol. 1, no. 2 a John drawing entitled *Labour* also appeared – a man digs the earth while a woman and children, in a composition resembling that of *A Family Group*, watch his actions with apparent fascination.

3. On the colony phenomenon see in particular Nina Lübbren, *Rural Artists' Colonies in Europe, 1870–1910*, Manchester: Manchester University Press, 2001.

4. Freeman in Judi Freeman et al., *Fauve Landscape*, exhibition catalogue, Los Angeles County Museum of Art, London, New York, Sydney, Toronto: Guild Publishing, 1990, p. 51.

5. Manguin's *Landscape* was reproduced in vol. 1, no. 4, Spring 1912. John's pure landscapes, like *Landscape at Chirk*, 1911 (Leeds City Art Gallery) show similar tendencies.

6. Roger Benjamin, 'The Decorative Landscape, Fauvism and the Arabesque of Observation', *Art Bulletin*, June 1993, vol. LXXV, no. 2, p. 384.

7. Huntly Carter, 'The Independants and the New Institution in Paris', *New Age*, 25 May 1911, pp. 82–3. Cited in Bullen, (see note 1), p. 223.

8. Robert Dell, 'Introduction' to *Modern French Artists*, Brighton, June 1910, in Bullen, ibid., p. 85.

9. Jonathan Benington, *Roderic O'Conor: A Biography, With a Catalogue of his Work*, Belfast: Irish Academic Press, 1992, p. 118.

10. O'Conor was in Paris in the Spring of 1892 and could therefore have seen the Van Gogh retrospective organized by Emile Bernard. See Roy Johnston, *Roderic O'Conor, 1860–1940*, exhibition catalogue, Barbican Art Gallery, London and Ulster Museum, Belfast, 1985, p. 43.

11. Roger Billcliffe notes that Fergusson saw the Whistler memorial exhibition in 1903, see *The Scottish Colourists, Cadell, Fergusson, Hunter, Peploe*, London: John Murray, 1996 (1st edn, 1987). Arthur Melville's influence also resulted in Fergusson's first encounter with a southern climate – his trip to Spain and Morocco in 1897.

12. In the collection of Kelvingrove, Glasgow.

13. See Elizabeth Cumming, in Philip Long with Elizabeth Cumming, *The Scottish Colourists, 1900–1930*, National Galleries of Scotland, Edinburgh, 2000, p. 42. The quote also appears in Roger Billcliffe, (see note 11).

14. On Rice's development from illustration to painting at this stage, see Carol A. Nathanson, 'Anne Estelle Rice: Theodor Dreiser's "Ellen Adams Wrynn"', *Women's Art Journal*, Fall 1992/Winter 1993, pp. 1–9.

15. Quoted in Freeman, (see note 4), p. 110.

16. For excellent discussion of this identification see Robert Herbert, 'Painters and Tourists: Matisse and Derain on the Mediterranean Shore', in ibid., pp. 153–8.

17. Roger Benjamin in Freeman, ed., ibid., p. 247.

18. For a useful typology of landscapes in French painting see Richard Thomson, *Landscape Painting in France, 1874–1914*, exhibition catalogue, Edinburgh, National Gallery of Scotland, 1994.

19. On the distinction between the pastoral and the picturesque in relation to French painting at this period, see also Judi Freeman, in Freeman, ed., (see note 4), p. 26.

20. Robert Gathorne-Hardy, ed., *Ottoline: The Early Memoirs of Ottoline Morrell*, London: Faber, 1963, p. 188.

21. Ibid., p. 201.

22. Reprinted in Charles Harrison and Paul Wood, eds, *Art in Theory, 1900–1990, An Anthology of Changing Ideas*, Blackwells, 1996, pp. 72–8. Extracts of these were published in English by Lewis Hind in 'The New Impressionism', *The English Review*, 7 December 1910, cited in Anna Gruetzner Robins, *Modern Art in Britain, 1910–1914*, exhibition catalogue, London: Barbican Art Gallery and Merrell Holberton, 1997, p. 199.

23. Here quoted from Harrison and Wood, eds, op. cit., pp. 72–8.

24. Cited in Mark Antliff, *Inventing Bergson: Cultural Politics and the Parisian Avant-garde*, Princeton, NJ: Princeton University Press, 1993, p. 73.

25. On this see 'J. D. Fergusson' in Frank Rutter, *Some Contemporary Artists*, London: Leonard Parsons, 1922, p. 162.

26. Fry and Rutter were on difficult terms by 1913. This was due in part to Fry's antipathy towards Futurism and his public falling out with Wyndham Lewis, but was also perhaps a factor in his general disregard for the Rhythmists.

27. Frank Rutter, *Revolution in Art, An Introduction to the Study of Gauguin, Van Gogh and other Modern Painters*, The Art News Press (November) 1910, pp. 3–4.

28. Roger Fry, 'Post-Impressionism', *Fortnightly Review*, January–June 1911, vol. 95, pp. 866–7.

29. Laurence Binyon, 'Post-Impressionists', *Saturday Review*, 12 November 1910, pp. 609–10.

30. Frank Rutter, *Art in My Time*, London, 1933, pp. 132–4.

31. Roger Fry, 'Post Impressionism', *Fortnightly Review*, (see note 28), pp. 863–5.

32. Letter to Pissarro from Estaque, July 1876, cited in John Rewald, ed., *Paul Cézanne: Letters*, Oxford: Bruno Cassirer, 1976, (1st edn, 1941), pp. 145–9.

33. Sheila MacGregor, in *John Duncan Fergusson, 1874–1861*, exhibition catalogue, Duncan R. Miller Fine Art, n.d., n.p.

34. On modernism in the 1920s see Kenneth E. Silver, *Making Paradise, Art, Modernity, and The Myth of the French Riviera*, Cambridge, MA: MIT Press, 2001, pp. 70–1.

35. Bergson had lectured in London in 1910.

36. John Middleton Murry, 'Art and Philosophy', *Rhythm*, vol. 1, 1911, p. 9.

37. F. A. Lea, *The Life of Middleton Murry*, London: Methuen & Co., 1959, p. 24.

38. The phrase appears in the Round Robin letter that arose from the dispute between Lewis and the Omega Workshops over displays for the 'Ideal Home' exhibition in 1913. Cited in W. K. Rose, ed., *The Letters of Wyndham Lewis*, Norfolk, CT: New Directions, 1963, p. 49.

39. Kirsten Simister points out that another picture, *Etude de Rhythm*, similar to the later work was exhibited at the Salon des Indépendants earlier in the spring of 1911, so this may be the original source for the cover design. See *Living Paint, J. D. Fergusson, 1874–1961*, Edinburgh and London: Mainstream Publishing Company, 2001, p. 51.

40. In the Museum of Fine Arts, Boston.

41. Anne Estelle Rice produced a related line drawing of a nude women posing in front of a flat decorative background of foliage for *Rhythm*, Autumn, 1911, p. 22. For excellent discussion of Rice see Carole A. Nathanson, *The Expressive Fauvism of Anne Estelle Rice*, exhibition catalogue, New York: Hollis Taggart Galleries, 1997.

42. On *Les Eus*, see Antliff, (as in note 24). See also Elizabeth Cumming in *Colour, Rhythm and Dance, Paintings and Drawings by J. D. Fergusson and his Circle in Paris*, Scottish Arts Council, 1985. Sarah Whitfield discusses the importance of the Sardana dance in *Fauvism*, London and New York: Thames & Hudson, 1991, p. 155.

43. *The Festival of St John*, 1875 is in the Chrysler Museum, Norfolk, Virginia.

44. For extremely interesting discussion of the cultural significance of dance and its representations in the Edwardian era, focused particularly in its relation to Wyndham Lewis's representations, see Lisa Tickner, *Modern Life and Modern Subjects*, New Haven and London: Yale University Press, 2000, pp. 99–111.

45. In *Rhythm*, vol. 2, no. 7, August 1912, pp. 106–10. This also cited in Tickner, ibid. To Rice, Leon Bakst, 'convinces the spectator of the artist's power to create, as opposed to the apologetic groveling of the aesthete before nature'.

46. Holbrook Jackson, *Romance and Reality, Essays and Studies*, London: Grant Richards Ltd, 1911, pp. 182–3. A signed copy of this book dedicated to Fergusson and Estelle Rice is in the Fergusson Foundation archive in Perth.

47. Ibid., p. 184.

48. Michael Sadleir, 'Fauvism and a Fauve', *Rhythm*, Summer, 1911, pp. 14–18.

49. For discussion of the gender implications of Bergson's theories of creativity, see Antliff, (note 24).

50. Review of 'The Letters of Van Gogh', in *Rhythm*, vol. 2, pp. 16–19.

51. *Rhythm*, vol. 1, no. 1, p. 20.

52. On this see Benington, (as in note 9), p. 121.

53. For reproductions of Friesz, see *Fauve Painting, 1905–7, The Triumph of Pure Colour*, exhibition catalogue, London: Courtauld Institute Gallery, 2001.

54. On Bonnard's influence see Roy Johnston, exhibition catalogue, *Roderic O'Conor, 1860–1940*, Barbican Art Gallery, London and Ulster Museum, Belfast, 1985, p. 88.

55. See Margaret Morris, *The Art of J. D. Fergusson: A Biased Biography*, Glasgow and London: Blackie, 1974, p. 69. Fergusson goes on in this letter to the author to describe the Cap: 'There's a little port for boats; a road round, with rocks and pine trees and 10 minutes away on the other side, a fine sand beach with pine trees. It is practically an island and quite quiet ... All round my place are flower nurseries, fields of flowers. No slums.'

56. Denys Sutton, ed., *Letters of Roger Fry*, London: Chatto & Windus, 1972. Letter to Vanessa Bell, August 1911, no. 314, p. 350.

57. The philosophy of G. E. Moore is perhaps significant here in the emphasis on the creation of 'Good states of mind'.

58. Fry in the catalogue of the 'Second Post-Impressionist' exhibition, reprinted in *Vision and Design*, Oxford: Oxford University Press, 1981, (1st edn, 1920), pp. 168–9.

59. Simon Watney, 'The Connoisseur as Gourmet' in *Formations of Pleasure*, London: Routledge & Kegan Paul, 1983, pp. 70–5.

60. Clive Bell, 'The Debt to Cézanne', *Art*, London: Perigree Books, 1981, (1st edn, 1914), p. 140.

61. O. Raymond Drey, 'Post-Impressionism, The Character of the Movement', *Rhythm*, vol. 2, no. 13, February 1913, p. 369.

62. On this see Nathanson, 1997, (see note 1).

63. Nathanson, ibid., p. 18. The letter was written to Theodore Dreisser. Nathanson stresses the possible influence of Kandinsky on Rice's thinking at this point, but also the influence of the 'spiritual transcendence of line' in El Greco's art, shown at the Salon d'Automne in 1908.

64. Richard Thomson points to an elision between the female figure and the forms of landscape in Othon Friesz's *Paysage (La Ciotat)*, 1907, Thomson, *Monet to Matisse*, Edinburgh: National Gallery of Scotland, 1994, pp. 106–7.

65. Nathanson, (as in note 41), p. 19.

66. See Richard Shone, *The Art of Bloomsbury, Roger Fry, Vanessa Bell and Duncan Grant*, London: Tate Gallery Publishing, 1999, pp. 75–8.

67. Benjamin uses the terms 'social restorative' in his discussion of Matisse in 'The Decorative Landscape, Fauvism, and the Arabesque of Observation', *Art Bulletin*, vol. LXXV, no. 2, June 1993, pp. 295–316.

68. For such a reading, see Christopher Reed's essay in *Not at Home, The Suppression of Domesticity in Modern Art and Architecture*, London and New York: Thames & Hudson, 1996.

69. T. E. Hulme, 'Modern Art – 1: The Grafton Group', *New Age*, 1914, pp. 341–2, Cited in Bullen, (see note 1), pp. 476–80.

70. Antliff, (see note 24), p. 84.

71. J. Middleton Murry, introduction to exhibition catalogue, *Painting and Sculpture by J. D. Fergusson*, The Connell Gallery, 1918, n.p.

72. Frank Rutter, *Some Contemporary Artists*, London: Leonard Parsons, 1922, p. 165.

73. Ibid.

74. J. Middleton Murry, 'Coming to London – VIII', *The London Magazine*, July 1956, vol. 3, no. 7, p. 33.

75. *Summer* was sketched in 1914, but not completed until 1934.

5 A sympathetic country

1. John visited Cornwall in 1913, personal circumstances having soured his affection for Wales. He stayed at Lamorna Cove in the company of Alfred Munnings and Harold and Laura Knight, where he recounted 'numerous beanos' with the artistic community. In the intervals he would 'go in search of Dorelia, and do little studies of her in various poses on the rocks'. See Michael Holroyd, *Augustus John, A Biography*, vol. II, *The Years of Experience'*, London: Heinemann, 1975, pp. 38–9.

2. See especially Caroline Fox and Francis Greenacre, *Painting in Newlyn, 1880–1930*, exhibition catalogue, Barbican Art Gallery, 1985, see also Mrs Lionel Birch, *Stanhope A Forbes ARA and Elizabeth Stanhope Forbes, ARWS*, London, 1906.

3. The specific types of leisure activity being emphasized in paintings like those of Forbes and Bramley are important. Highly organized and controlled, they might be assumed by the middle classes to have a civilizing effect on the lives of the indigenous population. Such a development needs to be seen in the context of a whole history of incidents in the nineteenth century where working-class leisure pursuits resulted in threatening disorder. For discussion of Durkheim see Chris Rojek, *Ways of Escape: Modern Transformation in Leisure and Travel*, London: Macmillan, 1993, pp. 41–4. Rojek cites Durkheim's *The Elementary Forms of Religious Life*, New York: Free Press, 1912, pp. 475–6.

4. Dean MacCannell, *Empty Meeting Grounds – The Tourist Papers*, London: Routledge, 1992, p. 1.

5. For discussion of the part of the railway in forming the 'imagined geography' of Cornwall, see Chris Thomas: 'See Your Own Country First: the geography of a railway landscape', in Ella Westland, ed., *Cornwall: The Cultural Construction of Place*, Patten Press, 1997, pp. 107–28.

6. As Deborah Cherry's study of the experience of women artists in Newlyn in the earlier period of the 1880s has argued: 'It was in these overlaps between social and professional spaces, in the meeting of high art and holiday making, in the visual coincidences between Royal Academy paintings and tourist photography that a specifically metropolitan perception of Newlyn was formed.' Deborah Cherry, *Painting Women – Victorian Women Artists*, London: Routledge, 1993, p. 168. Cherry was persuaded by Nicholas Green's important analysis in *The Spectacle of Nature*, and his argument that the artistic invasion into the forests of Barbizon was 'paradigmatic of metropolitan colonialism more generally', Manchester: Manchester University Press, 1990, p. 118.

7. Hugh Stokes, 'Sea-Pictures', *The Ladies Realm*, May–October 1904, p. 442.

8. On these debates see especially Anna Davin, 'Edwardian Childhoods, Children, Image and Diversity' in Jane Beckett and Deborah Cherry, eds, *The Edwardian Era*, exhibition catalogue, Phaidon and Barbican Art Gallery, 1987, p. 62.

9. There are some interesting exceptions to the trend I have identified here. For instance Stanhope Forbes in 1885 produced studies of children playing in the sand with buckets and spades – precursors to Knight's picture. But the general development I have outlined remains clear.

10. J. K. Walton, *The English Seaside Resort – A Social History 1750–1914*, Leicester: Leicester University Press, 1983, p. 41.

11. The artist whose pictures bear most resemblance to Knight is perhaps Harold Harvey. His *A Quiet Paddle* (reprinted in *Impressionism in Britain*, exhibition catalogue, Kenneth McConkey, Yale University Press and Barbican Art Gallery, 1995, p. 136) of 1913 of two young girls dangling their feet in the rock pools near to the water's edge demonstrates the same shift in interest from local fisherfolk to children and holiday-makers. Harvey also produces pictures of young women seated on cliff-tops – but these occur typically in the mid-1920s and bear comparison to Knight's works of around 1917.

12. The quotation is from F. G. Stephens in *The Athenaeum*, 5 May 1894, p. 587, cited in John Christian, ed., *The Last Romantics, The Romantic Tradition in British Art, Burne-Jones to Stanley Spencer*, Barbican Art Gallery and Lund Humphries, 1995, (1st edn, 1989), p. 122.

13. In 1904 Forbes fabricated her own legend in her illustrated book *King Arthur's Wood*, produced for and about her son Alec and set around their home 'Higher Faughan' (Cornish for 'hiding place'). The book evoked references to Mallory's *Morte d'Arthur* and Spenser's *Faerie Queen*. For recent discussion of the artist, see *Singing from the Walls, The Life and Art of Elizabeth Forbes*, Judith Cook, Melissa Hardie and Christiana Payne, Penlee House Gallery and Museum and Sansom & Company, 2000. Forbes and her family went on a painting holiday to the Pyrenees in 1898 and this book records her account of the 'picturesque' rural population, the 'nobly poised' young women and the young men 'looking like Greek gods', see p. 105.

14. C. F. G. Masterman, *The Condition of England*, London: Shenval Press.

15. See introduction to Rob Shields, *Places on the Margin, Alternative Geographies of Modernity*, London: Routledge, 1991.

16. Philip Payton, 'Paralysis and Revival: the reconstruction of Celtic-Catholic Cornwall, 1890–1945', in Westland, ed., (see note 5), p. 25. Payton correlates the de-industrialization of the county, the decline of the tin-mining industry, with the attempt by the Cornish middle class to construct a post-industrial cultural identity in the concept of 'Celtic Cornwall' which co-opted elements of the wider Celtic Revival, see pp. 27–8.

17. Norman Garstin, 'West Cornwall as a Sketching Ground', *The Studio*, 1909, pp. 109–10.

18. This black-chalk and watercolour is reproduced in Caroline Fox, *Dame Laura Knight*, Oxford: Phaidon, 1988, p. 37.

19. *The Magic of a Line, The Autobiography of Laura Knight*, William Kimber, 1965, pp. 138–9.

20. Cited in A. L. Rowse, ed., *A Cornish Anthology*, A. Hodge, 1968, p. 11.

21. Quoted in Denys Val Baker, *The Timeless Land: The Creative Spirit in Cornwall*, Adams & Dart, 1973, p. 43.

22. Unsigned article in *The Saturday Review*, 5 February 1908, p. 171.

23. W. H. Hudson, *The Land's End* (1st edn, 1908) Wildwood House, 1981, pp. 52–3.

24. For discussion of this kind of desire for authenticity, see John Urry, *The Tourist Gaze*, London: Sage Publications, 1990, Dean MacCannell, (as in note 4), and James Buzard, *The Beaten Track – European Tourism, Literature, And the Ways to 'Culture'*, Oxford, 1993. See also Robert Herbert, *Monet on the Normandy Coast, Tourism and Painting*, Yale, 1994.

25. *Cook's Traveller's Gazette*, March 1906, pp. 12–13.

26. On the National Social Purity Crusade, a conservative reform group who formed a 'forward movement' in 1908 to raise personal and social purity standards, see Samuel Hynes, *The Edwardian Turn of Mind*, Princeton: Princeton University Press, 1968, especially chapter 7.

27. The transition, to a contemporary critic, was 'a passage from peril to peace. Many of the best of Mr. Tuke's drawings and pictures are in this glad, radiant kind, evocations of sunburnt mirth, with lighted flesh as the most lyric of all the notes', *The Art Journal*, 1902, pp. 358–9. Carefully arranged compositions like *The Bathers*, 1889, of three or five figures became increasingly formulaic. Their theme, the hedonism of youth in nature, was consistently reiterated in works like *Beside Green Waters*, 1897 and *An Idyll of the Sea*, 1898.

28. *The Art Journal*, 1902, p. 219.

29. Marion Hepworth Dixon, *Ladies Realm*, May–October 1905, p. 591.

30. 'Berlin Studio Talks', *The Studio*, vol. 44, 1908, p. 295. Two of Tuke's pictures, *Euchre* and *A Summer's Day* were purchased for collections in Bavaria. Aspects of Nietzsche's philosophy, influential amongst certain English intellectual circles at the turn of the century, are significant in this context.

31. Pater's appeal was clearly in evidence by the 1890s. See for instance Arthur Symons's appreciation in *The Savoy*, December 1896, reprinted in *Studies in Two Literatures* the following year.

32. From 'Winckelmann', *The Westminster Review*, 1897, reprinted in Richard Aldington, ed., *Walter Pater, Selected Works*, London: Heinemann, 1948, p. 99. Connections between Tuke's imagery and the circle of literary homosexuals around C. Kains Jackson and the cult of the 'new chivalry' have been explored elsewhere, see for example Marcia Pointon's introduction to David Wainwright and Catherine Dinn's *Henry Scott Tuke, Under Canvas, 1858–1929*, Sarema Press, 1989. These writers and poets identified with Tuke's exaltation of the youthful masculine ideal. This material has also been considered by Joseph Kestner, who describes in relation to Tuke, 'a constellation of Aryan race, ephebia, nudity, the solar and the Apollonian', which he regards as an 'ideograph of masculine ideology'. See *Masculinities in Victorian Painting*, Aldershot: Scolar Press, 1995, p. 266.

33. Paul Delany, *The Neo-Pagans, Friendship and Love in the Rupert Brooke Circle*, Macmillan, 1987, p. xiv. He sees Neo-paganism as a reaction against 'a lingering Victorianism, and as signalling a tentative emancipation – expressed in the culture of liberal public schools like Bedales, in the popularity within certain circles of writers like Walt Whitman and in those simple life ideals of Carpenter'.

34. Shane Leslie, in his nostalgic rant against the changes in modern society in 1916, fondly remembered an Eton before the 'sturdy squierarchy' was swamped by Jews, financial magnates and the 'sons of Orientals', and where a 'love of athletics made boys more Greek than Christian in their ideals', *The End of a Chapter*, London: Constable & Co., 1916, pp. 42–6.

35. For example in 1911 when Knight showed her *Daughters of the Sun* at the Royal Academy, Tuke exhibited his *The Reef*, another of his formulaic nude and semi-clad groups of three young men in the sand at the water's edge, (see *Royal Academy Illustrated*, 1911).

36. In a very few instances Tuke had attempted legendary, mythological subjects in works like *Perseus and Andromeda*, 1889, and the quite ludicrous *Hermes at the Pool*, 1900 which he himself recognized as a failure and later destroyed – see B. D. Price, ed., *The Registers of Henry Scott Tuke, 1879–1928*, Royal Cornwall Polytechnic Society, Falmouth, 1983.

37. C. Kains Jackson, 'H. S. Tuke, ARA, *The Magazine of Art*, 1902, pp. 337–43.

38. Letter dated 10 January 1893, quoted in Maria Tuke Sainsbury, *Henry Scott Tuke – A Memoir*, London, 1933, p. 107.

39. For an interesting discussion of the shift from 'aesthetics to athletics' between the fin de siècle and the 1930s see Paul Lewis, 'Men on Pedestals', *Ten 8*, 7 June 1985, p. 24.

40. *The Magazine of Art*, 1902, p. 340.

41. See Sander L. Gilman, *Health and Illness – Images of Difference*, London: Reaktion Books, 1995, p. 54.

42. Max Nordau's *Degeneration* went into four editions in 1895, the year of its production. Degeneracy was to be discovered amongst those who were in some quarters much revered as the creators of new art.

43. Ebenezer Wake Cook, *The Morning Post*, 19 November 1910, p. 4. Cited in J. B. Bullen, ed., *Post Impressionists in England*, London: Routledge, 1988, pp. 118–20.

44. George Bernard Shaw, 'The Sanity of Art', first published in 1895 in the American journal *Liberty*, reprinted in Harrison, Wood and Gaiger, eds, *Art in Theory, 1815–1900, An Anthology of Changing Ideas*, Oxford: Blackwell, 1998, pp. 806–12.

45. Sir William Blake Richmond, 'Post Impressionists', *Morning Post*, 16 November 1910, p. 5, see Bullen, (as in note 43), pp. 114–17.

46. T. B. Hyslop, 'Post Illusionism and the Art of the Insane', *Nineteenth Century*, February 1911, pp. 270–81, cited in Bullen, (as in note 43), pp. 209–22.

47. Kate Flint, 'Moral Judgement and the Language of English Art Criticism 1870–1910', *Oxford Art Journal*, 1983, vol. 6, no. 2, pp. 60–2.

48. Winckelmann's 1764, 'History of Antique Art', cited in Brian Reade, ed., *Sexual Heretics, Male Homosexuality in English Literature from 1850–1900*, London: Routledge and Kegan Paul, 1970, p. 48.

49. Pater on Winckelmann, ibid., pp. 99–103.

50. *The Saturday Review*, 20 August 1910, pp. 229–30.

51. Ibid.

52. *The Saturday Review*, 22 May 1897, p. 572.

53. *The Saturday Review*, 6 May 1899, p. 557.

54. *Hermes* was one of his few mythological studies of a nude male, here posing at the water's edge wearing what is supposedly a warrior-God's helmet. See B. D. Price, (as in note 36).

55. *The Saturday Review*, 26 May 1900, p. 647.

56. *The Fortnightly Review*, 1900, p. 1032.

57. For interesting discussion of this problem in relation to French Salon pictures of bathers see *Seurat and the Bathers*, John Leighton and Richard Thomson, Yale & National Gallery, 1997, p. 105.

58. For discussion of the significance of the Boy Scouts Movement, formed 1906, and the Girl Guides, 1912, see Allen Warren, 'Citizens of the Empire: Baden Powell, Scouts and Guides and an Imperial Ideal, 1900–40', in John MacKenzie, ed., *Imperialism and Popular Culture*, Manchester: Manchester University Press, 1906.

59. As William Greenslade describes it in relation to H. G. Wells's *Time Machine*, of 1896: 'The landscape of the degenerate unfit of the fin de siècle seemed to be a continuous tract of sunlessness; a dark, dank world inhabited by barely visible creatures of stunted physical growth, of bleached or white, colourless skin.' 'Fitness and Fin de Siècle', in John Stokes, ed., *Fin de Siècle/Fin de Globe: Fears and Fantasies of the Late Nineteenth Century*, London: Macmillan, 1992, p. 40.

60. Arthur Reddie, 'Watercolours and Oil Paintings by S. J. Lamorna Birch', *The Studio*, vol. 64, 1915, pp. 169–78.

61. Laura Knight, *Oil Paint and Grease Paint*, London, 1936, p. 162. Interestingly her real experience conflicts with the description of one writer, proclaiming the delights of Newlyn to the readers of *The Magazine of Art* in 1890: 'at the present time the young women are very handsome and both young and old are fresh looking, robust and sprightly', 'Newlyn and the Newlyn School', vol. 13, p. 200.

62. *The Art Journal*, 1897, 'Summer Time at St Ives, Cornwall', p. 293.

63. *Oil Paint and Grease Paint*, (see note 61), p. 175.

64. *The Magazine of Art*, 1902.

65. Arthur Symons, 'Cornish Sketches', *The Saturday Review*, 7 September 1901, pp. 297–8.

66. Knight's description of her methods is contained in Janet Dunbar, *Dame Laura Knight*, London and Glasgow: Collins, 1975, p. 85. *Daughters of the Sun* was highly praised at the Royal Academy of 1912, and went on a tour of provincial galleries. However the asking price of £600 was unforthcoming and it was later destroyed by the artist.

67. Knight, *The Magic of a Line*, (see note 19), p. 139.

68. 'The Cornish Sea, Boscastle', *The Saturday Review*, 14 September 1901, pp. 330–1.

69. Gail Cunningham, *New Women and the Victorian Novel*, London: Macmillan, 1978, p. 155.

70. Ibid., p. 155.

71. Journals such as *The Ladies Realm* began to cover subjects like gardening, golf, swimming etc. from this period. Features on diet signify the shift from the rather massive proportions of the

late Victorian ideal, to the fitter and more slender proportions that reflected the new models of womanhood, also advocated by contemporary dress reformers.

72. Havelock Ellis began his *Studies in the Psychology of Sex* in 1897 and the sixth volume appeared in 1910.

73. Letter to Ernest Collings, 1913 from 'The Letters of D. H. Lawrence' (1932), cited in Judy Giles and Tim Middleton, eds, *Writing Englishness, 1900–1950: An Introductory Sourcebook on National Identity*, London: Routledge, 1995, p. 31.

74. Knight, *The Magic of a Line*, (see note 19), p. 140.

75. For more discussion see Patricia Cunningham, 'Annie Jenness Miller and Mabel Jenness; Promoters of Physical Culture and Correct Dress', *Dress*, 1990, vol. 16, pp. 49–60.

76. Laurence Binyon, 'Post Impressionists', *The Saturday Review*, 12 November 1910, pp. 609–10.

77. Quoted in Caroline Fox, *Stanhope Forbes and the Newlyn School*, David & Charles, 1993, p. 70.

78. Norman Garstin, 'The Art of Harold and Laura Knight', *The Studio*, vol. 57, 1912–13, p. 183.

79. Holroyd, (see note 1).

6 An ideal modernity: Spencer Gore at Letchworth

1. The term used by Alex Potts in his essay, 'Constable Country between the Wars', in Raphael Samuel, ed., *Patriotism: the Making and Unmaking of British National Identity*, London: Routledge, 1989, p. 175. See also David Matless, *Landscape and Englishness*, London: Reaktion Books, 1998, especially his discussion of preservationist discourse in the inter-war period, pp. 26–30.

2. Jack Wood Palmer, *Spencer Frederick Gore, 1878–1914*, exhibition catalogue, London: Arts Council of Great Britain, 1955, p. 7.

3. Cited in Donald Read, ed., *Documents from Edwardian England, 1901–1915*, London: Harrap, 1973, pp. 27–30.

4. C. B. Purdom, *The Garden City of Tomorrow: A Study in the Development of a Modern Town*, London: Dent, 1913, pp. 166–7. Purdom was quoting from Dr Arthur Newsholm's 'Vital Statistics' on the gains from being born in a healthy district.

5. See C. F. G. Masterman, ed., *The Heart of the Empire: Discussion of Modern City Life in England*, London: Fisher Unwin, 1902, p. 7.

6. *To-Morrow: A Peaceful Path to Real Reform*, republished in a revised edition in 1902 as *Garden Cities of Tomorrow*. The Garden Cities Association was founded in 1899. See Donald Read, (as in note 3).

7. Examples of these postcards, from 1906, are in the collection of the First Garden City Heritage Museum, Letchworth.

8. In 1901 Ashbee had considered Letchworth as a potential site for his Guild of Handicraft before moving to Chipping Campden. The Garden City Movement, at least at first, shared some of the fundamental aspirations of the 'Simple Life' Movement, which had resulted in earlier communities like those at Clousden Hill in Norton, Purleigh in Essex and Eric Gill's at Ditchling. See Fiona MacCarthy, *The Simple Life: C R Ashbee in the Cotswolds*, London: Lund Humphries, 1981.

9. Cited in Jan Marsh, *Back to the Land: The Pastoral Impulse in England from 1880–1914*, Quartet Books, 1982, pp. 238–9. Marsh describes the early establishment in Letchworth of 'The Cloisters', the community of New Age disciples formed by Blavatsky's followers Annie Lawrence and J. Bruce Wallace. Gore's son Frederick remembered that a Blavatsky book, presumably *The Key to Theosophy*, sat on his father's bookshelf. See *Spencer Frederick Gore, 1878–1914*, exhibition catalogue by Frederick Gore and Richard Shone, London: Anthony d'Offay, 1983.

10. For discussion of the connections between late-Victorian progressive idealists and the appeal of theosophy and eastern mysticism, see Tom Steele, '1893–1900: Socialism and Mysticism', *Alfred Orage and the Leeds Art Club, 1893–1923*, London: Scolar Press, 1990. For a good critique of utopianism in this period, see Stefan Szczelkun, *The Conspiracy of Good Taste, William Morris, Cecil Sharp, Clough Williams Ellis and the Repression of Working Class Culture in the Twentieth Century*, London: Working Press, 1993, p. 36.

11. For example, Robert Blatchford's socialist paper *The Clarion*, extolled the benefits of practical ruralism, walking, cycling etc.

12. In 1893 Lucien Pissarro moved to Epping Forest, where he painted the small corners of landscapes and wooded lanes which clearly interested Gore. Both Pissarro and Steer produced contrasting types of landscape painting around the turn of the century. As Frank Rutter put it, 'Steer excelled in painting the wide-open spaces of England. Pissarro gave clear and more

intimate views of her copses and her orchards', in *Art in My Time*, London: Rich & Cowan, 1933, pp. 121–2.

13. Applehayes farm near Clayhidon in Devon belonged to Harold Harrison, an ex-Slade student, who invited his friends to visit. Gore, Gilman, Robert Bevan and, on one occasion Stanley Spencer, stayed there. There had been no modernization at Applehayes so it was, for these artists, the epitome of a remote and essentially timeless, rural idyll.

14. There are close similarities in composition and handling with Monet's 1902, *La Grande Allée, Giverny*, which Gore might well have seen at Bernheim-Jeunes on his trip to Paris in 1905. The more striking comparison however is with Monet's *Une Allée du Jardin de Monet, Giverny*.

15. See Jack Wood Palmer, (as in note 2), 1955, p. 4.

16. After financial difficulties in 1904 Gore's father had deserted his family and died two years later. His mother then moved to Garth House, Hertingfordbury, far from the family home at Holywell in Kent. Frederick Gore and Richard Shone described the house, with its tennis lawn and rose gardens 'as the epitome of modest comfortable country life as … for example, in the contemporary short stories of Saki', see *Spencer Frederick Gore, 1878–1914*, (as in note 9).

17. John Rothenstein, for instance, later praised Gore's talent for 'the reconciling of differences that could honourably be reconciled', in *Modern Painters, Sickert to Smith*, London: Eyre & Spottiswoode, 1952, p. 198.

18. See Dean MacCannell's discussion in 'Landscaping the Unconscious' in Mark Francis and Randolph T. Hester, eds, *The Meaning of Gardens: Idea, Place, Action*, Cambridge, MA: MIT Press, 1991, pp. 94–100.

19. See 'The Garden with Special Reference to the Paintings of G. S. Elgood', *The Studio*, vol. 5, 1895, p. 51.

20. The quotation is from Nicholas Green in *The Spectacle of Nature: Landscape and Bourgeois Culture in Nineteenth Century France*, Manchester: Manchester University Press, 1990, p. 52. Green was referring to French parks, but his remarks are equally applicable here.

21. Gore's comment appeared in his article 'Cézanne, Gauguin, Van Gogh &c., at the Grafton Galleries', *Art News*, 15 December 1910, pp. 19–20, reprinted in J. B. Bullen, ed., *Post Impressionists in England: The Critical Reception*, London: Routledge, 1988, pp. 140–2.

22. Ibid., pp. 1–3.

23. See note 21.

24. Desmond MacCarthy, 'The Post Impressionists', Introduction to exhibition catalogue *Manet and the Post Impressionists*, London, Grafton Galleries, 8 November 1910–14 January 1911.

25. Henri Matisse, 'Notes of a Painter', first pub. as 'Notes d'un Peintre' in *La Grande Revue*, Paris, 25 December 1908, reprinted in Charles Harrison and Paul Wood, eds, *Art in Theory: An Anthology of Changing Ideas, 1900–1990*, Oxford, UK and Cambridge, USA: Blackwells, 1991, pp. 72–78.

26. Gore's particular approach to composition described here was of course especially common in the 1920s. Frank Rutter observed in 1926 that, 'there is less and less of the "foggy" impressionist type of picture in which "atmosphere" is the goal, and more and more of a clear-hewn type of picture in which the accent is laid on design'; see 'The Triumph of Design', in *Evolution in Modern Art*, London: Harrap & Co., 1926, p. 134.

27. John Woodeson noted the influence of Derain in particular on Gore, see 'Spencer F. Gore', unpublished MA report, Courtauld Institute, 1968, pp. 85–8. He points to the similarities between Gore's *Cinder Path* and Derain's *Landscape at Cassis* and later between Gore's *Icknield Way* and Derain's 1908, *Landscape at Martigues*. Gore stayed at Letchworth between August and November in 1912 and the second Post-Impressionist show was held between that October and January 1913. Gore himself stated in his article in the *Art News*, that he found nothing of great interest in 'Piccasso [sic] and Matisse', but 'such painting as Herbin's *Maison au Quai Vert* (108) arouses our curiosity', 'Cèzanne, Gauguin', (see note 21), p. 20.

28. Quotation from 'Recent Poster Art', *The Studio*, vol. 80, 1920, pp. 147–8.

29. Quoted in Purdom, (see note 4), p. 105. Gardening signalled a positive forward-looking mentality for this author: 'A garden makes you think of the future, for you cannot be in it without wondering how this and that will turn out,' p. 107.

30. Raymond Unwin, 'Town Planning in Practice', 1909, reprinted in Richard T. Le Gates and Frederic Stouts, *The City Reader*, London: Routledge, 1996, p. 357.

31. 'Realities at Home', in Masterman, (see note 5), p. 7.

32. Purdom, (see note 4), pp. 38–9.

33. Alex Potts, (see note 1), p. 175.

34. Stephen Daniels, 'The Making of Constable Country, 1880–1940', *Landscape Research*, vol. 16, 1991, p. 15.

35. Ibid., p. 14. The illustration of 1928 was reproduced in Herbert Cornish, *The Constable Country*, 1932.

36. G. M. Trevelyan, 'Past and Future', in Masterman, (see note 5), also cited in B. I. Coleman, ed., *The Idea of the City in 19th Century Britain*, London: Routledge & Kegan Paul, 1973, p. 212.

37. Wendy Baron cites Gilman's label on the back of the picture: 'The colour found in natural objects (in the field of beans for instance in the foreground), is collected into patterns. This was his own explanation.' See Wendy Baron, *The Camden Town Group*, London: Scolar Press, 1979, p. 292.

38. Letter to his pupil J. Doman Turner, cited by John Woodeson, *Spencer Frederick Gore*, exhibition catalogue, The Minories, Colchester, 1970, n.p. Gore is often contradictory in his writings, but in general we find him increasingly privileging the imagination and formal innovation.

39. Similar interpretations of comparable compositions have been made, for example, in relation to Van Gogh's *Summer Evening, Arles* of 1888 and of Pissarro's *Banks of the Oise*, 1873. Richard Thomson argues that the two images produce a 'double conjunction of ancient and modern', see *Monet to Matisse: Landscape Painting in France, 1874–1914*, Edinburgh, National Gallery of Scotland, 1994, p. 125.

40. Purdom, (see note 4), p. 118.

41. See Charles Harrison, 'Impressionism, Modernism and Originality', in Frascina, Blake et al., *Modernity and Modernism: French Painting in the Nineteenth Century*, New Haven and London: Yale University Press and The Open University, 1993, p. 189.

42. See P. J. Waller, *Town, City and Nation: 1850–1914*, Oxford: Oxford University Press, 1983, p. 179.

43. P. G. Konody, 'Art and Artists: English Impressionists', *The Observer*, 27 October 1912, p. 10, report in J. B. Bullen, ed., (see note 21), p. 388.

44. Anna Greutzner Robins has considered Gore's *Letchworth Station* in the context of the painter's 'keen interest in the modern landscape'. She is ultimately in agreement with Konody's interpretation. See 'The English Group', *Modern Art in Britain, 1910–14*, exhibition catalogue, London: Barbican Gallery and Merrell Holberton, 1997, pp. 104–5.

45. The drawing is reproduced in *British Modernist Art: 1905–1930*, exhibition catalogue, Hirschl and Adler Galleries, 1988, p. 34. The photograph of Letchworth Station at the time Gore painted it is reproduced in Mervyn Miller, *Letchworth: The First Garden City*, Chichester: Phillimore, 1993, p. 57 (1st edn 1989). The wooden station was demolished in 1912, just after Gore's painting, so the new houses shown on the photograph must already have been erected by that date, i.e. before the painting.

46. Charles Harrison, *Modernism*, London: Tate Gallery Publishing, 1997, p. 37. Drummond's painting is in Southampton Art Gallery.

47. Erich Franz in E. Franz and B. Growe, *Seurat Drawings*, Boston, 1984, p. 61. Cited in John Leighton and Richard Thomson, *Seurat and the Bathers*, London: National Gallery Publication, 1997, p. 21.

7 Dwellers in the innermost: mystery and vision

1. Robert Ross, *The Georgian Revolt: The Rise and Fall of a Poetic Ideal, 1910–1922*, Faber & Faber, 1965, pp. 41–4.

2. There were five anthologies of Georgian poetry published between 1912 and 1922, all edited by Edward Marsh.

3. An example of Austin's verse, 'An Autumn Dirge', appeared in *The Magazine of Art* in 1894, p. 415, 'Now the last load hath dipped below the brow, And the last sheaf been piled and wheeled away – And Memory sits and sighs, contrasting Then with Now.'

4. Ross, (see note 1), p. 28.

5. Raymond Williams, *The Country and the City*, London: Chatto and Windus, 1973, p. 259.

6. For a biographical study, see John Hatcher, *Laurence Binyon, Poet, Scholar of East and West*, Oxford: Clarendon Press, 1995. Briefly, the son of an Anglican clergyman, Binyon was born in 1869 and was educated in London, winning a scholarship to Trinity College, Oxford in 1887, where he was companion to and deeply influenced by the Indian poet, Manmohan Ghose. By this date Binyon was developing his own verse, culminating in the *First Book of London Visions* in 1896. Financial security and the opportunity to develop his knowledge and passion for Oriental art was derived from his position at the British Museum from the 1890s and from this point his career took three directions, as poet, as expert on Oriental art, and as commentator for journals like *The Saturday Review* on the contemporary art scene. Having worked first in the British Museum department of Printed Books, he was transferred to Prints and Drawings in 1893. By that stage he was already familiar with Vale Press artists and those of the New English Art Club.

He was editor of the Artists Library in the 1890s and commissioned Roger Fry on Bellini in 1899 and William Rothenstein on Goya in 1900.

7. Laurence Binyon, 'E Pur Si Mouve', *The Saturday Review*, 31 December 1910, p. 840.

8. Laurence Binyon, 'Art and Life', *The Saturday Review*, 20 August 1910, p. 230.

9. 'E Pur Si Mouve', (as in note 7).

10. Laurence Binyon, 'Spirituality in Art', *The Saturday Review*, February 1910, pp. 169–70.

11. Ibid.

12. Roger Fry, 'The French Post Impressionists', preface to catalogue of the 'Second Post Impressionist Exhibition'. Reprinted in J. B. Bullen, ed., *Vision and Design*, Oxford University Press, 1981, pp. 166–70. For Fry the imaginative life requires no action, it contains a 'different set of values, and a different kind of perception'. In 'An Essay in Aesthetics', pp. 13–14, Fry's analogy was that of watching a street scene in a mirror, where there is less of a temptation to 'adjunct ourselves', to its actual existence, 'it is easier to abstract ourselves completely, and look upon the changing scene as a whole. It then at once takes on the visionary quality.'

13. For Fry, William Blake was indifferent to the actual material world; his was 'an intimate perception of the elemental forces which sway the spirit'. But the artist never lost touch with the external world completely: '… his wildest inventions are but recombinations and distorted memories of the actual objects of sense', in 'Three Pictures in Tempera by William Blake', 1st pub. in *The Burlington Magazine*, March 1904, pp. 204–6, reprinted in *Vision and Design*, op. cit., (1981 edn), pp. 149–53.

14. Ibid., p. 153.

15. Samuel Smiles, 'Samuel Palmer and the Pastoral Inheritance', *Landscape Research*, Winter 1986, pp. 11–15. *The Valley Thick with Corn* is in the Ashmolean Museum, Oxford.

16. The group included John Currie (see chapter 4), and Maxwell Gordon Lightfoot, who died in 1911 and painted flower studies and the occasional bather scene with influences from Art Nouveau to Puvis de Chavannes. His work is discussed in *M. G. Lightfoot, 1886–1911*, exhibition catalogue, Walker Art Gallery, Livepool, 1972. Allinson was primarily a landscapist, his works stylized and clearly modelled, see *Adrian Allinson, 1890–1959*, exhibition catalogue, Fine Art Society, 1984. After leaving the Slade in 1910, Ihlee had an exhibition at the Carfax Gallery in 1912, and also showed at the Leicester, Chenil and Goupil Galleries. He painted landscapes and figure studies and spent the inter-war years living at Collioure, see exhibition catalogue, Belgrave Gallery, London, 1978.

17. Spencer's *Nativity*, was his first large-scale composition, a set subject at the Slade, but painted at Cookham and influenced in particular by the outdoor composition of Piero della Francesca's *Nativity* (to be seen at the National Gallery) as well as by the Gauguins seen at Roger Fry's 'Manet and the Post Impressionists' exhibition of 1910–1911. For more discussion of this work, see *Stanley Spencer RA*, Royal Academy of Arts, exhibition catalogue by Keith Bell, 1980, pp. 42–4. Rosenberg's 'Puvis like' *Sacred Love*, a flat, unmodulated depiction of semi-nude couples in a wooded landscape, shares the same crowded, claustrophobic space, the same absence of any real sense of recession. The picture is illustrated in Ian Parsons, ed., *The Collected Works of Isaac Rosenberg*, Oxford University Press, 1979, no. 8.

18. It was a 'healthy reaction, a movement in the right direction', see 'Post Impressionists', *The Saturday Review*, 12 November 1910, pp. 609–10.

19. Binyon had known Ricketts since c.1895 when with C. J. Holmes he joined the 'Vale' artists circle. See J. G. P. Delany, *Charles Ricketts; A Biography*, Oxford University Press, 1990, p. 54.

20. Binyon felt that Ricketts, like Augustus John, shared Blake's native instinct for 'summarizing form and feature and suppressing detail and background, the more to concentrate on images embodying the live breath of passion, pity, rapture and pain', 'E Pur Si Mouve', (as in note 7).

21. 'Post Impressionism at the Grafton Galleries', *Pages on Art*, London, 1913, pp. 151–8. 'Monsieur M Denis alone has brought a decorative or symbolic element to this agony of Impressionism, and with him we are on familiar ground.'

22. See Charles Ricketts, 'Japanese Painting and Sculpture at the Anglo-Japanese Exhibition', in *Pages on Art*, ibid., pp. 167–86. The Anglo-Japanese Exhibition was held at The White City, Shepherd's Bush.

23. Binyon never satisfactorily explained his difficulties with the art of Matisse, hurriedly resorting to the kinds of racial distinctions that were already well rehearsed by 1910. 'E Pur Si Mouve', (as in note 7).

24. Lawrence Binyon, 'Post-Impressionists', *The Saturday Review*, 12 November 1910, pp. 609–10. By contrast, Roger Fry approved the similarity between Van Gogh and Blake: 'Like Blake, Van Gogh saw the arrogant spirit that inhabits the sunflower', etc. For Fry, Van Gogh's distortions and exaggerations of things seen are only the measure of his deep submission to their essence. 'The Post Impressionists', *Nation*, 3 December 1910, pp. 402–3.

25. Laurence Binyon, op. cit.

26. Laurence Binyon, (as in note 7), pp. 840–1.

27. Laurence Binyon, *The Art of Botticelli, an Essay in Pictorial Criticism*, London, 1913.

28. Spencer was given a copy by the Slade student Gwen Raverat in 1911.

29. In E. T. Cook and A. Wedderburn, eds, *The Works of John Ruskin*, vol. XXIV, George Allen, 1906, pp. 40–1.

30. Ibid., p. 27. Such a view was commonplace by the early 1900s, see for example, E. Phythian, *The Pre-Raphaelite Brotherhood*, Ballantyne Press, n.d., c.1910.

31. 'The Post Impressionists at the Grafton: The Twilight of the Gods', *Morning Post*, 7 November 1910, p. 3, in J. B. Bullen, ed., op cit.

32. For more discussion see David Fraser Jenkins, 'Slade School Symbolism', in *The Last Romantics, The Romantic Tradition in British Art, Burne Jones to Stanley Spencer*, Lund Humphries and Barbican Art Gallery, 1989, p. 75.

33. 'The Grafton Gallery – 1', *The Nation*, 19 November 1910, p. 331.

34. Cited in Royal Academy, *Stanley Spencer* exhibition catalogue, 1980, p. 49. P. G. Konody later praised the picture's 'sense of awe that makes unquestionably a very powerful and direct sense of appeal', *Observer*, 4 January 1920.

35. Ibid.

36. Samuel Smiles made similar points in his discussion of Palmer: 'We are presented with an image of cultural stasis, of a fixed world self-sufficient in its workings, a microcosm that need not participate in anything beyond its own terms of reference', (see note 15), p. 13.

37. These Royal Academy shows are listed in Keith Bell (see note 17), p. 20. For more recent reference to the influences of Pre-Raphaelitism, Samuel Palmer and Blake, see Timothy Hyman and Patrick Wright, eds, *Stanley Spencer*, exhibition catalogue, London: Tate Publishing, 2001.

38. Anon, 'The English Pre-Raphaelites', *The Magazine of Art*, 1900, p. 125. Percy H. Bates's book (George Bell & Sons) had been published in the previous year.

39. See *The Collected Works of Isaac Rosenberg*, (see note 17), p. 285.

40. Letter to Gordon Bottomley, 1 August 1912, included in Andrew Causey, ed., *Poet and Painter, Letters between Gordon Bottomley and Paul Nash, 1910–46* (1st pub., 1955), Redcliffe, Bristol, 1990, pp. 42–3, Bottomley was born in Keighley in 1874, lived most of his life at Silverdale near Grange-over-Sands and suffered continual ill health. He developed friendships from around 1903 with Laurence Binyon, W. B. Yeats and Edward Thomas. His own literary and artistic tastes were for Rossetti and he stated that he had learnt from him 'that art is a distillation of life and nature, not a recording or a commentary, and only incidentally an interpretation', see intro. p. xiii.

41. 'Slade Students' Originality and Knowledge', *The Saturday Review*, 23 November 1912, p. 640.

42. *A View of Cookham* is in the collection of Tullie House Art Gallery, Carlisle, and is illustrated in the Royal Academy catalogue, (as in note 37). Even here, however, a Pre-Raphaelite influence is clear. This is a plateau landscape, viewed from a high vantage point with a high horizon, of the kind produced by Ford Madox Brown and Holman Hunt.

43. The term is Gary Day's in Clive Bloom, ed., *Literature and Culture in Modern Britain*, vol. 1, 1900–1929, Longman, 1993. Day cites John Masefield's dilemma and his realization that, 'When I am buried, all my thoughts and acts, Will be reduced to lists of dates and facts', pp. 36–8.

44. Cited in Keith Bell, *Stanley Spencer, A Complete Catalogue of the Paintings*, Phaidon, 1992, pp. 19–22.

45. *The Fruit Sorters* was described by *The Pall Mall Gazette* as, 'a mixture of arbitrary simplification with realistic detail'. It was bought for the Contemporary Art Society via Lady Ottoline Morrell. For more discussion of the work see John Woodeson, *Mark Gertler, Biography of a Painter 1891–1939*, Sidgwick & Jackson, 1972, p. 340.

46. In a review of 'The New English Art Club', *The New Age*, 4 June 1914, cited in Osbert Sitwell, ed., *A Free House: or the Artist as Craftsman*, London: Macmillan, 1947, p. 290. The Contemporary Art Society was founded in 1910 self-evidently to encourage patronage of modern artists by committee and save them from dependence solely on the whims of any one individual. Edward Marsh maintained a strong involvement with the society.

47. Frances Spalding describes sources for this work. See her *Duncan Grant, A Biography*, London: Chatto & Windus, 1997, p. 102.

48. Although Spalding reports that Grant had begun this work with the express intention of poking fun at the high seriousness with which subject pictures like this one were held. *Adam and Eve* is now lost, but a photograph appears in Simon Watney, *The Art of Duncan Grant*, London: John Murray, 1999, p. 35 (1st pub. 1990).

49. John Rothenstein, 'Stanley Spencer', *Modern English Painters*, vol. 2, *Innes to Moore* (1st pub. 1956), London: Arrow Books, 1962, p. 143. Stressing the instinctive English romantic tendency, Rothenstein continued, 'Like Constable a little more than a century earlier, Stanley Spencer went to school in London simply to find technique to express a way of seeing already, in its essential character, in being', p. 147. More recent critics, like Peter Fuller, took a similar line, emphasizing his connection with the Pre-Raphaelite tradition above any part in the development of European modernism. For Fuller, the 'imaginative and spiritual response to the world of nature', was fundamentally an English attribute. Peter Fuller, 'The Last Romantics', *Modern Painters*, Spring 1989, p. 27.

50. Letter dated 12 December 1919, see *Poet and Painter*, (as in note 40), pp. 115–16.

51. Letter from Bottomley to Nash, March 1911, ibid., p. 31.

52. Cited in Keith Bell, see note 44, p. 29.

53. Penguin Books, 1954 (first published 1911), p. 344.

54. In Geoffrey Keynes, ed., *The Poetical Works of Rupert Brooke*, London: Faber & Faber, 1974, p. 68. *Grantchester, The Old Vicarage*, was written in the Café des Westens, Berlin in May 1912.

55. Robert Graves, *The Common Asphodel; Collected Essays on Poetry 1922–1949*, Hamish Hamilton, 1949, pp. 112–13.

56. 'E Pur Si Mouve', (see note 7).

57. Edward Thomas, *The Country*, B. T. Batsford, 1913, p. 6.

58. Letter to Gordon Bottomley, July 1911, *Poet and Painter*, (as in note 40), p. 21.

59. For more discussion, see Day in C. Bloom, ed., (as in note 43), pp. 36–7. Day argues that night scenes, like Robert Nichols, 'The Tower', increased the mystery of nature in contrast to the dreary regularity of urban life.

60. Raymond Williams, (see note 5), pp. 251–2. Williams cites the persistent undercurrent of the rural/sexual metaphor in the writings of Lawrence.

61. See Roger Cardinal, *The Landscape View of Paul Nash*, Reaktion Books, 1989, p. 31.

62. Letter to Bottomley, 1 August 1912, in *Poet and Painter*, (as in note 40), p. 42.

63. *The Collected Works of Isaac Rosenberg*, (see note 17), p. 286.

64. Letter to Bottomley, 12 September 1922, *Poet and Painter*, (as in note 40), p. 154. Nash was referring especially here to *The Apple Gatherers*. By the 1920s his admiration had faded.

65. 'E Pur Si Mouve', (see note 7).

66. 'Art and Life', (see note 8), pp. 229–30.

67. The quote is from a review in *The Connoisseur*, November 1912, p. 192. The critic praised the picture's conviction, its fine sense of colour and composition, but felt the painter needed to shake off 'the artificial convention of Post Impressionism'.

68. 'Romance and Reality', *The Saturday Review*, 21 December 1907, p. 760.

69. Marsh's father had been a Master of Downing College and Marsh was a Cambridge contemporary of Bertrand Russell, taking a first in the Classical Tripos. He first entered the Civil Service as Chamberlain's assistant Private Secretary. He was described positively as a dilettante by Bernard Denvir in 1947, for his literary skills as editor, writer and translator and wide ranging support for all areas of the arts, especially theatre. Denvir outlined Marsh's art collection which began with his purchase of Herbert Horne's collection of drawings by Blake, Cozens, Girtin and Gainsborough. His first contemporary purchase was Duncan Grant's *Parrot Tulips*, acquired in 1911.

70. T. E. Hulme, 'Modern Art, The Grafton Group', *The New Age*, January 1914, pp. 341–2. Hulme had been sent down from St John's College. In 1913 he had translated Bergson's *Introduction to Metaphysics*, shortly afterwards becoming influenced by Wilhelm Worringer's *Abstraction Und Einfühlung* (Abstraction and Empathy). He substituted the term 'geometric' for abstract and 'vital' for empathetic. The former became the basis of his praise for those artists involved in the Vorticist group, most notably Gaudier Brzescka and David Bomberg. Empathetic art he identified negatively with the Bloomsbury Group. Hulme was killed at the Front in 1917.

71. It is interesting that Fry's landscapes were perceived to be less 'post-impressionist' than his figure studies and still lifes. One critic writing in 1912 felt they were 'more like extreme examples of impressionism, highly simplified no doubt, but still reproducing the actual facts of a scene modified only to a slight degree, and one could admire them wholeheartedly without accepting the advanced principles of the new cult'. *The Connoisseur*, vol. XXXII, 1912, p. 133.

72. Edward Marsh in *Art in England*, ed., R. S. Lambert, London, 1938, p. 80.

73. Cited in Robert Ross, (see note 1), p. 109.

74. The Morrells visit to Cookham in a London cab is described in Gilbert Spencer, *Stanley Spencer by His Brother Gilbert*, Victor Gollancz, 1961. Ottoline Morrell also arranged for Gertler's *Fruit Sorters* to be shown in Bedford Square to influential people. The effects of the relationship between the 'alien' Gertler and the cultural elite of Bloomsbury has been discussed by Janet Wolff: 'The Failure of a Hard Sponge: Class, Ethnicity and the Art of Mark Gertler', *New Formations*, no. 28, Spring, 1996, pp. 44–64.

75. Cited in John Woodeson, *Mark Gertler: Biography of a Painter, 1891–1939*, Sidgwick & Jackson, 1972, p. 107.

76. See Brooker and Widdowson in R. Colls and P. Dodd, eds, *Englishness, Politics and Culture, 1880–1920*, London and Sydney: Croom Helm, 1987, p. 117.

77. *The Studio*, vol. 97, January–June 1929, 'The Edward Marsh Collection', pp. 178–86.

78. Raymond Williams, (see note 5), p. 258.

79. From 'Primitive Scenes and Festivals', in *The Homing of the Winds and other Passages in Prose*, London: Faber & Faber, 1942, pp. 145–7.

80. James Bone, 'The Tendencies of Modern Art', *Edinburgh Review*, April 1913, reprinted in J. B. Bullen, ed., *Post Impressionists in England: The Critical Reception*, London: Routledge, 1988.

Leaving the landscape

1. Mills's pamphlet is discussed in Samuel Hynes, *The Edwardian Turn of Mind*, Princeton: 1968, pp. 24–5. As Hynes points out, Mills in effect posits an English Golden Age here, which is 'agrarian, seafaring, frugal and pious'.

2. Witness the Rev. C. S. Dawe's remark about the Boer War in his chapter on the 'Imperial spirit of our race', 'what a marvellous effect [it] has had in drawing out the great qualities of our race, and in uniting the whole empire … men of all classes from prince to peasant … Still more remarkable was the effect which the need of the great mother had upon her sons in all parts of the empire', etc., see *King Edward's Realm*, London: The Educational Supply Association, n.d. (c.1902), p. 216.

3. Edward Said's formulation of the concept of imperialism has been instructive here. In a number of ways his discussion of orientalism relates to an understanding of the implicit functions of ruralism. 'At some very basic level', he maintains: 'Imperialism means thinking about, settling on, controlling land that you do not possess, that is distant, that is lived on by others … Colonialism which is almost always a consequence of imperialism, is the implanting of settlements on distant territory … Imperialism … lingers in a general cultural sphere as well as in specific political, ideological, economic and social practice.' *Culture and Imperialism*, Vintage, 1993, pp. 5–8. In his earlier work Said quotes from Rudyard Kipling's writings about the road the 'white men' take in the colonies, 'when they go to clean a land', *Orientalism, Western Conceptions of the Orient*, Penguin, 1991, (1st edn, 1978), p. 222. Imperialists usually battle for land and what emerges is a process of purification, an unpeopling of the territory, or at the very least the removal of native stock from positions of power. For Said, 'the geographical space of the Orient was penetrated and worked over … The cumulative effect of Western handling turned the Orient from alien to colonial space.' Ibid.

4. Said maintains that throughout the nineteenth century, the discourse of Orientalism was 'vulnerable to modish and influential currents of thought in the West', i.e. to the effects of imperialism, positivism, utopianism, Darwinism, racism', ibid., p. 43 – so was the discourse of ruralism in the period of this study.

5. W. J. T. Mitchell, 'Imperial Landscape', in Mitchell, ed., *Landscape and Power*, Chicago: University of Chicago Press, 1994, p. 15. The quotation is from Emerson's *Nature*, 1836. Mitchell also quotes Williams, 'a working country is hardly ever a landscape', *The Country and the City*, London: Chatto & Windus, 1973, p. 120.

6. I thank Simon Faulkner here for a conversation on different forms of 'colonial' visual ownership. See also Nicholas Thomas, *Possessions*, London and New York: Thames & Hudson, 1999.

7. Said, *Orientalism*, (see note 3), p. 227.

8. Sir F. Younghusband, 'Inter Racial Relations', *Sociological Review*, III, 1910, cited in Donald Read, *Documents from Edwardian England, 1901–1915*, London: Harrap, 1973, pp. 173–6.

9. Mitchell has described this situation in relation to landscape in general quite perfectly. 'Landscape', he argues, 'might be seen more profitably as something like the "dreamwork" of imperialism, unfolding its own movement in time and space from a central point of origin and folding back on itself to disclose both utopian fantasies of the perfected imperial prospect and fractured images of unresolved ambivalence and unsuppressed resistance', (see note 5), p. 10.

10. Symons, A., *London: A Book of Aspects*, 1909, facsimile edn in *Degeneration and Regeneration: Texts of a Pre-Modern Era*, Fletcher and Stokes, eds, Garland Publishing, 1984, p. 76.

11. P. Nash and G. Bottomley, *Poet and Painter; Letters between Gordon Bottomley and Paul Nash 1910–1946*, Radcliffe Press, 1990 (1st pub. 1955).

12. Cited in Edward Thomas, *The Heart of England*, London: J. M. Dent, 1906, pp. 108–9.

13. In *England after the War, A Study*, Masterman observed that the civilization of the pre-war world 'has vanished in the greatest secular catastrophe which has tormented mankind since the Fall of Rome', London, n.d., c. 1922, quoted in David Peters Corbett, *The Modernity of English Art, 1914–30*, Manchester: Manchester University Press, 1997, p. 63. It is interesting that Masterman, like Ellis, should also use the comparison with the decline of Rome here.

14. e.g. See Ian Jeffrey, *The British Landscape; 1920–1950*, Thames & Hudson, 1984, see also Charles Harrison, 'Still Life and Landscape in the Twenties', in *English Art and Modernism, 1900–1939*, New Haven and London: Yale University Press, 1994 (1st pub. 1981).

15. Witness the circulation during the war years of popular anthologies of verse about the countryside and ruralist prose; also the choice of artists like Steer and Clausen as official war artists documenting the war effort at home.

16. This point has been acknowledged more readily by cultural and literary rather than art historians. Simon Miller, for example, has remarked that in the inter-war period, landscape was 'an icon in which agricultural production was at best incidental and at worst antagonistic', but it is important to note that, 'such imagery was in no way a radical departure from the English tradition, 'but rather built upon an established iconography received from earlier literary traditions such as the Romantics and, more recently, the Georgians', 'Urban Dreams and Rural Reality: Land and landscape in English Culture, 1920–1945', *Rural History*, vol. 6, no. 1, 1995, p. 93.

17. I think in particular here of John Barrell's *The Dark Side of the Landscape: The Rural Poor in English Painting, 1730–1840*, Cambridge: Cambridge University Press, 1980.

Select bibliography

Not all the detailed bibliographical information given in the footnotes (for instance for the citation of individual contemporary reviews) is included in this select bibliography.

Antliff, M., *Inventing Bergson: Cultural Politics and the Parisian Avant-garde*, Princeton, NJ: Princeton University Press, 1993

Baker, D. V., Quoted in *The Timeless Land: The Creative Spirit in Cornwall*, Adams & Dart, 1973

Baron, W., *The Camden Town Group*, London: Scolar Press, 1979

Barrell, J., *The Dark Side of the Landscape: The Rural Poor in English Painting, 1730–1840*, Cambridge: Cambridge University Press, 1980

Bate, P., *The English Pre-Raphaelite Painters*, London: George Bell & Sons, 1899

Beckett, J. & Cherry, D., eds, *The Edwardian Era*, London: Phaidon Press and Barbican Art Gallery, exhibition catalogue, 1987

Bell, C., 'The Debt to Cézanne', *Art* (1914), London: Perigree Books, 1981

Bell, K., *Stanley Spencer, A Complete Catalogue of the Paintings*, London: Phaidon, 1992

Benington, J., *Roderic O'Conor: A Biography, With a Catalogue of his Work*, Belfast: Irish Academic Press, 1992

Benjamin, R., 'The Decorative Landscape, Fauvism, and the Arabesque of Observation', *Art Bulletin*, vol. LXXV, no. 2, June 1993

Bennett, A., *Town and Country*, London, 1907

Bennett, G., Folklore Studies and the English Rural Myth, *Rural History*, vol. 4, no. 1, 1993

Berman, M., *All that is Solid Melts into Air*, London: Verso, 1983

Bermingham, A., *Landscape and Ideology: The English Rustic Tradition, 1740–1860*, Berkeley, CA: 1986

Bertram, A., *Paul Nash: The Portrait of an Artist*, London: Faber & Faber, 1955

Billcliffe, R., *The Scottish Colourists, Cadell, Fergusson, Hunter, Peploe* (1987), London: John Murray, 1996

Bilton, J., 'An Edwardian Gypsy Idyll', *Feminist Art News*, vol. 3, no. 1, 1989

Binyon, L., *Landscape in English Art and Poetry*, London, 1931

—— *The Art of Botticelli, An Essay in Pictorial Criticism*, London, 1913

Blanche, J-E., *Portraits of a Lifetime, The Late Victorian Era, The Edwardian Pageant, 1870–1914*, London: J. M. Dent & Sons, 1937

Bloom, C., ed., *Literature and Culture in Modern Britain*, vol. 1, 1900–1929, London: Longman, 1993

Borland, M., *D. S. MacColl: Painter, Poet, Art Critic*, Harpenden, Herts: Lennard Publishing, 1995

Bourdieu, P., 'Class, Taste and Life-Styles', *Distinction. A Social Critique of the Judgement of Taste* (1979), London: Routledge, 1989

Bourne, G., *Change in the Village* (1912), New York, 1969

Brettell, R., *A Day in the Country*, Los Angeles County Museum of Art, exhibition catalogue, 1984

Brettle, J. & Rice, S., *Public Bodies – Private States, New Views on Photography, Representation and Gender*, Manchester: Manchester University Press, 1994

Broude, N., *Impressionism, A Feminist Reading, The Gendering of Art, Science and Nature in the Nineteenth Century*, New York: Rizzoli, 1991

Brown, F., Recollections, *Art Work* vol. 6, nos. 23 and 24, 1930

Brown, M. R., *Gypsies and other Bohemians. The Myth of the Artist in Nineteenth Century France*, UMI Research Press, Studies in the Fine Arts: The Avant Garde, no. 51, 1985

Bullen, J. B., ed., *Post Impressionists in England: The Critical Reception*, London: Routledge, 1988

Buzard, J., *The Beaten Track: European Tourism, Literature and the Ways to 'Culture'*, Oxford, 1993

Cannadine, D., *Ornamentalism, How the British saw their Empire*, London: Allen Lane, The Penguin Press, 2001

Cardinal, R., *The Landscape Vision of Paul Nash*, London: Reaktion Books, 1989

Carpenter, E., *Civilisation: Its Cause and Cure*, London, 1906

Carter, E., Donald J. and Squires, J., eds, *Space and Place: Theories of Identity and Location*, London: Lawrence & Wishart, 1993

Causey, A., *Paul Nash*, Oxford: Clarendon Press, 1980

—— ed., *Poet and Painter, Letters between Gordon Bottomley and Paul Nash, 1910–46* (1955), Redcliffe, Bristol, 1990

—— Camden Arts Centre, *Mark Gertler: Paintings and Drawings*, London: exhibition catalogue, 1992

Cherry, D., review of Christopher Wood's 'Paradise Lost', *Art History*, Sept. 1989

—— *Painting Women: Victorian Women Artists*, London: Routledge, 1993

Clausen, G., *Bastien-Lepage as Artist*, in Andre Theuriet, *Jules Bastien-Lepage and His Art*, London: Fisher Unwin, 1892

—— *Six Lectures on Painting*, London, 1904

—— *Royal Academy Lectures on Painting: Sixteen Lectures Delivered to Students of the Royal Academy of Arts*, London: Methuen, 1913

Clements, K., *Henry Lamb, The Artist and his Friends*, Bristol: Redcliffe Press, 1985

—— and Martin, S., *Henry Lamb, 1883–1960*, catalogue of an exhibition, City of Manchester Art Galleries, 1984

Cobden-Unwin, S., *The Land Hunger, Life under Monopoly, Descriptive Letters and Other Testimonies from those who have Suffered*, London: Fisher Unwin, 1913

Coleman, B. I., ed., *The Idea of the City in 19th Century Britain*, London: Routledge & Kegan Paul, 1973

Colls, R. and Dodd, P., eds, *Englishness, Politics and Culture, 1880–1920*, London and Sydney: Croom Helm, 1987

Compton, S., ed., *British Art in the Twentieth Century: The Modern Movement*, London, 1986

Cook, E. T. and Wedderburn, A., *The Works of John Ruskin*, vol. XXIV, London: George Allen, 1906

Coombes, A. E., 'Museums and the Formation of National and Cultural Identities', *Oxford Art Journal*, vol. 11, no. 2, 1988

Coombes, H., *Edward Thomas*, London: Chatto & Windus, 1956

Cooper, D., 'The Problem of Wilson Steer', *Burlington Magazine*, vol. 84, 1944

Cooper, E., *The Life and Work of Henry Scott Tuke*, London: Gay Men's Press, 1987

Corbett, D. P., *The Modernity of English Art*, Manchester: Manchester University Press, 1997

—— and Perry, L., eds, *English Art, 1860–1914, Modern Artists and Identity*, Manchester: Manchester University Press, 2000

——, Holt, Y. and Russell, F., eds, *The Geographies of English Art, Landscape and the National Past, 1880–1940*, London and New Haven: Yale University Press, 2002

Cork, R., *Vorticism and Abstract Art in the First Machine Age*, 2 vols, Gordon Fraser, 1976

—— *Art Beyond the Gallery in Early Twentieth Century England*, New Haven and London: Yale University Press, 1985

Crawshaw, C. and Urry, J., 'Tourism and the Photographic Eye', in Rojek, C. and Urry, J., eds, *Touring Cultures, Transformations of Travel and Theory*, London and New York: Routledge, 1997

Cumming, E., *Colour, Rhythm and Dance, Paintings and Drawings by J. D. Fergusson and his Circle in Paris*, Scottish Arts Council, 1985

—— and Long, P., *The Scottish Colourists, 1900–1930*, National Galleries of Scotland, Edinburgh, 2000

Cunningham, G., *New Women and the Victorian Novel*, London: Macmillan, 1978

Cunningham, P., 'Annie Jenness Miller and Mabel Jenness: Promoters of Physical Culture and Correct Dress', *Dress*, 1990, vol. 16

Dangerfield, G., *The Strange Death of Liberal England, 1910–14* (1935), Capricorn Books, 1961

Daniels, S., *Fields of Vision: Landscape Imagery and National Identity in England and the United States*, London: Polity Press, 1993

Davies, M., *Life in an English Village*, London, 1909

Davin, A., 'Imperialism and Motherhood', *History Workshop*, vol. 5, 1978

Delaney, J. P., *Charles Ricketts: A Biography*, Oxford: Oxford University Press, 1990

Delany, P., *The Neo-Pagans, Friendship and Love in the Rupert Brooke Circle*, London: Macmillan, 1987

Denvir, B., 'Sir Edward Marsh', *The Studio*, July 1947

Dewhurst, W., *Impressionist Painting, Its Origin and Development*, 1904

Ditchfield, P. H., *Cottage and Village Life*, Dent (1912), facsimile ed., Bracken Books, 1993

d'Offay, A., *Spencer Frederick Gore, 1878–1914*, exhibition catalogue, 1983

Doyle, B., *English and Englishness*, London: Routledge, 1989

Dunbar, J., *Dame Laura Knight*, London and Glasgow: Collins, 1975

East, A., *Landscape Painting in Oil Colour*, London: Cassell & Co., 1906

Easton, M. ed., *Augustus John; Portraits of the Artist's Family*, catalogue of an exhibition, University of Hull, 1970

—— and Holroyd, M., *The Art of Augustus John*, London: Secker and Warburg, 1974

Eisenmann, S., *Gauguin's Skirt*, London: Thames & Hudson, 1997

Falkenheim, J., *Roger Fry and the Beginnings of Formalist Art Criticism*, Ann Arbor, Michigan: University of Michigan Press, 1980

Farley, J. W., *Pull No More Poles, An Account of a Venture among Hop Pickers*, Faith Press, 1962

Fauve Painting, 1905–7, The Triumph of Pure Colour, exhibition catalogue, London: Courtauld Institute Gallery, 2001

Fergusson, L., 'Souvenir of Camden Town, A Commemorative Exhibition', *The Studio*, 1930, vol. 99

Flint, K., 'Moral Judgement and the Language of English Art Criticism, 1870–1910', *Oxford Art Journal*, 1983, vol. 6, no. 2

—— *Impressionists in England: The Critical Reception*, London: Routledge & Kegan Paul, 1984

Ford Madox Ford, *Provence* (1935), New York: The Ecco Press, 1979

Fordham, M., *Mother Earth*, Simpkin, Marshall, Hamilton, Kent and Co., 1908

Forge, A., *Philip Wilson Steer*, Arts Council of Great Britain, exhibition catalogue, 1960

Fothergill, J. and Browse, L., *J. D. Innes*, London: Faber & Faber, 1946

Fox, C., *Dame Laura Knight*, London: Phaidon, 1988

—— *Stanhope Forbes and the Newlyn School*, David & Charles, 1993

—— and Greenacre, F., *Painting in Newlyn 1880–1930*, Barbican Art Gallery, exhibition catalogue, 1985

Francis, M. and Hester, R. T., *The Meaning of Gardens, Idea, Place, Action*, Cambridge, MA: MIT Press, 1991

Fraser Jenkins, A. D., *Augustus John, Studies for Compositions*, exhibition catalogue, National Museum of Wales, Cardiff, 1978

Fraser, D. J., *J. D. Innes at the National Museum of Wales*, Cardiff, exhibition catalogue, 1975

—— *The Last Romantics, The Romantic Tradition in British Art*, Barbican Art Gallery, exhibition catalogue, 1989

Freeman, J., ed., *The Fauve Landscape*, London and New York: Guild Publishing, 1900

Fry, R., *Vision and Design* (1920), edited by J. Bullen, Oxford: Oxford University Press, 1981

Gathorne-Hardy, R., ed., *Ottoline: The Early Memoirs of Ottoline Morrell*, London: Faber, 1963

Giddens, A., *Durkheim: His life, Writings and Ideas*, Harvester Press, 1978

Giles, J. and Middleton, T., eds, *Writing Englishness, 1900–1950, An Introductory Sourcebook on National Identity*, London: Routledge, 1995

Gilman, S., *Health and Illness – Images of Difference*, London: Reaktion Books, 1995

Gore, F. and Shone, R., *Spencer Frederick Gore, 1878–1914*, catalogue of an exhibition London: Anthony d'Offay, 1983

Gould, P., *Early Green Politics: Back to Nature, Back to the Land, and Socialism in Britain, 1880–1900*, Brighton: The Harvester Press, 1988

Graves, R., *The Common Asphodel; Collected Essays on Poetry, 1922–1949*, Hamish Hamilton, 1949

Green, N., *The Spectacle of Nature, Landscape and Bourgeois Culture in Nineteenth Century France*, Manchester: Manchester University Press, 1990

Griffiths, S., *John Currie, Paintings and Drawings, 1905–14*, exhibition catalogue, City Museum and Art Gallery, Bethesda St Hanley, Stoke-on-Trent, 1980

Halton, E. G., *Modern Painting 1: The Work of Laura and Harold Knight*, London, 1921

Harrison, C. and Wood, P., eds, *Art in Theory, 1900–1990, An Anthology of Changing Ideas* (1992), Oxford, UK and Cambridge, USA: Blackwells, 1996

Harrison, C., 'Impressionism, Modernism and Originality', in Frascina, Blake et al., *Modernity and Modernism: French Painting in the Nineteenth Century*, New Haven and London: Yale University Press and The Open University, 1993

—— *English Art and Modernism, 1900–1939* (1981), New Haven and London: Yale University Press, 1994

Hartrick, A. S., *A Painter's Pilgrimage through Fifty Years*, Cambridge: Cambridge University Press, 1939

Harvey, D., *The Condition of Post Modernity; An Enquiry into the Origins of Cultural Change* (1980), Oxford: Blackwell, 1990

Hassall, C., *Edward Marsh – Patron of the Arts: A Biography*, London, 1959

Hatcher, J., *Laurence Binyon, Poet, Scholar of East and West*, Oxford, 1995

Heller, A., *A Theory of Feelings*, Assen, 1979

Hemingway, A., *Landscape Imagery and Urban Culture in early Nineteenth Century Britain*, Cambridge: Cambridge University Press, 1992

—— 'National Icons and the Consolations of Imagery', *Oxford Art Journal*, vol. 17, no. 2, 1994

Herbert, J., *Fauve Painting: the Making of Cultural Politics*, New Haven: Yale University Press, 1992

Hewison, R., *The Heritage Industry, Britain in a Climate of Decline*, London: Methuen, 1987

Hind, C. L., *Days in Cornwall* (1907), London: Methuen, 1924
—— *Landscape Painting from Giotto to the Present Day, Vol. II, From Constable to the Present Day*, London: Chapman and Hall, 1924
Hissey, J. J., *Untravelled England*, London: MacMillan, 1906
Hobsbawm, E., *Industry and Empire, From 1750 to the Present Day*, Harmondsworth: Pelican, 1981
Holroyd, M., *Augustus John, Vol. 1, The Years of Innocence, Vol. II The Years of Experience*, London: Heinemann, 1974 and 1975
—— *Augustus John, The New Biography*, London: Chatto & Windus, 1996
Holt, Y., *Philip Wilson Steer*, Seren Books, 1992
—— 'Nature and Nostalgia, Philip Wilson Steer and the Edwardian Landscape', *Oxford Art Journal*, vol. 19, no. 2, 1996
—— 'London Types', *The London Journal*, vol. 25, no. 1, 2000
Holton, S. S., *Feminism and Democracy, Women's Suffrage and Reform Politics in Britain 1900–1918*, Cambridge: Cambridge University Press, 1986
Howard, E., *Garden Cities of Tomorrow*, London: Faber & Faber, 1902
Howkins, A., *Reshaping Rural England, A Social History*, London: Harper Collins, 1991
Hudson, W. H., *The Land's End*, Hutchinson & Co., 1908
Hussey, D., *George Clausen*, Ernest Benn, 1923
Hutchinson, S., *The History of the Royal Academy, 1768–1968*, London: Chapman & Hall, 1968
Huyssen, A., *After the Great Divide, Modernism, Mass Culture, Post Modernism*, Indiana, 1986
Hyman, T. and Wright, P., eds, *Stanley Spencer*, catalogue of an exhibition, London: Tate Publishing, 2001
Hynes, S., *The Edwardian Turn of Mind*, Princeton: Princeton University Press, 1968
Inglis, F., 'Landscape as Popular Culture', *Landscape Research*, vol. 12, no. 3, 1987
Ironside, R., *Wilson Steer*, London: Phaidon, 1943
Jackson, H., *Romance and Reality, Essays and Studies*, London: Grant Richards Ltd, 1911
—— *The 1890s: A Review of Art and Ideas at the Close of the Nineteenth Century*, London, 1913
Jacobs, M., *The Good and Simple Life, Artist Colonies in Europe and America*, London: Phaidon, 1985
Janowitz, A., *English Ruins: Poetic Purpose and the National Landscape*, Cambridge: Cambridge University Press, 1990
Jeffrey, I., *The British Landscape, 1920–1950*, New York: Thames & Hudson, 1984
Jenkins, P., 'The Englishness of Stanley Spencer', *Modern Painters*, Jan. 4, 1991
John, A., *Chiaroscuro, Fragments of an Autobiography*, Jonathan Cape, 1962
—— *Finishing Touches*, Jonathan Cape, 1966
Johnston, R., *Roderic O'Conor, 1860–1940*, exhibition catalogue, Barbican Art Gallery, London and Ulster Museum, Belfast, 1985
Kestner, J., *Masculinities in Victorian Painting*, London: Scolar Press, 1995
Keynes, G., *The Poetical Works of Rupert Brooke*, London: Faber & Faber, 1974
King, J., *Interior Landscapes: A Life of Paul Nash*, London: Weidenfeld & Nicolson, 1987
Knight, L., *Oil Paint and Grease Paint* (1936), Harmondsworth: Penguin, 1941
—— *The Magic of a Line: The Autobiography of Laura Knight*, William Kimber, 1965
Lambert, R. S., ed., *Art in England*, Harmondsworth: Penguin, 1938
Laughton, B., 'Steer and French Painting', *Apollo*, vol. 91, 1970
—— *Philip Wilson Steer, 1860–1942*, Oxford: Clarendon Press, 1971
Laver, J., *Portraits in Oil and Vinegar*, John Castle, 1925
Le Gates and Stouts, eds, *The City Reader*, London: Routledge, 1996
Lea, F. A., *The Life of Middleton Murry*, London: Methuen & Co., 1959

Leighton, J. and Thomson, R., *Seurat and the Bathers*, National Gallery Publications, 1977

Leslie, S., *The End of a Chapter*, Constable & Co., 1916

Light, A., *Forever England; Femininity, Literature and Conservatism Between the Wars*, London: Routledge, 1991

Lloyd, C., ed., *Studies in Camille Pissarro*, London: Routledge & Kegan Paul, 1986

London, J., *People of the Abyss*, London, 1903

Lowenthall, D., 'British National Identity and the English Landscape', *Rural History*, vol. 2, 1991

Lübbren, N., *Rural Artists' Colonies in Europe, 1870–1910*, Manchester: Manchester University Press, 2001

Lucas, J., *England and Englishness: Ideas of Nationhood in English Poetry 1688–1900*, London: Hogarth Press, 1992

—— *The Radical Twenties Aspects of Writing, Politics and Culture*, Five Leaves Publications, 1995

Ludovici, A. M., *Nietzsche and Art*, New York, 1911

MacCannell, D., *Empty Meeting Grounds – The Tourist Papers*, London: Routledge, 1992

MacCarthy, F., *The Simple Life; C. R. Ashbee in the Cotswolds*, London: Lund Humphries, 1981

MacColl, D. S., *Nineteenth Century Art*, Glasgow, 1902

—— *The Slade, A Collection of Drawings and some Pictures done by Past and Present Students of the London Slade School of Art, MDCCCXCIII–MDCCCCVII*, 1907

—— *Life, Work and Setting of Philip Wilson Steer*, London: Faber & Faber, 1945

MacGregor, S., *John Duncan Fergusson, 1874–1861*, exhibition catalogue, Duncan R. Miller Fine Art, n.d.

MacKenzie, J., ed., *Imperialism and Popular Culture*, Manchester: Manchester University Press

Mackenzie, J. M., *Propaganda and Empire, The Manipulation of British Public Opinion, 1880–1960*, Manchester: Manchester University Press, 1984

Macniece, L., *The Poetry of W. B. Yeats* (1941), London: Faber & Faber, 1967

Marriot, C., 'Masters of Modern Art: Augustus John', *Colour Magazine*, 1918

Marsh, E., *A Number of People: A Book of Reminiscences*, Heinemann, 1938

—— *Art in England*, edited by R. S. Lambert, London, 1938

Marsh, J., *Edward Thomas, A Poet for His Country*, Elek Books, 1978

—— *Back to the Land, The Pastoral Impulse in England from 1880–1914*, Quartet Books, 1982

Martin, W., ed., *Orage as Critic*, London, 1974

Masefield, J., 'The Land Workers', in *Collected Poems*, London: Heinemann, 1923

Masterman, C. F. G., *The Heart of the Empire, Discussions of Modern City Life in England*, London: Fisher Unwin, 1902

—— *In Peril of Change*, London: Fisher Unwin, 1905

—— *The Condition of England*, London: Methuen, 1909

——, Hodgson, W. B. and Others, *To Colonise England, A Plea for a Policy*, London: Fisher Unwin, 1907

Matless, D., *Landscape and Englishness*, London: Reaktion Books, 1998

McCarthy, D., (intro.) *Manet and the Post-Impressionists*, Grafton Galleries, exhibition catalogue, 1910

McConkey, K., 'The Bouguereau of the Naturalists: Bastien-Lepage and British Art', *Art History* vol. 1, no. 3, 1978

—— *A Painter's Harvest, H. H. La Thangue, 1859–1929*, Oldham Art Galleries and Museum, exhibition catalogue, 1978

—— *Sir George Clausen, RA, 1852–1944*, Bradford and Tyne & Wear Galleries & Museums, exhibition catalogue, 1980

—— *British Impressionism*, London: Phaidon, 1989

—— *Impressionism in Britain*, Yale University Press and Barbican Art Gallery, exhibition catalogue, 1995

—— *An English Idyll, A loan exhibition of works by Sir Alfred Munnings*, Sotheby's, January 2001

—— and Holt, Y., *British Impressionism*, Daimaru Museum, Tokyo, exhibition catalogue, 1997

McWilliam, N., ed., *Life and Landscape, P. H. Emerson in East Anglia, 1885–1900*, Sainsbury Centre for Visual Arts, exhibition catalogue, 1986

Michel and Fox, eds, *Wyndham Lewis on Art-Selected Writings, 1913–56*, London, 1969

Miller, M., *Letchworth: The First Garden City* (1989), Chichester: Phillimore, 1993

Miller, S., 'Urban Dreams and Rural Reality: Land and Landscape in English Culture, 1920–1945', *Rural History*, vol. 6, no. 1, 1995

Mingay, G., ed., *The Victorian Countryside*, London: Routledge, 1981

Mitchell, C., 'Time and the Idea of Patriarchy in the Pastorals of Puvis de Chavannes', *Art History*, vol. 10, no. 2, June 1987

Mitchell, W. J. T., *Landscape and Power*, Chicago: University of Chicago Press, 1994

Mitford, M., *Our Village*, London: Macmillan, 1893

Moore, G., *Modern Painting*, Walter Scott, 1898

Morris, M., *The Art of J. D. Fergusson: A Biased Biography*, Glasgow and London: Blackie, 1974

Morris, W., *News from Nowhere*, London: Longman, 1891

Munro, J., *Philip Wilson Steer: Paintings, Watercolours and Drawings*, Arts Council of Great Britain, exhibition catalogue, 1985

Nash, P. and Bottomley, G., *Poet and Painter; Letters between Gordon Bottomley and Paul Nash 1910–1946*, Redcliffe Press, 1990 (1st pub. 1955)

Nathanson, C. A., 'Anne Estelle Rice: Theodor Dreiser's "Ellen Adams Wrynn"', *Women's Art Journal*, Fall 1992/Winter 1993, pp. 1–9.

—— *The Expressive Fauvism of Anne Estelle Rice*, exhibition catalogue, New York: Hollis Taggart Galleries, 1997

Nevinson, C. R. W., *Paint and Prejudice*, London, 1937

Nicholson, A. et al., *Towards a New Landscape*, London: Bernard Jacobson, Ltd, 1993

Nowell-Smith, S., ed., *Edwardian England* (1901–1914), Oxford: Oxford University Press, 1964

O'Day, A., ed., *The Edwardian Age, Conflict and Stability, 1900–14*, London: Macmillan, 1979

Parsons, I., ed., *The Collected Works of Isaac Rosenberg*, Oxford: Oxford University Press, 1979

Patrick, J., 'Agricultural Gangs', *History Today*, March, 1986

Payne, C., *Toil and Plenty, Images of the Agricultural Landscape in England, 1780–1890*, New Haven and London: Yale University Press, 1993

Pemble, J., *The Mediterranean Passion, Victorians and Edwardians in the South*, Oxford: Clarendon Press, 1987

Philips, C., *Frederick Walker and his Works*, London: Seeley & Co., 1905

Phythian, E., *The Pre-Raphaelite Brotherhood*, Ballantyne Press, c. 1910

Powell, D., *The Edwardian Crisis, 1901–1914*, Basingstoke: Macmillan, 1996

Price, B. D., ed., *The Registers of Henry Scott Tuke, 1879–1928*, Royal Cornwall Polytechnic Society, Falmouth, 1983

Pugh, S., *Reading Landscape, Country – City – Capital*, Manchester: Manchester University Press, 1990

Purdom, C. B., *The Garden City of Tomorrow, A Study in the Development of a Modern Town*, London: Dent, 1903

Ransome, A., *Bohemia in London*, Chapman & Hall, 1907

Read, D., ed., *Documents from Edwardian England, 1901–1915*, London: Harrap, 1973

Reade, B., *Sexual Heretics, Male Homosexuality in English Literature from 1850–1900*, London: Routledge & Kegan, Paul, 1970

Reed, C., ed., *Not at Home, The Suppression of Domesticity in Modern Art and Architecture*, London and New York: Thames & Hudson, 1996

Rees, A. L. and Borzello, F., eds, *The New Art History*, London: Camden Press, 1986

Rewald, J., ed., *Paul Cézanne: Letters* (1941) Oxford: Bruno Cassirer, 1976

Rich, P., 'Elite and Popular Culture: Patriotism and the British Intellectuals c.1886–1945', *History of European Ideas*, vol. 11, 1989

Ricketts, C., *Pages on Art*, Constable & Co., 1913

Rider Haggard, H., *Rural England, Being an Account of Agricultural and Social Researches Carried Out in the Years 1901 & 1902*, 2 vols, London: Longman, 1902

Robins, A. G., *Modern Art in Britain, 1910–1914*, London: Barbican Art Gallery and Merrell Holberton, exhibition catalogue, 1997

Robinson, A., *Poetry, Painting and Ideas, 1885–1914*, London: Macmillan, 1985

Robinson, D., *Stanley Spencer: Visions from a Berkshire Village*, London: Phaidon, 1979

Rogers, T., ed., *Georgian Poetry 1911–22: The Critical Heritage*, London: Routledge & Kegan Paul, 1977

Rojek, C., *Ways of Escape: Modern Transformation in Leisure and Travel*, London: Macmillan, 1993

Rose, W. K., ed., *The Letters of Wyndham Lewis*, Norfolk, Connecticut: New Directions, 1963

Ross, R., *The Georgian Revolt: The Rise and Fall of a Poetic Ideal, 1910–1922*, Faber & Faber, 1965

Rothenstein, J., *Augustus John*, London: Phaidon, 1944

—— *Modern English Painters, Sickert to Smith*, 1952, and *Lewis to Moore*, 1956, Eyre & Spottiswoode

Rothenstein, W., 'Recollections', *Art Work*, vol. 5, no. 19, 1929

—— *Men and Memories, Recollections of William Rothenstein; 1872–1900, vol. 1*, Faber & Faber, 1932

Rowan, E., *Some Miraculous Promised Land, J. D. Innes, Augustus John and Derwent Lees in North Wales*, Mostyn Art Gallery, exhibition catalogue, 1982

Rowse, A. L., *A Cornish Anthology*, A. Hodge, 1968

Royal Academy of Arts, *Post Impressionism; Cross-currents in European Painting*, Weidenfeld & Nicholson, exhibition catalogue, 1979

Rutter, F., *Revolution in Art, An Introduction to the Study of Gauguin, Van Gogh and other Modern Painters*, The Art News Press, 1910

—— *Some Contemporary Artists*, London: Leonard Parsons, 1922

—— *Since I Was Twenty-Five*, London, Constable, 1925

—— *Evolution in Modern Art; A Study in Modern Painting, 1870–1925*, Harrap, 1926

—— *Art in My Time*, Rich and Cowan, 1933

Said, E., *Orientalism; Western Conceptions of the Orient*, Harmondsworth: Penguin, 1991

—— *Culture and Orientalism*, Vintage, 1993

Sainsbury, M. T., *Henry Scott Tuke – A Memoir*, London, 1933

Samuel, R., 'The Making and Unmaking of National Identity', *Patriotism*, vol. 111, National Fictions, London: Routledge, 1989

Sayer, K., *Women of the Fields; Representations of Rural Women in the Nineteenth Century*, Manchester: Manchester University Press, 1995

Schapiro, M., *Theory and Philosophy of Art, Style, Artist and Society*, New York: George Brazilier, 1994

Schiff, R., *Cézanne and the End of Impressionism, A Study of the Theory, Technique, and Critical Evaluation of Modern Art*, Chicago: University of Chicago Press, 1984

Schwabe, R., 'Three Teachers, Brown, Tonks and Steer', *The Burlington Magazine*, June 1943

Schwarz, B., 'Englishness and the Paradox of Modernity', *New Formations*, 1987

Scott, W. S., *The Riviera*, London: A. & C. Black, 1907

Seddon, R., *J. D. Innes*, Graves Art Gallery, Sheffield, exhibition catalogue, 1961

Shannon, R., *The Crisis of Imperialism, 1865–1915*, Paladin, 1976

Shaw C., and Chase M., eds, *The Imagined Past: History and Nostalgia*, Manchester: Manchester University Press, 1989

Shaw, G. Bernard, 'The Sanity of Art', 1895, reprinted in Harrison, Wood and Gaiger, eds, *Art in Theory, 1815–1900, An Anthology of Changing Ideas*, Oxford: Blackwell, 1998

Shields, R., *Places on the Margin; Alternative Geographies of Modernity*, London: Routledge, 1991

Shone, R., *The Art of Bloomsbury, Roger Fry, Vanessa Bell and Duncan Grant*, London: Tate Gallery Publishing, 1999

Short, B., *The English Rural Community, Image and Analysis*, Cambridge: Cambridge University Press, 1992

Silver, K. E., *Making Paradise, Art, Modernity, and The Myth of the French Riviera*, Cambridge, MA: MIT Press, 2001

Simister, K., *Living Paint, J. D. Fergusson, 1874–1961*, Edinburgh and London: Mainstream Publishing Company, 2001

Sitwell, O., *The Homing of the Winds and other Passages in Prose*, London: Faber & Faber, 1942

—— ed., *A Free House: or the Artist as Craftsman, being the Writings of Walter Richard Sickert*, London: Macmillan, 1947

Skipwith, P., *William Stott of Oldham and Edward Stott*, Fine Art Society, exhibition catalogue, 1976

Sontag, S., *Illness as Metaphor*, London: Allen Lane, 1978

Spalding, F., *British Art Since 1900*, New York: Thames & Hudson, 1986

—— *Duncan Grant, A Biography*, London: Chatto & Windus, 1997

—— et al., *Landscape in Britain, 1850–1950*, Arts Council of Great Britain, Hayward Gallery, exhibition catalogue, 1983

Spencer, G., *Stanley Spencer by his Brother Gilbert*, Victor Gollancz, 1961

Stanley Spencer, Royal Academy of Arts, exhibition catalogue, 1980

Stedman Jones, G., *Outcast London*, Oxford, 1971

Steele, T., *Alfred Orage and the Leeds Art Club, 1893–1923*, London: Scolar Press, 1990

Stevenson, R. A. M., *Velazquez*, London: George Bell & Sons, 1895

Stokes, J., ed., *Fin de Siècle/Fin de Globe: Fears and Fantasies of the Late Nineteenth Century*, London: Macmillan, 1992

Stratton, M., ed., *The Country*, Fellowship Books, c.1912

Sutton, D., ed., *Letters of Roger Fry*, London: Chatto & Windus, 1972

Symons, A., *London: A Book of Aspects*, 1909, facsimile edn in *Degeneration and Regeneration: Texts of a Pre-Modern Era*, Fletcher and Stokes, eds, Garland Publishing, 1984

Szczelkun, S., *The Conspiracy of Good Taste, William Morris, Cecil Sharp, Clough Williams Ellis and the Repression of Working Class Culture in the Twentieth Century*, Working Press, 1993

Taylor, J., *A Dream of England, Landscape, Photography and the Tourist's Imagination*, Manchester: Manchester University Press, 1994

Thomas, E., *The Heart of England*, London: J. M. Dent, 1906

—— *The South Country*, London: J. M. Dent, 1909

—— *The Country*, Batsford, 1913

—— *The Icknield Way*, Constable, 1913

Thomas, N., *Possessions*, London and New York: Thames & Hudson, 1999

Thompson, E. P., *The Making of the English Working Class*, London: Gollancz, 1963

Thompson, F., *Lark Rise to Candleford* (1939), Oxford: Oxford University Press, 1969

Thomson, R., *Monet to Matisse, Landscape Painting in France, 1874–1914*, Edinburgh: National Gallery of Scotland, 1994

Thornton, R. K. R., ed., *Ivor Gurney, War Letters*, London: Hogarth Press, 1984

Tickner, L., *The Spectacle of Women, Imagery of the Suffrage Campaign, 1907–14*, London: Chatto & Windus, 1987
—— *Modern Life and Modern Subjects: British Art in the Early Twentieth Century*, New Haven and London: Yale University Press, 2000.
Tonks, H., 'Notes from Wanderyears', *Art Work*, vol. 5, no. 20, 1929
Turner, B., 'A Note on Nostalgia', *Theory, Culture and Society*, vol. 4, 1987
Urry, J., *The Tourist Gaze: Leisure and Travel in Contemporary Societies*, London: Sage Publications, 1990
Vaughan, W., 'The Englishness of British Art', *Oxford Art Journal*, vol. 13, no. 2, 1990
Wagner, A., 'Courbet's Landscapes and their Market', *Art History*, vol. 4, Dec. 1981
Wainwright, D. and Dinn, C., *Henry Scott Tuke, Under Canvas, 1858–1929*, Sarema Press, 1989
Waller, P. J., *Town, City and Nation, 1850–1914*, Oxford: Oxford University Press, 1983
Walton, J. K., *The English Seaside Resort – A Social History, 1750–1914*, Leicester: Leicester University Press, 1983
Watney, S., *English Post-Impressionism*, London: Studio Vista, 1980
—— 'The Connoisseur as Gourmet' in *Formations of Pleasure*, London: Routledge & Kegan Paul, 1983
—— *The Art of Duncan Grant*, London: Murray, 1990
Weisberg, G. P., *The European Realist Tradition*, Indiana: Indiana University Press, 1983
—— *Beyond Impressionism, The Naturalist Impulse in European Art 1860–1905*, New York: Thames & Hudson, 1992
Westland, E., ed., *Cornwall: The Cultural Construction of Place*, Patten Press, 1997
Whitfield, S., *Fauvism*, London and New York: Thames & Hudson, 1991
Wiener, M., *English Culture and the Decline of the Industrial Spirit, 1850–1950*, Cambridge: Cambridge University Press, 1981
Williams, I. F. and Parris, L., *The Discovery of Constable Country*, Hamilton, 1984
Williams, R., *The Country and the City*, London: Chatto & Windus, 1973
Wolff, J., 'The Failure of A Hard Sponge: Class, Ethnicity and the Art of Mark Gertler', *New Formations*, Spring 1996
Wood, C., *Paradise Lost: Paintings of English Country Life and Landscape – 1850–1914*, London: Barrie & Jenkins, 1988
Wood, P. J., *Spencer Frederick Gore, 1878–1914*, Arts Council of Great Britain, exhibition catalogue, 1955
Woodeson, J., *Mark Gertler, Biography of a Painter, 1891–1939*
—— *Spencer Frederick Gore*, Minories, Colchester, exhibition catalogue, 1970
Wright, P., *On Living in an Old Country, The National Past in Contemporary Britain*, London: Verso, 1985

Index

Picture or book titles are given under artist or author in *italics*.
Plate numbers are given in brackets after the title.
Figure numbers are given in brackets after the page numbers on which they appear.